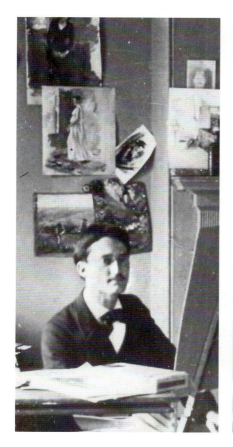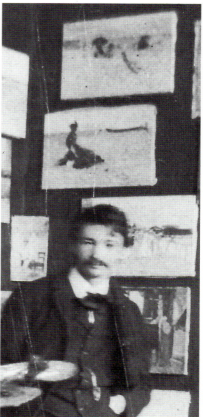

Revolutionaries of Realism

THE LETTERS OF JOHN SLOAN
AND ROBERT HENRI

Edited by Bennard B. Perlman

Introduction by Mrs. John Sloan

Princeton University Press · Princeton, New Jersey

Published by Princeton University Press,
41 William Street, Princeton, New Jersey 08540

In the United Kingdom:
Princeton University Press, Chichester, West Sussex

Library of Congress Cataloging-in-Publication Data
Sloan, John, 1871–1951.
Revolutionaries of realism : the letters of John Sloan
and Robert Henri / edited by
Bennard B. Perlman ; introduction by Mrs. John Sloan.
p. cm.
Includes bibliographical references and index.
ISBN 0-691-04413-9 (cloth : alk. paper)
1. Sloan, John, 1871–1951—Correspondence. 2. Henri, Robert,
1865–1929—Correspondence. 3. Artists—United States—
Correspondence. I. Henri, Robert, 1865–1929. II. Perlman,
Bennard B. III. Title.
N6537.S57A3 1997
709′.2′273—dc20
[B] 96-27113

This book has been composed in Galliard
by The Composing Room of Michigan, Inc.

The publication of this book was aided by a grant from
the John Sloan Memorial Foundation

Princeton University Press books are printed on acid-free paper
and meet the guidelines for permanence and durability of
the Committee on Production Guidelines for Book Longevity
of the Council on Library Resources

Printed in the United States of America

10 9 8 7 6 5 4 3 2 1

10 9 8 7 6 5 4 3 2 1 (pbk.)

DESIGNED BY LAURY A. EGAN

To Miriam, Helen, and Janet

Contents

✳

List of Illustrations	vii
Acknowledgments	xv
Preface	xvii
Editorial Note	xxiii
Introduction by Mrs. John Sloan	xxv
1893 to 1899	1
1900 to 1909	39
1910 to 1919	193
1920 to 1929	255
Epilogue	323
Chronology	332
Selected Publications: John Sloan	341
Selected Publications: Robert Henri	342
Index	343

List of Illustrations

✳

1. Robert Henri in his studio at 806 Walnut Street, Philadelphia, 1893. Photograph. Courtesy Janet J. Le Clair. ... 2

2. John Sloan in his first Philadelphia studio at 705 Walnut Street, 1893. Photograph. Delaware Art Museum, John Sloan Archive. ... 3

3. The Charcoal Club, 1893. Photograph. Delaware Art Museum, John Sloan Archive. ... 4

4. 806 Walnut Street, Philadelphia, 1956. Photograph by the editor. ... 6

5. Henri and Sloan at baseball game, Spring, 1893. Photograph. Delaware Art Museum, John Sloan Archive. Photographer: Gossy. ... 7

6. Henri, *Concarneau Street Scene,* 1894. Pen, brush, and ink on paper, 15¾ × 10⅜ inches. Photograph courtesy A. M. Adler Fine Arts. ... 10

7. Sloan reclining on Henri's "rag bag," 806 Walnut Street, 1894. Photograph. Delaware Art Museum, John Sloan Archive. ... 11

8. Sloan, *On the Pier,* 1894. Resort page, *Philadelphia Inquirer,* 22 July 1894. Pen, brush, and ink on paper, 13⅛ × 10⅛ inches. Delaware Art Museum, Gift of Helen Farr Sloan. ... 12

9. Sloan, *Woman and Butterfly,* 1895. Cover for *Moods: A Journal Intime,* vol. 2, 25 July 1895. ... 17

10. Sloan, *Dramatic Music,* 1896–97. Oil on canvas, 78 × 103 inches. The Pennsylvania Academy of the Fine Arts, Philadelphia. Commissioned by the Pennsylvania Academy. ... 23

11. Sloan, drawing of Henri's oil *Une Paysane* (A Peasant), 1897. Pen and ink on paper. Reproduced in the *Philadelphia Press,* 24 Oct. 1897. ... 25

12. Linda Craige, ca. 1897. Photograph courtesy T. Huston and Ruth I. Craige II. Photographer: Krips. ... 26

13. Henri, *On The Marne,* 1899. Oil on canvas, 26 × 32 inches. Spanierman Gallery, New York. Photographer: Geoffrey Clements. ... 36

14. Henri, *La Neige* (The Snow), 1899. Oil on canvas, 25⅝ ×

$32\frac{1}{4}$ inches. Musée d'Orsay, Paris (former Collection of the
Musée du Luxembourg). 38

15. Henri, *East River, Snow,* 1900. Oil on canvas, $25\frac{1}{4} \times 32$ inches.
Archer M. Huntington Art Gallery, The University of Texas
at Austin, Gift of Mari and James A. Michener, 1991.
Photographer: George Holmes. 42

16. Sloan, *Independence Square,* 1900. Oil on canvas, 27×22
inches. Mr. and Mrs. Alan D. Levy, Los Angeles, California.
Photograph courtesy Kraushaar Galleries. Photographer:
Geoffrey Clements. 44

17. Sloan, *Old Walnut Street Theater,* 1899/1900. Oil on canvas,
$25\frac{1}{8} \times 32$ inches. John Sloan Trust. Photograph courtesy
Kraushaar Galleries. Photographer: Geoffrey Clements. 45

18. Henri, *The Café Terrace,* 1899. Oil on canvas, $32 \times 25\frac{3}{4}$
inches. Collection of Mr. and Mrs. Raymond J. Horowitz. 46

19. Sloan, *Tugs,* 1900. Oil on canvas, 24×32 inches. Nathan
Emory Coffin Collection of the Des Moines Art Center.
Purchased with funds from the Coffin Fine Arts Trust,
1959.33. 47

20. Sloan, *East Entrance, City Hall, Philadelphia,* 1901. Oil
on canvas, $27\frac{1}{4} \times 36$ inches. Columbus Museum of Art,
Ohio, Museum Purchase, Howald Fund. 52

21. Dolly Sloan, ca. 1904–06. Photograph. Delaware Art Mu-
seum, John Sloan Archive. Photographer: John Sloan. 57

22. Henri, *The Rain Storm—Wyoming Valley,* 1902. Oil on canvas,
26×32 inches. Collection of Bernice and Joseph Tanenbaum.
Photograph courtesy ACA Galleries. 59

23. Henri, *Landscape at Black Walnut, Pa.,* 1902. Oil on wood
panel, $5\frac{3}{4} \times 8$ inches. Photographer: Geoffrey Clements. 60

24. Sloan, *The Row at the Picnic,* 1902. Etching, 6×4 inches.
Delaware Art Museum, Gift of Helen Farr Sloan. 61

25. Sloan, *The Sewing Woman,* 1901. Oil on canvas, $19 \times 16\frac{1}{8}$
inches. The Metropolitan Museum of Art, Bequest of
Margaret S. Lewisohn, 1954 (54.143.7). 68

26. Henri, *Portrait of Miss Leora M. Dryer in Riding Costume,*
1902. Oil on canvas, 78×38 inches. Photograph courtesy
Janet J. Le Clair. Photographer: Walter Russell. 71

27. Henri, *Street Scene with Snow (West 57th Street, New York),*
1902. Oil on canvas, 26×32 inches. Yale University Art
Gallery, Mabel Brady Garvan Collection. Photographer:
Joseph Szaszfai. 73

28. Henri, *Cliffs and Sea, Monhegan,* 1903. Oil on wood panel,
8×10 inches. Photographer: Geoffrey Clements. 76

29. Henri, *Rolling Sea,* 1903. Oil on wood panel, $7\frac{1}{2} \times 9\frac{1}{2}$
inches. Arthur G. Atschul. 77

30. Henri, *Girl in White Waist,* 1901. Oil on canvas, $77\frac{1}{4} \times 38$
inches. Photograph courtesy Janet J. Le Clair. 82

31. Henri, *Young Woman in Black,* 1902. Oil on canvas, $77 \times 38\frac{1}{2}$ inches. The Art Institute of Chicago, Friends of American Art Collection, 1910.317. 83

32. Henri, *Portrait of Frank L. Southrn, M.D.,* 1904. Oil on canvas, 32×26 inches. Sheldon Memorial Art Gallery, University of Nebraska-Lincoln, Gift of Olga N. Sheldon, 1982.U-3363. 86

33. Sloan, *Dock Street Market,* 1903. Oil on canvas $24\frac{1}{4} \times 36\frac{1}{4}$ inches. Montgomery Museum of Fine Arts, Alabama, Association Purchase. 87

34. Henri, *John Sloan,* 1904. Oil on canvas, $56\frac{5}{8} \times 41\frac{1}{8}$ inches. The Corcoran Gallery of Art, Gift of Mr. and Mrs. John Sloan. 88

35. Sloan, *Portrait of Robert Henri,* 1904. Lithographic pencil on paper, $11\frac{7}{8} \times 10$ inches. Sheldon Memorial Art Gallery, University of Nebraska-Lincoln, F. M. Hall Collection. 1940. H-210. 89

36. Sloan, *Violin Player* (Will Bradner), 1903. Oil on canvas, 37×37 inches. Delaware Art Museum, Gift of Helen Farr Sloan. 90

37. Henri, *Lady in Black* (Linda Henri), 1904. Oil on canvas, 78×38 inches. The Parrish Art Museum, Southampton, New York, Gift of Paul Peralta. 91

38. Tintype photograph of Robert and Linda Henri, John and Dolly Sloan at Coney Island, 1904. Delaware Art Museum, John Sloan Archive. 93

39. Henri, *Young Woman in White* (Eugenie Stein), 1904. Oil on canvas, $78\frac{1}{4} \times 38\frac{1}{8}$ inches. National Gallery of Art, Washington, Gift of Violet Organ. 95

40. Sloan, *The Coffee Line,* 1905. Oil on canvas, $21\frac{1}{2} \times 31\frac{5}{8}$ inches. The Carnegie Museum of Art, Pittsburgh, Fellows Fund, 83.29. 101

41. Sloan, *Memory,* 1906. Etching, $7\frac{1}{2} \times 9$ inches. Philadelphia Museum of Art, Anonymous Gift. 103

42. Henri, *The Art Student* (Josephine Nivison), 1906. Oil on canvas, $77\frac{1}{4} \times 38\frac{1}{2}$ inches. Milwaukee Art Museum, Purchase, Acquisition Fund. 105

43. Sloan, *Fifth Avenue Critics,* 1905. Etching, 5×7 inches. Delaware Art Museum, Gift of Helen Farr Sloan. 110

44. Sloan, *The Women's Page,* 1905. Etching, 5×7 inches. Philadelphia Museum of Art, Print Club Permanent Collection. 110

45. Sloan, illustration for Laura Campbell's "The Inspiration of Perot," 1906. *Collier's,* 11 Aug. 1906. Photograph courtesy Delaware Art Museum. 111

46. Sloan, illustration for E. J. Rath, "His Nobler Ambition: Little Wellington Joins de Gang," 1906. *The Saturday Evening Post,* 21 Apr. 1906. Photograph courtesy Delaware Art Museum. 111

47. Henri, *The Children of Mrs. George Sheffield,* 1906. Oil on canvas, 70 × 50 inches. Photograph courtesy Janet J. Le Clair. 114

48. Henri, *Spanish Gypsy Mother and Child* (Maria and Consuelo), 1906. Oil on canvas, 78 × 38 inches. Sheldon Memorial Art Gallery, University of Nebraska-Lincoln, Gift of Olga N. Sheldon, 1982.U-3362. 130

49. Henri, *El Matador* (Felix Asiego), 1906. Oil on canvas, 77 × 37 inches. Photograph courtesy Peter A. Juley & Son Collection, National Museum of American Art, Smithsonian Institution. 131

50. Henri, *La Reina Mora* (Milagros Moreno), 1906. Oil on canvas, 78 × 42$\frac{1}{16}$ inches. Colby College Museum of Art, museum purchase from the Jere Abbott Acquisitions Fund. 135

51. Sloan, *Stein, Profile (Foreign Girl)* (Eugenie Stein), 1904–05. Oil on canvas, 36 × 27 inches. Photograph courtesy Kraushaar Galleries. Photographer: Geoffrey Clements. 139

52. New York newspaper headlines announcing the formation of The Eight, 1907. 140

53. Sloan, *South Beach Bathers,* 1907–08. Oil on canvas, 26 × 31$\frac{3}{4}$ inches. Walker Art Center, Minneapolis. 153

54. Gertrude Käsebier, *Robert Henri,* 1907. Photograph. Courtesy Delaware Art Museum, Gift of Helen Farr Sloan. 154

55. Gertrude Käsebier, *John Sloan,* 1907. Photograph. Courtesy Delaware Art Museum, Gift of Helen Farr Sloan. 155

56. Henri, *Laughing Child* (Cori), 1907. Oil on canvas, 24 × 20 inches. Whitney Museum of American Art, Gift of Gertrude Vanderbilt Whitney, 31.240. 156

57. Henri, *Dutch Girl in White* (Martche), 1907. Oil on canvas, 24 × 20 inches. The Metropolitan Museum of Art, Arthur H. Hearn Fund, 1950. 157

58. Henri, *Dutch Soldier,* 1907. Oil on canvas, 32$\frac{5}{8}$ × 26$\frac{1}{8}$ inches. Munson-Williams-Proctor Institute, Museum of Art, Utica, New York. 162

59. Henri, *Eva Green,* 1907. Oil on canvas, 24$\frac{1}{8}$ × 20$\frac{3}{16}$ inches. Wichita Art Museum, Wichita, Kansas, The Roland P. Murdock Collection. 174

60. Henri's diagram showing the placement of The Eight in their Macbeth Gallery exhibition, 1908. Collection of Janet J. Le Clair. 178

61. "New York's Art War and the Eight 'Rebels,'" *New York World,* Sunday magazine, 2 Feb. 1908. 179

62. Sloan, *Hairdresser's Window,* 1907. Oil on canvas, $31\frac{7}{8} \times 26$ inches. Wadsworth Atheneum, Hartford, The Ella Gallup Sumner and Mary Catlin Sumner Collection. 180

63. Henri, *Martche in White Apron,* 1907. Oil on canvas, 32×26 inches. Mrs. Howell H. Howard. Photograph courtesy Peter A. Juley & Son Collection, National Museum of American Art, Smithsonian Institution. 181

64. Marjorie Organ, ca. 1907. Photograph. Collection of Janet J. Le Clair. Photograph courtesy Delaware Art Museum. 182

65. Henri, *El Picador* (Antonio Banos, "Calero"), 1908. Oil on canvas, 87×37 inches. The Charles and Emma Frye Art Museum, Seattle, Washington. 186

66. Henri, *Spanish Girl of Madrid* (Modiste), 1908. Oil on canvas, $57\frac{1}{2} \times 38\frac{1}{4}$ inches. Photograph courtesy Chapellier Galleries. 187

67. Henri, *The Equestrian* (Miss Waki Kaji), 1909. Oil on canvas, $77 \times 37\frac{1}{8}$ inches. The Carnegie Museum of Art, Carnegie Institute Purchase. 198

68. Henri, *Volendam Street Scene,* 1910. Oil on canvas, $20\frac{1}{8} \times 14$ inches. National Gallery of Art, Gift of Mr. and Mrs. Gerard C. Smith. 200

69. Henri, *And this is what happened in the studio, Oct 22, 09* (John Butler Yeats, Sloan, and Henri), 1909. Graphite on paper, $6\frac{3}{4} \times 9\frac{1}{2}$ inches. Delaware Art Museum, Gift of Helen Farr Sloan. 203

70. Henri, *Portrait of John Butler Yeats,* 1909. Oil on canvas, $32\frac{1}{4} \times 26\frac{3}{8}$ inches. Hirshhorn Museum, Gift of Foundation 1966. 204

71. Sloan, *My Two Friends, Robert Henri and John Butler Yeats,* 1910. Oil on linen mounted on cardboard, 9×11 inches. Owner unknown. Photograph courtesy Kraushaar Galleries and the Delaware Art Museum. 205

72. Sloan, *Yeats at Petitpas',* 1910. Oil on canvas, $26\frac{3}{8} \times 32\frac{1}{4}$ inches. The Corcoran Gallery of Art, Museum Purchase. 206

73. Sloan, *Wet Night on Broadway,* 1911. Oil on canvas, 27×22 inches. Delaware Art Museum, Gift of the John Sloan Memorial Foundation. Photograph courtesy Kraushaar Galleries. Photographer: Geoffrey Clements. 211

74. Sloan, *Mr. Gottlieb Storz,* 1911. Oil on canvas, $41\frac{1}{4} \times 33\frac{1}{4}$ inches. Western Heritage Museum, Omaha, Nebraska. 212

75. Henri, *Meenaune Cliffs, Achill Island, County Mayo, Ireland,*
1913. Oil on canvas, 26¼ × 32 inches. Photograph courtesy
Chapellier Galleries. Photographer: Walter Russell. 217

76. Henri, *Achill Girl* (Mary), 1913. Oil on canvas, 24 × 20
inches. Private collection. Photograph courtesy Hirschl &
Adler Galleries. Photographer: Helga Photo Studio. 218

77. Sloan, *Renganeschi's Saturday Night,* 1912. Oil on canvas,
26¼ × 32 inches. The Art Institute of Chicago, Gift of Mrs.
John E. Jenkins, 1926.1580. 221

78. Sloan, *McSorley's Bar* (McSorley's Ale-House), 1912. Oil on
canvas, 26 × 32 inches. The Detroit Institute of Arts,
Founders Society Purchase 1924.2. 222

79. Sloan, *Chinese Restaurant,* 1909. Oil on canvas, 26 × 32½
inches. Memorial Art Gallery of the University of Rochester,
Marion Stratton Gould Fund. 223

80. Sloan, *Clown Making Up,* 1909. Oil on canvas, 32 × 26
inches. The Phillips Collection, Washington, D.C. 224

81. Sloan, *Sunday, Women Drying Their Hair* (Sunday, Girls
Drying Their Hair), 1912. Oil on canvas, 26 × 32 inches.
Addison Gallery of American Art, Phillips Academy,
Andover, Massachusetts. 1938.67. 226

82. Sloan, *Movies,* 1913. Oil on canvas, 19⅞ × 24 inches.
The Toledo Museum of Art, Museum Purchase Fund. 227

83. Sloan, *Brace's Cove, Gloucester,* 1914. Oil on canvas, 21 × 24
inches. Photograph courtesy Delaware Art Museum. 228

84. Henri, *Himself* (Johnny Cummings), 1913. Oil on canvas,
32¼ × 26⅛ inches. The Art Institute of Chicago, Walter H.
Schulze Memorial Collection, 1924.912. 230

85. Henri, *Herself* (Mrs. Johnny Cummings), 1913. Oil on canvas,
32 × 26 inches. The Art Institute of Chicago, Walter H.
Schulze Memorial Collection, 1924.911. 231

86. Sloan, *Gloucester Trolley,* 1917. Oil on canvas, 26 × 32 inches.
Canajoharie Library and Art Gallery. 234

87. Henri, *Indian Girl of Santa Clara, New Mexico* (Gregorita),
1917. Photograph courtesy Janet J. Le Clair. 241

88. Henri, *Pepita of Santa Fe* (Julianita), 1917. Oil on canvas,
24 × 20 inches. Los Angeles County Museum of Art, Mr.
and Mrs. William Preston Harrison Collection. 242

89. Henri, *Little Girl of the Southwest* (Lucinda), 1917. Oil
on canvas, 24 × 20 inches. Delaware Art Museum, Special
Purchase Fund, 1920. 243

90. Sloan, *Ancestral Spirits,* 1919. Oil on canvas, 24 × 20 inches.
Museum of Fine Arts, Museum of New Mexico, Gift of
Dr. Edgar L. Hewitt. 250

91. Sloan, *Street in Moonlight, Santa Fe,* 1919. Oil on canvas, 24 × 20 inches. John Sloan Trust. Photograph courtesy Delaware Art Museum. 251

92. Sloan, *Santa Fe Canyon,* 1919. Oil on canvas, 20 × 24 inches. John Sloan Trust. Photograph courtesy Delaware Art Museum. 252

93. Sloan, *Main Street, Gloucester,* 1917. Oil on canvas, 26 × 32 inches. New Britain Museum of American Art, Connecticut, Harriet Russell Stanley Memorial Fund. Photographer: E. Irving Blomstrann. 253

94. Henri, *Portrait of Dieguito,* 1916. Oil on canvas, $65\frac{3}{8}$ × $40\frac{7}{8}$ inches. Museum of Fine Arts, Museum of New Mexico, Gift of the Artist. Photographer: Bob Nugent. 254

95. Sloan, *Boys Swimming, Santa Fe,* 1920. Oil on canvas, 20 × 24 inches. Photograph courtesy Delaware Art Museum. 264

96. Sloan, *East at Sunset, Kitchen Door,* 1920. Oil on canvas, 16 × 20 inches. Photograph courtesy Kraushaar Galleries. Photographer: Geoffrey Clements. 266

97. Sloan, *Music in the Plaza,* 1920. Oil on canvas, 26 × 32 inches. Museum of Fine Arts, Museum of New Mexico, Gift of Mrs. Cyrus McCormick. 267

98. Henri, *Portrait of Fayette Smith,* 1920. Oil on canvas, 37 × 58 inches. Photograph courtesy Peter A. Juley & Son Collection, National Museum of American Art, Smithsonian Institution. 272

99. Henri, *Summer Storm,* 1921. Oil on canvas, $26\frac{1}{8}$ × $32\frac{1}{8}$ inches. The Frances Lehman Loeb Art Center, Vassar College, Poughkeepsie, New York. Gift of Mr. and Mrs. Charles J. Malmad, 1977.1. Photographer: Walter Russell. 277

100. Sloan and Henri in Sante Fe, 1922. Photograph. Delaware Art Museum, John Sloan Archive. Photographer: William Pugh. 278

101. Sloan, *The Cot,* 1907. Oil on canvas, $36\frac{1}{4}$ × 30 inches. Bowdoin College Museum of Art, Brunswick, Maine, Bequest of George Otis Hamlin, 1961.62. 289

102. Sloan, *Pig-Pen-Sylvania,* 1916. Oil on canvas, 20 × $23\frac{3}{4}$ inches. Bowdoin College Museum of Art, Brunswick, Maine, Bequest of George Otis Hamlin, 1916.51. 290

103. Sloan, *Signals,* 1916. Oil on canvas, $19\frac{7}{8}$ × 24 inches. Bowdoin College Museum of Art, Brunswick, Maine, Bequest of George Otis Hamlin, 1961.56. 291

104. Sloan, *Blonde Nude,* 1917. Oil on canvas, 20 × 24 inches. Bowdoin College Museum of Art, Brunswick, Maine, Bequest of George Otis Hamlin, 1961.53. 292

105. Henri, *Argentina of Madrid,* 1924. Oil on canvas, 32 × 26

inches. Photograph courtesy Nedra Matteucci's Fenn
Galleries, Santa Fe. 297

106. Sloan, *Chama Running Red*, 1925. Oil on linen, 30 × 40
inches. The Anschutz Collection. Photographer: Malcolm
Varon. 305

107. Sloan, *Here It Is, Sir, Hope You Like It*, Sloan presenting
Henri with a copy of A. E. Gallatin's just-published book,
John Sloan, 1926. Graphite on paper, $10\frac{3}{4} \times 7\frac{5}{8}$ inches.
Private collection. 306

108. Sloan, *The Town Steps*, 1916. Oil on canvas, $32\frac{1}{8} \times 26\frac{3}{16}$
inches. Los Angeles County Museum of Art, Mr. and Mrs.
William Preston Harrison Collection. 309

109. Henri, *Roshanara*, 1919. Oil on canvas, 50 × 60 inches.
Photograph courtesy Peter A. Juley & Son Collection,
National Museum of American Art, Smithsonian
Institution. 313

110. Sloan, *Twenty-Fifth Wedding Anniversary*, or *On the Rocks*,
1926. Etching, 4 × 5 inches. Bowdoin College Museum of
Art, Brunswick, Maine, Bequest of George Otis Hamlin,
1961.69. 314

111. Henri, *The Brown-Eyed Boy* (Thomas Cafferty), 1926. Oil on
canvas, $24\frac{1}{4} \times 20\frac{1}{4}$ inches. The Baltimore Museum of Art,
Anonymous Gift, BMA 1934.55.1. Photograph courtesy
Janet J. Le Clair. Photographer: William McKillop. 319

112. Sloan, *Robert Henri, Painter*, 1931. Etching, 14 × 11 inches.
Graphic Arts Collection, Visual Materials Division,
Princeton University Library. 329

113. John Sloan and his wife Helen painting in the studio at the
Hotel Chelsea, New York, 1950. Photograph. Courtesy
Delaware Art Museum, John Sloan Archive. 330

Acknowledgments

✳

Any recognition of those to whom the editor is indebted must begin with the two artists themselves. Obviously John Sloan and Robert Henri established and maintained a special kinship with each other all of their lives, one which encouraged each to preserve the correspondence of the other.

To Helen Sloan I offer special laurels, for as a former student of Sloan's and as his widow, she has eagerly shared her expertise and time during the three years of my research associated with this project. No inquiry of mine has proven too insignificant for her to investigate, a quality I sensed in this very special individual when we initially met at the Whitney Museum of American Art on Eighth Street in New York shortly after John Sloan's death.

Janet J. Le Clair, the present heir to the Henri Estate, is, like Helen Sloan, a longtime friend who has responded to my numerous queries and encouraged me to pursue this project.

Julian J. Foss, a collector of Henri's art and memorabilia, is due a special note of thanks for providing me, in 1962, with photocopies of several additional Sloan letters to Henri which he had acquired from the Henri Estate.

The Sloan-Henri letters could not have been published without the aid of staff members at the two institutions where the correspondence is housed. At the Beinecke Rare Book and Manuscript Library at Yale University, Patricia Willis, curator of American literature, was especially helpful in responding to my requests, as was William Hemmig, public services assistant. And at the Delaware Art Museum, repository for the Henri letters to Sloan, timely assistance has been provided by the following: the late Rowland Elzea, retired associate director; Jeanette Toohey, curator of collections; Dr. Mary F. Holahan, registrar; Harriet Memeger, head librarian; Beth Davis, assistant librarian; and Lee Ann Dean, archivist for the Frank E. Schoonover Collection, Helen Farr Sloan Library.

Additional individuals whose cooperation has proven invaluable include: Susan Bath, librarian, Baltimore County Library; Jean Bellows Booth, daughter of George Bellows; Marietta Boyer, librarian, Pennsylvania Academy of the Fine Arts; Kim Clark, cataloguer for the National Museum of American Art/National Portrait Gallery; David Dearinger, as-

sociate curator of paintings and sculpture, National Academy of Design; Amy DeBusk, Baltimore Museum of Art Library; and James R. DeWalt, assistant librarian, Social Science and History department, Free Library of Philadelphia.

Also Kirby Dilworth, assistant head, and John Forbis, staff librarian, both of the Music and Art department, The Carnegie Library of Pittsburgh; Denise Gallagher, interlibrary loan supervisor, Baltimore County Library; Eric Gordon, senior painting conservator, The Walters Art Gallery; Jeanie M. James, archivist, The Metropolitan Museum of Art; Marisa Keller, acting archivist, The Corcoran Gallery of Art; Cheryl Leibold, archivist, The Pennsylvania Academy of the Fine Arts; and Irene Chapellier Little, retired director of the Chapellier Galleries and Henri's dealer.

And Stephanie Moye, librarian, the National Museum of American Art/National Portrait Gallery; Cynthia Ott, art specialist, Archives of American Art, Washington; Carole M. Pesner, director of the Kraushaar Galleries, Sloan's long-time dealer; Cheryl Saunders, Registrar's Office, Carnegie Museum of Art; A. Catherine Tack, art librarian, Music and Art Department, The Carnegie Library of Pittsburgh; Wendy Thompson, The Baltimore Museum of Art Library; and Kym Wheeler, Archives of American Art, Washington.

Recognition must also be given to the devoted staff of Baltimore's Enoch Pratt Free Library, tireless individuals whose assistance with this research have proven invaluable: Ellen Luchinsky, department head, Fine Arts; Thomas Himmel, Faye Houston and Deborah Pines, of the Humanities Department; Harriet Jenkins, Social Sciences and History; Marcia Dysart, Daria Phair, Eleanor Swidan and Emile Thoreau, General Information and Reference; Ana Amalia Gosnell, of the Patterson Park Branch; and Peggy D'Adamo, State of Maryland Pratt Night Owl Reference Service.

To my two editors at Princeton University Press, Elizabeth Powers and Elizabeth Johnson, a special note of thanks.

And, most importantly, to my wife Miriam, whose forty-five years of constant support and encouragement continue to make research and writing in American art a joyous undertaking.

Preface

She'll wish there was more, and that's the great art o' letter-writin'.
CHARLES DICKENS, *Pickwick Papers*

The existence of correspondence between Robert Henri and John Sloan was revealed to me some four decades ago while I was researching a book about American art and The Eight. A former Henri student named Manuel Komroff wrote:

> I am glad Mrs. John Sloan spoke to you about Henri. Sloan was a very dear friend. You know of course the letters of John Sloan and Henri. I do not know if they were published but I remember reading them. They are very important.

That was in 1956, three years before Henri's sister-in-law and the heir to his estate, Violet Organ, died and left the Sloan correspondence to the Beinecke Rare Book and Manuscript Library at Yale University. Mrs. John (Helen) Sloan preserved the Henri letters following her husband's death in 1951, and in 1978 presented them to the library named in her honor at the Delaware Art Museum.

All of the letters known to exist between the two artists are reproduced here in full, as well as those by the artists' wives.

✳

Throughout the nineteenth and early twentieth centuries the National Academy of Design dictated the course of American art, promoting a restrictive style that favored classical subjects and techniques. The annual juried exhibitions sponsored by the Academy were the artists' primary entree to patrons and subsequent sales. Acceptance to the Academy's shows offered painters credibility and marketability; rejection could signal the opposite. Original subject matter or technique often guaranteed a painter that rejection.

It was apparent to Robert Henri as early as 1894 that the National Academy of Design's yearly exhibitions were moribund. After viewing that year's show, he likened its galleries to cemeteries, the art an array of igno-

rance, imitations, and fads. Henri and John Sloan rebelled against the Academy's injustice of rejecting innovative art in order to maintain its own status: The two men spearheaded an Independent Movement that initiated exhibits selected by the artists themselves, exhibits free of any organizational control.

It was not purely by chance that Henri and Sloan, who sought independence for themselves and others, should have met in the city of American independence, Philadelphia. As a result of the Philadelphia Centennial Exposition of 1876, which marked the United States' one hundredth year of independence, that city became a great magnet for business, science, and the arts. The Sloan family moved there in the centennial year; Henri's settled in nearby Atlantic City seven years later. When Robert Henri's drawings attracted the attention of the family milkman, a former Philadelphia art student, he was encouraged to enroll at the visitor's alma mater, the Pennsylvania Academy of the Fine Arts. Henri followed the advice.

After two years he continued his art education in Paris, in time rejecting the restrictive academic approach taught there in favor of the freedom and spontaneity he observed in the work of Manet, Velasquez and Hals.

After Henri returned to the United States he promoted a bravura technique when meticulous brushwork was the norm. Similarly, when most American artists were depicting human forms in drapery amid remote classical settings, Henri and Sloan painted contemporary, everyday sitters. And when others portrayed urban life in America as New York's Upper Fifth Avenue, Sloan and Henri painted scenes from the Lower East Side. They were dubbed leaders of the Ashcan School, a group that included George Luks, William Glackens, Everett Shinn, and George Bellows.

This struggle to transfer power from the Academy to the artists themselves represented a great risk. For their steadfast adherence to contemporary subject matter, Henri and Sloan were often rejected by the Academy; such examples of their art remaining unseen and unsold. Henri, who hungered for prestigious portrait commissions for much of his career, received relatively few, resorting instead to painting what he referred to as "my people." And Sloan, whose records of New York's seamy side are revered today, did not sell his first painting until 1913, at the age of forty-two (and that to a former high school classmate, Dr. Albert C. Barnes). Throughout their lives both Henri and Sloan supplemented their incomes from painting with careers as teachers. Sloan also worked as a newspaper and magazine illustrator. Their commitment to artistic freedom earned both the respect of their fellow artists.

As Thomas Eakins had learned years before, realism was a hard sell even in portraiture. In 1904 Henri painted the likeness of Willie Gee, the black youth who delivered his newspaper. The portrait reveals a wide-eyed coun-

tenance depicted with dignity; his blue-gray jacket has no patches or tears as would be found in paintings of more popular, picturesque waifs. The canvas went unsold for fifteen years, yet even after it was purchased by a Washington museum in 1919 the subject matter proved unacceptable, for a few years later the canvas was returned to the artist in exchange for another, less controversial portrait.

Sloan, too, had difficulty gaining acceptance. Typical of his encounters was the American Water Color Society's invitation to exhibit his set of ten New York City etchings at the Society's annual show. Here, he planned, to hang his pompous ladies in *Fifth Avenue Critics* and his unkempt mother of the slums gazing longingly at the newspapers' fashionable Gibson Girl–type illustrations on *The Women's Page*. But in the end only six of the prints were actually shown when the others were deemed "too vulgar." Although revisionists have sought to diminish the revolutionary nature of Henri's and Sloan's subject matter at the outset of the twentieth century, contemporary critics referred openly to the artists as "apostles of ugliness" and "men of the rebellion."

American literature evinced a parallel concern for realism, yet Henri and Sloan were little affected by it. They read Emerson and Whitman, to be sure, plus Ibsen and Zola, yet evidence is lacking that either of the painters delved into the short stories or books of Stephen Crane, Thorstein Veblen, Lincoln Steffens, or David Graham Phillips. Their kinship with the lower class was more closely associated with *The Yellow Kid*, the comic strip originated by Richard Outcault and later continued by their fellow artist, George Luks. Here was a neighborhood populated by ruffians and street urchins who played amid backyards, clotheslines, and fire escapes.

The lives and art of Henri and Sloan were inextricably linked to the Lower East Side. When Henri moved from Philadelphia to New York, his first teaching position there was at an exclusive girls' finishing school near Central Park, yet he could only afford to rent a flat overlooking the East River, one block from the coal-loading piers and not far north of the slaughterhouses and the city's garbage dump.

Sloan lived even farther south, on Twenty-third Street, where he made a practice of gazing into the rear windows of his back alley neighbors and recording, in etchings and oils, the scenes he witnessed. When Henri once wrote him regarding the risqué apparel of a group of female bathers on a beach, Sloan responded that he had upon occasion seen women bathing in the rear rooms on Twenty-second Street with much scantier clothing.

In the story of American art's coming-of-age, Robert Henri and John Sloan stand tall among those in the vanguard of the campaign. For his part, Henri is credited with leading the charge against an entrenched academic establishment and being the first to scale the barricades. Sloan was

an invaluable partner in further opening the breach. Although there was no unconditional surrender, the Academy was ultimately dethroned, destined never to regain its role as tastemaker.

<center>✳</center>

As the John Sloan-Robert Henri letters reveal, these two individuals maintained a special friendship throughout their lives. Their correspondence ended only upon the death of Henri.

Some 202 letters and postcards are reproduced in this volume, nineteen of which were written by the artists' wives. Thirty-one of Henri's missives to Sloan are postcards, a form Sloan abhorred. After receiving eight of them from Henri during the summer of 1906, he confided in his diary on August 9:

> Have heard from Henri only in this way. Rather dislike the postcard fad. Would rather have had a letter from a friend than a damaged photograph of a street in the town they stop in, or a canceled ink stained reproduction of a painting.

Never one to express such feelings strongly to Henri, Sloan limited the comments in his correspondence to "you have written and postcarded me several times" and "nothing but postcards from you so far." The criticism of the practice was apparently too subtle for Henri, who continued to correspond in this manner during each trip abroad.

Nonetheless, it is just such picture postcards that reveal which works of art Henri found most appealing, and those he wished to share with Sloan: compositions by Hals and Rembrandt from Holland, Goya and Velasquez from Spain. Many of these are of commonplace subjects, such as Goya's depiction of a city, a peasant, a mender of toys, or photographs of a fisherwoman and a chaotic Paris market scene reminiscent of Fulton Street in New York. The subjects' importance to Henri is evidenced by a picture postcard of gypsies he sent from Spain in 1908. Two summers later he was painting them there.

In an early letter, Sloan recounts the hijinks in Henri's former studio, where the regular weekly "orchestra" was tuning up, with Sloan scraping an umbrella across an easel in imitation of a bass viol, Everett Shinn using two tin plates for cymbals, and George Luks bellowing into a conch shell. Subsequent letters mention the other members of The Eight—William J. Glackens, Arthur B. Davies, Maurice B. Prendergast, and Ernest Lawson—as well as those in the Henri-Sloan circle, including Anshutz, Hovenden, Redfield, Schofield, Grafly, A. Stirling Calder, Leon Kroll, George Bellows, Rockwell Kent, Randall Davey, Isadora Duncan, and Mary Fanton Roberts.

In addition to text, many of the Sloan-Henri letters contain illustrations, some fanciful caricatures, others masterful artistic statements, the total col-

lection of which has never been reproduced. For the most part, Henri's were dashed off quickly, sometimes in a minute or two, while Sloan's, usually more complex in both subject matter and technique, took many times longer. An intriguing comparison between similar subjects, of Henri at his easel, may be found in the letters of 5 September 1907 and 27 January 1908.

The humor inherent in the Sloan sketch is not an isolated example but rather typifies both his writing and his art. When Henri wrote in June 1906 about his having crossed the Atlantic without becoming seasick, Sloan responded by mailing him a letter written in circles, calculated to induce dizziness if read twice after each meal. In a 1922 letter Sloan combined his dislike of Prohibition with news of the Boston arrest of Isadora Duncan for what police termed indecent exposure while performing: "They can't stop bootlegging but they can bare legging." Writing to Henri the following year, he revealed that several of his friends had advised the purchase of Liberty Bonds as a safe investment, concluding that "this combination of Liberty and Bondage appeals to the average American of today."

Sloan even permitted this jocular tone to creep into the titles of several of his works: A 1916 oil of some pigs was dubbed *Pig-Pen-Sylvania,* and on the occasion of his and his first wife's silver anniversary in 1926, he produced a party invitation in the form of an etching with the dual titles *Anniversary Plate* and *On the Rocks*. While depicting himself and his mate clinging to each other atop a mass of boulders in rough seas, Sloan was still piqued that Prohibition would prevent the celebrants from legally enjoying liquor poured over ice.

Yet in the final analysis it is the letters themselves that offer revelations not found elsewhere. After Sloan began painting seriously in 1897 at Henri's suggestion, he sometimes sought out the older artist's opinion of his efforts. "Let me know if it looks well to you," he requested, enclosing a photograph of *East Entrance, City Hall, Philadelphia.* ("It pleases me mightily just as it is," was Henri's response.)

And beginning on 12 January 1908 one is able to follow the drama of Henri's leaving New York only three weeks before the opening of The Eight Show, and his stream of letters explains the various delays in returning to Manhattan. (He finally arrived back on the scene less than forty-eight hours prior to the exhibition debut.) However, readers hoping to learn the reactions of Henri and Sloan to the The Eight Exhibition or the Armory Show will not find them here; since both artists were in New York City for those momentous occasions, communications between them were apparently made either face-to-face or by telephone.

✳

When Robert Henri lay dying in a New York hospital in June 1929 Sloan sent him one last letter, concluding it with the "hopes that you may soon be able to join us in Santa Fe." It was an act of love, of respect and encouragement, one that masked Sloan's true feelings of an impending, grievous loss.

John Sloan's final tribute to his most treasured friend was the organization of a letter-writing campaign urging the Metropolitan Museum of Art to honor Henri with a major Memorial Exhibition. Once this was accomplished, Sloan produced an etching of Henri that served as the frontispiece for the catalogue, and wrote the catalogue introduction as well. Together the image and the words serve as a fitting tribute.

It is my wish that this volume be thought of as a tribute to the contributions of both men.

Bennard B. Perlman
BALTIMORE

Editorial Note

∗

The letters of John Sloan and Robert Henri are reproduced here exactly as they appear in the originals. This includes all misspellings, omitted capitals and punctuation, and faulty grammar. On the few occasions where it is deemed appropriate to insert a correction, this appears in brackets following the writer's offering. All extant postcards are also reproduced in this volume. Where legibility allows, postcards are reproduced so that the original message is visible. In other cases a transcription is provided.

Some of the Sloan letters to Henri survive only as typed transcripts, and these are so noted throughout the volume. They were produced by Violet Organ, Henri's sister-in-law (and heir to his estate until her death in 1959), probably with the intention of incorporating them into her proposed biography of Henri, a project upon which she intermittently labored over a lengthy period of time. On the occasion of our initial meeting in 1952 in Henri's former studio, her unfinished manuscript was at hand.

The disposition of those original letters is unknown, although it has been determined that on at least one occasion her nephew, John Le Clair, either sold or presented a group of Sloan letters to a Henri collector. Photocopies of these originals were forwarded to the editor and are included in their proper chronological order in this book.

Introduction

*

John Sloan met Robert Henri at a costume party (all stag) held for alumni and students of the Pennsylvania Academy of the Fine Arts in Philadelphia. It was December 1892, only a few months after the death of Walt Whitman. Sloan and Henri discovered a mutual admiration for the great American poet. Sloan offered to give the older artist his copy of *Leaves of Grass,* a fine edition which he had acquired while working at Porter and Coates, the Philadelphia bookstore.

From the print department there, Sloan was permitted to borrow originals by Dürer and Rembrandt, of which he made copies that sold for five dollars each, thus adding to the modest salary he earned as an assistant cashier. When his father failed in business after years as a travelling salesman, Sloan abandoned his academic studies just prior to graduation from high school to become the main support of his parents and two younger sisters. When he met Henri, Sloan was working as an illustrator for the *Philadelphia Inquirer.*

Henri's family, by contrast, provided Henri with financial assistance for many years; he was able to study and travel abroad. He also developed as a teacher, refining his rare ability to recognize and encourage creative talents of all kinds. When his first wife died in 1906, a distraught Henri asked Sloan to take his place. The ensuing six-week apprenticeship served as Sloan's entree into a lengthy teaching career of his own, one which similarly stressed the realist point of view plus creative independence.

The letters of these two friends bring the men into our presence. They were leaders of rare integrity, not seeking power in the cultural world or financial success. As realists, their contribution to American art of this century has been neglected and forgotten, although some of their students, like Stuart Davis, "Sandy" Calder, and David Smith, started with the realist tradition just as Mondrian did.

In 1927, fourteen years after the Armory Show, I enrolled in John Sloan's class at the Art Students League. I was sixteen, taking a year off from academic studies at the Brearley School, where I had been learning about Thoreau, Emerson, and Whitman. I was to study with Boardman Robinson, whose wife was a patient of my father's.

In the afternoon class for painting and drawing, I started a timid pencil study of "Susie," the large, pink, nude model who claimed to have been a

chorus dancer in the Ziegfeld Follies. There was a total silence in the room when I looked up to see a gray-haired gentleman in a business suit standing in the doorway. He set his cane against the wall and started to lecture. "I am not here to teach you young people any one way to draw—I am here to help you. I want to help you find a purpose, a reason for painting."

These are from notes I started to take immediately, filling the background of my figure study. The voice was that of John Sloan, but it appeared to me to be in the same generous spirit of Whitman as I had studied him the previous year. After addressing the entire class, Sloan began to give individual criticisms, sometimes speaking quietly to a particular student, often raising his voice for all to hear when the criticism was less personal. In one of those quiet moments, I suddenly realized that the teacher was standing beside me. "I don't usually like students to take notes. They often get things garbled. But so far you are reporting accurately. I'll come back later to see how it is going." And so began the work I had found, to save the living voices of creative teachers—diaries, letters, verbatim notes.

The next year I met Robert Henri at the opening of the Morton Gallery, started by my mother's cousin who had studied with Henri. It was in an apartment on West Fifty-third Street in New York. Cousin Nora came through the crowd to introduce me to Henri as a student of his friend, John Sloan. A tall man with slightly Asian eyes, he shook hands firmly and encouraged me to keep working with a fine teacher.

A few months after this, Sloan was giving an open criticism about dozens of pictures that were stacked around the League's main gallery. When the crowd around Sloan began thinning out, I caught a glimpse of Robert Henri walking across the room with a limping gait. He was headed in my direction and came over to speak with me—an act of gracious encouragement, memorable, invaluable. Not long thereafter, Henri was in the hospital with cancer of the pelvis.

Sloan said that Henri, although a friend, was very close-mouthed about his private life, "like a clam." It was obvious that secrets were being concealed (there were rumors about the art world that he may have been of royal birth). When Sloan moved Henri's furniture and books from one studio to another, he found childhood books inscribed with another name. Years after Henri died, Sloan told me he wondered whether Henri would have told him the whole story if he had known that his illness was fatal.

This correspondence, with its careful editing and illuminating footnotes, is a valuable document researched with Bennard Perlman's customary diligent care. Without the scholarly accuracy and amplification we would not have this living memory preserved in print.

Helen Farr (Mrs. John) Sloan

1893

TO

1899

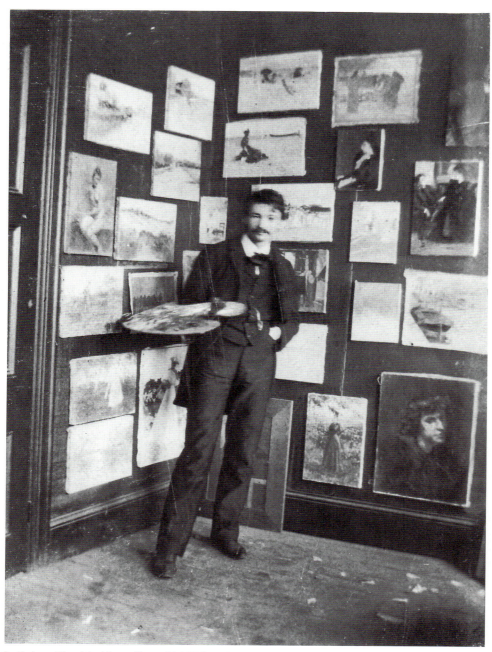

1. Robert Henri in his studio at 806 Walnut Street, Philadelphia, 1893

When Robert Henri and John Sloan first met at Christmastime 1892, amid the frivolity of forty artists and art students in sculptor Charles Grafly's Philadelphia studio, they discovered that their own studios were but a block apart. Sloan shared his with Joseph Laub, who like himself was a newspaper artist; their single room had only two windows facing south.

On the other hand, Henri's work space was larger and contained a bay of windows plus a skylight, all admitting the more desirable north light.

When Sloan learned of Henri's intention to relinquish his studio, the men's lifelong correspondence and friendship began.

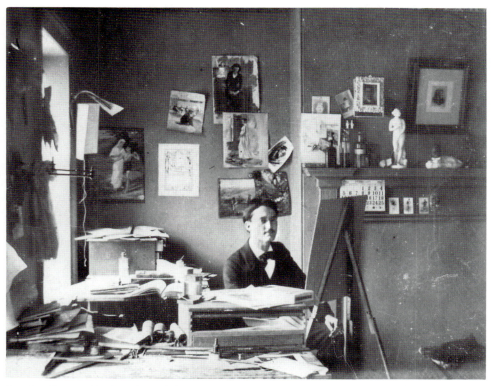

2. John Sloan in his first Philadelphia studio at 705 Walnut Street, 1893

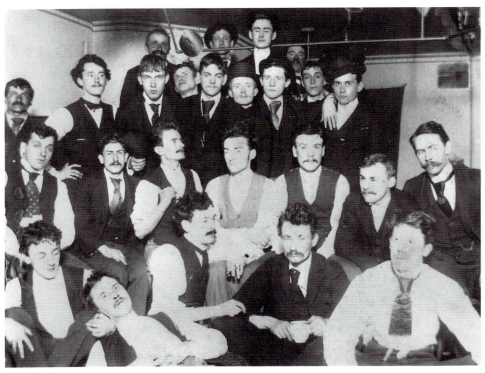

3. The Charcoal Club, 1893

Phil. 8/5/93

Dear Henri:—

The C.C.[1] on hearing that "you and others had <u>not</u> given us the shake" promptly grasped a new lease on life; but thats another story.—

Davis[2] mentioned to me the other day that you had spoken to him of giving up your present studio[3] in the Fall Also that you had given him the refusal of it at that time.

With Davis' permission I write to ask if that refusal could be transferred to Laub[4] and myself as we should like to place our selves under a skylight[5] this Winter.

Hoping that you will not regard this as a "Notice of Eviction"
I am yours

John F. Sloan[6]

[1] The Charcoal Club was an evening art class organized in March 1983 by John Sloan and Joseph Laub, newspaper artists on the *Philadelphia Inquirer,* for fellow artists of the press. Robert Henri and Sloan provided critiques.

[2] Edward Wyatt Davis was a newspaper artist who became art editor of the *Philadelphia Press*.

[3] At 806 Walnut Street.

[4] Sloan's and Laub's studio was at 705 Walnut Street.

[5] Henri had added the skylight to his top-floor studio.

[6] Sloan soon dropped his middle initial; his middle name was "French," which he abandoned as a romantic encumbrance.

Aug 29/93

Dear Henri:—

We saw Grier[1] this forenoon, he is perfectly willing that we should have the studio but has received no notification from you of your intention to leave. Please notify him before the end of the month, (two days yet) provided you have not done so by mail before this reaches you.

He also says that we should have a note from you stating that we are satisfactory successors to you.

He also says (being somewhat verbose) that we should make some arrangement, in regard to Mr Kelly's[2] effects, with you

He also said much more that filled much time and destroyed much oxygen but we escaped in time

Dont forget to notify, as we shall give our present landlord notice on Thursday

Yours
John F. Sloan

[1] George W. Grier was the landlord for 806 Walnut Street.

[2] James B. Kelly was an instructor of portraiture and anatomy at the Pennsylvania Academy of the Fine Arts, with whom Henri had studied the previous year.

Atlantic City
Sept. 3, 1893

Messrs Laub and Sloan
Dear friends:

Wrote on the 29th August to Mr Grier giving notice of quittance of Studio and remarked your moral characters and high sunday school class averages as evidence of eligibility to successorship to myself—from which cause I suppose all is well and well arranged and I would like to hear from you to that purpose.

Sincerely
Robert Henri

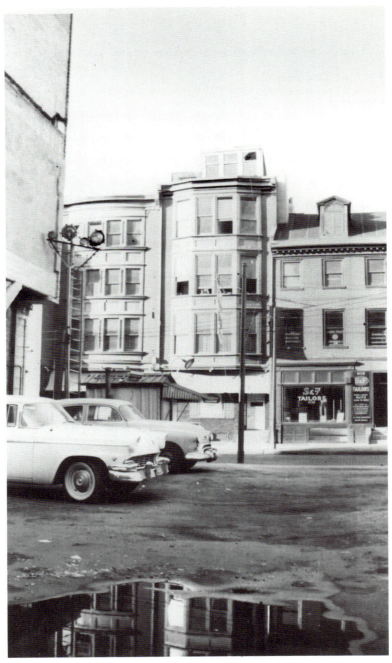

4. 806 Walnut Street, Philadelphia, 1956

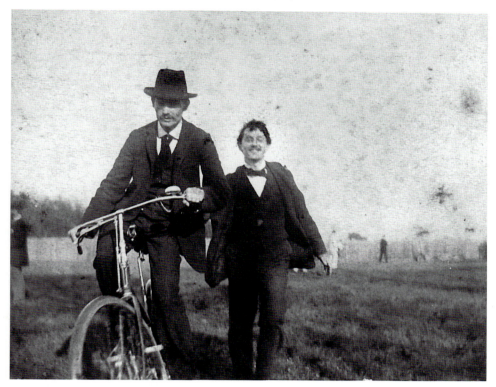

5. Henri and Sloan at baseball game, Spring 1893

Phila. Sept 5– 93

Dear Henri:—

"We have met the enemy and he is ours"

We are a terrible example of "A little 'leven'[1] leveneth the whole lump"
viz

7 0 5 Walnut St
1 1
8 0 6 Walnut St

"Nuf said"

I enclose a bicycological study, entitled—"Gravity and Mirth"[2] The
"gravity" will be noticed reaching for the off lower leg of the figure with
the excessive clothing movement. This figure, which is at present <u>in</u> the
foreground, will, if gravity achieves its object, be presently <u>on</u> the fore-
ground. The ethereal figure in the middle distance is said to express

[7]

'mirth"; but beneath the set calm of that neck tie-bestudded bosom, and the studied simplicity of that cheek piercing smile there is a lesson of mighty import. For despite the flatulent appearance of those two waist-coats they contain, if reports be true, fully five fourths $\frac{5}{4}$ of the liquid refreshments which graced the wide Campagna[3] which stretches away beneath their feet (and wheels)

Still, foot marks are road dents and someone remarks that rodents mean "Rats!!"—

So farewell from your friend

John F. Sloan

Sworn and Certified
Ante Mortem statement of the above

J. E. Laub

[1] Eleven.
[2] The enclosed "bicycological study" was a photograph which appears on page 7.
[3] Country.

After teaching a private art class near Philadelphia during June 1894, Henri and Eustace Lee Florance, a writer-friend for whom he would make a series of illustrations, left for Concarneau, France, the following month.

Phila. July 30. 1894

Dear Henri:—

Glad to hear that you stole a march on Father Neptune by carrying your own make of sea sickness aboard. Glad also to hear that you fell into good company

Things have been up to this time quiet but warm

Fox[1] is generally sole and only on Tuesday's[2] but Fox, I find, is good company.

The Japanese style has made a hit. I have received a letter from the editor of the "Inland Printer" (a Chicago journal devoted to the interests of Publishers and Printers and a publication of good standing), in which he expresses his interest in my work on the "Inquirer" and asks for a selection of my drawings a portrait of yours truly and biographical data for publication in a future issue of his magazine

I shall respond.

It will be a splendid "boost" for me I think

He and I spent last Sunday at Atlantic City saw Southrn[3] for a few

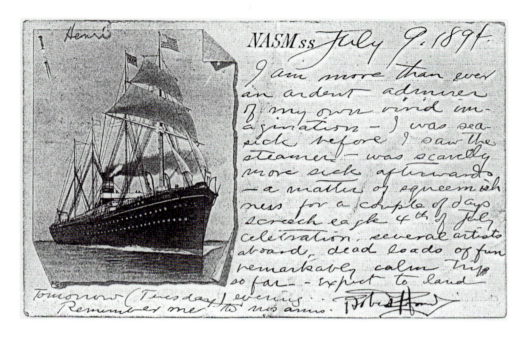

Henri

NASM ss July 9. 1894.

I am more than ever an ardent admirer of my own vivid imagination — I was seasick before I saw the steamer — was scarcely more sick afterwards — a matter of squeemishness for a couple of days. screech eagle 4th of July celebration, several artists aboard, dead loads of fun remarkable calm trip so far — expect to land tomorrow (Tuesday) evening ... Remember me to mes amis.

minutes, said he had heard from you, also spent quite a part of the day with Mrs. L—[4]

Glackens[5] has left the "Ledger" and has returned to the "Press"

Breckenridge[6] is to be secretary of the faculty at the Academy this year no other changes are announced.

Davis and I spent a Sunday shooting frogs at Redfield's[7] a week or two ago.

Williamson[8] spending his vacation in Florida keeping his dramatic brain warm

I suppose that you will have reached Italian stamping ground by the time you receive this

Hope you are still single Great Scott! Its hard to think of letter wadding, guess I wont wad.

<div align="center">au revoir
John Sloan</div>

Done.

Between a tin roof extra warm and a dirty floor Phila Aug 3, '94

[1] George B. Fox was a former classmate of Henri's at the Academy.

[2] Refers to Tuesday evening discussion groups inaugurated in the studio at 806 Walnut Street the previous fall.

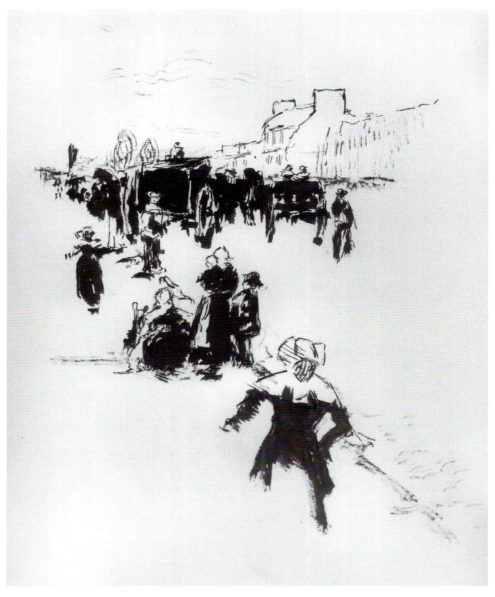

6. Henri, *Concarneau Street Scene*, 1894

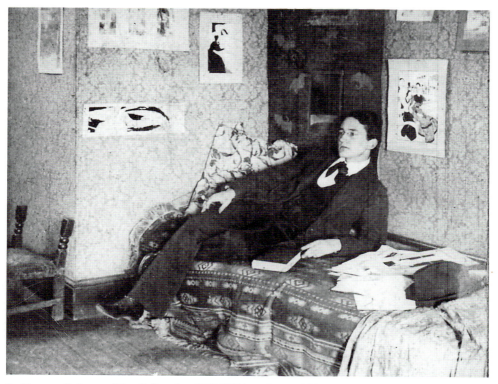

7. Sloan reclining on Henri's "rag bag," 806 Walnut Street, 1894

[3] Frank Southrn, whose real name was John A. Cozad, was Henri's older brother.

[4] Mrs. Richard Henry (Theresa) Lee was Henri's mother. The family name had originally been Cozad, but after Henri's father, John Jackson Cozad, was accused of killing one of his employees in Cozad, Nebraska, a town he founded, the family settled in Atlantic City and assumed new identities. The sons were passed off as half-brothers; thus Robert Henry Cozad became Robert Henri, and his true identity was not revealed during his lifetime.

[5] William J. Glackens (1870–1938) was a newspaper artist who had studied at the Pennsylvania Academy with Sloan.

[6] Hugh H. Breckenridge (1870–1937) was an Academy graduate and former classmate of Henri's.

[7] Edward W. Redfield (1869–1965) was a classmate of Henri's at the Pennsylvania Academy.

[8] Charles S. Williamson, a fellow Academy student with Henri, became known as the playwright of 806 for penning parodies in which the men acted. In these theatricals, Sloan regularly played the heroine and Henri the villain.

8. Sloan, *On the Pier,* 1894

Sloan adopted a Japanese-inspired style in his newspaper work, which consisted of providing illustrations for feature articles and producing decorative headings. In contrast, his friends William Glackens, George Luks, and Everett Shinn were quick-sketch artists who dashed off on-the-spot drawings for breaking news stories.

Sloan was unable to work with equal speed, causing Henri to quip that "'Sloan' must surely be the past participle of 'slow'" (Helen Farr Sloan, John Sloan notes).

Henri tried sharing his former studio at 806 Walnut Street with Sloan and Laub, but the crowded conditions prompted Henri to move to 1717 Chestnut Street, where he shared studio space with Glackens, who in turn released his former studio to Luks.

On 8 June 1895 Henri and Glackens sailed for Europe, where they would spend the next two years. The following letter by Henri, written hurriedly four days prior to sailing, concerns drawings by Henri and Sloan's sister slated for an end-of-term exhibit at the School of Design for Women.

<div align="right">

Atlantic City
June 4, 95

</div>

Dear Sloan:

You know I am in a rush.

Lewis didn't come to see me at school[1] or send for drawings as per agreement. The drawings are down at studio.

The one with trees is not fixed.[2]

Would have fixed it but for rush.[3]

Will you take matter in hand. You could take Lewis up to school and get drawings that will do more justice, particularly to your sister.[4]

Miss Sartain[5] would be quite willing to lend them.

I will be up on Friday on the rush leave Sat. morning for N.Y.

Of course I will see you.

<div align="center">

Sincerely
Henri

</div>

[1] School of Design for Women in Philadelphia, where Henri was completing his third year on the faculty.

[2] Sprayed with fixative to prevent smearing.

[3] Henri was preparing to leave for Europe with Glackens and Elmer Schofield, an Academy alumni.

[4] Sloan's sister Marianna was a Henri student at the School of Design.

[5] Emily Sartain was principal of the School of Design.

Paris July 29, 1895

Dear Sloan:

Want to ask you to do some business for me. In a day or so you will receive a blank from Western Penna Ex. Society (Pittsburg) which please fill out for me & send.

Robert Henri
Morgan, Harjes & C[ie]
 31 B[d] Haussmann Paris
Title – Portrait of a lady[1]
Price – 300[00]
insurance – 300[00]
Call for (give time at your place)
Return to (you)
Born (leave blank)
Societys (" ")
Schools (" ")
Honors (" ")

You will greatly accomodate me by doing this.
Please do not delay as the time will be very short Of course it is the portrait I left with you.

We had a good voyage. Glack Schoffield and I after seeing the Salons for about 10 days, went on bike trip to Brussels, Antwerp Rotterdam Amsterdam Harlem & Hague. Great trip, beautiful senery. Passed through the Champaigne district of france. Such wine! so cheap. and so much of it! oh, la! la!

Munich beer in Belgium and Holland 3¢ a glass. Cigars in Holland less than a cent each—but in Holland other things dear. Franz Hals Rembrant and all that crowd of great masters. It was a very large trip—we wished we had John Sloan with us many a time.

Glack and I at present temporarily settled in studio of friend of mine who is away. Gorgeous studio. Gobelin tapestry etc, etc. Worked last week for first. This is the place. Grafly[2] & wife settled in first class studio. Mike Dansig talks french like a parisian & has lost a good deal of his english. "Remember me to Sloan very warmly—and the crowd in general" says Glack

How about the book "Moods"? Is it out havent heard from u. yet. Lets hear from you and by the way is the portrait (the one in question in this letter) holding its own—that is, not cracking?

Give regards to all the fellows

Please remember me to Miss Sloan.

Sincerely yours,
Robert Henri

31 B^d Haussmann, Morgan Harjes & C^{ie} Paris

[1] Henri's *Portrait of Sara J. Field*, 1895, a full-length painting of a Pennsylvania Academy student.

[2] Charles Grafly (1862–1929) was a sculptor who had been a classmate of Henri's at the Academy.

806 Walnut St
Philadelphia
Sept. 2/95

My Dear Henri:—

Your letter's instructions are fulfilled. The "portrait blonde" is in good condition no sign of cracking and it is safe in Pittsburg long ere this. Moods is out and I gave your address to "St. Elmo L."[1] so that if he has sent a copy you probably have received it. The cover is not altogether satisfactory in result to me the darker green is not at all correct and the flesh color is too light you have of course noticed (if you received your copy) that there are abortions in the shape of pictures inside. In spite of all admonitions L—— insisted on inserting such things as "Spring" by Miss Evans "A book Plate" Strattons decoration to Has. Morris's[2] poem "Gould's Japanese Girl" and one or two others. The result might have been so much better that it is rather disappointing.

Many sincere thanks for your remembrance of me when passing on wheel through the Paradise of wine and cigars and Rembrandts I suppose you have heard already of Hovenden's[3] tragic death. He lost his life while trying to save a little girl from being overrun by a locomotive—his best work I venture to say. Old Rothermel[4] passed in his chips the next day. Breckenridge spliced:—[5] Our friend Smith is beginning to come around Tuesdays again—he has been fastened to a female forever, also. I wonder who, afterwhile, will be "The Sole Surviving Bachelor" There is a dullness in the Artistic Atmosphere which while making me feel damnedly lonely is to yourself and Glack flattering to an immense degree. The Moods crowd never turns up Tuesdays, and the only way to get up amusement is to start a poker game; of course when I am the only one present even this form of vice can not be indulged in, and I smoke alone. I have a scheme for bringing Reddy[6] from his Glenside fireside which I shall have to work as I have not seen him for months—poker announcement of course.

Seems to me you fellows have been away your two years already; better shake the dust of that Gobelin tapestry and stuff off your shoulders and come back;—of course this is not imperative, but if I dont have some companionship damned if I don't think I'll be driven to marriage.

Spent a week at Atlantic City, stopped by to see Dr. Frank[7] and found him deep in the turmoil of building a wine room, there is an awfully nice house around and above it, too, the best looking house in Atlantic City to my mind—It has shelves all around and there will be a table in the centre (the wine room, not the house) and the walls have the privilege of holding up to view the finest collection of "Henris" of any in the country (the house, I mean) not the wine room). He tells me he has secured some eighty gallons of Egg Harbor wine which he intends to store in it (the wine room) but hanged if I can tell you any more about the house I get tangled in my descriptions and constantly revert to the "preferred".

Well, old man, go right on with your work and don't forget that anything that you want to exhibit can be forwarded to your "Sole American Agent" also a letter now and then to break the monotony of his existence. Don't forget that as Art Editor (or assistant Editor, as they have put Dr. Davis[8] on the job with me because he "knows Walter Crane[9] and Joe Pennell[10] and others don't y'know") I want you and Glack and any other of your friends over there to send something for the next number of "Moods" and I'll try to see to it that the surroundings are more completely artistic than they were last time.

Shake hands with Glackens for me and tell him "I hope I see you well, old Dinkbotts."[11]

The remaining few send best regards, so does Shinn,[12] and so does Davis, and so does

Your ever friend

John Sloan

To M. Robert Henri
 a Paris
 or elsewhere

[1] Elias St. Elmo Lewis was an editor of *Moods*, a monthly magazine.
[2] Harrison Smith Morris was author of *Madonna and Other Poems*, published in 1894.
[3] Thomas Hovenden (1840–1895) was one of Henri's teachers at the Academy.
[4] Peter Frederick Rothermel (1817–1895), a painter of historical subjects.
[5] Married.
[6] Edward Redfield.
[7] Frank Southrn, who was a physician.
[8] Edward W. Davis.
[9] Walter Crane (1845–1915) was a British painter and engraver.
[10] Joseph Pennell (1857–1926), the expatriate American artist and writer.
[11] A nickname for Glackens derived from "Inkblots."
[12] Everett Shinn (1873–1953) was a fellow newspaper artist in Philadelphia.

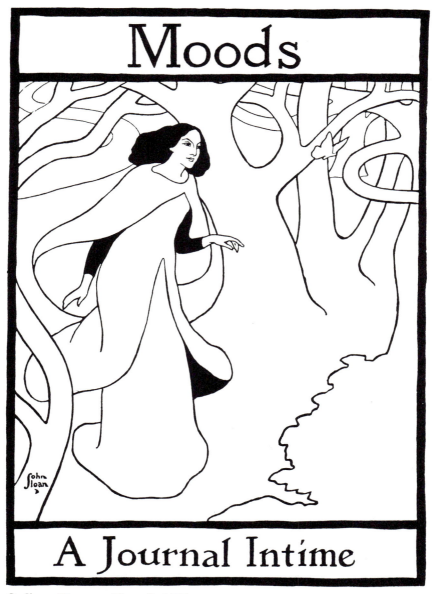

9. Sloan, *Woman and Butterfly*, 1895

806 Walnut St
Phila. Dec 8 1895

Dear Henri:— Dear "Degenerate Type":—

There—this letter is started at last Ive been waiting and hoping for some subject matter for a letter for weeks but as nothing occurs now, Ive plunged into ink and will take my chance on some inspiration

Oh my! its quiet. I wish it were possible for me to follow your footsteps to Paris and accept the "shake down" you so kindly offer As for the cold to cure I guess I could contract that all right and of course should not flinch at the "fine" and curaço

I have one wheel out of the rut, or at least into a shallower rut. I have left the Inquirer and cast my fortunes with Preston,[1] "Dinkbots," Davis, Ruyl,[2] Crane,[3] Howes and Company Mark makers and pen pushers; Office 5th floor Press Building.

I am in better company and am getting more money for which Allah be thanked and may he speed the day when I shall quit the newspaper business entirely

Tuesday nights are getting "curiouser and curiouser." They lack peaceful contemplativeness and intellectual tone I'm afraid; You know they showed symptoms of this kind of degeneration even before you left and of course when you—well we wont be complimentary—

The manner of a Tuesday night these days is something after this wise:—

Scene 806 Walnut St 4th floor time Tuesday 8.30 P.M. Darkened studio save for the reflected glare from Gilmores over the way.
Enter John Sloan followed up steps by Kellys ghost (you know the sound) gropes way across the room to the old black shelf, finds match after much fumbling among bric a brac, turns on gas, attempts to strike match, fails once, more fails, <u>curses</u>, (Match strikes only on box) Ghost laughs as Sloan seeks box, at last finds it and gas is lit. S. lights pipe, fixes stove, wanders aimlessly about room, wishes he was more industrious, lights another pipe load, [ditto marks under "wanders aimlessly about room"] etc
Exit Ghost

Enter Preston, greetings, both light pipes, wander [ditto marks under "aimlessly about room"] wish they were hard workers, start to have an edifying conversation on the benefits of thinking much and working little. (Noise Below as though a herd of cattle were being driven up stairs) Enter "Ebby" Shinn and "Dinkbots," Sr. The latter is usually sober perhaps. Enter Howes, of Boston, bearing package of cheese Enter Davis, bearing loaves of bread (On the night in evidence, the first time since you left enter) Redfield, horticulturalist,

Pessimist, Painter and Poker fiend "star" seller at the recent Art Club exhibition he sold a picture perhaps he has written the tidings to you ere this "well any way"

Poker game starts at once between Reddy Sloan and Dink distant mutterings of "Welsh Rarebit" "Come on Dink" Start her up "Drop that game" etc. Mutterings reach thunder pitch and as Dink is "in" 25 cents he quits and starts the Rarebit—Dink mounted on stepladder is captain and "Centre" the rest of the team are stationed at the 35 yard line armed with plates and burned bread in slices (The Gamblers are to be euch'red out of their rarebit by football strategy) The cheese begins to simmer in the frying pan which Dink holds over the gas burner. "4"–"11"–"2"–"8"–"16"–"24"–"15"–"10" shouts Captain Luks[4] the cook and the solid phalanx of hungry men come plunging down on the Rarebit (The Gamblers keep on playing) The cheesy greasy mass is splashed over everything but every one gets some share (excepting the Gamblers) who however manage to secure a portion of a portion through earnest pleading with one who has more than he can eat) "Wheres the whiskey?" S. produces ½ pint another is sent for a punch is brewed and then the regular weekly "Orchestra" tunes up: Luks is past master of the Conch shell bass horn, "Chimmy"[9] Preston thrums the broken guitar, two tin plates furnish Shinn with cymbals, Davis plays the ocarina and groaning in a bottle while passing an umbrella across the front of an easel make a bass viol accompaniment to Sloans manner of thinking. All visitors are armed with other strange noise making devices. Hell Howls! The "Houla Houla" Dance is played and Sloan dons a wig and ballet skirt and does the Danse du Ventre Luks immitates every living man, beast, bird, and fiend, and winds up with a long side splitting discourse on—Oh well you have met him. (The Gamblers resume playing) Train time comes for "Chimmy" Preston and others. none but the Gamblers are left. The game goes on. At last it's over. S. is star looser, of course (not for very much this night however and this is really the first game since you left—You see Reddy has not been on hand) All exit Sloan puts out gas and exits Enter Kellys dear old Ghost (Sings)

One of them still am I
Never to really die
So long as Tuesday night shall last.

Singing and quaffing beer,
Little they think I'm here
Seeking for the comrades of the past

May Fortune each befriend
 And guide them to the end
And Merry men and good men may they be

 When friends of friends are met
 Let no ones friend forget
 To smoke a pipe and drain a glass for me

(Exit Ghost)

The footsteps on the stairs cease, the front door bangs shut, silence, — gloom, curtain)

————

O say: how about those photographs you were to pick up for me in Paris, guess you've forgotten to send them haven't you

I have asked "St Elmo" about Moods he says he sent two copies addressed to you c/o Morgan Harjes Et Cie one for you one for Glack.

By the way, I guess this number (our number) is the last of "Moods" Lewis has kind o' droped out he's hare brained you know

I sent your Blond Portrait to Pittsburg and Rudy[5] tells me it is well placed perhaps you have received a check for it for ought I know I have not heard whether the exhibition is over or Not, at any rate the cat[6] has not "came back" to me.

We are thinking of getting up a Variety Bill for Christmas jamboree at Studio.[7]

There has been a Swedish exhibition at the Academy work is very interesting but peculiar Zorn's[8] work is awfully clever but seems thin, lacks dignity, too damnedly clever. The work looks too easy for him, where work is so easily done thought should be harder, it seems to me. (of course I speak of only what I have seen)

There has been a "Womans Edition of the Press" Sister[9] made a poster for it of course under the eagle eye of The Art Editor Miss Sartain all my sister's best sketches for posters were turned down and the worst perhaps of her sketches selected the old lady is certainly a bug-bear in a case like this.

I wish I could wind up this letter by jumping in and sealing myself up but Im afraid I cant afford the stamps so Ill send my best Christmas wishes to Henri & Glackens and back them up with remembrances from Preston Davis Luks Shinn and the rest of the true Believers Dont get even by waiting long before you let me hear from you both

 Your each ones friends
 John Sloan

[1] James M. Preston (1873–1962) was a newspaper artist who studied at the Pennsylvania Academy.

[2] Louis H. Ruyl was an artist on the *Philadelphia Press.*

[3] Frank Crane, art editor of the *Press* and an illustrator who was an important influence on Sloan's early work.

[4] George Luks (1867–1933) was a fellow newspaper artist who had studied at the Academy.

[5] J. Horace Rudy was a newspaper artist and former Pennsylvania Academy classmate of Sloan's.

[6] Catalogue.

[7] Similar to the Grand Christmas Effusion held the previous year.

[8] Anders Zorn was a Swedish painter, sculptor, and etcher.

[9] Marianna Sloan.

Paris Dec 28, '95

Dear Sloan:—

Kind invitation received many thank, A Happy New Year to all the boys

Henri & Glack

806 Walnut Street
Philadelphia
Feb. 7. 97

Dear Henri:—

Here's a letter from a stranger:—

I sincerely hope that you have berated me as often as I have you in the past twelve months for non appearance of a letter—if you have we're "square".

I get inklings of your doings of course but I know that you receive no inklings of mine. [letter torn] Rumor does not get a large enough fistfull to warrant so long a journey.

Glackens' return was but a fleeting satisfaction. The Metropolis[1] beckoned and he hied him hence; I suppose that you have heard through him that he is now doing work for the N.Y. Herald but of course you have not heard by that medium that he is doing excellent work—he is in a class by himself amongst the newspaper artists and it is a long step from him to the nearest.

Grafly, Pop Grafly, delivered the photographs in good order, and I need not tell you that they pleased me immensely.

The Japanese print is swell and Wilson can tell you how much I prize it. I myself must thank you for your trouble and kindness (my! how formal that sounds don't take it so)—

You and Finney[2] and Glack are placed abominably in the Academy exhi-

bition; trimming most artistically the window behind the orchestra chairs. By shading my eyes and squinting I find that I like what I can see of yours.[3]

Off and on, principally the former, during the summer and fall and winter I have been trying to do my share in putting a band of mural villainy about the innocent walls of the Academy Lecture Room[4]—I am afraid that it will result in a one ring circus, with poor Henry D.[5] in the part of star clown and myself and most of the others in the capacity of right able assistants.

However, I feel that I will have learned very much in my struggle in the (in this case) covered canvas arena.

Do you remember young Josephs of the North American,[6] who put you to your best efforts one evening in the old chalk-marking trick? A bright young fellow who had more ambition than the average young newspaper writer [in] Phi[la.]—I have just heard of his death [letter torn] journey from Venezuela He had been there the best part of a year, if I rightly remember, and had written interesting accounts to the papers—died of Venezuelan fever after facing that dangerous climate so long—

One of my first thoughts was that he had swung the chalk-mark beyond us this time; Still there's a melancholy surety of our "tying" eventually. Poor fellow, I tried to paint his portrait on[ce and] suppose Providence thought I'd try again.

Jove! but the memoirs of a year in my life [can be] quickly summed up— If there comes no change in movement of events twill be a case of multiplying zero by ? years—and my death notice will come cheaply at forty cents the line.

I am not married; I'm not engaged; I'm not in love,—These are all good "nots" for they show that I am considerate of the happiness of womankind.

Don't think that I am becoming melancholy from the forgoing—that would be more excitement than I am allowed.

And now—what are the prospects for a hand-shake within the year? I won't be able to travel to proffer it but I hope you will.

With regards from your friends within my bailiwick,

 Yours

 John Sloan

[1] New York City.

[2] Harry Finney, a former Academy student who went to Paris with Henri in 1888 to study at the Académie Julian.

[3] Henri's painting was *Suzanne* (*Profile—Suzanne with Cup*), 1895.

[4] Sloan's two contributions were *Dramatic Music* and *Music* (later retitled *Terpsichore*). He received no remuneration for them.

[5] Henry T. Thouron (1851–1915), a professor of composition, who asked Sloan, Henri,

10. Sloan, *Dramatic Music*, 1896–97

and eleven other former Academy students to paint the murals. Henri rejected the offer. Sloan, who misheard Thouron's middle initial, referred to him as "Henry D." instead of "Henry T."

6 A staff member of the Philadelphia newspaper.

Henri returned from France in September 1897, though his reputation as an artist had preceded him. An article in the New York Herald *the previous spring, concerning the Champ de Mars Salon in Paris, characterized his paintings there as "displaying technical skill and good qualities" ("Champ de Mars Vernissage,"* New York Herald, *24 Apr. 1897).*

As a consequence Henri was awarded his first one-man show at the Pennsylvania Academy from October 23 to November 13 of that year. He displayed 117 paintings, two-thirds of which were scenes of Paris and Normandy, the rest portraits and figures. Among them were In the Garden of the Luxembourg, Night—14th July in Paris, Normandie Interior *and* A Peasant. *The reviews were favorable: A critic for the* Inquirer *proclaimed him "a prophet of the new" ("Art Notes,"* Philadelphia Inquirer, *24 Oct. 1897), while the* Ledger *dubbed his show "one of the most interesting . . . exhibitions held in the Academy during the last few years" ("A New Painter,"* Philadelphia Ledger, *25 Oct. 1897).*

Sloan did his part to promote the exhibit at his paper, with the result that the Press *ran two stories on it.*

[*From Sloan to Henri*]

[1897; undated]

Said a rising young artist named Henri
Whose favorite grog was Rock n Rye
 As my paintings won't sell
 I will step down to Hell
And paint Sacred Subjects from Mem'ry.
 J.S.[1]

Spring at "806"
 Circa 1895–94[2]

1 When the show closed without a single sale, Sloan sought to ease Henri's disappointment by penning this limerick.

2 What appears to be a postscript to Sloan's humorous verse is, in all probability, a note written by Henri referring to a Sloan drawing or a photograph of the studio, the original of which is unknown.

11. Sloan, drawing of Henri's oil, *Une Paysane* (A Peasant), 1897

While Henri was in Paris, he organized several art classes in his studio, for which he provided weekly critiques. After his return to Philadelphia in the fall of 1897, he continued the practice, utilizing Sloan's studio at 806 Walnut Street.

In June 1898 Sloan joined the New York Herald *art staff, a move prompted by the outbreak of the Spanish-American War. Because New York newspapers sent their own artists to Cuba to cover the conflict, replacements were recruited from among the Philadelphia papers. Sloan, it turned out, was unhappy in Manhattan, causing his return to Philadelphia and the* Press *within a few months.*

Also in June 1898 Henri married Linda Craige, one of his students, and the newlyweds set out for Paris and a honeymoon which evolved into a fourteen-month residency in the French capital.

12. Linda Craige, ca. 1897

806 Walnut St Phila.
July 21–1898

Dear old Henri[1]—

Your letter in my pocket and wondering what there was to tell you new in the old procession "806—Hercules—Hercules—to Bess—Press to Camac St Etc"

I covered the route the day of its receipt. Suddenly a telegram from Crane,[2] New York Herald, later in the day Crane himself and now I am booked for New York

Surely tis as tho' the bronze creation of the Elder Calder[3] should leave his perch on the City Hall I wonder how you would have advised me? I think I have done as you would suggest—I will have a better opportunity and self preservation will necessitate my keeping out of the clutches of the "dry rot" Dont ever betray me but I said "Yes" under the influence of two or three of the whiskies that Scotland was named after—But how did I forget old "806"? It nearly breaks my dusty heart to leave it but then I leave it with Laub and Preston who promise to respect the dirt—guard the Books—pay rent and honor our memory—I stare blankly around the old room now and the scenes I can recall to my minds eye with this old "stage" as a background[4] make me physically weak when I think of "Curtain"

Today is Thursday I go Monday The Heralds allowance is to be $50-per week. The frames paintings and so forth are to remain here in charge of Laub unless you wish to make some other disposition of them For the present I hold the lease and am responsible for the rent.

No mail has been sent here for you outside of a circular or two one of which came this week and I think it important enough to send you the essential pages herewith.

Ruyl has seen the portrait and has said nothing much about it he liked it as a painting but I do not think he was quite satisfied I told him to do as he thought best that such were your instructions to me

When I get the book bills off my hands perhaps I can begin to save for the trip to Paris till then I must forswear such distant visits.

My Best regards to Mrs. Henri

John Sloan

I have carried this in my pocket and mail it from N.Y.

[1] Henri was six years older than Sloan, gaining him the nickname of "Old Man."

[2] Frank Crane, art editor of the *Herald*, formerly of the *Philadelphia Press*.

[3] Alexander Milne Calder, who created the statue of William Penn atop the Philadelphia City Hall.

[4] The area of the studio formerly used for amateur theatricals.

Paris Sept. 1898

Dear Sloan:

I enclose a letter just received.[1] It has greatly affected me. I send it to you because I think it can best be the encouragement the writer hoped to attain through me.

Whatever her cause for interest in you, be it love friendship—or you may think her simply busy—(I hold her in highest esteem). This letter is an appreciation of you so take it for what it is really worth.

I have cut from the letter the part which does not appertain to you. I do not know whether she would like my sending it, but no matter. It is because I think it will serve its own purpose.

If your scrape is as bad as her letter seems to make it, then, old man, you are in a pretty bad scrape. If it is get together and get out of it—not so easy as said I know—sometimes one has to run away to get out of such affairs—but don't ruin yourself. Can't you get together some money and come over here—It would do you good every way and give you time to think a bit—and, if matters are as her letter suggests—give you the chance to get a new valuation of your self, for you are no ordinary man and you can neither do as much nor as little as most men do. Her letter has disturbed me greatly—and I would give a good deal to come to see you. A friend is worth something at such times—You will probably have a chance to make some fine studys in friendship before you get through with this affair—I am taking it always as she suggests. It will do you good no doubt, if you pull through and survive it. And you must survive for the glory of the old Studio. You want to be a great artist—and you can if you only get yourself together—and for gods sake just give up running with the gang— the smart young men about us always seem to be so much wiser and look down on our youthful ambitions until, if we go much amongst them we do begin to doubt our fine old Studio aspirations. A man to make anything out of himself, has got to flock by himself. Of course I am not so much worried about you taking a mistress and all that—Most men do more or less—and a good many come out of it all right

Whether you can—well, don't forget that you are John Sloan and don't give up the old Studio ideas. I look back on them and on our old friendship in such a way that I cannot bear to think that you could, in any way, give up. I have had few close friendships—Yourself and Reddy the closest and your success and happiness is a great deal to me. Take care of yourself then John for your own sake and for mine if for no other and dont in the heat of the thing, ruin your chances of success and of life's happiness by any too hasty doings.

I wish you could come over here. Madame and I often talk of you and wish to have your company and fine sympathy.

Let's hear from you and tell me all about it—I got your letter about

leaving Phila—Have by the way sent to have the pictures etc taken away—as I think they had better be in storage.

Have you any news of Glackens—I haven't heard a word of him since his departure for Cuba. Hope he had not too hard time of it and that his exploit has proven successful.

Don't fail to write me and take good care of your self.

<div style="text-align: right">
Your friend

Robert Henri
</div>

alias "the old man"

P.S.—Madame says to give you her best wishes, and we both hope to see you over here

[1] From one of Henri's students, Miss Crooks, who wrote to warn him that Sloan was living in New York with a woman she described as "a common woman met up on the street" (see letter of 1 Oct. 1898). In fact, Sloan had been introduced to Anna Maria "Dolly" Wall in Philadelphia the previous May, and invited her to accompany him in July when he moved to New York to work on the *Herald*. Sloan married her three years later.

<div style="text-align: right">
Paris, 21 Sep. 98
</div>

Dear Sloan:

Just rec'd enclosed from Miss Crooks. It seems that she in her good intentions has gotten her foot in it again. Too bad and glad that all this terrible state of affairs does not exist—It might have, tho', John, for we are all of the flesh you know. I hope since there is not a female in the matter, you may be laying aside ducats out of the fabulous sums you are making per to come over to france—Paris.

Don't be hard on Miss Crooks for her sensation and mistake, for she, I know from all I have gotten to know of her, is kind and generous, and her interest in you in this matter, tho' on mistaken grounds was of the right—friends—sort. After all, one can not put aside the real feeling she has shown for you—for, while it is at times irksome, it is on these who interest themselves in us that we go to lean when in need of sympathy.

So glad you <u>haven't</u> got into a scrape, so easy to do, and so hard to get out of, and counting on hearing from you very soon

I am yours with benedictions

<div style="text-align: right">
Henri
</div>

Kindest regards from Madame

October 1st 1898[1]

My dear "Ole Man"—

Your letter compensates for all the annoyance that Miss C——'s letters and interest in my welfare have caused me for the last four years; and I must "hasten to answer with deliberation" as it were Your fears are based on wrong and distorted information. Miss C—— I have no doubt has my best interests at heart but I can assure you old boy that I also have the same and tho' I perhaps am not so energetic in evincing my own penchant for my progressing—as she, I still have quiet hopes for a small portion of success in this world.

Without ridiculing her letter to you (which I suppose you would not "stand for") I must tell you that in reading the greater part of it over I could hardly restrain an impulse to commit it to memory It is in many ways so like one of W'msons[2] despairing lady speeches in the old studio plays—Now seriously—To begin with perhaps you should know that her information comes from young Birkmire a cripple on the Press Art Staff—this she told me. Meeting him on a trolley car; and using that power, undeniably hers, of making the unwatchful mouth say things which the brain will deplore, she seems to have heard a lurid tale, or has "luridicated" it herself. A tale of a "common woman met up on the street," of friends vainly solicitous, of leaving them to "go with this and another and a crowd of coarse men to the Rathskeller." She puts so Dante like a profundity to the word one might think it was the place to which Hell sent its evil doers—Youve been to the Rathskeller—you know what it is—she evidently thinks it out herself—as you may perhaps be able to ascertain thru a casual inquiry of Ruyl who is or will soon be in Paris. (Of course he may not look on the girl as I do) The coarse woman is a little girl I met some five months ago she does not mind sitting with me and drinking in any place I may elect. She has been at the studio and I had called at her boarding house frequently. I only know what she has told me of her "past". It does not much matter whether her story is true or not so far as I am concerned it makes no serious difference so that nothing was in evidence—I did not meet her in the street. She was not of the street. The night I went away or said goodbye to the Press Art Dept boys they were in a body taking me to the Rathskeller to give me a "send off" we passed her on the street with a friend, and as she was known by sight to many of them, they told me to walk back and invite her—I did so. she and her friend came with us to the Rathskeller—Davis, Preston, Ruyl, Schaadt, Birkmire, Keller, Howes, Magraw, Smith and myself were the "coarse men" no others were there. after being there and having "lunch" at a Chinese restaurant (in a body) we separated (I took the little girl perhaps home perhaps not) Wyatt took her friend home. I have brought her to New York and am living steadier and with less dissipation than in the last

year & a half I dont associate with anybody outside the Herald Office get home early and as for her being after my money—Rot! I give her when I go out in the morning less than 50 cents for dinner and incidentals I am not flush by any means I have as you know book bills and a family in Philada to look after, & 30⁰⁰ rent here.

I am not "changed" save as you may see above—of course when you "jumped into harness and flew the coop" I was in the blues—and on one fatal afternoon with a couple of "rickys"³ in my head I told her (Crooks) so <u>Told her</u> that I was going to the <u>dogs</u> as she says in the letter (but I had not yet met the <u>girl</u>) She takes all that is said by a fool with a couple of drinks seriously. I never intend, and you surely dont seriously think it of me, to give up my good opinion of myself and my work I may be lazy and so on but I'm conceited—too conceited to send myself in the direction of eventually making stuffing for sausages.—Well I guess you are about set right now in regard to the woman in the case Ill assure you once more of any [*next page missing*]

¹ Letterhead is The New York Herald, New York.
² Charles S. Williamson's
³ A drink containing liquor, lime juice, sugar and soda water.

[From Sloan to Henri]

[Oct. 1898; undated]

[*First page missing*] still having an interest in life and that my scrape is not so bad as she (Crooks) has represented it to be She may give it a nasty turn if she goes around Philadelphia spreading her story so that it reaches my Family but I can only hope for the best Crooks came over here to see me as she threatened in your letter and as she put it in terms of "picking up a woman in the street and vulgar woman" I denied her story. The crowd by the way <u>never</u> tried "vainly" to "persuade me to drop the woman" . I have been over in New York nine weeks now—I am not as much of a star on the Herald as I was on "the Press"—no matter—the Press has been unable to fill my place as yet and is still further crippled by the loss of Louis Ruyl whom you have probably seen by this time he left about 2 weeks ago to go over to Paris and will call on you if he has not already—He can do such things. I dont seem to be able to get any money together. The work here is done under less pressure in a way one is given more time and is expected to work carefully—you know the Herald style of illustration I suppose.

Glackens I see quite often he returned in about the 3ʳᵈ week of Au-

gust His stuff or rather a portion of it is published in Oct. McClure's Magazine and is awfully fine in spite of what is plainly poor reproduction owing to too much reduction in size[1] The work was done just as published <u>on the field</u>. He tells most interesting accounts of his adventures when he once is started I told him gently of your turning Benedict You should have seen him stare He said that he would write to you but I suppose has put it off from time to time. I go out to Philadelphia on a visit every month and as it happened was in the Studio seeing Joe Laub when young Mr. Craige[2] came in with your note about your pictures & frames.

I therefore sorted the things out myself reserving a small frame or two which Joe said would not be in his way I have not moved all my stuff over here yet still have heart strings round the old place heart ropes almost heart hopes Davis has been sounding me on two or three occasions since I have been here, on the subject of returning to the Press the best offer being an intimation of <u>above</u> 40 dollars I would be sorely tempted to return for 50—50 in Phila. would equal 75.00 here as my expenses are so much heavier in New York. However nothing less than that sum would bring me back. The City of New York is I think finer more artistic and what is very important a good thing done in New York is heralded abroad—a good thing done in Philadelphia is—well— <u>done</u> in Philadelphia And now old fellow let me hear from you quickly again if only a scrap of a note to tell me that you feel easier in regard to me than you were There is no need of my trying to put on paper an expression of my love for you my real friend (even that sounds formal, doesn't it?)

Goodbye, old fellow with best regards and good wishes for the Madame.

Yours—John Sloan

[1] Glackens came to New York from Cuba, where he had been sent by *McClure's* to produce field drawings of the Spanish-American War. Because the magazine was a monthly, his artwork of the Armistice, which took place in July 1898, did not appear until the October issue.

[2] Henri's brother-in-law.

Paris 14 Oct. 1898

Dear John Sloan:

Well, the upshot of the whole matter is that yesterday I rec'd a letter from you which gave so much pleasure in the reading both from what it said and its style, that I am glad I sent you the letter I had received concerning you—Before sending it I tossed up considerably whether I should trouble you with it at all as there are matters in which there should be no outside interfearance and generally no outsider can justly judge of them— I am mighty glad that you shook off the old dust of Phila for I believe you will get much advantage in being in a new surrounding. I always find a

move productive of an awakening of some sort. It has always done me good to come over here and it has always done me good to go back again—although I have had a hard time making up for the inactivity of all last winter, when I painted so little.

Louis Ruyl has been here some time and is getting along wonderfully well for a stranger and one who does not know the language. We see him two or three times a week. He has seen his people, the commissioners, and has I believe gotten together a lot of stuff on the strike which is now going on.[1] the Exposition works, and I believe is looking somewhat after the Dreyfus case[2]—but of that there can be but little material these days. He has none of the native bashfulness, and makes the most of what french he has picked up together with the spanish previously picked up. Paris did not come up to expectation but he likes it better now. I really believe he wants to stay, and I've no doubt that a man with the "push" he has can do it either by working for the NY papers or I wouldn't be in the least surprised to hear in a short time of his getting on the staff of a Paris paper. He told me about Glack and his experiences down in Cuba. I should like to see the veteran himself and get him in a state to spin some of his war experiences. I can imagine Glack kicking for more hard tack and objecting to bullets riddling his paper as he sketches.

I bought the October McClure and liked the things immensely fine feeling in all the lines and they give a fine idea of how men felt down there. I wondered if my liking them so much might not be partly prejudice & was glad to hear you speak so highly of them too. I felt very much the fault of reduction and dislike the two thin lines around the pictures as borders. Enjoyed reading the article, which I think exceptionally well chosen and well written. I am anxious to get hold of the next number—hoping that there will be more stuff of Glack's in it.

I am working awfully hard these days, never worked more in my life—and well, I have hopes to acomplish something before the winter is over.

Let's hear from you soon. Madame sends best wishes

<div align="center">Yours
Henri</div>

[1] A strike of workers in the building trades who were employed at the site of the World Exposition scheduled to open in 1900.

[2] The reconsideration of the verdict against Captain Alfred Dreyfus, the French army officer accused of spying for Germany.

Philadelphia Oct 30—'98

To Robert Henri in Paris:

Dear Henri:—

Perhaps old man some explanation of the date line at the top of this page is first in order—For I am back in Philadelphia and again on the Press—and once more occupy the old "806" studio where you may yet hope to see me in old age surrounded by books and stage properties dating back as far as The "Widow Cloonan's Curse"[1]

But dont think that I have been unable to hold my own in the Metropolis or that I have returned once more to sleep the sleep of the Philadelphian I have returned by my own wish—and under my own steam—to the Press The Town and the Studio in order to be worked under <u>more pressure</u>. Of course a New Yorker might not believe it but it is a fact—A newspaper artist on the Herald the Greatest Paper in the World dont know what work is compared to the artist on the "Press" of Philadelphia The reason is easily given. The Herald has 18 men on its regular staff (all good men and "thorough") It has also 10 men at least in the outside. The Herald likes work "tickled up" & "finished" The artist is expected to do so and is given time to do so. The Press has 9 men—5 of them <u>only</u> are equals in quality of work (from a newspaper standpoint) to the Herald staff The Press can not give a man the time to "finish" even tho' the editors may wish to see Herald work in the "Press". Now if Sloan <u>must</u> do newspaper work is he not better off where he is the big frog in the little puddle and where he dare not take the time necessary to turn out slick newspaper work I think so—and as the Press with much groaning came up to $45 per and as $45 here is equal to $65 in New York I feel quite well satisfied with the change I have learned a great deal in the 3 months of New York and somehow I feel differently from my old rusty self This may be a delusion however At any rate I'll give myself a trial and see whether I am changed at the end of, say a year.

I feel more like an artist in Philadelphia, even tho' the <u>town</u> is so ugly compared with N.Y.

And already I have had a chance to spread myself in a full page drawing for the Sunday Press. Of course my work will be "under a bushel" here in Philadelphia The world won't know what it misses in not seeing the Press But on the other hand my bad efforts wont be seen—majority sways—

I hope you will not feel disappointed in hearing of my return—you know <u>your</u> letter says "It has always done me good to come over here and it has always done me good to go back again"—I agree with you perfectly; even the 3 months have done me good and I'm back to find out whether the last part of your statement holds good for me.

Jimmy Preston has dropped newspaper work and is doing work for The Saturday Evening Post, a weekly magazine run by the Ladies Home Jour-

nal Publishers he gets children stories to do and seems to be much more in his proper element

Philadelphia has just pulled thro' a Peace Jubilee three days of Naval, Military and Civic parades and general foolishness Crowds in town, and after 12 oclock at night no one sober a great Court of Honor on Broad street between Chest. & Walnut Sts which looked pretty fine altho not perfect in design. I will see if I can get a print of a photo which Davis took at <u>night</u> showing the Illuminations <u>Poor</u> old William on the Tower[2] has had a circle of electric lights on his hat all week as well as the lights which were around his feet when you saw him last.

Postscript after carrying the above in my pocket for 3 weeks.

Nov. 20 Well I still think the change was all right I have been painting 2 or 3 mornings a week in a class which we ("The Press Gang") have started at the studio and am making some progress (I think) Miss your criticism tho'. Have seen a couple of drawings from Ruyl sent to the Press and in the last one I think there is considerable improvement in his work. Remember me to him if you see him tell him to write if he gets a chance

The old 806 is looking in better trim than it has for years Joe[3] and I have thrown out lots of stuff and it looks like a work room. Suppose I'll see something of yours at the Academy this Ex.?

My regards to Mrs Henri and best wishes for you and your work

Sincerely your friend
Sloan.

[1] An original production featuring Henri and Sloan among the cast.
[2] A reference to Calder's sculpture of William Penn atop the Philadelphia City Hall.
[3] Joseph Laub.

Paris 5th Nov. 1899.

Dear Sloan:

This is not the first letter I have begun to you since my last—However I hear from you occasionally from those who come over and I suppose you hear of me from those who come back. There has been a sense of satisfaction that the old place is still home. I'll admit I was worried about 806 when you went away much as I was pleased that you got for a while out in another world, and I would give a little to look in on you for a while— When you decide to take another trip into the world you want to come over here—it's my old NY—but I believe it is a good one—both for my own gratification and your advantage—so you can expect me to keep it up. We talk very often of you, and how glad we would be if you were here.

Night before last we spent at Reddy's[1] and then you were sorely needed.

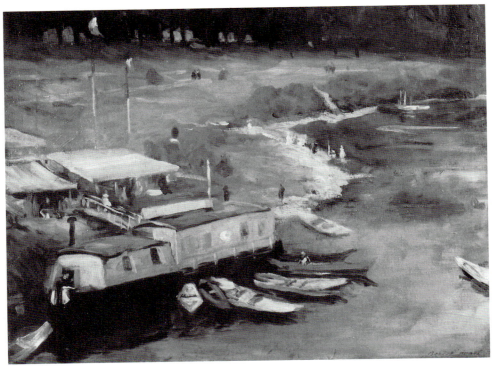

13. Henri, *On the Marne*, 1899

Poor Reddy and I, the last of the pokerites, with a game of seven up, a bottle of rum and some quarts of cider and each of us a cold to cure. You had better come over. Preston seems to like his life in Paris very much, we have at times seen a good deal of him, but of late only occasionally but that has been because of our going so little to the café in this season, and being at work all the day there is so little opportunity. Miss Field, Miss Butcher and Miss Ingham of the class at 806[2] are over here now, and Miss Burton and her sister, too Miss Burton is working in the Whistler Class (but Whistler hasn't decided to appear as yet this season they tell me) and as yet the others havent settled down. They brought great news about Glackens and also of Davies, whose work they saw in N.Y. before leaving.[3] I wonder if you ever see Glack—I only hear of him through others or by those splendid things that occur in the magazines. We see Wetherall too occasionally—getting on well—and the new arrival Addams.

Are you interested in the work of Daumier—I am sending you by mail in a paper a few drawings (lithographs) by him—They came out in the "Charavari", I think about 25 years ago—If they will interest you, and they have not arrived about the time of this letter you can claim them at the post office as they do not come under the head of tarif—and if they did, then their value is but three cents a piece—I paid that—that is, three sous each for them Daumier was a great painter as well as draughts-man—there was one of his pictures "En troisieme class" view of a third class french RR carriage with wonderfully drawn & interpreted charac-ters—most masterfully painted (none of the modern so highly esteemed clever smartness—but great solid simple painting) It is a picture that ranks at least with the best of Millets—and if they were side by side I might say more.—

You know Reddy was first at Brolles (Forest of Fontainebleu)—since he has come to live at Charenton (or rather Alfort, across the river from Char-enton) It's practically Paris—being the East outskirt of the city on the river. Beautiful place within half an hour of the Louvre by boat and on the edge of the country in the other direction. Reddy did good things down in Brolles in spite of the season being the green period for forest and the place not being just the right kind of subject for the painter of creeks and snow But now, since he is at Charenton he has done work that is far ahead of all he has ever done before. River scenes looking towards Paris—He has found the thing he likes to paint and plenty of it. He has left all his old successes way behind with this new work

At present we are making new canvas for a hard winters work.[4] Must do a lot this year. There are so many exhibitions to go on. I was not invited to the Academy show, therefore will not be seen there, but will have things pretty much everywhere else this winter. Of course you have heard that I sold a picture to the Luxembourg Gallery,[5] which must have pleased the Business Manager.[6] I intend to send you a photo of it later

I hear that Glackens is coming over about Christmas time—You had better arrange matters to come along with him. From what I have heard of the way you are getting ahead you must have a hand full of the neccessare by this time layed away for a Paris trip I dont know how long it will be before we come home—we will be here all this winter at any rate. Hello to Davis and all the old stock—and heres hoping that some day there will be another eleven act tragedy[7] with all the old favorites, the same author,[8] the same premiere danseuse the same leading lady[9] the same number of kegs of supper and all at 806

Yours, and kindest remembrances from my wife,

Robert Henri

49 B^d du Monparnasse
 Paris.

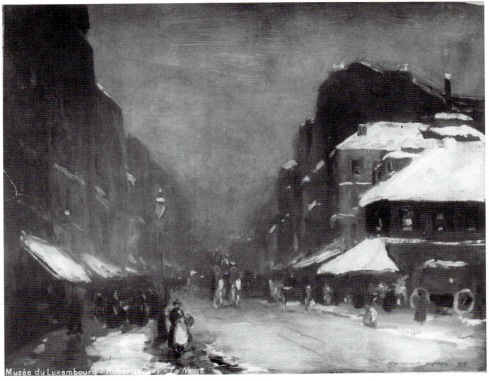

14. Henri, *La Neige* (The Snow), 1899

[1] Edward Redfield and his wife had just taken an apartment at Alford on the outskirts of Paris.

[2] These women were among a group Henri had taught in a private art class for six months beginning in November 1897. Because 806 then served as Sloan's studio, he was allowed to observe the sessions in exchange for Henri's use of the space. One of the students was Linda Craige, whom Henri married.

[3] The paintings by Arthur B. Davies (1862–1928) were exhibited at the Macbeth Gallery, where Henri had initially viewed his work in 1894.

[4] *On the Marne* was among the Henri paintings produced while staying with Redfield at Alford.

[5] Henri's *La Neige* (The Snow), 1899, was acquired by the French Government for the Luxembourg Gallery in June 1899.

[6] Sloan.

[7] A reference to *The Widow Cloonan's Curse*.

[8] Charles S. Williamson.

[9] Sloan.

1900
TO
1909

Upon returning to the United States in August 1900, Henri decided to move to New York, so Sloan planned a combination welcome home and send-off party.

Sept. 1900[1]

Dear Henri:

Suppose you wondered at my nonappearance the rest of last week. I spent it in bed—am just beginning to feel a bit better.

I am sending out invites for Saturday 22nd, afternoon and evening open house "806". Only inviting Reddy, Schof.,[2] Graf.[3] Calder, Breck.[4] Henri and Sloan. Perhaps will write to Glack though I suppose he will not be able to get over. We could go to some show in the afternoon and play "poke" in the evening and have a little "farewell reunion" as it were.

Let me know.

Yours
Sloan

[1] Autograph missing. Text taken from transcription made by Violet Organ, Henri's sister-in-law and heir to his estate. The original letter has been lost or destroyed, and with it, Sloan's drawing of the skylight.

[2] Elmer Schofield (1867–1944), a former Pennsylvania Academy student who had accompanied Henri and Glackens to Paris in 1895.

[3] Charles Grafly.

[4] Hugh Breckenridge.

Atlantic City Sept 19, 1900

Dear Sloan:
 Coming. 22nd
 Yours
 Henri

Henri learned from Arthur B. Davies of a teaching position at the Veltin School, a finishing school for girls in New York (Henri diary, 21 Sept. 1900). He applied for the job and upon his selection, he and Linda moved to an apartment on East Fifty-eighth Street overlooking the East River. It was from this vantage point that Henri began making panoramic views of the waterway.

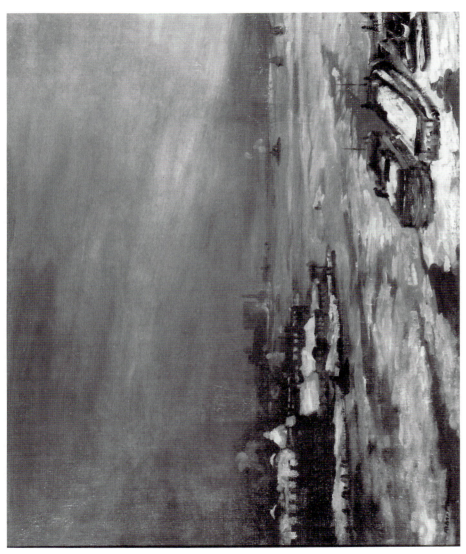

15. Henri, *East River, Snow*, 1900

[Nov. 1900; undated]

Dear Henri:—

Just a few lines to let you know that my picture has been accepted in Pittsburg[1] and Joyful news (by way of Rudy)[2] You and I are both on the line[3] at least one of yours is I think Rudy said the full length portrait was on the line the other not well hung at least for night light (the condition under which he saw it).

Preston has returned perhaps he has been in to see you as I think he went to New York last week

The Walnut S Theatre[4] which I sent to Chicago[5] has also been accepted so you will be able to appreciate my joyful feelings all around

How goes the New York by this time? I suppose you are hardly settled yet.

Remember me to Mrs Henri and all the folks

By the way I was in N.Y. for 55 minutes last week on the explosion[6] could not spare time to wander about tho'

well goodbye

<div align="right">
ever yours

Sloan
</div>

[1] *Independence Square,* 1900, in the Carnegie Institute Annual. Henri's two accepted entries were both simply titled *Portrait.*

[2] J. Horace Rudy was by then a designer of stained glass in Pittsburgh.

[3] As significant as having a painting accepted in a major annual show was where it was hung; in those days works were arranged in three and four rows on a wall, and only those placed at eye level, "on the line," could be properly seen.

[4] *Old Walnut Street Theater,* 1899/1900.

[5] The Art Institute of Chicago's Annual Exhibition.

[6] On November 4 a fire and explosion on Broome Street completely wrecked a five-story building. In a front-page story, the *New York Times* reported that doors were hurled across the street and the noise of the explosion was heard for several blocks.

Jan 9—1901

Dear Henri:—

Your pathetic series of notes on the door and the Christmas wishes at the Press made me feel very sorry that I had not arrived earlier in the day of your flying trip thro' Philadelphia

I hear from Redfield that you had sorry treatment from N.A.D.[1] I was thrown out entirely he says he is hung up above the line.

I understand him to say that only one of yours gets in here at the Pa.F.a.[2] They tell him that his work is not up to his standard and they have fired most of mine I believe[3] J.L. Jr.[4] I guess.

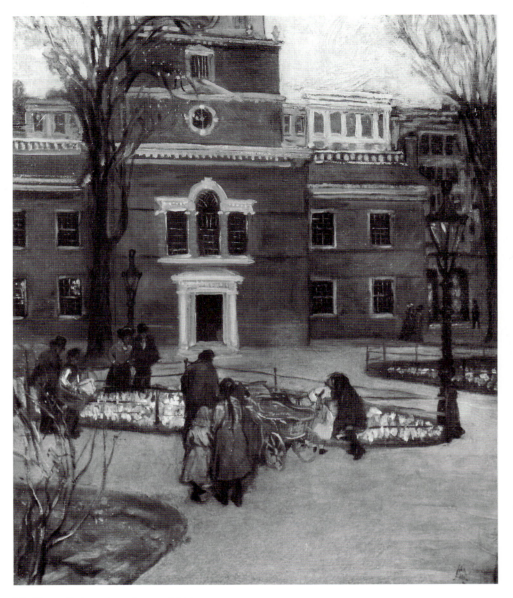

16. Sloan, *Independence Square*, 1900

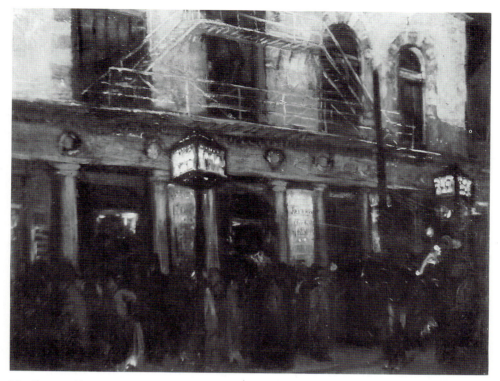

17. Sloan, *Old Walnut Street Theater*, 1899/1900

I want to invite you to run over here with Mrs Henri during the P.A.F.A. Exhibition and stay a few days with us at Lansdowne[5] My wife[6] has been cherishing this scheme for some weeks and if you can possibly make the trip I hope that you will do so

You could come over on a Friday and stay till Tuesday or Wednesday couldn't you?

Let me know, there is time to arrange more definitely in the next week or two.

<div align="right">

Yours
Sloan

</div>

[1] All of Henri's paintings were rejected from the National Academy of Design's 1901 Annual.

[2] Pennsylvania Academy of the Fine Arts' 70th Annual Exhibition. Actually, Henri had three oils accepted: *The Café Terrace*, 1899; *The Green Cape*, 1899; and *Young Woman in an Old Fashioned Dress*, 1898.

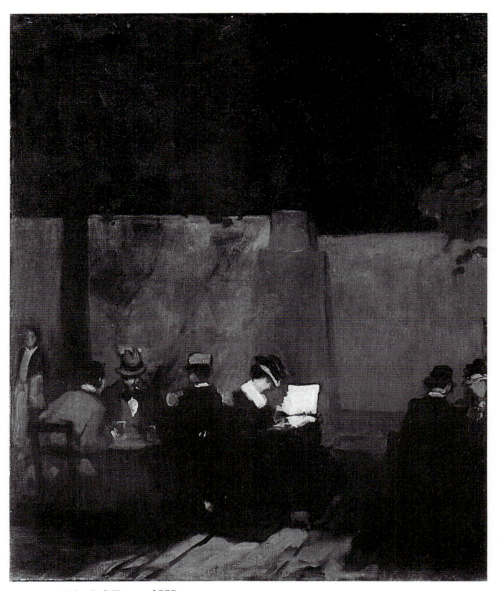

18. Henri, *The Café Terrace,* 1899

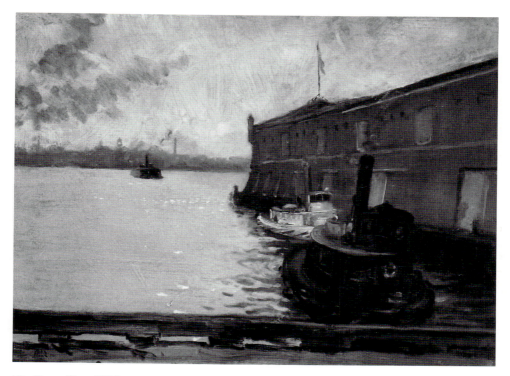

19. Sloan, *Tugs*, 1900

[3] Sloan was also represented by three paintings: *Tugs*, 1900; *Independence Square;* and *Old Walnut Street Theater.*

[4] John Lambert Jr., an influential friend of Harrison S. Morris, the secretary and managing director of the Pennsylvania Academy.

[5] Sloan's family's home outside of Philadelphia.

[6] Sloan lived with Anna Maria "Dolly" Wall as his common-law wife for at least a year prior to their wedding on 5 August 1901 at the Church of the Annunciation in Philadelphia.

<div style="text-align: right">

Wednesday [27 March 1901]
Phila

</div>

Dear Henri

 The invitation is <u>yours</u>—

 I was thinking of writing to extend the hospitality of The Shack but thought that you would understand that you could always be accommodated.

 I won't be able to attend the "sermon"[1] but if you will see me in the

afternoon of Friday I'll arrange to meet you afterward Or if I don't see you before then I will be at the studio at 11 oclock Friday night waiting for you

Best wishes for the "Sermon"

Yours
Sloan

[1] Henri's address, "Talk on Art," to be delivered to the students of Philadelphia's School of Design for Women on Friday evening, 29 March 1901.

Many artists experienced a general sense of frustration that their access to the public was blocked. More often than not their canvases were rejected from the major art annuals of the National Academy of Design and the Society of American Artists, the tastemakers of their day. The few private galleries specialized in showing Old Masters and European imports, and non-jury group exhibits arranged by the artists themselves were virtually unheard of at the time.

It was in this environment that Henri initiated an exhibition that opened at the Allan Gallery on 4 April 1901, in which he and Sloan were among the participants.

512 E. 58th St N.Y. City
Apr 6. 1901

Dear Sloan:

Expected you last night—suppose you have decided to come next week—Let me know beforehand—At the Society[1] you are placed thusly

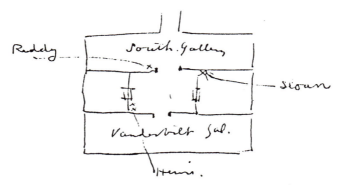

You are on the line in corner, but light is quite good and I find picture looking better than in Phila. Reddy has excellent place on line, one of first things to be seen on entering gallery

I have one on line—one above The one above at great disadvantage
and the other badly surrounded.[2]

So much for society.

Had to pay bill at APSCo.[3] for release of your pictures. They are hung
in Allan Gallery 14 West 45th St The gallery is a nice little one but with
dark ends and corners. Your theatre and tugs in excellent light—the two
portraits in dark but look well everybody is equally arranged half in
light & half in dark[4]

Think you will be pleased to see us all in a little ex of our own.

This is the main wall. The "line" is hung down within about 15 inches of
floor so that both upper & lower lines are equal. The show is Sloan, Glack,
Maurer[5] (the best things Maurer has done) Fuhr[6] Perrine[7] and Price.[8] The
work of the latter (two things) not counting for much. One of Perrine's
excellent tho' miserably framed—and another very good by him.

<div align="right">

Yours

Henri

</div>

Has that manuscript of mine been returned to you?—the "art talk"[9]

[1] Society of American Artists.

[2] Sloan's accepted entry in the Twenty-third Annual Exhibition of the Society of American
Artists was *Independence Square*; Henri was represented by *A Café—Night*, 1899, and *On the
Marne*, 1899.

[3] Artists' Packing and Shipping Company.

[4] Sloan exhibited *Tugs, Old Walnut Street Theater*, and two unidentified portraits; Henri
showed *Ballet Girls*, 1894, and *The White House (Concarneau)*, 1899, and two additional
works.

[5] Alfred Maurer (1868–1932). This was only the second time his work had been shown in
New York City.

[6] Ernest Fuhr.

[7] Van Dearing Perrine (1868–1955), a painter and writer.

[8] Willard Bertram Price, an artist and former Chase student.

[9] Henri's "Talk on Art" had been delivered the previous week.

[April 1901; undated]

Dear Henri:—

I was very glad to hear from you in regard to the location of the Society and Allen Gallery pictures I suppose you misunderstood me in regard to my visit I told you that I would know beforehand

I now proceed to do so I will start from here on Friday night coming. will arrive before midnight and dont want you to hesitate to let me know if (owing to increased size of your "Menage") you will be inconvenienced in any way

Just while I was thinking desperately as to how to begin my "Sherlock Holmes" task of finding the "Sermon" Mss. (for you see it is a delicate matter to probe a female on such slight evidence as was in my posses- sion)—it turns up not Miss Dunbar not Miss Wolfe but Miss Byrnes whose name neither of us had mentioned she is not connected with any paper so it was in perfectly safe hands

I have an idea that it would be well to print it tho' will talk to you on the subject later

Again, if Friday night is inconvenient don't fail to write me

Yours
John Sloan

[April 1901; undated]

Dear Henri:—

Have your article well under way now & will send you the Paper which contains it on appearance.

I will not be able to save your mss.[1] as they always cut matter up into "takes" in the composing room. Will try to get you a couple of proofs from the galleys before publication

My sister you may be glad to hear has sold 4 water colors in the current ex at the Art Club This sounds too bad & good. The things were interesting tho.

I suppose the Police are able to cope with the Allen Gallery sight seers all right.

Well I suppose that is about all. Ive to communicate just now. Remem- ber me to all the folks

Yours
Sloan

[1] Henri's "Talk on Art." Sloan's perseverance paid off, for the Henri lecture was published in the *Philadelphia Press* on 12 May 1901.

806 Walnut Street.
May 28, 1901[1]

Dear Henri:

I am glad that the way of Presentation of the Art Talks was satisfactory to you. I only have heard one mention of it and that was very favorable. I dont mix much with art folks now adays. Expelled from the Fellowship[2]—not on the list for the artists Festival here in the Fall[3]—am outcast—what a splendid chance to do good work is mine.

For now the studio is full of light—it will be a treat for you to see it—the light space is about 8 x 11 divided thus [drawing of old skylight of 36 pieces.]

I have dropped attempt at portrait and am working now on the City Hall doorway which I spoke of having in mind.[4] I will enclose a photograph which I made of it yesterday. Let me know if it looks well to you. Miss Perkins you will be glad to hear has won the traveling $600 scholarship at the School of Design. We are all tickled to death about it—it was a very hot contest. Believe her and Miss Koenig (Dangerfields choice). Miss Sartain had the deciding vote and the portrait which you saw at the Academy Ex this year was a deciding factor. I have neither seen or heard of Redfield since his ex. at the Art Club. I suppose the factory at Center Bridge[5] is in active operation to spare him.

But Oh I have received an invitation to exhibit at Pittsburg this time which is of course a great satisfaction. The "Independence Square" seems to have given me a start out there. I do hope that I shall have something in its class to send.

I am sorry that you dont feel settled or properly studio'd in New York. My fine change in 806 makes me realize and sympathize keenly with your bad light difficulties, and I wish we were nearer; your opinion and our opinions when together a[re] much satisfaction to me. I want to show you things; each time I do anything I miss you.

Remember me to Glack. I hope he is in good health and the same for you and Mrs Henri and the folks.

Well, the whistles are shrieking "one oclock." The grindstone at South and Chestnut Streets[6] calls me. I must with my nose hasten to it.

Good luck, good friend, Goodbye

Sloan

[1] From a typed transcription.

[2] The Pennsylvania Academy Alumni Association.

[3] The Festival was to feature tableaux representing various Renaissance and Baroque artists.

[4] *East Entrance, City Hall,* 1901.

[5] A village north of Philadelphia where Redfield resided.

[6] The Press building where Sloan worked was located at Sixth and Chestnut Streets. When this was typed from the original, "Sixth" was misread as "South."

20. Sloan, *East Entrance, City Hall, Philadelphia*, 1901

New York
June 15 1901

Dear Sloan:

Have intended writing every day since receiving your letter but as usual have put off—not without some excuse however for I have been considerably upset by moving—Have moved the studio—residence still 512 E. 58—to the Sherwood Bdg 57th St & 6th Av.—got by chance one of the excellent studios—Frank Dumond[1] had it and it is likely that I will be able to hold on after his lease is run out—his lease is untill May next at any rate. Am greatly pleased and have been busy trying it having painted a full length and some other things.

Am glad to hear that the window works of 806 have been a success and wish you great luck now that the new Era is on. Shall look forward to seeing the old place up to date and hope you use it as much as possible— you must not let the glory of "Indipendance Square" go to sleep.

There is nothing much new outside the change of shop and the hot weather.

Now about the photo of the picture. It pleases me mightily just as it is— fine value of height, and carrying up. cuts off much to my taste and is sure to come out a rival of the "Square" if you get the figures below to give as much of that eternal business of life—going in and coming out, as you got the eternal park loitering sense in the other

It seems to me that you will surely get another good thing out of it. Here's to you

Yours
Henri

Studio 19, Sherwood Bdg
57th & 6th Ave.

[1] Frank Vincent Du Mond (1865–1951) was an artist and a teacher at the Art Students League.

Nov. 9 1901

Dear Henri

I suppose you had a good smile over my telegram—"The Pass was lost"—I thought that as I had it in the same pocket as the newspaper clipping I might have dropped it in the studio somewhere suppose tho' that I cant hope to have the luck of finding it

I enclose clipping from North American about Glack which mentions you

[53]

Tell Glack I'm not to blame for the blackboard end of the story[2]
It's advertising anyway and good in the end.
I thought you were entitled to further enlightment on the telegram
The Pass by the way is made in the name of "Stewart" I think
Yours
J Sloan

[1] Letterhead is The Press Company, Art Department, Philadelphia, Pa.
[2] That is, that the end of the story was "erased" or deleted.

Nov 12 1901[1]

Dear Henri:—
 I herewith transcribe some remarks and plans from a letter of Rudy's just received—
 "Your picture is on the line Henri on the line in same room.[2]

"Redfield has picture
"either side of Henri's
"All of you are
"well placed
"Henri especially
"so, his can be
"seen through
"a door from the
"main room and
"as it is one of
"the strongest pieces
"of painting in the
"show it asserts
"itself at once
"and will be
"recognized as such.

"I received a commission from a party here who dines every day with "the man who purchased Schofields picture last year 3 or 4 business

"men get together every day at noon and he told me the conversation
"sometimes runs to painting etc. I put in a word for you fellows
and "advised him to watch pictures you send here.

"They are men who have the stuff to buy them and I hope Phila
"group will be well represented in the sales this year.

"Henris painting is the best of his
"that I have seen * * * * you
"should feel proud * * * * pictures
"accepted are on the line in a
"show where the conditions are
"more severe than any show on
earth"

Well solong—so so.

<div align="right">Sloan</div>

[1] Letterhead is The Press Company, Art Department, Philadelphia, Pa.
[2] Sloan's painting titled *The Young Mother* and Henri's *Portrait of a Young Woman* were included in the 6th Annual International Exhibition at the Carnegie Institute, Pittsburgh, 7 Nov. 1901 to 1 Jan. 1902.

<div align="right">

Lansdowne Pa—
Nov 17, 1901

</div>

Dear Henri

To think that I should get that ticket after losing it on the public stairway of Glackens Studio—luck—dumb luck—

Thank you for sending it I will try to get over before Jan 1st so as to use it If the wife and I get over together we may take advantage of your offer of a "shake down"

And here at her request I must ask you to be sure to let us put you and Mrs Henri under roof here at Lansdowne In case you come over for a few days during the Academy Exhibition.

If you decide to go to the Pittsburg exhibition, could you not arrange to spend the night here and start early the next morning for Carnegie's Pet? and if you do go dont fail to let me steer you to Rudy he would be very much pleased to take you around Im sure

Thank Glackens for finding the ticket thank him also for knowing or dwinning that the name "Stewart" on the pass was my travelling soubriquet Best wishes for Mrs Henri and yourself

<div align="right">

from
Sloan.

</div>

Phila Apr, 1902[1]

Dear Henri:—

This introduces my friend Mr. Sotter[2] of Pittsburg. He has been with our friend Rudy in the stained glass line and is now studying at the Academy for a few months.

He is, through Rudy's influence and his own judgment a sincere admirer of your work and has expressed a wish to meet you.

I had hoped to be able to go over to New York Friday night, but am afraid I'll not be able to get thro the paper work in time.

The notice you sent sounds like a <u>victory</u>.

Success in sight
Vale
John Sloan

[1] From a typed transcription.
[2] George William Sotter was a landscape painter. Sloan painted a portrait of him in 1902.

In 1902 William Glackens was approached to illustrate a fourteen-volume edition of the novels of Charles Paul de Kock. Sensing the magnitude of the project, he enlisted the participation of his friends, so Sloan, Everett Shinn, and George Luks each contributed illustrations.

[Aug. 1902; undated]

From the Old Man of 806
 To The Old Man;—[1]
 These:—

Oh Robert:—

Know then that I am now really the above, for a week since, after a siege of paper hanging and carpet laying, the little wife and I took up our residence at the old Studio (may its many memories survive) and are living most comfortably and happily. We made by our own hands (or the wife's) our breakfasts and our lunches, our dinners we fare out for

The principal object of this note is to let you and Mrs Henri know that we are prepared to receive visitors of your exact description and from your city

I am this day beginning the second week of my two weeks vacation and am spending it like my first at my new old home once yours and always at your service I am working on etchings which thro' Glackens' kind word I have had a chance to do for an edition de-more than luxe of the

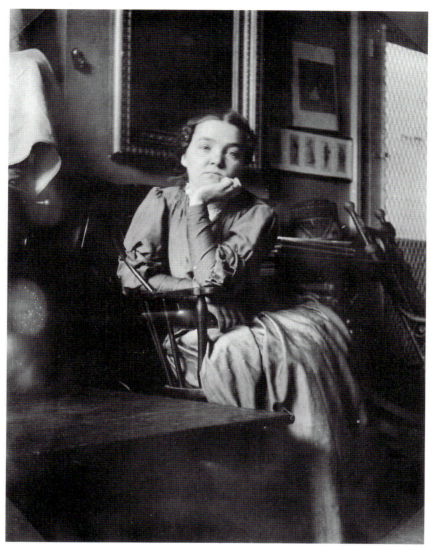

21. Dolly Sloan, ca. 1904–06

works of Paul de Kock, French Comedy Novellist early 19th Century. I
hope that if these suit the publisher (who has never seen my work) more
may follow

Let me hear from you How is Mrs Henri?[2] are you in town or away?

[57]

Can't you run over some time? Hows the good work going? My own and Mrs Sloan's best wishes.

<div align="right">
Yours

John Sloan
</div>

[1] Sloan now referred to himself as "the Old Man" because on 2 August 1901 he had turned thirty.

[2] Linda had taken ill during the summer; she spent two months under a doctor's care and recuperated at her family's home in Black Walnut, Pennsylvania.

<div align="right">
New York Aug 14 1902
</div>

Dear Sloan

May the memories of 806 never die, so say I, and may the Old Man of 806 and his wife be very happy there—never to leave save that the place become too small to hold their riches be those riches what they may, boys, girls or money. I'm hoping it wont be long before Mrs H. and I may be able to accept your invitation and come over and live a few days at home with you. Just now we are far from each other—and its hard—Mrs H. has been for a long time with her folks up in Wyoming Co. Pa.—there for her health wh[ich] was so run down.[1] after you were here I was up there for a month.[2] Since, I have been in New London Conn. painting a portrait—a full length—very beautiful woman. I just returned to the city day before yesterday and am to go back for another week. I'm hoping to get down as far as Reddy's about the end of the week—but at present nothing is sure. Maybe we might get there together for a day—we could put up with an old time shake down if he's full (shades of our youth!) and theres always more than one can eat at Reddys anyway. We could have a game of old time poker—send over for Scho who Reddy says now lives 20 miles away—nothing on a bike. clean them both out! Glack is making wonderful drawings for that lux de lux lux lux and he tells me that your stuff has met with great favor

It warms me up to see what the old stock company is doing—I always knew it though. Things have been prospering with the Old Man too—quite a shock.

I dont think it will be very long before Mrs H will be back to N.Y. altho she was to have stayed longer in the hills. I hardly think we'll last it out and besides the reports are that she is in very excellent health now.

Please remember us both kindly and affectionately to Mrs. S.

<div align="right">
Yours Ever

Robert Henri
</div>

58 W. 57

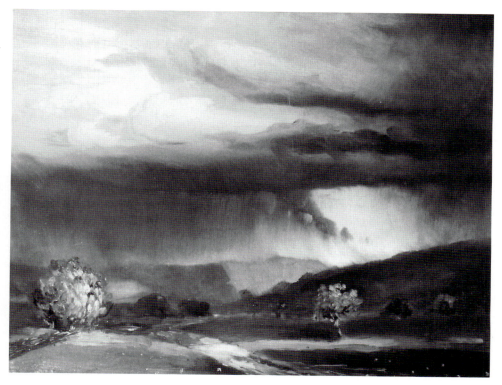

22. Henri, *The Rain Storm—Wyoming Valley,* 1902

[1] In April 1903 Linda Henri would go to Saranac Lake, New York, to the Adirondack Sanatorium's recently opened "cure cottages" for tuberculosis and remain there for five months.

[2] Beginning in mid-June 1902 Henri was with his wife in northeastern Pennsylvania, during which time he produced more than two dozen paintings, including *The Rain Storm—Wyoming Valley* and *Landscape at Black Walnut, Pa.*

<div align="right">

806 Walnut Street
October 11, 1902[1]

</div>

Dear Henri:

How do you like the above? I'm writing just to show you this paper with the old address punched into it. There is but little in the way of news.

The American Item Art Company opened this week and oh horrors, Redfield has a picture in it, without his consent you may be sure. I suppose

23. Henri, *Landscape at Black Walnut, Pa.*, 1902

Copyright 1902 by the Frederick J. Quinby Company

24. Sloan, *The Row at the Picnic,* 1902

its exhibited by some stockholder in the Society, perhaps Pfeifer.[2] You are not represented and you may be glad for any dealer who is a stockholder in this "Thing" may exhibit pictures. Davies has a couple. I suppose that he's not guilty. Harrington, Fitzgerald, Dantzig, Colin C. Cooper,[3] Snow and his daughter (snowflake) are represented in quantities. "Fitz" had 23 out of a total of 357.

You wrote as if you had heard of my work on the Paul de Kock etched illustrations. I have made four of them and may get more. I think that they have good points in the way of giving the period 1815. I will send you a proof or two. The Price of the Book will make proofs pretty scarce.

I have not done anything in paint for the last two months and am just starting to work again. I do wish you could drop over some time and see how different things look in the old "Hangout". We are right comfortably fixed now tho' Mrs Cooper is a good deal of a nuisance.

Our best regards to Mrs. Henri. I hope that her health has fully returned. Remember me to Glackens when you see him next.

Your lonely philadelphia friend,

John Sloan

[1] From a typed transcription.
[2] Frederick Pfeiffer was a Philadelphia art dealer.
[3] An American artist whom Henri had known since their student days at the Académie Julian in Paris.

58 w 57

Oct 13 1902
Dear Sloan:
Am not
behind
in the
fashions.
Yours
rec'd Am
having it
framed.
Look out
for me
Things
are do-
ing. I
expect
to knock
at 806

some
time on
Thursday
Hope I
wont
Have to
write on
the slate
Yours
with love
and
Best
Wishes
from
 M^{rs}
 to
 M^{rs}

 Henri

Oct 22 1902

Dear Sloan,

Saw Glack on Saturday. He said the limit about your etchings[1] Said he wd talk to the people[2] and thought he could succeed in making them have the work done by your man.[3]

I also showed the etchings to Davies who was in to see me a couple of days ago He said "Nothing better has ever been done" and a lot besides he said that would have pleased your ears and M^{rs} Sloans besides. They have made a great hit with M^{rs} H.

Yours

[1] Three illustrations for *Monsieur du Pont,* the first of a projected fourteen-volume edition of the novels, reminiscences and life of Charles Paul de Kock (1794–1871).

[2] The Frederick J. Quinby Co. of Boston, publishers of the de Kock series.

[3] Gustav A. Peters, of C. Peters' Sons, Philadelphia printer.

Henri was scheduled to hold a solo exhibit at The Pennsylvania Academy of the Fine Arts in November 1902. Since he was residing and teaching in New York, he asked Sloan to arrange for publicizing it in Philadelphia.

> 806 Walnut Street
> Philadelphia
> [Oct. 1902; undated][1]

Dear Henri:

I enclose a letter which came with some circular from the Pratt Institute. I opened it thinking it of no importance as many circulars which come to you at this address. I read it and am tickled "muc[h]ly" at its contents.

You will be able to move your whole exhibition from the Academy and show it in Brooklyn.[2] Things are certainly looking to youward.

I see by the papers that your exhibition here will only last from 15th to 30th. This seems pretty short.

Be sure to let me have some photos for the Press. It occurs to me that Mr. March[3] might give you a whole page display in the Sunday Press of the 16th November say some six or eight good interesting subjects. I will ask him and try to get him interested. In case he likes the idea we would want the photos next week.

I will suggest that he sends me over to N.Y. Saturday to make the selection of things to be photographed or perhaps to take a camera and do the work myself. Then if mine were not good I could telegraph you and you could have a good man do them on Monday or Tuesday and rush prints to us. If he decides to do it I will let you know tomorrow.

Mrs. Sloan sends her best wishes to Mrs. Henri and yourself.

> Adieu
> Sloan

[1] From a typed transcription.

[2] The letter invited Henri to have a one-man show at the Pratt Institute in Brooklyn immediately following his solo exhibit at the Pennsylvania Academy.

[3] Alden March, managing editor of the *Philadelphia Press.*

Oct 30 1902

Dear Sloan:

Bully for you just what I wanted—in both cases.—the letter from Brooklyn and your idea about the full page & photos.

There is a photographer here—name ["Tonelli" is crossed out] Tonnele who is A1 at picture photography—does his work at once & good. Just had him do a picture so that Miss Henderson would have it for use. He charged me $3⁰⁰ per plate & proof. 8 x 10.

Of course this runs into money but if they could not be had otherwise then I might as well spend the money—I'm used to it, and it wont make me more broke than I'll be any way if the worst comes. Hope the full page will be granted—God Bless you—and hope to see you here on Sat—and bring Mrs S too if you can.

We'll have a family party I'm getting my frames here—cheaper and as good as can be had—all set with diamonds—14 of them at one order—show will be completely (well) framed

All sorts of things are happening to me, good winds and ill winds howling all about. All sorts of changes taking place. Perhaps it's all for the good—Im hopeful, but want to see the good pretty soon

Jackson[1] is to do the selling.

Best wishes to both of you from both of us

<div style="text-align:right">Yours
Henri</div>

[1] Joseph Jackson, a former art editor of the *Philadelphia Ledger,* who was to receive a 10 percent commission on sales.

Oct 31 1902[1]

Dear Henri:—

Just received your letter and am afraid I was a bit too hopeful about the Sunday Page Idea I spoke to Mr. March today in regard to a display and find that he wont enthuse

If I only had a bunch of photographs in hand to talk on I might do better

The trouble (he thinks) with a page on your exhibition is that there is no excitement to hang the "story" on - Your achievement has nothing yellow in it[2]—If you were only twentyone years old and had suddenly jumped into fame there'd be a "story"

He suggests however that "business" in the exhibition would be very

much helped if you had several photographs ready to furnish prints to the papers and it might be that he would change his mind in the presence of a few very interesting photos.

The average newspaper photographer (supposing that the papers send men to photograph the works in the gallery) is either incompetent or too careless to do the pictures justice and if you select things with as much <u>interest</u> as possible (<u>without the color</u>) and have them photographed by a specialist you might find that more papers would use them.

The expense of this is a strong argument against it however.

If I feel rich I <u>may</u> be over on Sunday for a few hours to talk the matter over but dont count on me with surety.

As the paper has not taken up the scheme I won't get a pass.

I'm sorry that I raised your hopes but all may yet prove well.

<div style="text-align:center">Good luck to all
Sloan</div>

Talcott Williams[3] is sure to give you plenty of notice in the regular art notes columns <u>This from him</u>.

<div style="text-align:center">S.</div>

[1] Letterhead is The Press Company, Managing Editor's Office, Philadelphia, Pa.
[2] A reference to the sensationalism of Yellow Journalism.
[3] Editor of *The Press*.

[Nov. 1902; undated][1]

Dear Henri:—

I want to remind you that Yourself and Mrs Henri are invited to pitch your tents with us during your trips to the exhibition

I suppose that you will be over a day or two this week and more next

You know our accomodations and I feel sure that you will not hesitate to accept our very cordial invitation

I hope things are moving along smoothly toward success in the Show

<div style="text-align:center">Sincerely yours
John Sloan</div>

[1] Letterhead is 806 Walnut Street.

Nov 27 1902

Dear Sloan:

Letter from Noyes[1] in Boston states. "Coply ex [Copley exhibition] best he has ever seen in Boston.

"John Sloan sent his Independence Sqr wh I liked better than ever, and a pathetic, tender yet restrained woman sewing[2] This last was a great relief from the Churchills and Hazards and two unspeakable Paxtons[3]—etc" (these are heavyweight Boston portrait artists)

Evidently your things are well placed altho he does not mention the placing of any except my Girl with Cup[4] wh is O.K.—being on line on good wall. Have written him for particulars of hanging of your things & of Redfields

Hope the drawings are booming.

Best wishes to Mrs Sloan and much appreciation for our fine entertainment at the old playhouse[5]

Yours
Henri

[1] Carlton E. Noyes (1872–1950), a member of the English faculty at Harvard, whose portrait was painted by Henri in June 1902. Henri critiqued his manuscript for a book titled *The Enjoyment of Art*, published the following year.

[2] *The Sewing Woman*, 1901, and *Independence Square* were exhibited in the 2nd Annual Exhibition of Contemporary Art in Boston, 19 Nov. to 16 Dec. 1902.

[3] William W. Churchill, Arthur M. Hazard, and William M. Paxton (1869–1941).

[4] Henri's painting titled *Profile—Suzanne with Cup*, 1895.

[5] 806 Walnut Street.

Dec 9, 1902

Dear Sloan

Thanks for the clippings. In return I have the following from Noyes "Sloans Independence Square is hung on the line in the centre of a long wall in a small room. His woman sewing is skied in the corner of the large gallery." He remembers seeing two Redfields on line in large gallery.

All I have to add [is] that with the exception of the sewing girl we have been right well treated among strangers and that I am at last at work again wh makes me considerably more happy

Expect to hang pictures in Brooklyn about Monday next 15th Best wishes from Madame to Madame

Yours
Henri

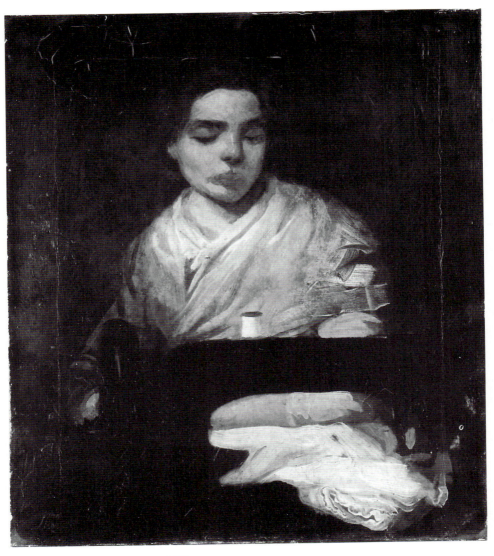

25. Sloan, *The Sewing Woman*, 1901

806 Walnut Street
Philadelphia
Dec. 18, 1902[1]

Dear Henri:—

Just received your Brooklyn Exhibition catalogue. It looks very important.

I have suggested to Rudy that he sees what the Carnegie Institute, Pittsburg thinks of having it out there. He writes me as follows:

"I have a list of Henri's Ex. at Philadelphia and I expect to show it and ascertain the position of the Institute.

"I heard that they did not try to secure DeMonvel's[2] show nor any of the recent English One Man Exhibitions because they wish to avoid the commercial side of the thing. They have within the last two years held exhibitions of LaFarge[3] and Vedder,[4] purchasing one of Vedder's for the permanent collection. I will see what can be done and let you know the result."

Perhaps if you see anything in this you might write to Rudy making any suggestions that would occur to you.

I am going to make a point of getting over to New York while the Brooklyn show is on.

That I wish it great success goes without saying.

We send our best regards to Mrs. Henri. Also the compliments of the season.

And I subscribe myself
Yours
John Sloan

[1] From a typed transcription.
[2] Maurice Boutet de Monvel (1851–1913), a French figure painter whose illustrations, in the Art Nouveau style, were admired by Sloan.
[3] John La Farge (1835–1910).
[4] Elihu Vedder (1836–1923).

N.Y. Dec 20 1902

Dear Sloan:

Yours rec'd—have written to Rudy and appreciate both his and your thought & efforts Would like very much to have the show out there. There might be a chance in it although Im afraid they are not much given to such as we. However they might risk a new American for once.

Glad to hear you will be over soon We shall look for you both and shall put you up in style in our 57th st mansion.

Have you sent to the N.Y. Academy show?[1] I believe the jury has just finished work Hear that Reddy went in with much favor and that my

two are in—the portrait of Miss Dryer[2] (full length in riding habit that was in Phila show) and a new snow landscape street scene.[3]

I dont know if Glack sent.

Ex[hibition] is open at Pratt. not so good a light as PAFA but all right.

Well, dont forget that you are coming over soon.

Best wishes from M[rs] H and I to you both.

<div align="right">Yours</div>

<div align="right">Henri</div>

[1] National Academy of Design's 78th Annual, held from 3 Jan. to 1 Feb. 1903.
[2] *Portrait of Miss Leora M. Dryer in Riding Costume,* 1902.
[3] *Street Scene with Snow,* 1902, later retitled *West 57th Street, New York.*

In October 1902 Henri had commenced teaching at the New York School of Art, across the street from his studio in the Sherwood Building. It was there that he began exerting his greatest influence, urging his pupils to paint with verve and dash, and to concentrate on depicting the life of the city around them.

Henri, too, became a chronicler of the urban scene, turning to subjects of everyday life in the streets. During that winter of 1902–03, however, when he sought to paint out-of-doors amid chilling winds and melting snow, he became seriously ill for a month with a cold that nearly developed into pneumonia (Walter Tittle diary, 18 March 1903, Archives of American Art).

This bout with sickness probably contributed to a change of focus in his work, for from this time forward Henri increasingly chose to depict the human figure rather than landscapes.

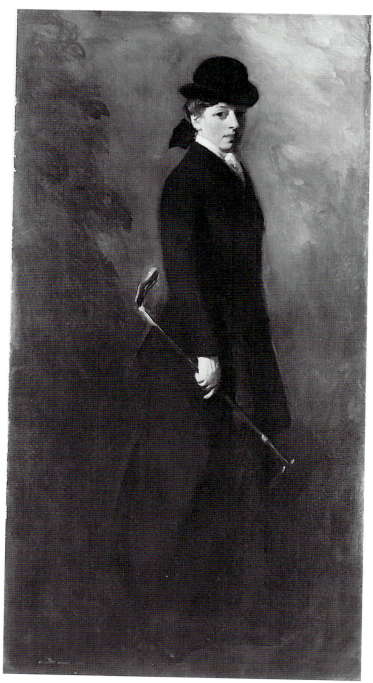

26. Henri, *Portrait of Miss Leora M. Dryer in Riding Costume*, 1902

Jan 16 1903
Friday

Dear Sloan:
 Reddy and I will arrive in Phila at 10 a.m. tomorrow—we are prepared
to meet all comers

[Aug. 1903; undated][1]

Dear Henri:—
 The offhand way in which your Name is mentioned among the Great in
the enclosed article will be of interest I'm sure.
 Then too it has been the usual thing for us to communicate with each
other about twice a year at least
 Not that there is anything of great import to write of I am working
pretty steadily the last month or so painting things some of which I'd like
you to see and comment on. I have entered three canvases for Pittsburg
this year You should perhaps land something out there this year as the
conditions are especially favorable to the Home Industries (at least so their
circulars state)
 The papers tell me that you are summering with Reddy at some place in
Maine[2] I imagine that you have been putting in a very pleasant summer

27. Henri, *Street Scene with Snow (West 57th Street, New York)*, 1902

if such be the case I suppose too that in a series of games lasting a month or two no one would lose heavily

No etchings are now being made by me for Quinby & Company as they now owe me nearly $600.00 and wont settle[3] Im afraid they went into this publishing without sufficient capital or else with foul intent At any rate its too bad for I enjoyed doing the work and had hoped that there would be plenty of it for the next year I wonder whether Glackens has had the same treatment I recommended Gruger[4] to them and he did a number of drawings for them but he has been buncoed too

However it may be as well, for I have had more time to paint than I would have had if this etching had continued

Here I cease Ill send this letter to your 57th St address marked For-

ward If it reaches you with Redfield at hand give him my best wishes

Mrs Sloan sends her regards to Mrs Henri and yourself and do try to drop in on us this fall or sooner

Good hap
John Sloan

I had a visit from Maurice[5] a few weeks ago he turned up and spent several hours with me and the Mrs. a most pleasant break in the monotony of things

[1] Stamped letterhead 806 Walnut Street.
[2] Boothbay Harbor and Monhegan Island.
[3] By mid-June 1903, Sloan had delivered 14 etched illustrations for inclusion in the Charles Paul de Kock publication. By mid-July he had been paid only $485 of the $1,070 due him, but in October, with the account paid in full, Sloan resumed work.
[4] F. R. Gruger (1871–1953), a former classmate of Sloan at the Pennsylvania Academy, was a newspaper artist and magazine illustrator.
[5] James Wilson Morrice (1865–1924) was a Canadian artist whom Henri had first met in Paris in 1895. Sloan appears to have misspelled his name.

At the invitation of Edward Redfield, Henri went to Boothbay Harbor, Maine, in June 1903 to spend the summer with him. In July they took a boat to Monhegan Island, fifteen miles off the Maine coast, where the two of them painted together.

Monhegan Island Maine
Sept 5 1903

Dear Sloan:

Yours rec'd and mighty glad to hear from you—sorry about Quimbys but on the whole very glad of it for to have made, even if you had to pay to do it, such work as that you did for them is all the pay inself—I'd rather have done as much than have millions of boodle—(not withstanding that business is business and boodle is needed in household affairs) You cut out a place way up top in that work—and lots of people know it and talk about it too and the rest of the gang is very proud about it. I dont know if Glack has been pinched any by their financial shortage. I wish you could just step up here for about a week. Reddy is here and we would give you a warm reception—hoping, naturally, to get what money you wouldnt need for board—we have played some—god knows how many games of seven-up—but you are about right—the game stands tie-away—since we have been on this island we have been too busy to play much, but at Reddys

place on the mainland we had little else to do, as Reddy had Lobsteritus and I don't care much for the landscape

This island is a bird—I painted a whole bunch of things and feel pretty good over a lot of them

Reddy, now in good health again is slinging the paint over big canvases, astounding the natives

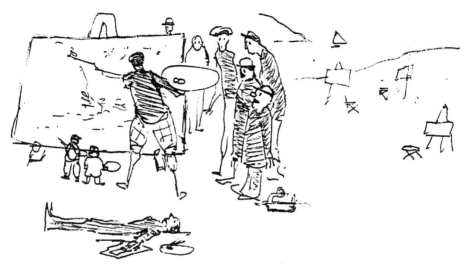

and astounding the local artists with his rapidity as well as with his results.

We expect to be back in N.Y. first of October and hope to see you soon

With best wishes from Mrs H and myself to Mrs Sloan and yourself

Yours

Henri

Oct 12 1903

Dear Sloan:

Yours rec'd and thank you very much for the invitation—expect to get over before the 25th but cant set the date just yet and cant say if Mrs H. will be here to make trip also—she may go up to her folks for a short visit instead. She wishes me to thank Mrs Sloan and yourself for her and we both hope to have you here this winter whenever you can get over—and as often. Glad the show is a good one[1]—have seen one notice which clipping bureau sent me (a comparison of a certain Haynes[2] work being made to mine)—Morrice's work was spoken of as "perhaps the best" (Ledger).

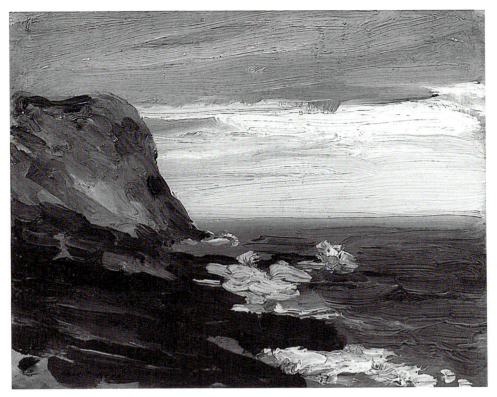

28. Henri, *Cliffs and Sea, Monhegan*, 1903

Sorry there are not more portraits—and I did not see the name of Guitone who is a grand portrait painter, stronger than Lavary. I'm afraid this rain storm is doing damage to Reddy. I see the river is over its banks and that there is no communication with him over his railroad branch. Hope they are all safe and property safe As to the notice in the Sun its just a fair square appreciation. I'm glad you got your money out at last & hope you will go on doing more now.[3] On the whole you might do well to pay to do and beggar yourself to do such work as that set of etchings. You cant know how many people admit it as master work—as for my having anything to say about them—as influence—its mighty little I've said—I've generally listened to what other people have to tell me about them. They do their own talking—your etchings.

Since we got back from Maine the weather has been damnable and I have become half crazy for I am anxious to get to portrait painting. Have had a model, but so far have only vaguely seen her—so dark it has been

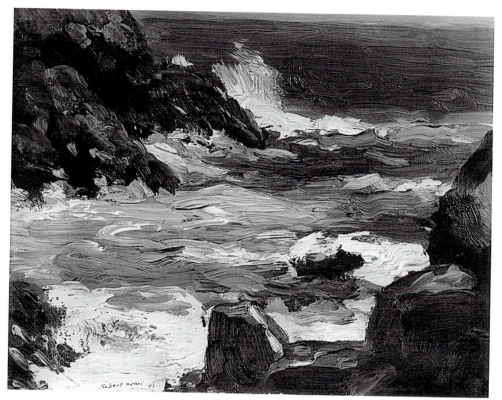

29. Henri, *Rolling Sea*, 1903

It will probably be next week that I make my trip to Phila—whether for but a one day dash or two I cant now say depends on whats afoot.

You know Reddy is on jurys galore—its possible he may be all knocked out for going with this storm—too bad if it should be so—for there is good value in the advantage of jury-ing—advertizes and makes others jurys respectful. Well—with best wishes from we-uns to you-uns.

<div style="text-align:center">Your un
Henri</div>

We went with the Laubs to dinner last week—had fine time They are both looking fine and just the same old good people as ever

[1] First Annual Exhibition of the International Society of Sculptors, Painters and Gravers of London, 4–27 Oct. The society had been founded in 1898 with Whistler as its first president.
[2] Arthur S. Haynes, an English landscape artist.
[3] De Kock illustrations for the Quinby Co.

<div align="right">N.Y. Oct 24 1903</div>

Dear Sloan:

Couldnt get over, sorry, expected to get in for last day of Int. Ex at Acad. Had to stay here today. Well, its their own fault, for not trying, that they do not show in N.Y. and they were very foolish not to book themselves for here. Much credit is do the managers outside of N.Y. for capturing to themselves such a prize—for I suppose it must have been a very fine show —I had expected to see many portraits—but heard there were but few.

Hear that Quinbys have settled up pretty much all around and that the thing is on the move again. Hope they get you to work again—provided no better opportunity turns up. I wish you could know on what a plane those etchings of yours have placed you in the minds of many—very many who know—and its been surprising how many unexpected ones have "known" in the particular case of your etchings. The word "master" is what generally comes to express the opinion of them—and you know what a daring thing it is to say of anyone who hasnt been heralded as such from afar

Got a letter from Rudy a while back. He seems to be digging his way through in great shape and his letter was full of health and youth. Since I have been back I have been at a couple of full lengths plugging very hard

Hope to see you soon, best wishes from M[rs] to M[rs]—too bad about Reddys wash out—god! what a lot Reddy has to cheerfully buck up against

<div align="right">Yours
Henri</div>

"A DREAM: 'When you get this done I'll have the whole family done too'."

[ca. Jan. 18, 1904; undated]

Dear Sloan

By a dull attention to business they got things half done at the N A Club[1] That is three names were left off the cards of invitation which it seems were printed long before we knew what the show wd be and your name in the last moment was left off the catalogue even though it was on his first proof. However a little girl has been occupied to correct in red ink all the mistakes so tho not in print you are written in bright red. We expect to see you and M^rs Sloan—when will you come we expect to take charge of you during your trip

I enclose some clippings.

<div align="right">

Yours
Henri

</div>

[1] The National Arts Club, where Henri organized an exhibition of works by Sloan, Glackens, Luks, Davies, Maurice Prendergast (1859–1924), and himself.

Jan 25 1904

Dear Sloan

Are you coming over? Let us know Have you heard that my fulllength girl in white waist was bought by Carnegie Institute (2000).[1] Have you heard that Wm J [Glackens] the "confirmed bachelor" is to marry Miss Dimock[2] next month?

I enclose new card and catalogue on which they have succeeded in getting "and John Sloan" The show[3] is cutting much ice. Tell me if I have sent you the Evg Sun article by Fitzgerald and the Town Topics Im all mixed up about what Ive sent you.

You should see your pictures—particularly Independence Sqr. It has fine place and looks great. There should be more newspaper notice of it but unfamiliar names are awkward to critics

Yrs

Henri

I am just enclosing 3 cards If you want any sent you let me know at once and I will send or have them sent to you

[1] *Girl in White Waist*, 1901.

[2] Edith Dimock was a socialite and art student from Hartford.

[3] At the National Arts Club. Henri exhibited nine works: *Portrait of a Girl*, 1901; *Portrait of Young Woman in Black* (Jesseca Penn), 1902; *Portrait of Miss E* (Grace Eldridge), 1902; *Portrait of a Young Woman in White* (Miss Morelle), 1903; *Monhegan Fish Houses*, 1903; *Burnt Head—Monhegan*, 1903; *Cliff and Sea*, 1903; *Island of Manana*, 1903; and *Portrait of Frank L. Southrn, M.D.*, (the artist's brother), 1904. Sloan showed his *Independence Square* and *The Sewing Woman*.

806 Walnut St.

Phila Jan 25—04

Dear Henri—

Acting on your kind suggestion Mrs. Sloan and myself will be in New York on Thursday next (28) We will probably arrive some time in the afternoon and will at once report at the Sherwood[1]

Suppose you have received the clippings on the Academy[2] Ex by this time

Many of the most pretentious things of the show are very very bad

I have two things accepted and hung in the main Gallery[3]—but above the line

They rejected my best thing I think however I dont feel very badly treated save in comparison with some of the wretched things on the line

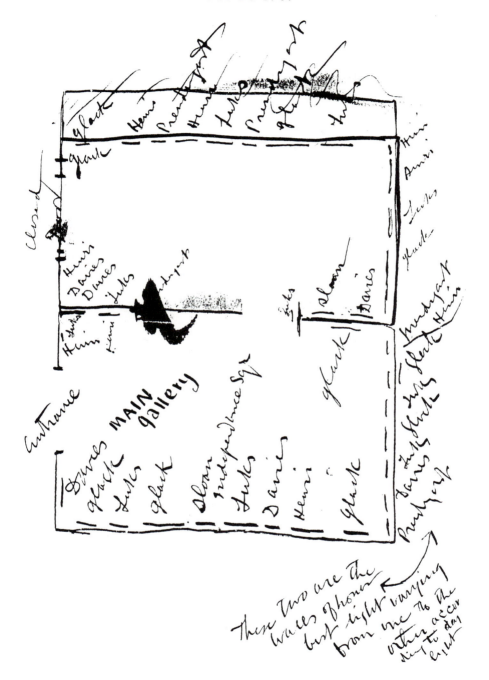

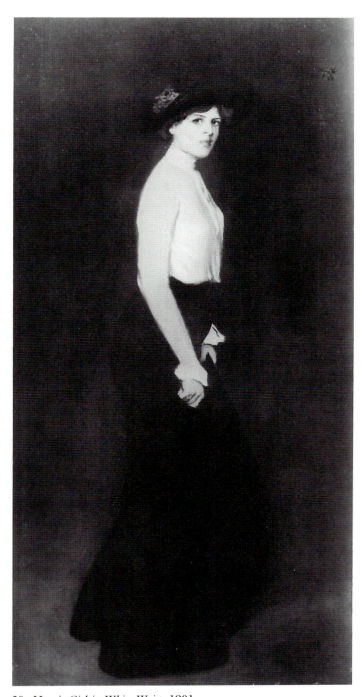

30. Henri, *Girl in White Waist,* 1901

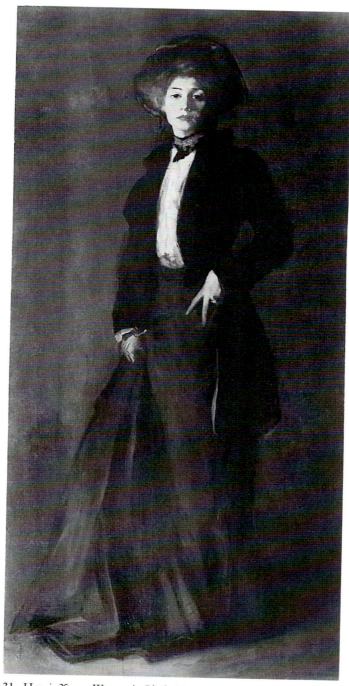

31. Henri, *Young Woman in Black*, 1902

More "jaw" when we meet Thursday
Till then and from then on

Yours
John Sloan

[1] Sherwood Studios.
[2] The Pennsylvania Academy's 73rd Annual Exhibition, 25 Jan. to 5 March 1904.
[3] *Dock Street Market*, 1903, and *The Look of a Woman*, 1903.

During their brief visit to New York, the Sloans not only viewed the exhibition but John had his portrait painted by Henri. Sloan, in turn, made sketches of Henri (figs. 34, 35).

[14 March 1904; undated postcard]

Did you only send the violin.[1] I thought you were to send the Market also[2]—if you did it did not come before us.[3] The Violin is in with much good favor. Glack Reddy Scho all O.K. Yours H.
When are you coming?

[1] Sloan's painting titled *Violin Player* (Will Bradner), 1903, was sent to the 26th Annual Exhibition of the Society of American Artists, 26 March to 1 May 1904.
[2] *Dock Street Market*.
[3] Henri was on the jury for the Society's exhibit.

Mch 18 1904

Dear Sln: I take my pen in hand to indite[1] you the following map[2]
Your picture though hung above line is looking bully fine. Scho is here. I have just defeated him with great ease in a game of billiards also three games of pool. I dont see any chance to get his money though There are hopes yet when the clan meets on the Varnishing (poker day).[3]

Yours, Henri

We expect you & Mrs Sloan. We propose to house the entire clan so dont fail to come both of you

[1] To write down.

[2] Of the Society of American Artists exhibit.

[3] The day prior to an exhibition opening when artists were permitted to touch up and varnish their paintings.

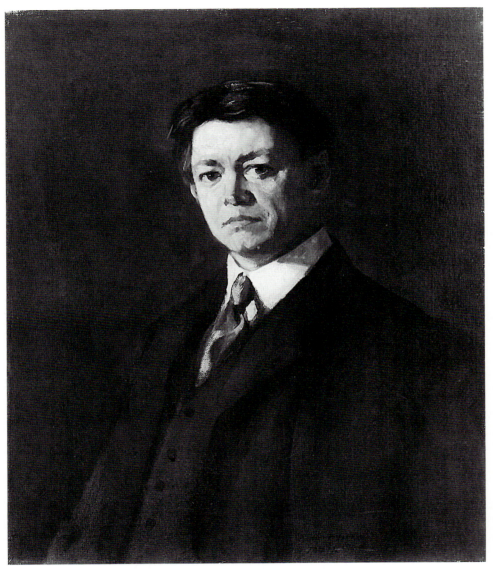

32. Henri, *Portrait of Frank L. Southrn, M.D.*, 1904

33. Sloan, *Dock Street Market*, 1903

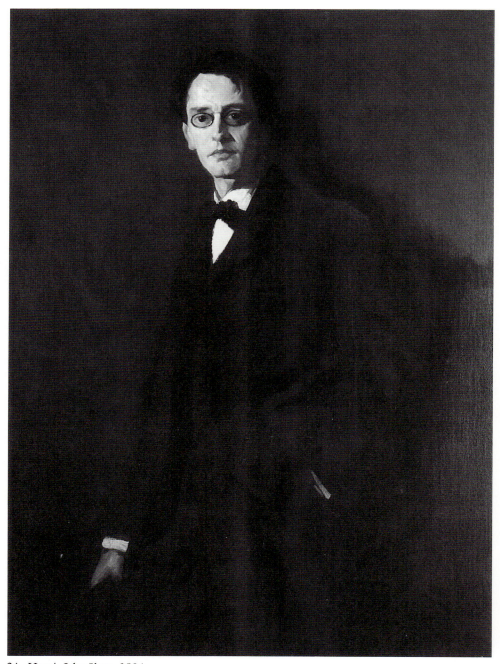

34. Henri, *John Sloan*, 1904

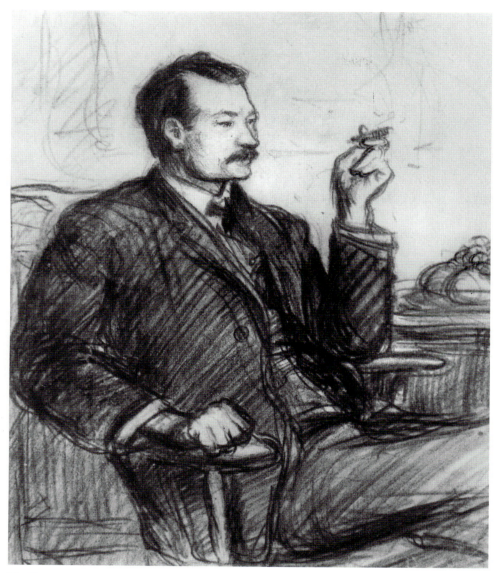

35. Sloan, *Portrait of Robert Henri,* 1904

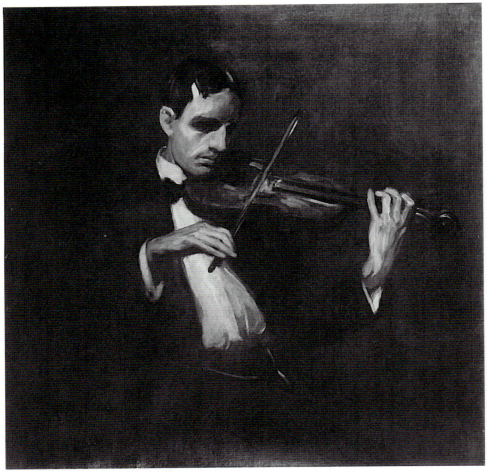

36. Sloan, *Violin Player* (Will Bradner), 1903

806 Walnut Street
Philadelphia
March 22, 1904[1]

Dear Henri:—

We will be over on Thursday[2] as you suggest. I have been intending to let you know definitely as soon as I had things arranged for the trip.

Am quite determined to move to New York in the next month or two so may do some ranch hunting while I am over. If you hear of any place suitable bear it in mind.

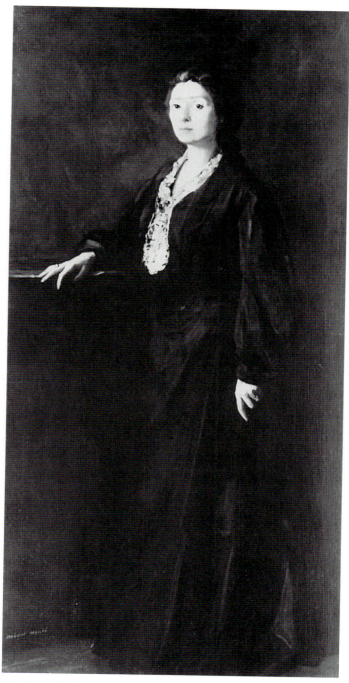

37. Henri, *Lady in Black* (Linda Henri), 1904

"Scho" has given cheerful details of the Society Exhibition[3] which have made me feel the necessity of New York as a residence.

My own and Mrs. Sloan's best regards to Mrs. Henri

See you at once

Yours

John Sloan

[1] From a typed transcription.

[2] 24 March.

[3] Sloan was represented by his *Violin Player*, 1903; Henri by *Portrait of Byron P. Stevenson, Esq.*, 1903, and *Lady in Black* (Linda Henri), 1904, a full-length likeness of his wife.

In April, the Sloans moved once again to Manhattan, this time for good. They initially resided in the Sherwood Building, on the same floor as Henri.

Shortly thereafter, however, Dolly was back in Philadelphia for what became a recurring treatment for alcoholism and associated ailments.

[*From Linda Henri to Dolly Sloan*]

June 15/1904

My dear Dollie,

I am so sorry that you are sick—its too bad—and I want to tell you to be perfectly at ease about John—he is well and we try to make him comfortable—he and Bob have gone now down to see how Quimby's have hung the pictures that they sent for unexpectedly yesterday—

The Laubs' party [came] off very well Monday—Fuhr and Gruger stopped in so we took them along—We miss you awfully—Dollie—but you must get real well and strong—before you venture on that long ride back—and know that John is being well taken care of—that is as well as is possible for us to take care of him—he drinks no coffee—and seems to be feeling perfectly well—and you know how much we enjoy having him with us—so you mustn't worry any Dollie—but just devote all of your energy to getting well—

Lovingly

Linda

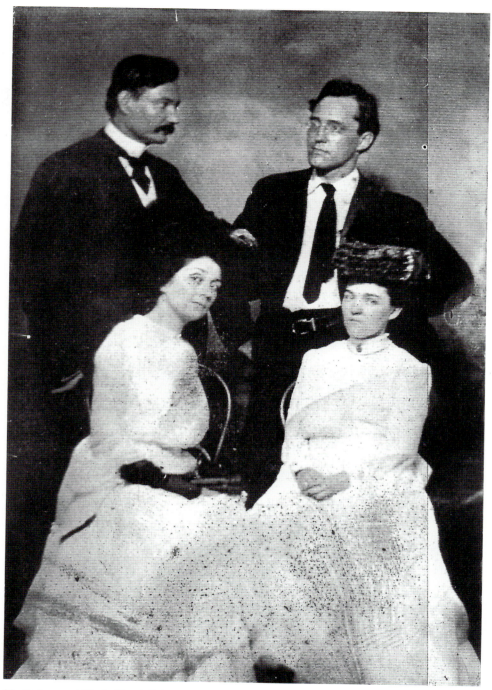

38. Robert and Linda Henri, John and Dolly Sloan at Coney Island, 1904

During the summer and early fall of 1904 Henri was in Cooperstown, New York, painting the portraits of Bishop Henry C. Potter and his stepson, F. Ambrose Clark. Seeking additional commissions while there, he asked Sloan to photograph a group of painted portraits in his studio and send him the photos.

Sept 3, 1904[1]

Dear Sloan:

Photos recd today for wh[ich] much thanks think they are remarkably good

what a group of views they are. The one I like best is the full face with things in the background. The two you marked X I dont like so much on acc[ount] of the blurred character of the one most fullface and the other isnt as beautiful as the one I have described as liking best and above all let us be beautiful and live up to it. The Stein[2] is a remarkably good reproduction I will send it along so they can use it if they like. How well the head and the trappings are reproduced—and the pho[tograph] certainly does look like Stein. I shd say they can get a good one of the artist from your photo. Doubt if Dixon Alleys will be as good Have not heard from them yet. I am working away getting on all right so far

It was fearfully hot work today. Glad that M^rs Sloan got so well over her <u>collapse</u> of just before my departure I collapse just twice a day here, dinner & supper time. Food has a great reviving power—take it. Have just read a beautiful piece of literature by Anatole France "The Crime of Sylvester Bonnard (Membre de l'Institute)" and tho translated it is a masterpiece of style

Hoping you are all well and happy, and thanking you very much

I am

Yours truly

Robert Henri

Hotel Fenimore
Cooperstown
New York

[1] Letterhead is Hotel Fenimore, Cooperstown, N.Y., H. E. Bissell.

[2] Eugenie Stein was a model employed by both Henri and Sloan. The photograph was of one of three portraits of her painted by Henri during April and June 1904.

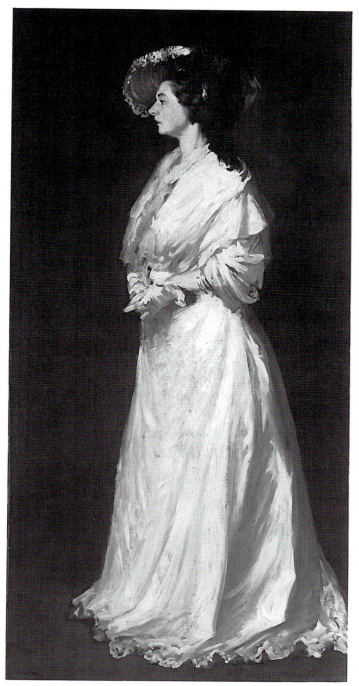

39. Henri, *Young Woman in White* (Eugenie Stein), 1904

Sept 19 1904[1]

Dear Sloan:

About the school[2] I suppose tomorrow Wednesday will be the day I shall be due there—and of course I shall not be on hand. I wrote Mr. Connah[3] about 5 days ago saying that I might not be on hand & that I had arranged with you and I asked him to let me know if it was Wednesday the 20th that I was expected. He did not answer my letter so I do not feel concerned in the matter and unless you have heard from him and made your arrangement I dont see that there is anything for us to do in the matter

It is even possible that he is thinking of having Mr Miller[4] carry on the class (which probably is a less expensive mode of procedure)

I suppose he has forgotten all about my letter. I expect to be home sometime this week—cant say just when at present. I shall be mighty glad to be on the old stamping ground again and in the company of mine own tribe

I am sorry you are to leave the Sherwood[5] but I hope you have got in your new studio the quarters that will be for the best.

Yours
Henri

[1] Letterhead is Hotel Fenimore, Cooperstown, N.Y., H. E. Bissell.
[2] The New York School of Art.
[3] Douglas John Connah, director and owner of the school, had purchased it from William Merritt Chase two years after Chase founded it in 1896. Although the artist-teacher Chase continued to instruct there, Connah changed the school's name.
[4] Kenneth Hayes Miller (1876–1952) was an artist and Chase's former student.
[5] The Sherwood Building, where Henri's studio was located and in which the Sloans had resided since moving to New York earlier in the year.

Sept 20, 1904[1]

Dear Sloan:

About three hours ago I mailed a letter to you about the school since then I have rec'd a letter from Mr Connah—he does not say what his arrangements are but says that every thing will be OK until I return so if you do not or have not heard from him you can count that he is having Miller or someone filling my place.

With Best Wishes to M[rs] Sloan & Yourself

I am
Yours Truly
Robert Henri

58 West 57th St New York City

[1] Letterhead is Hotel Fenimore, Cooperstown, N.Y., H. E. Bissell.

58 W 57 N Y
Sept 22—04

Dear Henri:—

Well I have been doing the Professor Act[1]—Connah sent over for me yesterday (Wednesday) afternoon—I went and did my little stunt, not too much scared I hope, in the Head[2] Class and in the evening the mens Life. This morning I tackled the men's Day Life—

The sense of responsibility certainly seems to rather awe me—I feel as tho' should I ever regularly teach it would be like taking holy orders in the church

I will go over Friday morning (tomorrow) unless you turn up which I understand is not likely

Heard from Schofield this morning a letter with poetry and illustrations Scho's drawings are remarkably knowing for a "landscape bird"

Saturday P.M. and Sunday last we spent on the Sea side with the Calders who have a cottage at Seaside Park N.J. We had a very pleasant time The Calder juniors are magnificent works I never was more impressed with children

Saturday we move to 165 West 23rd St of which below is a "drawerin"

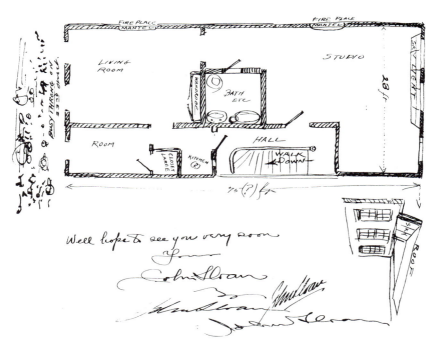

Well hope to see you very soon
Yours
John Sloan

[1] Sloan substituted for Henri at the New York School of Art.
[2] Portrait Class.

58 West 57
Nov 28 1904

Dear John

When I told you yesterday
 That Tuesday would be allright
For a family reunion and Pow Wow
 I did not remember that

There was to be a meeting
 Of the Society of American Artists
To vote for who would be jurors
 In next springs exhibition.

So I pen you this choice posey
 To let you know of the sad occurrence
And to beg you and M^{rs} Dolly
 To postpone until Thursday evening

At which time we hope you'll come
 And bring with you your toys
And we'll all sit round the table
 en draw en smoke.

Truly yours
Henri

Monday Evg. 30 Jan 05

Dear Sloan:
 Your card recd an hour after you were here—dont count on us for to-
morrow. Things are going better now[1] but we will be held down to the
nurse business for several days yet at best. It has been a struggle but we
now hope that the Gov[2] will pull through all right.
 We are mighty sorry we cant be with you

Yours
Henri

[1] A reference to the illness of Henri's father.
[2] A term Henri sometimes employed to refer to his father.

Feb 13 1905

Dear Sloans

Do not count on us for tomorrow tuesday. We are still out with the folks and will not be able to leave them the evening. Guess we had better call all off until next week when we hope sincerly to have all well. The Gov is now getting along finely, but my mother has taken a turn being sick and is down with a very bad cold

This winter is on its bum

Yours
Henri

[1905; undated][1]

Dear Henri:—

Do not expect us for dinner tomorrow evening. The World is Blue. Two scribner drawings back on my hands.[2] I am in a "state of collaps"

We will turn up in the evening later.

George Sotter stopped in this morning—he likes the Parrish[3] cover on Colliers this week. 'nuff said"

So long
Sloan

Wednesday 1 P.M.

[1] From a typed transcription.

[2] Sloan's first illustrations were accepted by *Scribner's* magazine for its November 1905 issue.

[3] Maxfield Parrish (1870–1966), the illustrator, enrolled at the Pennsylvania Academy the same year as Sloan.

[Nov. 1905; undated]

Dear Sloan

Stephenson[1] writes that he would prefer giving us our dinner at Mouquin's[2] at 6.45 on Saturday Asked me to let you know he having forgotten your address

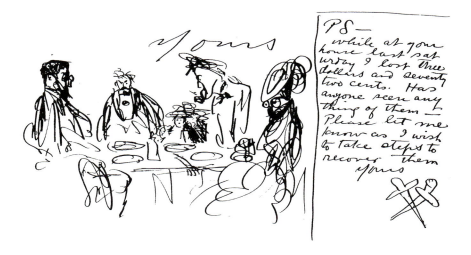

[1] Byron Stephenson, art critic for *Town Topics*.
[2] A restaurant which was a regular meeting place for the Henris, Sloans, James and May Preston, George Luks, and F. R. Gruger, all members of the old Philadelphia gang.

Nov 30 [1905]

Dear Sloan

Mrs Henri has been ill[1] and it now looks as if she will still be in bed though much better—on saturday, so we have to give up hope for our part attending Stephenson's dinner Its too bad—but she has been quite ill for two days past doctor etc, etc, high fever. Now much better. The SAA jury[2] will be Adams (sculp) Alexander, Blashfield, Chapman Chase Cox Curran Daingerfield Foster French Henri, Isham Jones, [Bolton] Jones, Kendall Kost La Farge, Loeb, Low, Millet, Murphy, Mettleton Prellwitz Smedley Wiles, Shirlaw, and hanging committee, Frank Dumond, Mac Neil (sculp) Carlsen.

The November number of the "Sketch Book" has a good reproduction of your breadline (and the other prize winners at Carnegie)[3] Letter from Scho announces that he is coming over to see us before sailing—"us" meaning all of us. He sails Dec. 9. We shall not attempt to contest your right to entertain him as the present illness puts us bedless and roomless

It has been partly on account of this illness that I have not brought Williamson down to see you as I wanted to do.

Yours
Henri

40. Sloan, *The Coffee Line*, 1905

[1] Linda's new illness was diagnosed as gastritis, and by the time this letter was written, a nurse and the family physician were constantly on hand. She died on 8 December at the age of thirty.

[2] Society of American Artists jury.

[3] *The Coffee Line*, 1905, by Sloan won an honorable mention at the Carnegie Institute, Pittsburgh, in part due to Henri's influential presence on the jury.

During much of the time since Henri married Linda, poor health caused her to stay with her parents in Black Walnut, Pennsylvania, or to remain for months at a time at Saranac Lake, New York, in one of the "cure cottages" for tuberculosis. In November 1904 she underwent surgery, but after briefly appearing to improve, she died the following month.

A grieving Henri accepted a commission to paint three children in Aiken, South Carolina, as a temporary escape from New York and memories; he left in mid-March 1906 after arranging for Sloan to take over his classes at the New York School of Art. It was the younger artist's first prolonged stint at teaching.

Sat 17 Mch 06[1]

Dear Sloans:

This is down south—balmy summer. Place is free and open—with variety.—The work is only getting into shape—was delayed by my canvases not coming. Have played some "bridge" am at present a few dollars ahead of the game—get a "bridge" outfit and learn the game its a good game as long as you know the players—and very interesting—Hearts nothing to it. I wish I could see the opening of the Society[2] wd like to see how things are recd by the public & would like to hear from you in that regard I wish you would send a framed print of the portrait of Linda[3] down here to me. I want to give one to M[rs] Sheffield and for various reasons I shd like to give it to her while I am here—she should be made acquainted with your work and will you have Rabinowitz[4] pack one framed india and one framed plain and one of each unframed and send the four to M[rs] T. Huston Craige[5] 9 South Millidgeville Ave Chelsea Atlantic City N.J. I would like very much to have M[rs] Craige get the prints soon and my return from here is so very indefinite. Hope this wont be too much trouble

Horse

Carriage Ride

Dress suit.

negro of

Sunny south.

Butler.

address. care M[rs] George Sheffield
 Aiken So. Carolina

41. Sloan, *Memory*, 1906

¹ Letterhead is Wistaria, Aiken, South Carolina.
² This was the final exhibition of the Society of American Artists before its amalgamation with the National Academy of Design.
³ Sloan's etching titled *Memory*, produced in January 1906.
⁴ Nathan Rabinowitz was Henri's art-supply dealer.
⁵ The mother of Henri's deceased wife.

165 W. 23 NYC
Mch 20—1906

Dear Henri:—

I sent the pictures as you desired in your letter received yesterday to Mrs Craige and to yourself sent both packages by express I hope that you will let me know whether yours reaches you in good condition—a card when it arrives will vindicate me as a packer and shipper or (I hope not) throw me into disgrace

The classes each week went all right I suppose—kicks, if such there were, were not registered with me—It's hard work and exhausting—your "states of collapse" will be forgiven by me in the future Yesterday, Monday, we had a very heavy fall of snow the second in a week—Winter seems to have found you in the way—and taken advantage of your absence to vindicate herself

I have not yet seen the Society Exhibition but Hatch told me that your "Art Student"[1] seems to be making a very pleasant impression The Art Notices of the N. Y. Herald will be found in the package with the picture which I sent to you I did not get the other papers Sunday—

I thought the portrait class pretty well crowded In the above the model is indicated by an arrow Puzzle find the "Professor"

Will write when I have seen the Ex[hibition] Do you also write to yours

John Sloan

P.S. This Fountain Pen works as tho' it had gold fish in it

[1] *The Art Student,* 1906, was a portrait of Josephine Nivison, future wife of Edward Hopper.

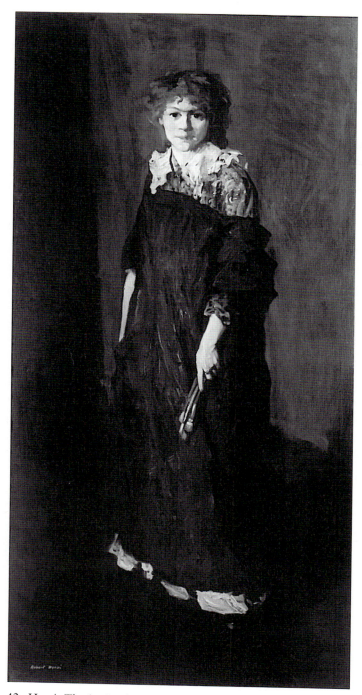

42. Henri, *The Art Student* (Josephine Nivison), 1906

[late March 1906; undated][1]

Dear Sloan:

Heard from Mrs. Craige that the etchings had arrived all right. she is greatly pleased. says she sees much of Linda in it and also speaks with appreciation of the other portraits in it. Wants me to express to you her appreciation and thanks etc. Dont fail to make a note of expenses of the shipment etc so that I can settle—and remind me of it too when I get back—When I get back—I dont know yet when I will get back for while the portrait of the three children is now finished (and to my satisfaction— It was a most difficult thing—the children being in two cases too young to do any posing other than to be present for a short while in the room while I worked—kept more or less on a chair where I could see them in many attitudes and moods—they are awfully good children however, and decidedly strong in character) I am still down for the full length of M[rs] Sheffield and I will have to go slow with that because she must go away and then as I most likely cannot finish before she goes will have to wait her return—I may yet be two weeks away. I hope you are not getting tired of the school. I have had a couple of letters expressing great satisfaction with the new Prof.

Of course I must get back near the middle of April at latest, as my time is up at the studio the first of May.

During all of your bad weather in NY it has been summer here. I have played a good deal of Bridge. have gone about somewhat in a social way. had a touch of tennis, one of golf—horses etc—but with all have been pretty well under the strain of the portrait.

My respects to Madame

Yours
Henri.

Did you send me that clipping of Fitz[2] dialogue article on SAA amalgamation[3] I cant tell if it is you or Fitz himself who sent it.

It certainly is a brilliant thing! a satire of first order.
Yours

[1] Letterhead is Aiken, South Carolina.
[2] Charles FitzGerald, art critic for the *New York Evening Sun*.
[3] With the National Academy of Design.

25 Mch 06[1]

Dear John

Hope you are getting along well at the school and like the job. I may come back some time

I haven't time to write. Best wishes to you both. Thanks for sending the etching.

Yours, Henri. Ex-prof.

¹Letterhead is Aiken, south Carolina.

[late March 1906; undated]

Dear Henri:—

Your picture letter setting forth the facts that you are painting with one hand and playing "bridge" and calling with the others made me feel (in your difficult "job") much abused also aggravated by the words "I may be back some time"

The letter saying that you had finished the portraits of the children to your satisfaction gave me a sense of relief and hope that your return might not be too far distant

I hope that I have given satisfaction as substitute in the School but do not feel very confident of it.—I have on one or two occasions felt that I was doing very well at other times it seems like singing a song repeating ideas etc.

If possible it would be fine if you could have the children picture photographed so that I could see it

I am glad that Mrs Craige liked the portrait plate and that my packing and shipping of the frames & glass was successful—

By the way you will be interested to hear that thro' notice in the Phila Press today I learn that the proof of this plate sent to Phila Water Color show has been sold—to whom I dont know—I dont even remember what price I put on it—

I have now five proofs of ten plates from Peters,¹ which look very well—Chas. Mielatz who is in charge of the etching end of the N.Y. Water Color show this year came to see me and wants me to send these ten and the Memory plate to the ex. Since they are insisting on white frames he says he will lend me frames for the ex.

No—I intended to cut out the Dialogue and send it to you but it slipped me so probably Fitz himself sent it to you

I enclose an editorial which appeared later on the same subject.

Last night Dolly and I went to the Francis² for dinner Preston's & Glackens went down to the "Lair beyond the Moat"³ and had a right good evening—Glackens, Shinn or somebody who dont care particularly for the credit has painted a big panel in the cellar showing J. M.⁴ in high hat and ladies lingerie playing "frog"⁵ with unmentionable accessories others of the crowd grotesquely disarrayed standing and seated around James says

"its too bad it will have to be painted out" I hope that this dont happen before your return for its a funny thing

I have finished the Collier story[6] and delivered it without much applause mine or theirs—And have about finished another better story for the Sat. Eve. Post[7] This work with the teaching has made me feel pretty busy— Well thats about all I have in the way of news—I wish you good success with the Mrs S. portrait and will hand over the "chair" at the school with great relief on your return Dont feel however that I'm worried <u>too much</u> by the Professional Duties I simply feel that perhaps Im very "flat" to the students in contrast

The Class in Composition

Best wishes from Mrs S
Yours
John Sloan

[1] The ten etchings printed for Sloan by Gustav A. Peters are known as his "New York City Life" set and include *Fifth Avenue Critics, The Women's Page*, and *Turning Out the Light.*

[2] Café Francis, at 53 West Thirty-fifth Street.

[3] The name given by the owner of the Café Francis, James Moore, to the basement confines of his four-story brownstone.

[4] James Moore was the grandson of Clement Moore, the author of "'Twas the Night Before Christmas."

[5] Leapfrog.

[6] Sloan provided three illustrations for "The Inspiration of Perot" by Laura Campbell, which appeared in the 11 August 1906 *Collier's.*

[7] His four illustrations for E. J. Rath's "His Nobler Ambition: Little Wellington Joins de Gang" accompanied the story in the 21 April 1906 issue of *The Saturday Evening Post.*

43. Sloan, *Fifth Avenue Critics*, 1905

44. Sloan, *The Women's Page*, 1905

45. Sloan, *Collier's* illustration, 1906

46. Sloan, *The Saturday Evening Post* illustration, 1906

Sloan's elation at being invited to exhibit his ten etchings of city life in the New York Water Color Society's exhibition turned to dismay when, at the preview showing on 2 May 1906, he discovered only six of the prints on view. The committee, he was told, had found the subject matter of the others "too vulgar" for a public exhibit (Sloan diary, 2 May 1906). Among those works rejected were Turning Out the Light, *which depicted a nightgown-clad woman with a man lying in bed beside her, and* The Women's Page, *which showed a woman in an untidy bedroom attired in only a slip.*

Henri encouraged his students to battle against the ideal and the beautiful, pointing out that a beggar by Rembrandt is valued as highly as one of his well-to-do gentlemen (Henri, The Art Spirit, *p. 136).*

Mch 30 '06[1]

I hope you are not tired out with my job because it dont look less now than two weeks more. I cant hope to be in NY before the 15th of Apr. I have the painting of M^rs Sheffield to do as she has put me off—social moment here you know—so that little has been done. I must wait a few days now before I can do it.

The portrait of the children is done and everybody in high state of satisfaction myself as well as the rest So far it has made a hit with everybody

This will give a slight idea of it, 50 x 72, all in white black shoes, white bow on hair of central figure['s] head yellowish sand color ground backgr[ound] thick mass of green—very warm foliage impression of branches & spotting of red flower of a japonese plant—flower like a blossom color of light red. Two or three touches of sky. children all blond but greatly varying each from other in type of blond. Central figure poses with beautiful distinction of carriage.

Best wishes to you both.

<div align="right">Yours
Henri</div>

The men are now at work making a foundation in the garden for the sun dial, wh only arrived a few days ago.[2]

P.S.—I am so sorry John that so short a professorship shd have given you such a severe look!

[1] Letterhead is Aiken, South Carolina.
[2] The sun dial was the work of sculptor A. Stirling Calder. In October 1905 Henri had learned that Calder was suffering from tuberculosis and required a stay in Arizona to regain his health. Henri prevailed upon Mrs. Sheffield to purchase the sun dial in order to provide Calder with much needed funds for the trip.

47. Henri, *The Children of Mrs. George Sheffield*, 1906

Apr 3 1906[1]

Dear John

Your drawing of your self as a composition professor is a beauty and I have often felt about that size myself—I am not surprised that you sometimes wonder they dont rise up at the oft repeated advice—but after all a thing has to be told many times over before it takes hold anywhere—I have often felt that I was not up to my standard and have thought I had lost my grip on them but it generally turns out that the grip is not lost and one is scoring just the same I know pretty well that the students are getting a lot of new stuff from you that they would not have had from me—A letter I recd from Pach[2] was enthusiastic about your criticisms I count on getting back about the 15th of April. I got fastened down here by M^rs Sheffield to wait her return on the 7^th—just to feed and drink, breathe the air play tennis—ride or drive if I want to—until she comes back when I am supposed to have good and plenty posing until I finish the portrait. I have prepared the canvas considerably and may pull through in good time. I have the Calder dial on hand now and hope to have it up in place by her return if I can get my men to move out of their pea[c]eable lethergy wh I dont blame them for having in this climate. It is the middle of summer but not too hot today. I have company in Miss Minnie Chappell who is an old friend of M^rs Sheffields—then there are the children and their nurses—the servants etc. Books to read but not much interest in reading them—rather too much time for sad thoughts—I go early to bed 10.30 to 12.

This being about my full history up to date
With best wishes to Mrs S and all the tribe.

Yours
Robert Henri

[1] Letterhead is Aiken, South Carolina.
[2] Walter Pach (1883–1958) was a student of Henri now being taught by Sloan.

Apr 5 1906[1]

Dear Sloans

I enclose tickets I have just recd from the SAA wh you may make use of.

Not much doing here at present. Its soft summer. Birds singing all about. Air laiden with fragrance. And altogether its too damned peac[e]able.

I may have lazyness in me but I never have been able to enjoy eating lotus

Sweet and dreamy peace—beautiful still moonlight—inactivity—standing still.—I would rather be damming a creek just to give it the pleasure of cutting a new bed.

I have been playing tennis—enough to know—But it is not a philosopher's game like golf. Lacks the romance. Its made up too much of sun on a flat yellow bottom of a wire cage you jump about in. A net always so high and in the same place. A certain kind of shoes. White trowsers, taste in socks. No hills to go over to other views no crush of grass under foot, no spring to drink at at the end of that long stretch. Golf might have its Izaac Walton.[2] Tennis could only have a Beau Brummell.

<div align="right">Yours
Henri</div>

That was pleasant to hear—of that sale of yours in Phila of the etching.

[1] Letterhead is Aiken, South Carolina.
[2] Izaak Walton (1593–1683), author of *The Compleat Angler* about the joys of fishing.

[*Card postmarked 8 April 1906*]

[April 1906; undated][1]

Dear Henri:

I think that you have a calling—Golf writer—or as you suggest, Isaac Walton of Golf. You made my hands itch for the grip of a driver, the swing from the spine, the crisp click of the contact, and then that long easy slice to the impenetrable, inscrutable rough at the right of the fair green.

Potts[2] and "we" about decided to go to Kittery Point, Maine—lowest point on the coast of Maine, across harbor from Portsmouth N.H. furnished cottage for 100. the season, four months if we wish. I think that "we" will be much better for the radical change of air this summer, and tho I'll have to keep my studio rent going in town here—I think the gain in health should make it worth the expense.

I suppose and hope that this will be my last week at the school, looking forward to your return about the 15th.

Saturday I painted Mrs. Hensche—posed for me. Found her very interesting and I think I have a right good start. Have had two good games of poker with Mr. and Mrs. Hensche.

We are having the usual rather chilly showers of April up here today—yesterday fine.

I have had a dozen portfolios made for the etchings and am making hinged folder mats for the proofs. I think they will look very fine. See you soon I hope.

Mrs. Sloan sends her especial regards.

> Yours
> John Sloan

[1] From a typed transcription.
[2] Sherman Potts was a former newspaper artist from Philadelphia.

165 W. 23
New York
June 9—1906—

Dear Henri:—

I hope that this may reach Madrid in time to welcome you to Spain—sort of a long range welcome you might call it.

No event of very great moment has transpired since your impressive figure disappeared from my gaze up the steps of the elevated Station at 23rd street so we have been able to settle down to miss you a great deal already—As I write I picture you on the high seas perhaps convalescing

seated in an easy chair in the door way of your spacious apartment on the upper deck surrounded by lady artists making drawings of you which they will sell to London Punch

I met Kirby[1] the other day and we went together to Van Cortlandt Park. He beat me on total score by only two strokes. I will not give the figures. Suffice it to say that I tied him on "match play" (by holes)—They are meditating setting a brass memorial slate in the sixth tee commemorating your feat of three strokes on that hole.

My Cousin Eleanor returned to Philadelphia yesterday—Sister Marianna arrived here to spend a week or so with us and work on water colors. Thursday we went to Coney Island and enjoyed the trip immensely. Tuesday Nan[2] & I went to the "Metropolitan"—I rather fear that the cleaning has done harm to the "Woman & Parrot"—Manet—I cant feel worried about the Rubens one way or another. Hope you wont be too busy to write to yours,

John Sloan

Mrs. Sloan sends the best wishes possible for your health and happiness—and safe return to our care. My sister also sends regards and wishes she were along with the class[3]

CROSS section; ROUGH sketch Showing the absurdity of calculating on a basis of "*Level* of the Sea"

[1] Rollin Kirby, an illustrator.
[2] Nickname for Sloan's sister Marianna.
[3] Henri's New York School of Art summer class in Madrid.

When our R. H. [Robert Henri] Meets His R. H. [Royal Highness].

June 13 1906
On the Raging Deep

Dear Sloans

We are up in the bow busy inspecting the backs of a flock of whales. flying fish have been flying around The only fault in the picture above is that there is really no one feeding the fish—nor has any one—nor have I fed fish this trip. A bit light in the top story and a bit sque[a]mish in the mornings—thats all—a mighty good time. We had some moist weather to start with but since it has been fine The Azores seemed to have entirely recovered from the ravages of Luks and Walsh.[1] We arrive in Gibralter tomorrow at about ten oclock

I wish we had you with us, M^rs S. You would have been a good sailor on so easy a trip.

My next letter will be written in spanish in Bulls blood.

Yours smoking

[1] William S. Walsh was literary editor for the *New York Herald*.

[June 1906; undated]

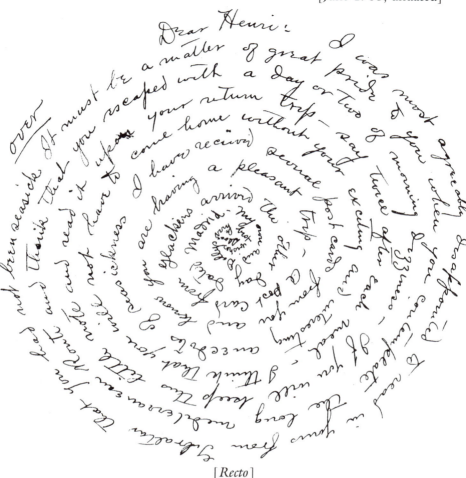

[*Recto*]

Dear Henri: I was most agreeably disappointed to read in yours from
Gibraltar that you had not been seasick It must be a matter of great pride
to you when you contemplate the long mediterranean Route and think
that you escaped with a day or two of morning dizziness—If you will keep
this little note and read it upon your return trip—say twice after each
meal—I think that you will not have to come home without your exciting
and interesting anecdotes of seasickness I have received several post cards
from you and know you are having a pleasant trip—A post card from
Glackens arrived the other day dated Madrid. My own and Dollys very
best wishes Sloan

[*Verso*]

'Hurrah' said Robert Henri Ive sailed the Ocean blue From Boston to Gibraltar I've never had to "spew"—"Yes I'm an able seaman and who would think" said he "The sight of labels on a trunk Once nauseated me?"—But o'er the Sea returning He read this spiral verse He turn'ed pale He sought the rail And did the poet curse

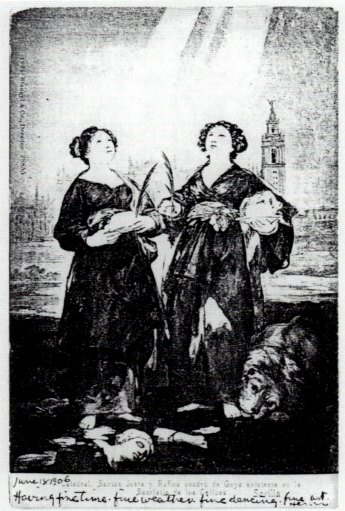

Vista General de la Alhambra y Granada desde la Silla del Moro
June 20 1906 - R. Garzón, Fotógrafo. Alhambra No. 21 *Add to this. Perfectly wonderful Color.* Henri

COPIA DE VELÁZQUEZ MUSEO DEL PRADO

Retrato del autor.

[*Card postmarked 1 July 1906*]

Hope you have enjoyed the country and are still there.
Yours
Henri

MONASTERIO DEL ESCORIAL: PALACIO

TAPIZ DE GOYA: EL CACHARRERO

48. -M. Moreno, fot.-Madrid

MONASTERIO DEL ESCORIAL
PALACIO: SALÓN DE RECEPCIONES
24—M. Moreno, fot.-Madrid

SEGOVIA
VISTA GENERAL
613 Hauser y Menet.—Madrid

*[Included in a letter from John Sloan to Dolly
written on 2 September 1906]*

[August 1906; undated]

I have received a nice long letter from Henri at last.[1] He is still in Madrid, has been painting. Portrait of Lieutenant in Spanish army,[2] a gipsy woman and baby,[3] a dressmaker type of the Spanish girl. Felix Asiego full length in gold and green, a bull-fighter, Matador.[4] The class has gone to Paris now. He says he has not decided when he will return, may be soon. Either side of Oct. 1st, not likely to go to Paris—will probably sail from Gibraltar.

Says he has a book with some Goya etchings in it for me.[5] "Tell Mrs. Sloan that I wish I were coming to dinner at 165 W. 23 tonight and my best wishes"

[1] The letter from Henri has not been found.

[2] The *Portrait of Lieutenant Don Clemente Cordillo Alveriz De Sotomayor,* a full-length likeness of the soldier in military dress holding a sword, was destroyed in 1935.

[3] *Spanish Gypsy Mother and Child* (Maria and Consuelo).

[4] *El Matador* (Felix Asiego).

[5] The book contained Goya's *Caprices, Disparates* and *Los Desastres de la Guerra.*

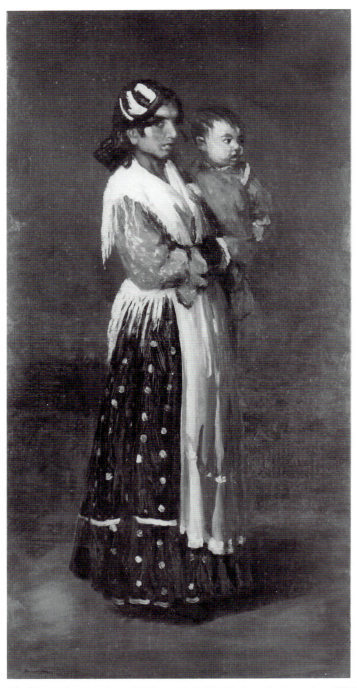

48. Henri, *Spanish Gypsy Mother and Child* (Maria and Consuelo), 1906

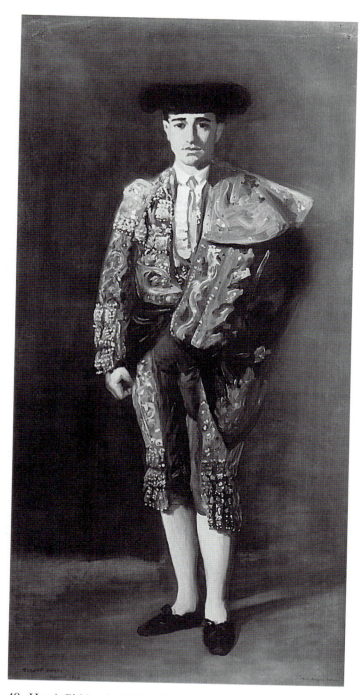

49. Henri, *El Matador* (Felix Asiego), 1906

FOT. LAURENT, MADRID

NÚM. 37—GOYA. - UN MAJO TOCANDO LA GUITARRA.

from
Henri.
aug 3.1 1906

2165 (b).—MUSEO DEL PRADO *La Maja vestida* GOYA

FOTOTIPIA LACOSTE - MADRID

[Card postmarked 1 Sept. 1906]

Madrid Sept 23, 1906

Dear Sloan:

I expect to sail about the 8th of Oct. Cant say for sure it is a matter of getting the berth—it is likely I will get it all right In that case I should arrive about the 18th possibly the 17th. Have been very busy lately since the hottest weather passed and could have a lot of things that wd carry me on for some time with most interesting subjects if I would stay I hope to do a bull fighter and a spanish dancer this coming wk—have done one of each of them already—am anxious to do others of them—you have already heard of the bull fighter Asiego—The dancer is "La Riena [Reina] Mora"[1] one of the successful dancers of Madrid—rich (for a dancer) thousands of dollars in costumes etc. I have done one large full length of her wh I think is a good one and did also a small 26 x 32 of her to give her—the latter turned out fine—think it is one of the best pictures that size I have painted. Am sorry to leave it behind but am glad it is a good one I am leaving

They have all been ready to do a lot for me, and I have filled a very pleasant position among this group of spaniards, and can say of them that they are an awfully fine set of people.

[133]

I suppose Connah has asked you to take my place at the school and hope you have taken it.

I will let you know as soon as I know precicely the date for my homecoming

With best wishes to Mrs Sloan and all.

<div align="right">Yours Henri</div>

[1] Milagros Moreno, who used "La Reina Mora" (The Queen of the Moors) as her stage name.

<div align="right">80 W 40
Dec. 23 06</div>

Dear Sloans:

We have been packing things up at the folks appartments because my mother is going over to Phila to stay with or near the Doctors[1] for a time and of course there is to be no housekeeping. Now there are a number of things here at the appartment that you might care to be loaded up with— for keeps of course—not as I did with my bed. We must get out either Thursday or Saturday as we don't want to run into a new months rent and so the stuff has to be disposed of at once. Principal among the things are an iron ¾ bed, good one, in good condition, with mattress in good condition and as I remember it very comfortable altho I think it cost but $8— the mattress. There is also another mattress that, though full size fits the bed only a little loosely. This is a $50.00 mattress made in two pieces. It is old but they say that renovating & recovering costs $4.00 and that it would be as good as new.—I have slept on it lately and it is decidedly comfortable as it is. There is a sofa that is in awful shape as to cover and one leg out of joint but all possible to repair—could be covered with the plain under-covering of furniture and then wear an overcover. It is a remarkably comfortable affair even now—when its lame leg is propped up—cost when it was new something over $100.00 so that it is good hair etc. It would be possible to make it into a very inviting place to sit down at another small

50. Henri, *La Reina Mora* (Milagros Moreno), 1906

expense I think.—I would take it but my one sofa suffices and I have too little room for more. There are two sofas that take up just the room of their seating capacity. They are in like bad condition as to cover but otherwise all right maybe a trifle weak in the springs of the seat but not too much so.

2 like this

portrait of the sofa

There is a good, real good wood—(It is not mahogony but equally good) washstand with good white marble top, drawer, and shelves below. Two chairs simply respectable of the dining room variety. They are all right but not fine. One or two other chairs that might bear looking at. One of those Redfield rocking chairs. a black walnut extension table in good condition (It is extension but there are no extra leaves. a right good kitchen table of the deal table variety like the one I am using as a palette. And in the kitchen there is a job lot of good and bad—some of wh things M^rs S. might find use for.

Now if in all this there is anything you want say so and I will give you a general warra[n]tee deed to them provided they can be removed before Sunday. There is also a sewing machine I believe it is good, though old. Let me hear from you at once so I can know what to expect. The bed is certainly good, mattresses also The big sofa could become very presentable and be exceedingly comfortable—and I believe there are some things in the kitchen that wd be desirable. What you dont want I shall have to chuck. My mother is here with me and will stay for about two weeks—till the 6^th Jan—in the studio.

We wish you all a very merry Christmas.

<div style="text-align:right">yours Henri</div>

Let me hear from you right away.

[1] The home of Henri's brother, Dr. Frank Southrn, and his wife, Jane.

Christmas day '06
Fort Washington

Dear Henri:—

We will be back on Wednesday (or at latest Thursday morning)

To begin with we will be most glad to have the bed and both mattresses.

Dolly says that as Ullmans[1] are thinking of starting housekeeping we had best take all the other things and what we <u>dont</u> use we can, if it is agreeable to you—hand over to them when they locate as they will as soon as Mrs. Ullman leaves the hospital. The operation seems to have resulted successfully so far Dolly had a letter from him today to that effect.

I saw Anshutz[2] last evening and the night before he asks after you and both he and Mrs. A. express sympathy in the loss of your father.

My sister also asks me to remember her to you

My mother is right well for her [age] and looks nicely I have made a photograph of her which is quite a success

Give my own and Dolly's best wishes to your mother

Will call you up on the 'phone Thursday morning If you send the things anytime after noon on Thursday we will be on hand to receive them

The seasons greetings

from yours
John Sloan

It is cold here

1 Albert E. Ullman, a promoter of art among other things, and his wife, Kitty.
2 Thomas Anshutz (1851–1912) was a teacher of Henri and Sloan at the Pennsylvania Academy. In 1905 and 1906 Henri invited him to present six weekly lectures on anatomy at the New York School of Art.

The amalgamation of the Society of American Artists and the National Academy of Design in April 1906 had been recommended by a six-member committee, of which Henri was a member. He was subsequently elected to serve on the Academy's thirty-man jury in March 1907, determined to fight for the inclusion of non-academic artists—especially his associates and students—in the forthcoming exhibition.

When Henri witnessed the outright rejection of Sloan's Stein, Profile *(Foreign Girl) and works by Glackens, Luks, Shinn, Rockwell Kent, and Carl Sprinchorn, while two of his own entries (*El Matador *and* Spanish Gypsy Mother and Child*) received less than unanimous approval, he withdrew the latter canvases, protesting what he considered the jury's exclusion of paintings by those who had "something vital to say" ("The Henri Hurrah,"* American Art News, 5 [23 March 1907], 4).

Sloan applauded Henri's act of defiance against the National Academy, expressing this sentiment in his diary for 3 March 1907:

> The puny puppy minds of the jury were considering his works for #2, handing out #1 to selves and friends and inane work and presuming to criticize Robert Henri. I know that if this page is read fifty years from now it will seem ridiculous that he should not have had more honor from his contemporaries.

The controversy expanded from mere studio talk to the pages of the press, with Henri pointing out

> The academy rejects good work right and left and the result is that the exhibitions are dull. . . . There are many, many good painters in the country whose work is never seen on this account. ("Doors Slammed on Painters," *New York Sun*, 12 April 1907)

With near-unanimous support from the daily press, Henri, encouraged by Sloan, the art critics and others, organized a non-jury Independent Show for the following season, composed of Sloan, Glackens, Luks, Shinn, Davies, Prendergast and Lawson—his "little coterie in New York" (James William Pattison, "Robert Henri—Painter," The House Beautiful, 20 [Aug. 1906], 19). *This show developed into "Eight American Painters," and the group of artists included in the show became known as "The Eight."*

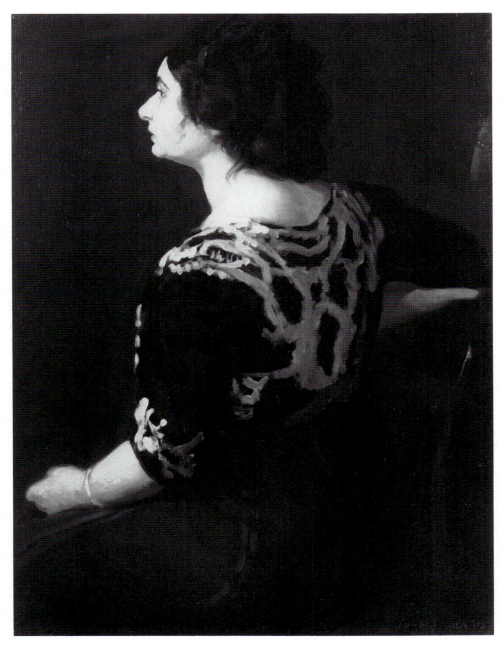

51. Sloan, *Stein, Profile (Foreign Girl)* (Eugenie Stein), 1904–05

8 ARTISTS SECEDE FROM THE ACADEMY

Revolt Led by Robert Henri, as Recently Predicted by The American.

When Robert Henri, the well-known painter and leader of what is known in art

STUDIOS AWAIT '8'S' STAND

EAGER TO KNOW IF THEY WILL SEND SPRING CANVASES.

The Time for Submitting Academy Pictures Is at Hand—Henri Incident Recalled — An Art Gallery Man's Opinion of the Controversy —One Refusal Already Received.

If rumors which at present are

ARTISTS JOIN IN AN EXHIBITION

Davies, Glackens, Henri, Lawson, Luks, Prendergast, Shinn, and Sloan Combine.

NEW ART SALON WITHOUT A JURY

Eight Artists Form Association in Opposition to the National Academy of Design.

MAY INVITE ENGLISHMEN

Mr. Robert Henri Heads the "Men of the Rebellion" Who Seek an Artistic Promised Land Here.

New York is to have a new salon paintings with the "Men of the Rebellion" headed by Mr. Robert Henri and others as its sponsors. Mr. Henri, since withdrawal from the jury of the recent exhibition at the Academy of Design on account of his dissatisfaction with the of pictures accepted, has been looked as the leader of an expedition to an Promised Land by a group of painters admire his style.

ACADEMY CAN'T CORNER ALL ART

Eight Progressive Painters Unite to Fight Reactionary Methods.

WILL SHOW THEIR WORK IN SPITE OF OLDER BODY.

As a result of the National Academy of Design's recent harsh attitude toward art and artists of vigorous and personal expression, a group consist

ART SECESSIONISTS TO EXHIBIT WORK

Paintings by "The Eight" Will Be Shown in February—None of Still Life Included.

Preparations for the coming exhibition of "The Eight" are in progress, stimulated by the present show of the National Academy of Design, for these painters believe they can reveal an art more forceful and individual than that

52. New York newspaper headlines announcing the formation of The Eight, 1907

The art dealer William Macbeth had agreed to schedule the exhibition for two weeks in February 1908 at his gallery in New York, yet insisted on a guarantee of $400 from the artists. Sloan acted as treasurer, collecting the money and acknowledging each contribution with a receipt.

A month after announcing the formation of The Eight, Henri embarked for Holland and a summer of teaching and painting.

[*Card postmarked 15 June 1907*]

[1] Nux Vomica was a tonic employed to induce vomiting.

S.S. FINLAND

June 21, '07
Dear John and Dolly with some
care I have prepared the above map
of my trip. Yours
Henri

MUSÉE ROYAL D'ANVERS. — *Jeune garçon pêcheur
des environs d'Haarlem.*

This is a very live Frans Hals altho the
background was possibly painted by
some one else. —
N. 188, G. H. Ed., A.
June 1907

[June 1907; undated]
["Study for one of 'The Syndics'," 1662, by Rembrandt]

MUSÉE ROYAL D'ANVERS. — *Portrait de femme,*
par Rembrand van Ryn.

N. 293, G. Ed., A.

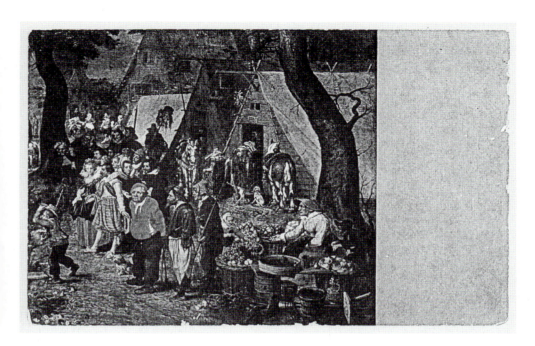

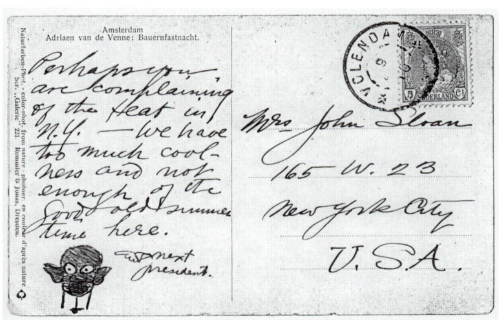

Amsterdam
Adriaen van de Venne: Bauernfastnacht.

Naturfarben-Phot. - color-phot. from nature : photogr. en couleur d'apres nature
Ser. „Galerie" 251 Romuler & Jonas, Dresden.

Perhaps you
are complaining
of the Heat in
N.Y. — We have
too much cool-
ness and not
enough of the
good old summer
time here.

next
president.

Mrs John Sloan
165 W. 23
New York City
U.S.A.

[*July 1907; undated*]
[*"Rural Shrove-Tuesday" by Adriaen van de Venne*]

[147]

Hotel Leeuwerik
Haarlem Holland
July 9 1907

Dear Sloans:

First it was cold rainy chill & we were unhappy—it still rains about every day more or less but is warm enough and the skys are wonderfully fine the Holland sky has a variety, activity, and a warmth, blue, gray that is unlike any other I have seen—Haarlem is rather much town for landscape work—the sea place near by is no good—dutch Atlantic City without any of that wh[ich] is good at Atlantic City. only the worst side of it

Have been to Amsterdam several times. great picture city.—Galleries Hals & Co fine. been to Volendam on the Zederzee—fishing town— Home of the Holland pot boiler— great stuff tho' if it had not been so abused—white headed boys wonderfully fine—big men and women—the costume of the men is the limit and yet I have seldom seen men with finer looks or general bearing.

Hoping you are Happy

Yours Henri

New York July 14 1907

Dear Henri:—

Your postals from Antwerp arrived also the illustrated note I see that you gave up your scheme for crossing the sea by "land" (Finland) and judge by the bag of gold beside you in the sketch that you traveled by "Bridge" Well, so you got over, I suppose the means must not be questioned.

Two or three things have transpired since you left—of first importance perhaps Mrs Glackens cleared of a boy on the Fourth of July—Glack's telegram reads "both feeling very well"—Dolly called at the hospital in about a week but could not see the mother They are keeping her very quiet. I've not seen Glack—he will become a connoisseur of infants now I suppose which will about round him off

About a week after you left I heard from Reuterdahl[1] that he had been asked if he would "consider a position as instructor in the Pittsburgh Art Students League" he told me that he was too busy—should he name me as a likely man for the place? I considered and said yes—then in a day or two got a note similar to his "would I consider the position" I answered yes. In about two weeks I had notice that I had been elected by vote of the members—what do you think of it?—$100 per month and expenses one days criticism a week twill be rather strenuous; trip by night a days work and return by night but I thought it best to take the chance school commences in October.

A friend of Miss Raymond's named Miss Blossom[2] bought a set of etchings.

A day or two after you sailed I called at Mrs. Käsebier's[3] and she gave me several proofs of your photos to take in charge till your return—thought best not to send them as they are right bulky and will keep till fall—their "beauty is beyond question"

Dolly leaves from Philadelphia tomorrow on her annual "tour of the Provinces" Have been working on two or three new canvases since you left—can't feel sure of them yet and have done a "story" for the Sunday Magazine last week.

A note of thanks for "photo" from Mrs. H. S. Morris.[4] I opened it as it was addressed to you here (165)[5]

Three or four clippings from Romeike[6] none of importance I am saving them for you.

I suppose that you have had nothing in the way of hot weather in fact it seems to me that I have read in the news that Europe was having a very cold summer.

There has been nothing intolerable here we have made two or three little excursions once to South Beach which is an interesting place[7] like a rudimentary Atlantic City perhaps—one trip to Coney Island which was very enjoyable we had a good day there—Over to Bayonne on the Fourth of July.

Potts[8] has been in to see us about three evenings since you left same old Potts—big bills back of him to pay but when he gets a bit of money he must have the latest—invisible suspenders and some inexpensive but new shirts.

Dolly tells me to say that you are very much missed in our evenings here at "165" and you certainly are—We hope that you are having a good time

How goes "the Dutch" as painting material? suppose you have a wonderfully clean studio where you leave your shoes outside the door—remember us very particularly to Miss Niles and Miss Pope[9]

I've run out of subject matter so will cut off right here with a hope expressed that I may hear from you soon I'm yours

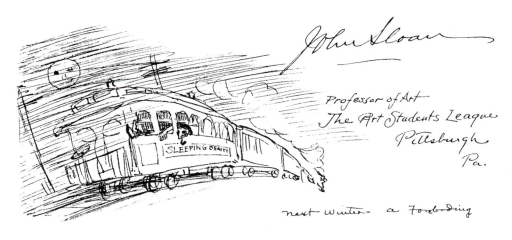

John Sloan

*Professor of Art
The Art Students League
Pittsburgh
Pa.*

next winter a foreboding

1 Henry Reuterdahl was a painter of seascapes.
2 Mary C. Blossom.
3 Gertrude Käsebier (1852–1934), a member of the Photo-Secession and the photographer chosen to take individual portraits of The Eight for publicity purposes.
4 Mrs. Harrison S. Morris.
5 Sloan's studio-apartment at 165 West Twenty-third Street.
6 Henri's newspaper clipping service.
7 The visit to Staten Island's South Beach the previous month resulted in Sloan painting *South Beach Bathers*, 1907–08.
8 Sherman Potts.
9 Helen Niles and Louise Pope were among the students enrolled in Henri's art class that summer in Holland.

address. Thos Cook & Son
Amsterdam Holland
July 28 1907[1]

Dear Sloans:
 Yours rec'd the other day. The Pittsburg teaching is news—its good to hear as to the appreciation it means—and money is money and a sure 100 a month is a good thing in these days—it will be earned though—I'm afraid you will get desperate tired of that trip—but much depends on whether RR travel upsets you if you can stand the sleeper and forget it all will be well but if it knocks you out for a day before and after its not very good wages—However in these days a sure hundred a month is a good thing and maybe it will serve as a bridge. just look at Chase rushing from his home to his classes in the N Y school—to his 5th ave studio, to his other New York studio, to Phila, to the school there, to his studio in Phila. going off to places to paint portraits of people who cant come to

[*Card postmarked 22 July 1907*]

him. and all done in the same day that we live so comfortably—but that is a matter of temperament and I dont know but that it costs as much one way as it gains another—but there is a good deal in the frame of mind about it, and perhaps if you look on that trip to Pittsburg as nothing or the simple inevitable like getting up and dressing in the morning it wont bother you too much or take more than its own time away from your work. Perhaps the teaching will have its benefits—anyhow it is a new experience and in these times 100 sure is a good thing. Make them pay <u>all</u> expenses and dont start them modestly—you will do them better work if you are made thoroughly comfortable. and it is really 36 or 40 solid hours service you give them for $25⁰⁰ which is comparatively rediculous pay in New York or Pittsburg. Things are going all right here. class doing well. Harris[2] has jumped from nowhere into doing lots of work on big canvases and most interesting stuff—he will land O.K. Miss Pope and Miss Niles are both doing fine—of course they had already their start.

It is rather odd that I have to tell of my own work—not to tell of big full lengths etc—the largest canvas I have painted here is 26 x 32—about 8 or 9 of them and the rest are about 22 x 26—and I have been perfectly con-

tented to do them. and what I have been doing is precisely what I hoped
to do—paint little dutch children. The number of my models have been
but 2. I could have many more but I found 2 at once so interesting that I
have not desired to change but have painted day after day new heads of the
same one I get at 4 every day and have until 7 the other from 2 to 4 on
Wed and Sat. This aft[ernoon] I am due to change—to paint a cab boy in
his hat—if he does not fail to turn up. he looks somewhat like this—the

hat is very near the right proportion he
was the first thing I saw in Haar-
lem. and I only saw him again yester-
day. instead, as I thought, of his being a
type he is just unique—and therefore as,
if not more interesting. One of my 2
models is a little white headed broad
faced red cheeked girl of about 8 always
laughing. I have painted her laughing
many times—the other is just the oppo-
site but just as dutch—white, delicate,
pathetic. I have enjoyed the work—and I
have worked very hard doing somewhat
in the class—and doing some few
sketches. One needs lots of sleep here
somehow—we get through dinner at 9
or 10 have an hour or 2 of bridge and
get up about 9 am seldom get much done in the mornings. Im afraid the
burden of my moving is on you—for in investigating steamers, we will be
lucky to get berths as early as Oct 1 so great is the traffic. My love to you
both

<div align="right">Henri</div>

[1] Letterhead is Hotel "De Leeuwerik," Haarlem.
[2] Hartman K. Harris.

53. Sloan, *South Beach Bathers*, 1907–08

54. Gertrude Käsebier, *Robert Henri*, 1907

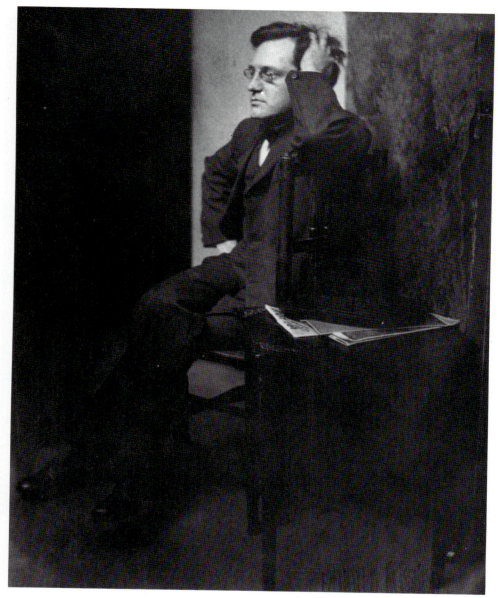

55. Gertrude Käsebier, *John Sloan*, 1907

56. Henri, *Laughing Child* (Cori), 1907

57. Henri, *Dutch Girl in White* (Martche), 1907

Museum Boymans - Rotterdam.

A. VAN OSTADE. De lachende boer. Peasant laughing.
Le Paysan. Der lachende Bauer.

class over now, but still here myself and doing lots of work. ♯ *aug 14 07*

Henri made a habit of testing Sloan's friendship and devotion by saddling him with various responsibilities: instructing Henri's art classes, seeing that his paintings were delivered to various exhibitions, even overseeing the September 1907 move of Henri's studio from the Beaux Arts building to a converted church on East Fortieth Street.

Henri left New York a month before the scheduled opening of The Eight exhibition on 3 February 1908 to carry out a portrait commission, leaving many of the details to Sloan.

FRANS HALS.
Regentessen van het oude Mannenhuis.

Hello —
Prof.
Yours.
H.
aug 14
1907

Aug. 14 1907[1]

Dear Sloan: It looks as if you are in for the moving because we have been unable to get passage on any boat before the 28th of Sept. Got passage on the Pottsdam of Netherland American Line to sail on that date. arrive the 6th or 7th October. I tried to get a boat earlier but could not.—for I did not want to put the moving job on your hands if I could help it. It is likely that I will go to England about Sept 1st to the sister of Miss Fisher,[2] who is the wife of the mayor (I believe it is mayor) of a north-of-England City— to paint her portrait. She is a prominent woman taking part in politics, temperance etc etc—the good of humanity—the best she knows how. It will be a trip of unusual interest if the portrait goes easily for the north of England in that district is the untraveled part—she (Miss Fisher) says it looks like Scotland (and of course I will have a glimpse in at London but will not delay as I want a bit of Paris before sailing. will take the steamer at Bouloigne France. The class is over, very successful as far as work— some excellent stuff. That part of the class for Italy has already moved on with Connah to Paris. some others have gone their way. the remnant is here yet. Miss Niles, Pope (Harris went to Paris today—he has done re- markably well) Miss Fisher, Miss Perry,[3] Rogers and Raymond. Miss Pope & Niles have worked most of the time from the model. done some

outdoor—Miss Pope has done one remarkably fine outdoor panel wh[ich] she has given to me. They expect before leaving to do a great deal of outdoor work. Miss Fisher & Perry have both done fine stuff—Miss Fisher is always fine. Miss Perry has come into her own this summer

I have been steadily plugging. Have painted over and over again three little girls.[4] one of my most interesting things is a cavalry soldier[5] The boy coachman with the big hat did not turn up when he promised we tried for him again but he failed again This last wk we have had Kermis[6] here and the town has been roistering, tho' not with much variety, and what there was of Browerlike dutch fete was somewhat damaged by that Anna Held Parisian Model tune—its eaten to the core of Holland. we had a great day taking the kids to the Kermis. Altogether I am satisfied with the summer as a good piece of working time. I like what I have been working at and consider that I have learned from this work very much— what I have on my canvases I can hardly judge until I get them home. I have done nothing larger than 26 x 32—and most of what I have done has been smaller. Love to you both—

<div align="right">Yours Henri</div>

[1] Letterhead is Hotel "De Leeuwerik," Haarlem.
[2] Elizabeth Fisher, a Henri student.
[3] Clara Greenleaf Perry (1871–1960), another pupil of Henri's.
[4] Cori and Martche were the names of two of them.
[5] *Dutch Soldier.*
[6] An outdoor festival.

Aug. 19 1907—I am going to Halifax Yorkshire England for about ten days to do a portrait. shall go about the 28th My address will remain Thos Cook & Son Amsterdam Will write from England—where I will have more time to write. This Portrait is probably Rubens best. Henri

[*Card postmarked 20 Aug. 1907*]

The class has gone—I still continue painting kids and some grown people
Hope to get back from England by the 10th and spend a day or two in Amsterdam to do some street sketches before leaving for Paris. Am hoping not to get seasick as I shall cross from Ostende which is only 3½ hrs to Dover. shall visit Antwerp—Brussels. And London on flying trip.

<div align="right">H</div>

Mauritshuis - 's-Gravenhage.3

(handwritten text surrounding the image): time to write. This Portrait is perfectly Rubens best. Henri.

(handwritten at top): Write from home.

(handwritten right side): My address will remain Thos Cooke + Son Australtan Will

PETRUS PAULUS RUBENS. Portret van Isabella Brandt.

(handwritten at bottom): Aug. 19 1907 I am going to Halifax Yorkshire England for about ten days to do a portrait. shall go about the 28—

On steamer for Dover from
Ostende. Aug 26. 1907[1]

Dear Sloans: According to scedule I am just a little more than one hour from Dover—having had a very easy passage—the trip from Ostende to Dover is only three hours and a half—these trembly little boats—long & narrow—are very swift. Ostende was brilliant rich and gaudy—tremendous display of sporty people. brilliant hotels restaurants in which dined the latest fads and fashions—and all in the full extreme. Good sight for a short trip There is a magnificent Kursalel[2]—music Pavillion and

58. Henri, *Dutch Soldier,* 1907

gambling establishment. but the sight was the bathing beach this morning where it seemed to me it was cool enough for clothes—the bathers seemed warm enough tho' some of them were beautiful some fat but there was no doubt about any of them for they were draped less than the possibility of fraud—some were:

skin tight and others were

and others more modest like this

but to be fair to No 1 she was a beauty—and she was numerous—you would approve the garment John—one piece—union—skin tight but shorter at both ends than you wear them—shorter than in my drawing. The tremble of this boat and its slight hump is not in sympathy with the genius of drawing—They all, fat, fine and flabby enjoyed being looked at and to please them I should have liked your opera glasses—many of my fellow watchers did have them and used them at both close and long range. There was one star sylph[3]—long of back and fine of hips round and plump of legs, of a beautiful whiteness of skin that showed perhaps more by the slightness of her suit—she had all eyes for a time and many of our feet were wet by the unheeded encroaching tide. I expect to be in London tonight will have a quick look at the Nat. Gallery tomorrow morning and will be in Halifax Yorkshire in the evening. There I am to paint the portrait of the wife of ex mayor etc etc—she being sister of Miss Fisher. I believe I have written of this before. I ought to get on well with it for I have had a steady practice now for a long time. Yesterday I was in Bruges (Misses Niles and Pope came as far as Ostende with me). Bruges is not half as good as you drew it. In fact the place is for water color and German sketch book artists—as Miss Pope said for those who love moss and vine grown ruins—Why the place has such a reputation save for a few fine pieces of architecture in church and town hall—I can't see.

At Brussels things seemed rather dead for a "Northern Paris" but we managed to see some good pictures. Among the best—and the most to my interest Hals great portrait of a Professor of Leiden[4]—you know it by reproduction. We went to a fine variety show in a handsome big hall—It

would make Keith & Proctor[5] ashamed of their bills. There was an unfortunate accident at the end—flying trapeeze stunt—they were preparing the net and one of the helpers was running with a rope to the corner of the net when the corner hook slipped and the poor fellow went headlong. He fell on his head among the seats. He was covered with blood and looked dead when they carried him out—next day it was said he was not fatally injured—the show went on. In Antwerp we visited the museums.—I see a fine ship out there—I shall return to Amsterdam when I finish in England—expect to work there two or three days—and then to Paris sailing, as I believe I have told you, from Boulogne via Potsdam. Holland-American Line—Sept. 28 to land in Ny. about 6th or 7th Oct. I am sorry the berth was so hard to get for I should have liked to sail early enough to save you your job of moving. I wanted to get back soon enough to relieve you of the task you have been so good to take on for me. I consider that this trip has been a valuable one—altho I bring home no large imposing canvases. Most of them about 22 x 26. But among them there are good ones and the study has been excellent.

They are nearly all heads—I am sorry I have not had more time to do some street pictures or landscapes. Of course in England I will have my hands full with the portrait altho I am told the landscape in that part is fine—large, sinister Scotch-like they say

My address will be still Thos. Cook & Son Amsterdam. Hope you are both happy. Yours

Henri

P.S.—I have just landed in Dover rushed through the customs with an opening and a closing—and am on the train for London—long seats in red plush figure against the windows and a sort of narrow table down the middle a uniformed young man rushed in "Will you have a basket sir." I didnt seem to know altho' others wanted baskets. "Will you have a cup of tea?" I said Yes and I got a large square basket with a zinc pan—when I raised the lid—divided to hold tea hot and bread, raisin cake sugar and cups & saucers all very good and sold by a big Hotel company—the Gordon Hotels—It cost a shilling

1 From a typed transcription.
2 Kursäal is a public room for guests.
3 A graceful, slender girl or woman.
4 Probably the Hals portrait of Johannes Hornbeek, a professor of theology at Leiden University beginning in 1654.
5 Two New York theaters.

Halifax Eng Sept 2, 1907

Dear Sloans—

Here I am in Halifax Yorkshire England pretty well up on the map of England and in a great moorland wh was once covered by the sherwood forrest where Robin Hood held forth—they have his grave about four miles from here—the grave to which he shot the arrow—at any rate he was buried somewhere near if not just 4 miles for these were his haunts. The moors are covered with heather and there is grouse in them—we ate a beautiful brace of them today. My portrait is progressing well having worked three days on it—my sitter Mrs Smith[1] being fine to paint and in a dress most paintable She an American—sister of Miss Fisher and wife of possibly the most prominent man in Halifax—He seems to be head of most everything and is ex-mayor. The work is being done in a studio we were able to get at the School of Technic (This is a big place about 150000 inhabitants) a most excellent studio

This afternoon I took a long walk over a moor with Miss Fisher (yesterday, Saturday, after work we took a drive and saw much of what is a rarely fine, severe country with rolling half mountains and many valleys, houses of stone grimly solid, and pasturelands mapped out between velvety brown colored stone fences. the green is deep solid and yet brilliant in the foreground and mist—maybe smoke from the great factorys veiling the beyond trees dark and solid in color—The house where Laurence Sterne wrote the Sentimental Journey looks as if it had not been used for fifty years but has only been deserted two years by a woman writer who lived there with her books until she went crazy and had to be taken to an insane asylum I wish I had had time or material to show what a splendid old place it is—They say it has a ghost—a little man with a black top hat—I looked in at dusk after having climbed into the garden—grown wild—but did not see him nor any material trace of the man who was so long being born—I could not get in but put an arm in a hole in a window to have that much of me at least visit the home of the great master of English humor and the way of expressing it. I will tell you more of the portrait when it is done. I have to pay the Bryant Park[2] for Aug and Sept and will send them a check as soon as I get back to my trunk in Amsterdam where I left my check book. I shall be there in about 7 days. Address me Thos Cook & Son Paris, France.

Henri

I enclose a touch of heather.

[1] Mrs. George H. Smith was the wife of the former Lord Mayor of Halifax.
[2] This refers to rent for his studio in the Beaux Arts building, which he planned to vacate by October 1.

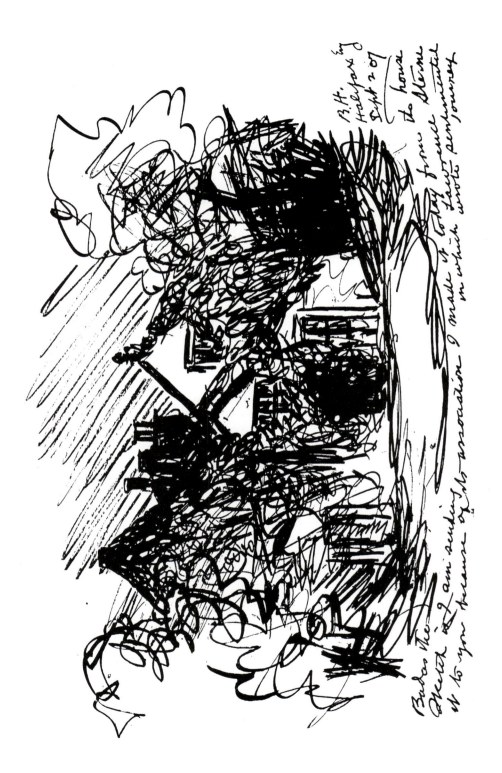

B.H.
Halifax N.S.
Sept 2 07

the horse
station

Below the
Sketch as I am sending
it to you because of the association I made it to fifty times from
in which wrote permanent
journey

Old Moot Hall, Hx.

Halifax England—
Sept 2 1907

I am enjoying much my trip to Halifax. It is a beautiful severe country.
Moor lands—very strong solid color, largness and extreme simplicity of
landscape. Houses very solid—stone You know this is the land of Robin
Hood—the Sherwood Forrest

yours H.

Halifax Yorkshire Eng Sept 2 1907

The Rocks, Halifax. *view of the moorlands H.*

RELIABLE SERIES

165 W. 23 Sep 5/07

Dear Henri:—

Tis near time that I should write for you have written and postcarded me several times—but I've been distracted Dolly and I spent two weeks in Fort Washington and came home on the 15th August, we were home ten day when received word that Mother was much worse—unconscious—we hurried back and after two terrible days of watching Mother died—still unconscious

This is my first experience of the great end of all of us—and it was a tremendously impressive thing in my life

My uncle, my cousin, Malcolm Stewart (you remember him the fine fellow) and I carried her with black gloves by nickeled handles to the hole on the hillside at St Thomas's Church cemetary Whitemarsh where her body now lies and will lie under 8 feet of yellow earth to be sometimes soaked with rain sometimes topped with snow sometimes grass

She suffered for fully twelve years I am glad to hear that you have the portrait of the mayor of Halifax to paint and know that you'll turn out a good thing for "His Honor" (and yours)

I fear that you will not find that I have produced much this summer, my "Spring sprint" left me and then my first and second visits home upset things

I called on Tonetti today but he was out so have just written to him to find out when Low[1] is entirely out of the studio when I will at once attend to your moving—You must not feel that you are putting me to any trouble in this matter for it is a great pleasure to me and to Dolly too, for she's going to have cleaning done you know—

The August "Studio" reproduces the full length Red haired girl in white of yours in an article on Worcester Art Museum[2]

The Pittsburgh "Index" Aug 31st expatiates at length on the new instructor for the Pittsburgh Art Students League[3]—a portrait of him and reproductions of two of his paintings—he winces with apprehension as the time draws near for his first appearance He wonders what his "policy" should be and whether he should have any (save perhaps an "accident" 880 miles each week by express hurtling thro' the night)

Think of it in two months I shall have travelled much more than the distance across the Atlantic and back

Which reminds me—I was charmed by your description of the Ostend bathing costumes tho' I have on one or two occasions seen ladies bathing in the rear rooms on 22nd St with much scantier clothes.

The magazines have left me quite severely alone this summer, one story for the Sunday Magazine and one from Munseys are all that have troubled my rest.

If you go to Paris dont forget to remind Morrice that he promised me a sketch Hope you enjoy your stay in England and have a pleasant voyage home to your new quarters which we will try to have in shape not "ship shape" for that might bring back your mal de mer.

Mrs Sloans best wishes and my own

Yours
John Sloan

Halifax to which many are consigned

Mercy!!—"The quality of mercy is not strained it droppeth as the gentle rain from Heaven—SHAKS[4]

[1] Will H. Low, whose studio at 135 East Fortieth Street would be occupied by Henri beginning later in the month.
[2] Henri's full-length painting, *Girl in White*, appeared on page LI of *The International Studio*.
[3] Sloan taught there for one semester beginning in October 1907.
[4] William Shakespeare.

On train from Halifax
to London Sept 6, 07

Dear Sloans:

The portrait is finished—has been approved a great success unanimously by all the family and now I am on my way to London—will have this (Saturday) night there. Go to Dover tomorrow, cross channel to Calais—as Lawrence Sterne whose house I have visited from top to bottom since writing you—did. Tomorrow night I will spend in Brussels—and next day will be in Amsterdam where I shall stay about two or 3 days—then to Paris. just as soon as I arrive in Amsterdam I will send to the Bryant park the amt due for Aug & Sep. so that all will be paid before you move me. I shall feel pretty guilty when the time comes for the moving to be having a good time when you are doing that annoying work—but

come to think of it I may not be having a good time—for I shall probably be at sea and if not very sea sick will at least be as I usually am—very doubtful In the exploration of L Sterne's house I failed to find a famed cealed chamber which subsequent tenants have been said never to open. I did find besides the cheerful and roman- tic rooms other rooms without windows or any sign of light source in them—and I did not see the ghost of the little man in the black hat—I shd have liked to have caught his likeness for an illustration to this letter. Nor have I seen the slender lady in gray who is said also to walk about the halls of "the Gleddings" look- ing and looking—with a white mantilla drawn about her head on the contrary I have had a most lively and cheerful 10 days at the Gleddings. They have done everything to help me in the work and have been splendid in their appreciation

of it. Had a grand celebration at its completion. I have taken trips afoot with Miss Fisher over the moors and to Old Halls of many gables and windows—looked at the house Defoe wrote Robinson Crusoe in visited families who live in old mansions still with battlements and remnants of feudal times—some of the people have a kind of antiquity seeing that they are decendants of long lines living in the same houses—We drove yesterday to the home of Charlotte Bronte—Haworth where we were met by one such descendant of an old family—Patrick Bronte the father lived long but his talented family were of short life Charlotte the longest of life was 39—Branwell the brother took to drink—one goes to the Black Bull Inn where he took his drink and where his 3 cornered comfortable chair is still in its corner—one can see that he was gifted with the powers of an entertainer from the very placing of the chair and in the museum of Bronte relics of drawings, sketches and scribblings that show he might have made a good artist The sisters—Charlotte and the others drew and painted things too but theirs were more orderly and I just looked out the window and saw

altho otherwise the landscape resembles Constable more than Pennsylvania.—excuse me—more orderly and more like lessons in art. Our host was a country gentleman—a bachelor who lives with a brother—fine fellows—at their beautiful house overlooking the valley and miles & miles of moorlands we had tea—they are always taking tea and there met a cousin of theirs a little old man who chuckled and looked like a jovial frog. He had been the pupil of medicine of the Dr who attended Charlotte B in her last illness. As we crossed at dusk the great moor a grouse fluttered from the heather and I had memorys of the wild and lonely west. The valleys are filled with villages of factorys and the homes of factory people it is a country of industry, grim severe and filled with hardy romance.

 Besides the pleasure of having done a very successful portrait of a most interesting woman I am mighty glad to have seen this Yorkshire and to know England here where the tourist does not wend his destroying way

<div style="text-align:center">Yours
Henri</div>

<div style="text-align:center">Expect to arrive tomorrow Thursday 12th at 10.45 PM. Henri</div>

Despite Henri's aspiration to garner a growing number of portrait commissions, he was equally comfortable painting non-paying sitters chosen from the populous at large. On Christmas Day 1907, for example, he posed a fourteen-year-old African-American girl named Eva Green, his janitor's daughter. Due to the youngster's joyful countenance, Henri initially titled the canvas Negro Girl Smiling *(Henri record book).*

On 5 January 1908, just a month prior to the opening of The Eight exhibition, Henri left for Wilkes-Barre, Penn., where he was to paint a portrait. During the ensuing weeks he alternated between Pennsylvania and New York, where he returned to teach his art classes. The portrait commission, which should have required a matter of days, dragged on because Henri ultimately painted three likenesses, the final canvas not begun until 27 January, only seven days before the exhibition was slated to open.

On the Train
Jan. 12 1908

Dear Dolly

I HAVE JUST THOUGHT OF THE ACADEMY INVITATION—I FORGOT ALL ABOUT IT—BUT BY MY GOING SO I SHALL HAVE THE PLEASURE AND THE HONOR OF YOUR VISIT ON THURSDAY (AFTER 3)

As a matter of explanation perhaps I had better let you know that the reason for the sheer beauty of the other lines of this letter[1] comes—never mind, the train just jogged my last idea out of my head and I don't know what the sheer beauty comes from

Yours Ever

I am having
good time.

[1] Capitalized lines represent lines that were written large. The large and small lines of text alternate on the page.

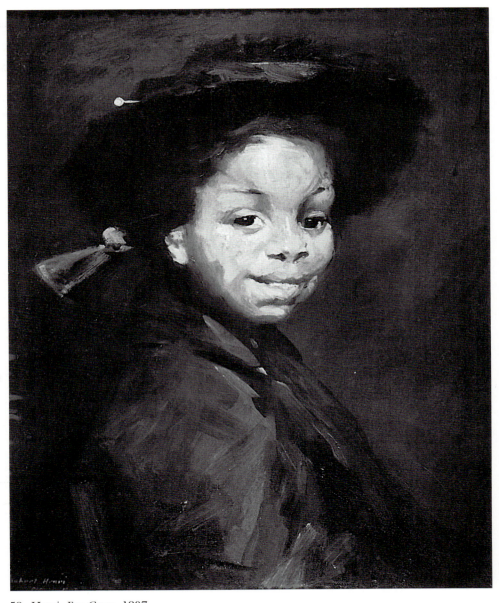

59. Henri, *Eva Green*, 1907

Wilkes-Barre Jan 24 1908[1]

Dear Sloan: I shall be back at latest Friday night.[2] It may be that I cannot make it before then as I must get this second portrait done this week if possible. It must be done while I can get my sittings If anything turns up address me as above I went to the Grand Opera House again tonight this time it was the Russell Bros a musical farce—not serious enough to be really funny but there was a fight in the gallery (packed) that looked for a while as if half the gallery would tumble down into the pit—and I saw a man get handcuffs snapped for trying to throw another man under a trolly car today—exciting!

Yours
Henri

Hope Dolly is better.[3]

[1] Letterhead is Wyoming Valley Hotel, Wilkes-Barre, Pa.
[2] January 31.
[3] Sloan noted in his diary on 21 January 1908: "Dolly is going to stay in bed as she is not very well."

Wyoming Valley Hotel
Wilkes-Barre Jan 27 1908[1]

Dear Sloan:

I cant get back—Expect to finish the new portrait of Mr. Smith tomorrow morning—practically done now—its a good one and will commence a portrait of M[rs] Smith at once—I fortunately brought with me an extra canvas. I may not get back until Saturday[2] am not sure

Have written to Sch[ool] and you will hear from them by letter or when you call them up on Wednesday morning.

I will write again.

Yours
Henri

¹ Letterhead is Wyoming Valley Hotel, Wilkes-Barre, Pa.
² February 1.

<div align="right">Jan 29 1908¹</div>

Dear Sloan

Hope you got thro' today without getting too tired of the job for I expect that I will not be able to get back tomorrow night for Friday I am getting along well with my portrait of Mʳˢ Smith—The second portrait of Mʳ Smith is finished—but Mʳˢ Smith cannot pose more than two hours a day and that prolongs matters—she is a good sitter though and I am hoping to get a very good thing of her If anything should turn up that I return tomorrow night I will come in "as I am passing through your town" to let you know of my presence.

It is not particularly gay here when there is no work going on—I had a very good dinner and pleasant evening at the Smiths tho'—today—and I feel that I am missing some of the fun of our exhibition in being away

<div align="right">Yours
Henri</div>

¹ Letterhead is Wyoming Valley Hotel, Wilkes-Barre, Pa.

<div align="right">Thursday, P.M.
[30 Jan. 1908; undated]</div>

Dear Henri:

Your letter just received—Yes I got thro' yesterday at the School all right and wont mind Friday at all so dont bother about that—but how about sending your pictures to Macbeth? He would like to have them there by Saturday noon if possible.

I have written to all the others to send their stuff by that time making no arrangement for them with the A.P.& S.Co¹ as I think they had better foot their own separate bills in this matter

The additional assesment for each man will be about $30.80 if there are no sales and no additional catalogues printed which is better than our calculation of $45.

I am counting on six frames from you then will only have one <u>framed</u> canvas to send from here.

You see that I <u>can't order</u> the A.P.S.Co to collect my frames and your pictures, not knowing when you will be there to let them in

If you solve this thing for both of us in your own mind or have thought

of it—all right Ill just rest quiet—unless I hear from you in the matter
Our best felicitations

Yrs
John Sloan

[1] Artists' Packing and Shipping Co.

Henri returned just two days prior to the opening of The Eight. He perused the exhibition catalogue at Sloan's studio, then expressed disapproval at the way his work appeared in it. Sloan, upset by Henri's seeming lack of appreciation for work done, confided in the pages of his diary: "Henri is very much disappointed with the reproduction of his painting in the catalogue and it is not very good— but as usual in these affairs, one or two do the work and the rest criticize" (Sloan diary, 31 Jan. 1908).

The Eight created a sensation, with Macbeth's packed by gallery-goers from morning until night. Seven works were sold, including four to Gertrude Vanderbilt Whitney.

A travelling show of The Eight was held in Philadelphia in March, then was sent on to eight other cities beginning in the fall. The exhibition and the artists have become legend in the annals of American Art.

In June 1908 Henri left with an art class for Spain. One of those signed up for the trip had secretly become his wife the previous month.

Moltke
June 2 08[1]

Dear Sloans,
 Forgive silence but a bargain is a bargain & we agreed to keep silent. It was to prevent newspaper notice etc—and we agreed on absolute silence —You know perhaps the Journal and World Drawings of Marjorie Organ, so in a way you know who I have married.
 No more now as it is time for mail to get on.

R Henri

address
Thos Cook & Son
Madrid Spain
until Aug 15 or further notice.

[1] Letterhead is Hamburg-Amerika Linie.

60. Henri's diagram showing the placement of The Eight in their Macbeth Gallery exhibition, 1908

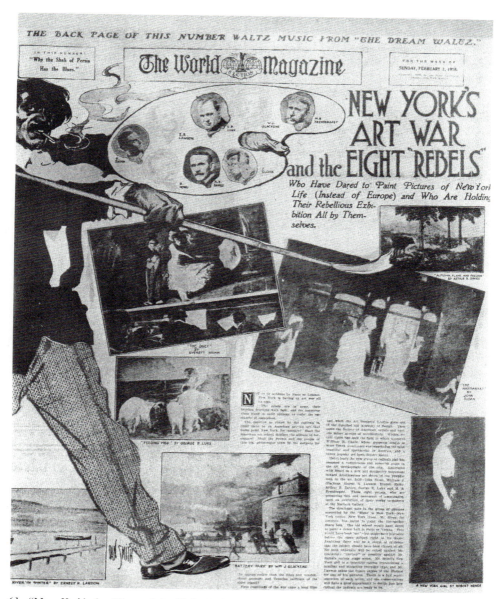

61. "New York's Art War and the Eight 'Rebels,'" *New York World*, Sunday magazine, 2 Feb. 1908

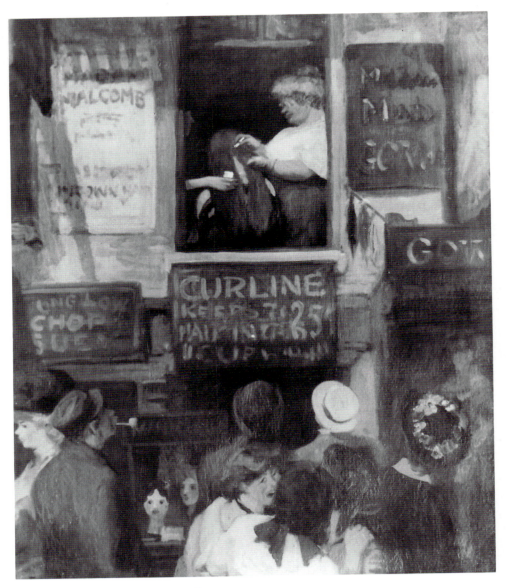

62. Sloan, *Hairdresser's Window*, 1907

63. Henri, *Martche in White Apron*, 1907

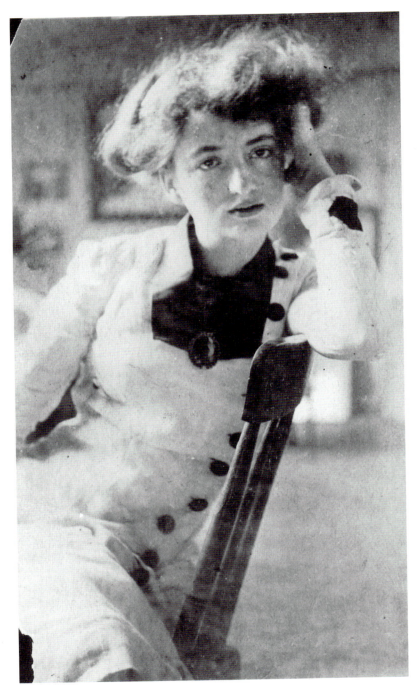

64. Marjorie Organ, ca. 1907

Cuevas de jitanos *all To the food.* *June 19. 1908* *Henri .* Granada
1905 Stengel & Co., Dresden 28529

165 W 23 N.Y. July 24 1908

Dear Henri:

Nothing but postcards from you so far. They are interesting tho, so keep on firing—but write once in a while. I might say the same to myself, yes that's so.

I suppose you received my postcard from Coytesville[1] on the Palisades. We stayed there nearly three weeks—then home to do 8 drawings for Scribners "The moonstone" (4) "New Magdalen" (4) for a cheap edition of Wilkie Collins works.

The latest information from Lichtenstein[2] in the West is that he has arranged for Chicago, a month—Toledo, a month, Detroit, a month, and Indianapolis. He will also if things come right fix it for Grand Rapids and Milwaukee, but he is waiting Cincinnati and Buffalo into line first, thus working back East with a view to a start in the West next year. He is certainly a brick the way he has taken hold for us. I made a number of 8 x 10 sketches while we were away and it was such a novelty to me to do outside work. Some of them are I think quite fair. The place is very interesting, no necessity to go far afield to find "motives"

No new excitement in the Third Term Puzzle.[3] Taft is nominated. Shinn was very sore over the Evening Sun's denial of the whole thing. I dont think it was necessary myself. I felt that since I had said "Go ahead" I had no right to kick

[183]

In arranging for your list in the coming 8 ex. I will make the prices conform in my judgement with those you had on last year at Macbeth's. Each man is to count on about 25 feet of running wall space. I will allow for no picture above the line—good spacing. We dont have to be exact in space calculations as these ex. are in City galleries and are capable of being stretched a bit. My own and Mrs. Sloan's best regards to Mrs. Henri and yourself—be happy.

<div style="text-align:center">

I am
Yours,
Sloan

</div>

¹ New Jersey. The Sloans stayed at a house where Joseph Laub and his wife were also summer boarders. The postcard sent from Sloan to Henri in Madrid has not been located.

² Carl B. Lichtenstein was the former manager of a book publisher who was entrusted with arranging The Eight travelling show because of his numerous museum contacts.

³ A toy created by Everett Shinn capitalizing on the uncertainty over whether Theodore Roosevelt would seek a third term as president. The question was answered when William Howard Taft was nominated at the Republican National Convention in June. In order to promote his puzzle, Shinn publicized the existence of a mythical "Theodore Roosevelt III Club" consisting of the artists in The Eight. "Artists Drop Work to Boom Roosevelt" announced the *New York Times* on 11 May 1908. The *New York Evening Sun* exposed the hoax in its May 29 edition.

BAYEN: BAILE Y MERIENDA EN EL PUENTE DEL CANAL

COLECCIÓN ROMO Y FÜSSEL.-TAPICES N. 1803

<div style="text-align:center">

[*Card postmarked 5 August 1908*]

[184]

</div>

Sept 3—1908[1]

Dear Sloans—

Just to dash off a line to you—The name on this paper does not count because we're in Madrid, and I haven't changed my style of hand writing, because this is Marjorie, who is doing the dashing off for me. Ive a letter from the Missus,[2] she told me of your getting pictures for the show, altho I did not get a very good idea of what you selected—Hope it was quality rather than quantity.

Too bad there was not more to select from, here the work I have done has been done lately or, rather is being done. So far of importance, full length of a Picador,[3] 3 full length dancers[4] A few small things—Had a cold for a while, and did little then, and the material was hard to get to start with. Will probably have the pictures in New York some time in November Some of them maybe before Will arrange for more rapid transit, than on the previous occasions We are enjoying the trip, and have had little time to write—class over now—excellent work—We will stay here some time yet—Have not fixed dates Was glad to get your letter and know that you'd been to the country, and that you had work on hand. Will write again—expect to have more time now that the class is over.

Best wishes to you both from us both—

Yours,
Robert Henri

[1] Letterhead is Hoteles Washington Irving, Alhambra, Granada.
[2] Henri's mother.
[3] *El Picador* (Antonio Banos, "Calero").
[4] *El Tango* (Manolita Maraquis), *Spanish Girl of Madrid*, and *Una Chula de Paseo* (A Pretty Girl Dancing).

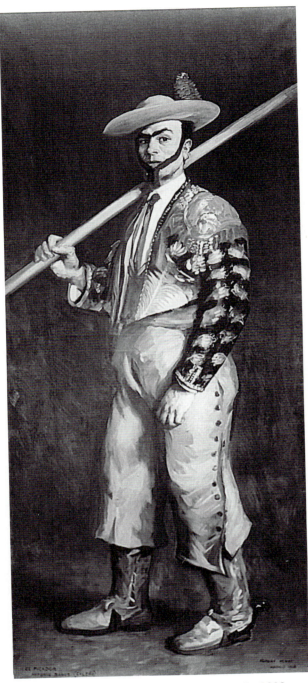

65. Henri, *El Picador* (Antonio Banos, "Calero"), 1908

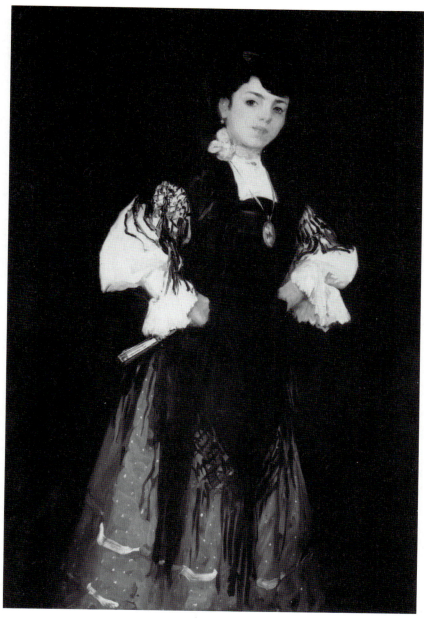

66. Henri, *Spanish Girl of Madrid* (Modiste), 1908

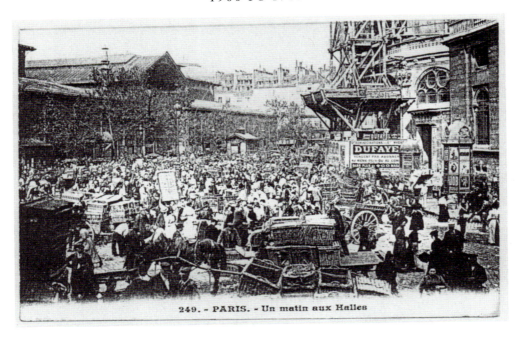

249. - PARIS. - Un matin aux Halles

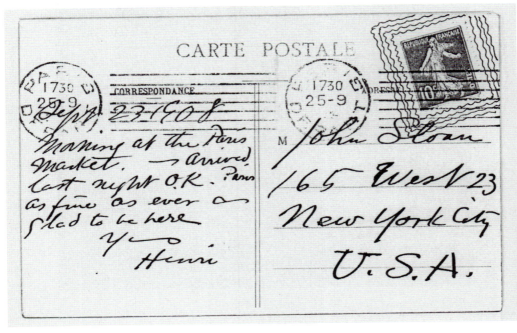

E. S. 139. BOULOGNE-sur-MER
Dame de la Halle et Pêcheuse de crevettes
Stévenard, édit., Boulogne sur-Mer

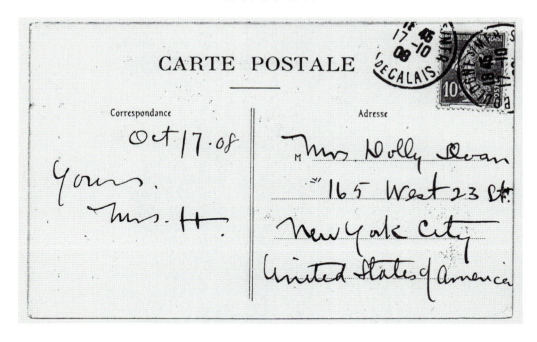

[*Card postmarked 17 Oct. 1908*]

We'll see you by the end of the month—

Yours
H
Oct 17 1908

[*From Dolly Sloan to Marjorie Henri*]

Philadelphia, 1909 [Jan.][1]

Dear Marjorie

I have been intending to write you ever since I reached Philadelphia but just did not seem to get to it. How are you? and how is "The Henri School of Art"? I hope it is booming and I am sure it is. Tell "Henri" that I met Mr. Grafly this morning and he told me to send his best wishes to him and Good Luck to the new school. Are you folks coming over to the Private View.[2] I expect to go and will write you both all about the show for I will also go and see the exhibition in the daytime and will send all of the newspaper notices that I can get hold of. I was told that this show is to be the

best ever. I went into the Art Club to see an exhibition by a man named "Gruppe". He had awfully nice frames and that is about all one can say about it and of course by the same token he had five marked sold.

Today is the first clear day we have had since I have been here. I am awfully homesick for you, Henri and John Sloan. I have been going to the doctor's every day taking treatments and I do not know whether today I am more nervous than usual or if I am worn out but I just felt as if I could sit down and cry for a week. I did indulge in a small fit of hysterics and feel a little better. Let me hear from you when you have time. Give my love to Miss Pope when you see her.

<div align="right">Love to the Henris, and John Sloan
from Dolly Sloan</div>

c/o F. J. Kerr
 1520 Arch St.

[1] From a typed transcription.
[2] The 104th Annual Exhibition at the Pennsylvania Academy, 31 Jan. to 14 March.

<div align="center">[From Marjorie Henri to Dolly Sloan]</div>

<div align="right">135 East 40 St.
Feb. 23, 1909</div>

Dear Mrs Sloan—

We dropped down in the hopes of seeing you last Thursday Eve, but you were not in, then Sunday night we found only Mr. Sloan and were quite disappointed. I imagined that you intended staying over for a week or so. Mr. Sloan says tho that you will be back for good in about 2 more weeks,—I hope you will the place seems very lonesome without you.

We were to dinner at Mrs Laubs last Friday Evening, and I stayed with her, until the boss,[1] and Mr. Laub returned from school I had a very pleasant evening—her sister, and Mr. Laubs sister were there visiting. Last Saturday evening we went to see "Salome"—second row in the orchestra —and Mary Garden is certainly it, and the Boss takes back every thing he ever said against her either as an actress or singer She's a wonder he says.

Mrs Laub, and Mrs Lee[2] want to be specially remembered to you, and were very sympathetic wanted to know if you looked badly and so on. I tell them no, that you never looked better than you did the night of the Academy opening, and its the truth.

Its been rather bad weather here mostly raining—However it doesn't seem to affect the bosses feelings, or good humour, for he's painting like everything on a portrait[3]—and its going to be an unusually fine thing—

He sends his regards and says to tell you that he'd write you a line himself only he's rushed to death—School[4] is still booming—Havent seen Miss Pope since that night we called on her I imagine she's out of town—Well good Bye, and I hope you'll be all thoroughly OK, by the 2 weeks.

<div style="text-align:center">Yours
Marjorie Henri</div>

[1] Robert Henri.

[2] Henri's mother.

[3] A full-length portrait of Mrs. William Rockwell Clarke.

[4] Henri left the New York School of Art in December 1908 in a dispute over $850 in salary owed him, and on 11 January opened the Henri School of Art in the Lincoln Arcade. By 23 February he was teaching portrait, life, and composition classes during the day and had just inaugurated an evening life class as well.

1910
TO
1919

The *Eight* was planned as a one-time event, for Henri and Sloan visualized a much larger group of independent artists banding together to exhibit. So when two of Henri's full-length canvases were rejected from the National Academy's 1910 Annual (one of which was a portrait of Marjorie), and Sloan's entries were also excluded, they spearheaded a large-scale Exhibition of Independent Artists.

The show was held in April 1910 in New York to coincide with the Academy's display, and 103 artists offered 631 paintings, drawings, and sculptures. The exhibition of so many unaffiliated artists was unique in its day, and some 2500 persons attended the opening. Following this triumph, Henri departed on his regular summer sojourn to Europe.

May 31, [19]10[1]

Dear Sloan

The rush was too much—was up last night till 3 and up at six—I needed a bath so took it—just up to my chin reserving my head for later—later never happened. Am aboard unwashed unshaved uncombed.—I got the Independents[2] clippings gathered together, got the photos but not sorted. Gave up the Independent clips and brought with me the photos tried to sort them with idea of sending them back with one of the many who were to see us off—but they were all snug in bed when we sailed and there was no one to send the photos back with. They go to europe!

We're down the pike now and will soon know what trouble is in store.

Yours
Henri

[1] Letterhead is T.S.S. "Ryndam," Holland-American Lines, Rotterdam.

[2] The Exhibition of Independent Artists, organized by Henri, Sloan, Arthur B. Davies, and Walt Kuhn, had been held 1–17 April in rented quarters at 29-31 West Thirty-fifth Street.

July 4 1910[1]

Dear Sloans:

We are here in Haarlem same place, same studio[2] and hard at work since the third day we came. practically nothing has happened except get up late go to work at about 11 or 12 quit an hour 3– to 4 then work until 7—8—8.30 It does not get really dark until about 9 o'clock and after that the sky holds a transparent deep blue that is beautiful—do not

know if this condition lasts later than 10.30 but it does till then and adds greatly to the beauty of the night street scenes. I have never heard this mentioned of Holland before but I suppose it has been—as of course its simply the result of the country being so far north. Miss Lauter and Miss Elmendorf[3] turned up here about 2 wks ago and last sunday we went to Volendam to visit them. Miss L. stays on. Miss E has already started for Germany—then Paris—and N.Y. Miss Niles is here. Randal Davy[4] also. One of the night class men Speicher[5] passed through here a few days ago with his bride. Its cold enough always for heavy clothes, but not too cold for flees and sometimes I have been frantic—I say I for I am the great flee sufferer[6]

[1] Letterhead is Hotel "De Leeuwerik," Haarlem.
[2] The Henris had occupied the same place two years before. He also painted one of the same models, Cori Peterson.
[3] Flora Lauter and Stella Elmendorf were students of Henri's in New York.
[4] Davey was a Henri student at his school in Manhattan.
[5] Eugene Speicher (1883–1962) was also a Henri student in New York.
[6] This letter from Henri is incomplete.

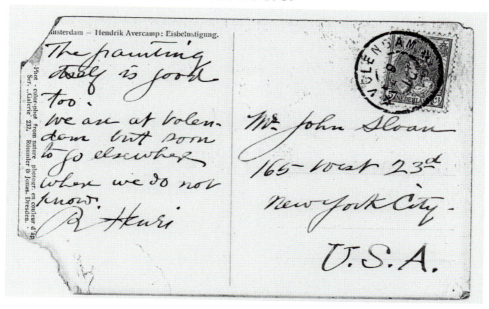

The painting itself is good too. We are at Volendam but soon to go elsewhere where we do not know. R. Henri

Amsterdam — Hendrik Avercamp: Eisbelustigung.

Phot - color-phot - from nature photogr. en couleur d'ap. Ser. „Galerie" 232. Römmler & Jonas. Dresden.

Mr John Sloan
165 west 23d
New York City.
U.S.A.

[*Card postmarked 8 July 1910*]

July 29 1910

Dear Sloan:

I found the enclosed in a bundle of stuff—thought I had finished and sent it.[1] We had a good seasons work at Haarlem now at Volendam "picture place" regular "charmingly interesting artists resort" but the sky is here anyway and we are getting some sea Zuider Zeee air and better food, dont know yet how long we will stay Have met here a lady of your Pittsburg class Mrs Sanders or Summers or something like that—said you were fine but too too severe—I said it was the truth that hurt. Carnegie[2] has bought my full length Jap in riding costume[3]—Helen Niles and Davy are here with us. M.[4] has made a lot of drawings that will interest you

Yours
Henri

c/o Thos Cook & Son
 Amsterdam
 Holland

[1] Henri may be referring to the unfinished letter of 4 July 1910.
[2] Carnegie Institute in Pittsburgh.
[3] *The Equestrian*, 1909, for which Miss Waki Kaji was the model.
[4] Marjorie Henri (1886–1930) was a cartoonist and comic strip artist for the *New York Journal* and had studied with Henri before their marriage.

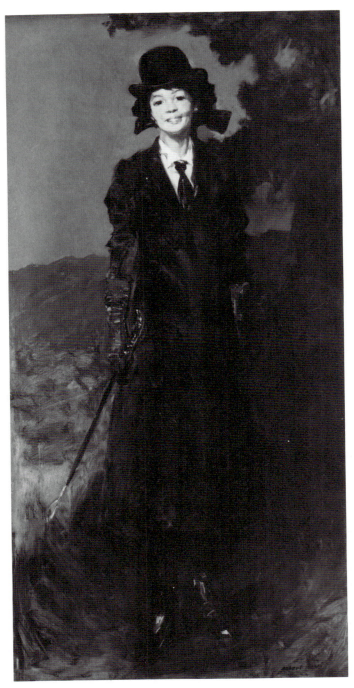

67. Henri, *The Equestrian* (Miss Waki Kaji), 1909

68. Henri, *Volendam Street Scene,* 1910

<div align="right">July 30 [1910]</div>

This is the boat that brings us from Edam to Volendam. Your papers of the fight were the first that we saw and they were most desired.[1] What we knew we had got in fragments from one dutch paper Have done a lot of work at Haarlem came here a few days ago. will stay for a short or long time according to the way things go

<div align="center">Yours,
Henri</div>

[1] The Jack Johnson – Jim Jeffries heavyweight fight on 4 July. Johnson won in fifteen rounds.

VELÁZQUEZ 1087.—MUSEO DEL PRADO

Retrato de una niña.

[From Marjorie Henri to Dolly Sloan]

Oct 31—1910

Dear Mrs. [Sloan]—

We're here in Spain painting gypsies.[1] I was very glad to get your letter telling me the news. its certainly very sad about Bell[2] Give our best regard to the Pettepaws crowd[3]—and dont forget us yourselves.

Yours Marjorie

[1] Henri's canvases included *Blind Gypsy Woman, Consuella—Gypsy Girl* and *Gypsy Girl "Pura."* The models were from the gypsy settlement near Toledo Bridge in Madrid.

[2] Eric Bell, an aspiring writer, had just been diagnosed as having tuberculosis.

[3] The Petitpas was a boardinghouse on West Twenty-ninth Street, whose residents in-

cluded the Irish artist John Butler Yeats (1839–1922). Sloan's painting, *Yeats at Petitpas*, 1910, also includes fiction writer Robert Sneddon; Fred King, an editor of *Literary Digest*; Eulabee Dix, a miniature painter and Henri model; and Mrs. Charles Johnston, the Russian niece of theosophist Madame Helena Blavatsky.

Henri and Sloan met the Anglo-Irish artist John Butler Yeats when he came to New York in 1909 on a lecture tour. Yeats decided to remain. The men enjoyed each other's company, and Yeats proclaimed Henri to be "the best painter in America" (William M. Murphy, Prodigal Father: The Life of John Butler Yeats, *Ithaca, N.Y., 1978, p. 360) and said of Sloan that of all the contemporary American artists, he was the one whose work was most likely to last. (Van Wyck Brooks,* John Sloan: A Painter's Life, *New York, p. 106).*

For his part, Henri labeled Yeats "the greatest British artist of the Victorian era" (Murphy, Prodigal Father, *p. 413), and Sloan declared that he "painted the best British portraits of the Nineteenth Century" (John Sloan,* Gist of Art, *New York, p. 105).*

Henri produced a quick drawing of the three men together in October 1909, then an oil after a Yeats lecture in his studio the following December. Sloan painted an oil of Yeats and Henri the next month, then began work on his famous Yeats at Petitpas' *in August 1910.*

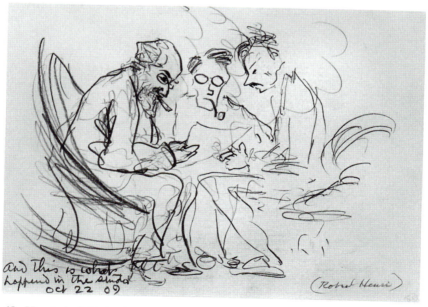

69. Henri, *And this is what happened in the studio, Oct 22, 09* (John Butler Yeats, Sloan, and Henri), 1909

70. Henri, *Portrait of John Butler Yeats*, 1909

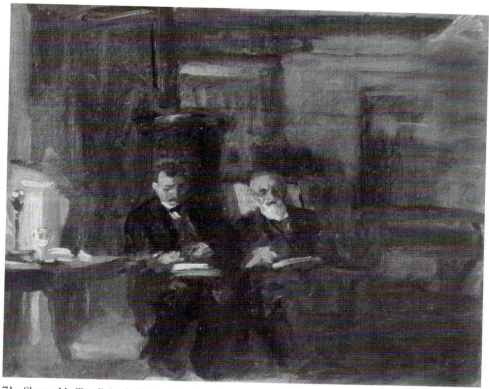

71. Sloan, *My Two Friends, Robert Henri and John Butler Yeats,* 1910

[March 1911; undated]

Dear Sloan

Davies[1] came in this evg. and we talked about the ex[hibition] matter[2] —he said he saw a rough draft of letter but that its impression was that K[3] acknowledged mistake regarding Academy restriction[4]—but of course there was no means of comparison having neither letter at hand draft or original I dont think there is any thing more to be said on the matter from my side I told D[5] that the letter was impertinent & one I could not take the time nor that I would care to answer. D is going to exhibit[6] says he has confidence in Kent, etc, thinks in my regard that Kents action has only been foolish youth action.—How different this would look to D were the action towards him instead of me. However I am out of the exhibition entirely unless Kent comes to me and makes satisfactory explanation of his letter and shows that all will be conducted in a sensible and fair way with

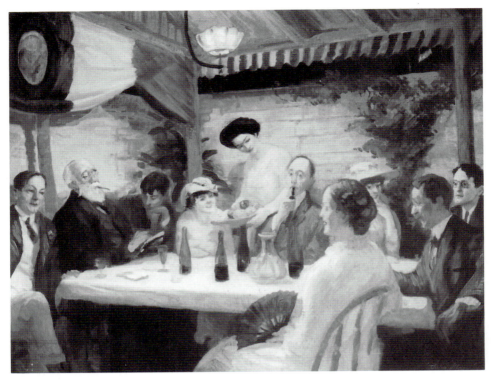

72. Sloan, *Yeats at Petitpas'*, 1910

the hanging etc to be done in some way that will be satisfactory method to all.

Hold letter until I call for it.

<div align="right">

Yours
Henri

</div>

1 Arthur B. Davies was a member of The Eight who helped promote the 1910 and 1911 Independent exhibitions.

2 The proposed 1911 Independent Show.

3 Rockwell Kent (1882–1971) was a former Henri student who was organizing the exhibition with financial backing and moral support from Davies.

4 Kent's condition for inclusion in the exhibition involved participants agreeing not to submit their paintings to the National Academy of Design annual.

5 Davies.

6 Although Davies' name does not appear on the catalogue cover and none of his works is listed inside, Kent verified, years later, that "Davies definitely did show pictures . . . I was in error in my book [*It's Me, Oh Lord*, N.Y., 1955] in not listing Davies as one of the exhibitors" (letter from Rockwell Kent to the author, 22 Sept. 1956).

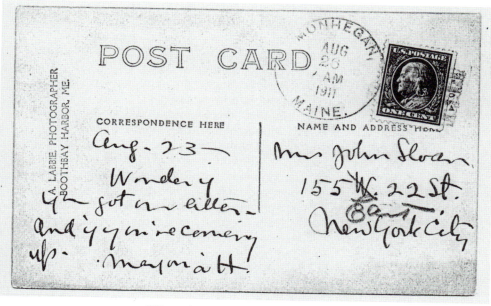

[View of Monhegan Island, Maine][1]

[1] Henri, who had gone to Monhegan Island with Marjorie earlier in the month, was joined there by George Bellows (1882–1925) and Randall Davey (1887–1964), two of his students.

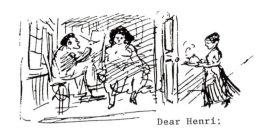

Dear Henri:

N.Y.C. Sep 1st 1911
155 E. 22nd st.

Dear Henri:

I have both your notes on how to get to Monhegan and the letters asking why we didnt let you know whether we had decided to come, but I'm out of the habit of writing so put if off—Tho' we have decided that it will be too expensive for us, costing nearly $100. for two weeks.

E. W. Davis looked us up and has asked us to spend a few days with them at Belmar N.J. on the coast and we have accepted, starting Monday—he says that Stuart[1] is doing some fine things down there. We had D.[2] to dinner and he was very interesting and worth while as usual.

I have been painting some during the last week got a Bowery wet night thing that I think is a good one tho' its shy on pink and blue,[3] and goes to my private stock, of course.

Painted two or three times from Stein, but while I had a good time with the struggle I've got nothing as yet

Last Sat. evening the good Roberts[4] took us to Mouquin's[5] to dine and we enjoyed a nice evening with them.

I'm still working sporadically on the drawing for Gaboriau[6] novels finishing the last volume now, and I'll be glad to get thro' the work and will of course worry if more dont turn up soon.

I wonder how you find the Maratta palette[7] in outdoor sketching practice on Monhegan and am looking forward to seeing the large sketch size things you are making.

We heard from Mrs Laub about two weeks ago she said that Joe had been home again for some days, very sick but coming around better—have not heard since how he is.

Wonder if you have had the Eight days of rain on Monhegan as we have

just had here, a dismal series it was—with the last two days steady down-pour till you'd wonder where all the water came from

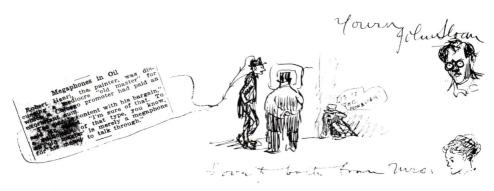

[1] Stuart Davis (1894–1964), a pupil of Henri's was the son of Edward W. Davis, art editor of *The Press* in Philadelphia.

[2] Edward Davis.

[3] *Wet Night on the Bowery*, showing the Third Avenue elevated.

[4] William and Mary Fanton Roberts (1871–1956); she was managing editor of *The Craftsman* and wrote under the pen name Giles Edgerton.

[5] A restaurant popular with artists and writers.

[6] Emile Gaboriau, the father of the French detective novel.

[7] A palette of ready-mixed pigments developed by Hardesty G. Maratta, a Chicago artist. It was comprised of twenty-four hues, with each one shaded from its most intense to least intense variation.

<div align="right">

10 Gramercy Park
Dec 24 1911

</div>

Dear Sloan

Merry Christmas to you and a hope that the family is a very big one and that they will keep you at work way into the New Year[1]—Dont get in a hurry to come back but do the portraits of all Omaha if they want you It will be good for them and good for you too So heres hoping that <u>work</u> will delay our seeing you soon. If there is anything you want here—(that is I am thinking you may run out of something command me.) If you send to Rabinowitz[2] for anything you might do well to send word of the same to me so that I can hurry him up or explain if he is in doubt you know we had many delays when we were at Monhegan

Heres Luck to you and again

<div align="right">

Merry Christmas!
from us both
Yours
Henri

</div>

¹ Sloan had received his first portrait commission, to paint a Nebraska brewer named Gottlieb Storz. Sloan subsequently produced a likeness of Mrs. Storz as well, keeping him in Omaha until mid-January 1912.

² Henri's paint dealer.

Dec 29, 1911

Dear Sloan

I'll bet you are doing better than you think—you demand so much more of yourself than a professional portrait painter demands of himself and so your road is a hard one to travel. I think I know all the troubles you have had—for your letters describe the situations of mind I have so often been in over a portrait. If by the time this reaches you you have not already landed with the portrait of the lady[1] and you are still in the wrangle over it—holding on to one thing while you reach for another—you might do a good thing by laying off your sitter for a day—and have a private go—taking up a new canvas and laying it in just like the old with whatever composition changes you might think advisable—virtually a fresh copy of the one in hand.

Its a job to do but I think you might in the doing of it find out just what is the matter.

The reason one picture does not go as well as another is because there is "something the matter"—some out-of-relation thing which perhaps for imitation sake you hold on to.

As for your sitters having such good faith in M^{rs} Finch's judgment[2]— they are bright for once—for they have an honest man instead of a confidence man, a real artist instead of a Julian academician,[3] a man of wit instead of a mut trying his level best to do the thing worth while—and whatever he does will be worth while

Things are still at a standstill as to the group[4]—have not yet the extra man but dont let that bother it is still time and I expect to see a lot of the people inside a week—Glack and the others and will probably get them to suggest someone will see Luks & Davies and will let them open the matter if they like. The thing that bothers me about it is that it looks to me very unwise for me to exhibit (on acc[ount] of the previous exhibition)[5] because there is a big fight afoot against the idea. Hoeber,[6] Amer[ican] Art News fighting hard (pointing towards virtues of Academy) None of the others seeing the drift and none of our own tongue tied waiters for the safe turn saying a word. so I fear that they may misrepresent my second appearance. It would be very easy to quote the "no twice in same season" clause and overlook the facts of that first group being a makeshift to fill the space vacated.

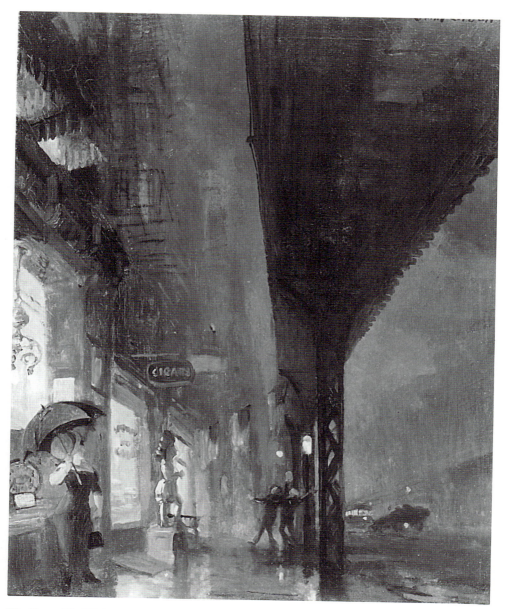

73. Sloan, *Wet Night on Broadway*, 1911

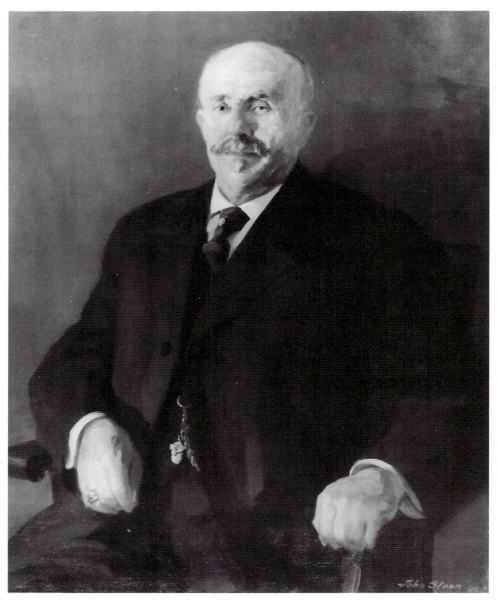

74. Sloan, *Mr. Gottlieb Storz,* 1911

However we shall have to see how that will arrange itself—I think however if you others will agree to my putting someone else in my place I will withdraw if I can find the one to put in What do you think?

Don't hurry—I say this because I imagine you would like to be back on the old stamping ground—but this is an important job and worth sticking at until you are satisfied—it may—it can result in your getting a whole series of portraits in Omaha or the west and that wd be worth while—and you would soon get so that it would not be such a strain—you are in an unusual field now and it would soon become as easy to you as making a drawing for an editor.

So dont hurry and dont leave the field until everything has been done that is to be done for the present or the future prospects

About the McD[7] of course I can attend to the business of that and your stuff—if you dont get back in time.[8]

<div align="right">Yours
Henri</div>

[1] The troublesome portrait was of Mrs. Storz; Sloan had completed her husband's likeness to his satisfaction.

[2] Jessica G. Finch, who ran a finishing school in New York. It was she who recommended to Gottlieb Storz that Sloan paint his portrait.

[3] Although Henri once prided himself on having studied at the Académie Julian, he now looked upon that training as academic and conservative.

[4] A group exhibit at the MacDowell Club of New York. Henri had been instrumental in having the club initiate jury-free, artist-organized exhibitions beginning in November 1911. Sloan was designated to invite the participating artists for a subsequent show, but Davies, Luks, Prendergast, and Walt Kuhn (1877–1944) all declined his offer. Although the "extra man" was eventually added, this gave evidence that The Eight were unalterably divided into two camps.

[5] Henri's paintings had been included in the inaugural exhibition the previous month.

[6] Arthur Hoeber, art critic for the New York *Commercial Advertiser*.

[7] MacDowell Club exhibit.

[8] Henri's offer to locate an "extra man" in the event that Sloan's return from Omaha was delayed.

Henri spent the summer of 1912 with an art class in Spain and returned to New York in October, when he was welcomed to Sloan's new studio at 35 Sixth Avenue.

11/13/12

Dear Henri's

*We surely will be in
and right glad to welcome
you to Greenwich Village
Tomorrow (Thursday)
Yours Sloan*

STUDIO
LARGEST
HOUSE
IN
GREENWICH

HOME
SMALLEST

A new art organization, the Association of American Painters and Sculptors, was founded in December 1911. Henri and Sloan were numbered among its twenty-five artist-members, and like most of them, concurred with the Association's goal of holding exhibitions of the best contemporary examples of American and foreign art. While Henri, Sloan, and others assumed that the emphasis would be on U.S. artists, the organization's president, Arthur B. Davies, had other ideas, preferring to assemble a collection that featured the European avant-garde.

The result was the 1913 Armory Show, held at the 69th Regiment Armory, where Marcel Duchamp's cubist Nude Descending a Staircase *and Matisse's* Blue Nude *typified styles of art virtually unseen and unknown in this country. Henri, having spent his summers in Holland and Spain, had been unintentionally shielded from the most advanced art being produced and shown in Paris, and he failed to expose his associates and students to such modern art.*

The Armory Show represented the shock of the new for American artists, superseding Henri's leadership. In a word, he had been dethroned. Symbolically, at the Independent School of Art, the former Henri school, students toasted him with the words: "The King is dead; long live the King" (author's conversation with Emil Holzhauer, 2 April 1978).

Henri's disillusionment and sense of embarrassment led him to cancel plans for a summer in Woodstock, New York, and go instead to far-away Ireland, where he could better reassess the direction of his art.

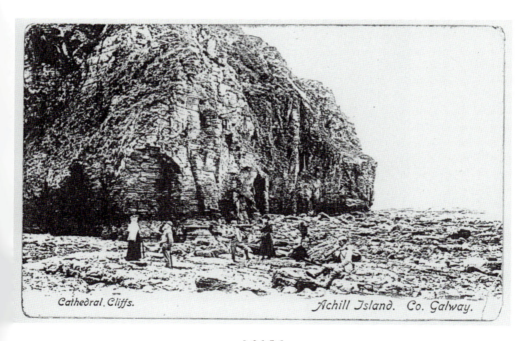

Cathedral. Cliffs. Achill Island. Co. Galway.

[From Marjorie Henri]

July 5 [1913]

Dear Sloans—

We're settled here in the Western World in a modern castle,[1] with large Hall 4 times too big for a Studio—They say Singe[2] stayed here & that the Play boy was founded in something that happened here—Bob expects to do great things—millions of all kinds of children in the most primitive [continued on next postcard] dresses—the[y] weave & dye their own

Seal Caves Achill Island Co. Mayo.

goods—and the effects are stunning Scenery immense—Wish seriously that you both were here—We'd have a wonderful-time Painting all day—and turkey trotting all night—great floor to the old Hall—and you know we brought our music box with us. Write us—some news

address: Corrymore Keel Achill Island, Co. Mayo

Love—Marjorie H.

[1] A nineteenth-century mansion built by Captain Charles Cunningham Boycott, whose refusal to reduce rents for tenant farmers prompted them to protest in a manner that has made his name a common word.

[2] John Millington Synge (1871–1909), Irish playwright, who wrote *The Playboy of the Western World,* first published in 1907.

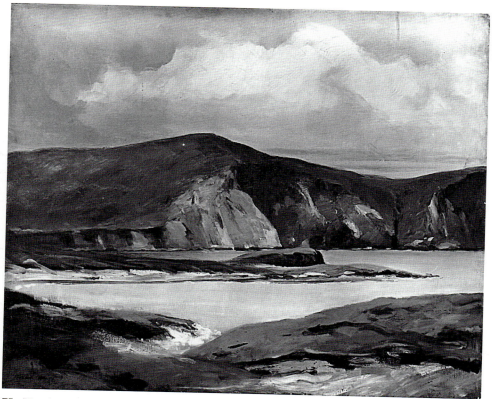

75. Henri, *Meenaune Cliffs, Achill Island, County Mayo, Ireland,* 1913

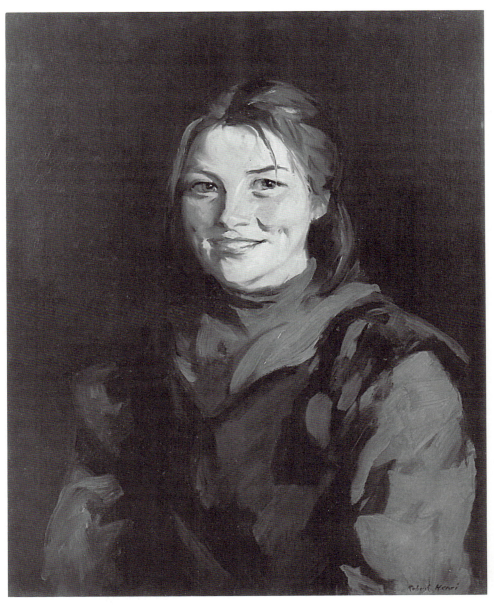

76. Henri, *Achill Girl* (Mary), 1913

[September 1913; undated]

Dear Sloan

I just want to tell you I am in Dublin and have seen the portraits painted by Mr. Yeats. They are wonderful. I wonder why some of the people who have been over here that we know have never spoken of them.

In my opinion Yeats is the greatest British portrait painter of the Victorian Era.

[Henri][1]

[1] This letter, the original of which no longer exists, was copied by Dolly Sloan in hers of 8 February 1922 to Lily and Lolly Yeats, daughters of John Butler Yeats, upon the occasion of his death in New York City. A typed transcript was provided by William M. Murphy of the original, in the collection of Michael Butler Yeats.

Tuesday Dec 1 / 14

Dear Henri—

My list for Panama Pacific Ex[1] now stands:—

[Note: The Sloan drawings above were placed on the page so that when the paper was folded the man's expression changed from happy to sad and a bowler hat was placed on his head.]
 [1] The Panama-California International Exposition opened in San Diego on 1 Jan. 1915, celebrating the completion of the Panama Canal.

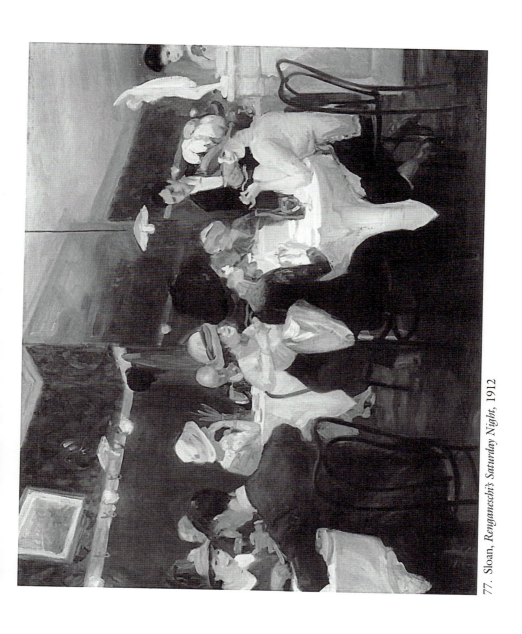

77. Sloan, *Renganeschi's Saturday Night*, 1912

78. Sloan, *McSorley's Bar* (McSorley's Ale-House), 1912

79. Sloan, *Chinese Restaurant*, 1909

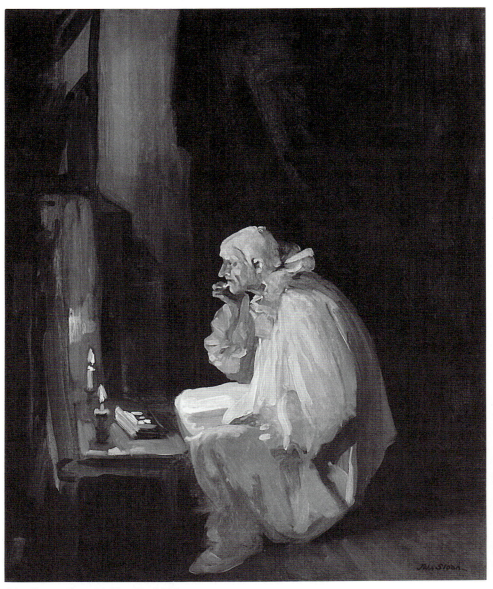

80. Sloan, *Clown Making Up,* 1909

Dec 8 1914

Dear Sloan

As I remember there was possible question about whether you wd send 5 or 6 to San Diego on acc[ount] of space. Send 6[1]

I suppose you have heard from D[r] Hewett[2] (San Diego) and from AP & S[3] who collect on 10th. Your picture is well hung in Wash[4] and looks fine. All our fellows have excellent places the prizes went to Wier,[5] Woodbury,[6] Beal[7] and Farley.[8] The Wier was O.K. Many fine pictures were exempt.[9]

Henri

[1] Sloan's entries were *Chinese Restaurant*, 1909; *Clown Making Up*, 1910; *Sunday, Girls Drying their Hair*, 1912; *Movies*, 1913; *Brace's Cove, Gloucester*, 1914; and *Autumn Dunes*, 1914.
[2] Dr. Edgar L. Hewett was in charge of the Art and Science displays at the Exposition.
[3] Artists' Packing and Shipping Co.
[4] Sloan's *Renganeschi's, Saturday Night*, 1912, in the 5th Biennial Exhibition of Oil Paintings by Contemporary American Artists at the Corcoran Gallery of Art in Washington, 15 Dec. 1914–14 Jan. 1915. Henri was represented by *Himself*, 1913, and *Herself*, 1913.
[5] J. Alden Weir (1852–1919).
[6] Charles H. Woodbury.
[7] Gifford Beal (1879–1956).
[8] Richard Blossom Farley.
[9] From prizes.

Aug 3 1915[1]

Dear John & Dolly Sloan

We got a breezy letter from Davey this morning and in it he said great landscapes are being done in the Sloan shop and that for passtime John was reading the true sense of Omar Kiam the old fake! I shd like to see the pictures and for relaxation would like to hear Omar Kiam shown up

⌣ note this word—same as "sloan up" It will be fine when we hold our private views for each other in the fall. I have been painting steadily. at first as usual nothing came but the last two weeks have been fruitful and maybe I have got some. Have been painting some gipsys. Having a good time working anyway and eating lobster, feel fine—wh I did not when we first came up. Last winter was a hard winter. We have a good little living bungalow convenient to P.O., Beach, stores, movie, apple trees in the yard full of green apples and rain trickling through them most of the time. I'm working in a good place—good light. wish sometimes for the sun of California or Spain but think the light is very good here anyway. I doubt if this place is as picturesque—that is from the painting point of

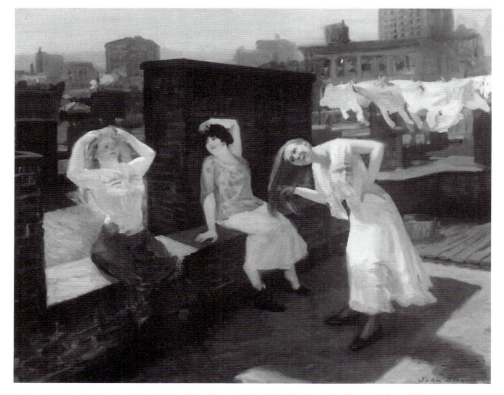

81. Sloan, *Sunday, Women Drying Their Hair* (Sunday, Girls Drying Their Hair), 1912

view as yours—altho it is probably more picturesque from the summerers point of view. There are a lot of artists here but as the place is no place at all—just a road with houses strung along for two or three miles there is no meeting people unless desired, and of course with work all day there is heavy enough fatigue at night not to go gadding. Bellows is a mile down the road—they[2] come up often evenings, when the weather was good sitting on our verandah wh has a mosquito proof part and a hammock. Ward[3] came with his guitar (he is a friend who used to come to the studio a good deal last winter—the NY park commissioner) he can play and sing with great ability Italian, Spanish, Hawaiian, So American, Negro etc etc folk songs and of course there were the Bellows and Kroll[4] and Berlin[5] (I doubt if you know him altho he professes a great deal of appreciation for you

 Down at the cove (2 miles) is the Fishing village, the Hamilton Easter

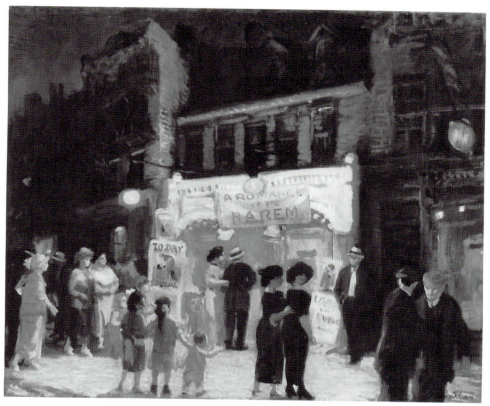

82. Sloan, *Movies,* 1913

Field[6] headquarters and class with the Baroness posing on the rocks a sirene against the sea with the students and post graduate artists making pictures in every idiom of her, modern style and ancient as the whim or the fashion suits them. The Baroness has made conversation lively on the verandahs of the summer hotels and boarding houses and the question of whether a lady or otherwise should be allowed to smoke cigarettes while walking the public way of Ogunquit has not yet been settled

The movie show is bad enough to be good, four coons entertained us in the church with as near coon dialect and jubalee songs as their Atlanta university education would permit—

Aug 5—sitting over a fire front warm back chilled. It rained more here yesterday than it did in Gloucester on a bet.

Great climate this!

Good luck to you Henri

83. Sloan, *Brace's Cove, Gloucester,* 1914

[1] Stamped letterhead is Robert Henri, Ogunquit, Maine.
[2] George and Emma Bellows.
[3] Cabot Ward.
[4] Leon Kroll (1884–1974) was an artist from Manhattan.
[5] H. Paul Burlin was another New York painter.
[6] Hamilton Easter Field (1873–1922), an artist, was director of the Thurnscoe School of Modern Art in Ogunquit, Maine.

During 1916, Henri painted one of his last full-length portraits, a commission from the socialite-sculptor Gertrude Vanderbilt Whitney. Upon completing her likeness, he produced a canvas, titled The Laundress, *of a day laborer with her basket of clothes tilted unashamedly toward the viewer.*

Throughout his career, Henri felt equally at ease portraying both ends of the social and economic spectrum.

[27 May 1917; undated]

Dear Sloan

This is some information I have gathered and it may also be of service to you—

Henri

I should have added that in case you use Sochnée frères Retouching varnish it shd always be removed (by alchohol) before painting over because there is no adhesion when painting over it—Picture liable to scale.

May 24 1917

Kerosene[1]	Good painting medium (add oil, linseed or poppy, when necessary or desired). Kerosene has a little paraphine wh[ich] is beneficial, rather than otherwise. The impurities now in kerosene not sufficient to need washing. Kerosene if you like can be washed by adding about equal parts water. Impurities fall through the water to bottom of vessel and then oil can be decanted.
Japan Gold size[2]	Is lead medium, should not be used except with lead pigments.
Cleaning old canvas and preparing with new coat.	Wash with "denatured alcohol," remove direct and continue to apply the denatured alcohol until paint is softened. Then apply while soft the new thin coat of zinc white. Two coats always better than one thick

84. Henri, *Himself* (Johnny Cummings), 1913

85. Henri, *Herself* (Mrs. Johnny Cummings), 1913

coat. The softening of the old paint will cause adhesion of the new coat.

To make absorbent canvas non-absorbent	varnish with "Maratta Painting medium"
Oiling out.[3]	use Maratta Painting medium
Varnish	pictures may be varnished with M. Painting medium or ordinary canvas may be varnished with this to insure better adhesion for subsequent coats, and it can serve to clean a canvas altho the alcohol process is more absolute. Every canvas before painting should be dusted off and its cleanliness from dirt, grease, etc insured.
To stop the cut of alcohol	use poppy or linseed oil over the places cutting too much.
	All the foregoing are from Maratta.
Preparation of raw canvas without glue size	Toch[4] says "Lay a good coat of paint composed of white lead, more zinc and Japan—should dry in a few days—sandpaper smooth—the next coat which shd also be a coat that does not dry glossy & that contains sufficient terpentine will make a perfectly smooth foundation. Dry in sun. Few authorities will agree to this nonsize prep[aration].

[1] Kerosene is seldom used for this purpose today, turpentine being the medium of choice.
[2] A quick-drying primary coat.
[3] Blocking the absorbent air holes of canvas by coating it with a slick medium.
[4] Maximilian Toch, in *The Chemistry and Technology of Mixed Paints* (1907).

252 E Main St
Gloucester Mass
June 7 / 17

Dear Henri:—
 I've been trying to guess the size of your head—with purchase of a Sou'wester in mind but the more I cogitate the less certain I grow—so you will have to let me know by mail.
 We have settled into our little red cottage now Its quite like our "summer home this being the third time we have kept it from being lonesome during the summer The weather has been a layer cake of cloud and sun-

shine, one, then t'other. I have not yet got to work painting—fixing the blame on my sore thumb—which I brought with me

Gloucester is much the same save on the coast—where the rich, like some pest, have eaten off acres of granite rocks and dunes and walled them in for themselves—I know the sea will be there long ages after "private property" has vanished from the earth—Meanwhile its an unconscionably long time to wait.

Stuart Davis "registered" up here only 1600 boys I'm afraid he has

put himself in a dangerous position as it would seem more likely that he draw a <u>black</u> bean up here than he would in N.Y.C. with its million.[1]

But—his father is keen for the war Remember Moses offering up his son Isaac? Let us hope that there may be somewhere a lamb caught in a thicket —a good bug lamb —to save them all.

I should say if asked that this town is not for the war very enthusiastically

Both send regards to both

Yours
John Sloan

[1] The method of drafting men in World War I in which gelatin capsules were used with black construction paper placed inside to hide the numbers.

10 Gramercy Park
June 23 1917

Dear Sloan

What did the hat cost? I have bought a fine waterproof, which covers me completely—a chauffeurs,[1] at Brooks Bros for 5^{50} This will go well with

86. Sloan, *Gloucester Trolley*, 1917

the hat. Dolly called up and said she wd call in if she had time We looked
for her but I guess she had a busy business. Its hot but for us not yet
uncomfortable Packing up in pajamas. We go Wednesday. Letters ad-
dressed to Santa Fe N.M. will be sufficiently addressed. Now about this
palette scheme (but before I go into it and make my drawings I want to say
what a fine drawing that one of yours was—in your last letter!) I had my
palette made of aluminum at much cost both in money and energetic
search for some one to do it. They all said it was impossible. I had a visit
one evening from Davis père[2] and he was a lot of help in establishing the
working place of the making of it. I had to do the thing in a life sized
pasteboard model and then I had to get some aluminum and do everything
to the pieces I had that wd be necessary in the making of it, such as bend-
ing, drilling, sawing and putting together the strips in egg box fashion—
which was Davis' idea—but this is talking about a thing not yet described

so I shall have to hurry up and get over on the next page where I can have plenty of room to draw. And so in this space I will say that the palette is composed primarily of two trays each $7\frac{1}{2}$ x 24 inches in width and length and $1\frac{1}{8}$ inches in depth and that these trays are divided into compartments wh are 2 x $1\frac{1}{2}$ x $1\frac{1}{8}$—the latter measure being of course the depth, and each of these trays can hold about the same quantity of paint as the jars we got last year I am not sure that your jars were the same size as mine which were like Winters[3]—anyway there is room for a goodly quantity and the trays can be flooded with water overnight or the whole immersed if more desirable.

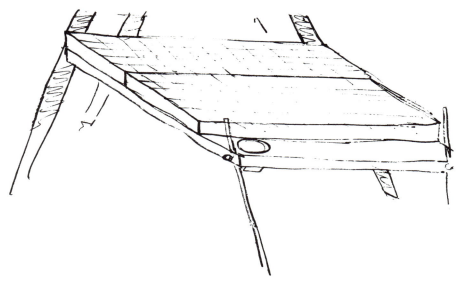

Here we have the two trays resting on their support wh is a frame 20 x 24 covered with a sheet of aluminum & wh carries with the canvases. attaches by screw hooks to eyes on the easel for its inner support and has legs; which are lengthened or shortened by aid of a screw, as outer supports. As the area covered by the two trays is 15 x 24 there remains a strip of 5 x 24 of the supporting aluminum covered frame and this strip serves for mixing and in it is cut the round hole to receive the Bellow's brush cleaner.[4] As each tray has 12 compartments lengthwise and five across the two sum 120 compartments ushering in a new era in the history of outdoor painting—for what artist did ever go out to sketch with an abundant pallette of 120 notes if he liked? and these carried in a box, made of light wood, 8 inches wide $4\frac{1}{2}$ inches high and about 29 inches long.

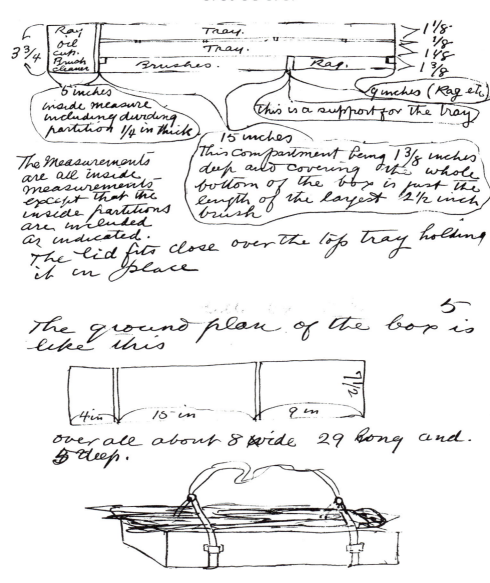

Rag
oil
cutr.
Brush
cleaner

3¾

Tray.
Tray.
Brushes. Rag.

1⅛·
⅛·
1⅛
1⅜

6 inches
inside measure
including dividing
partition ¼ in thick

9 inches (Rag etc)

this is a support for the tray

15 inches
This compartment being 1⅜ inches
deep and covering the whole
bottom of the box is just the
length of the largest 2½ inch
brush

The measurements
are all inside
measurements
except that the
inside partitions
are included
as indicated.
The lid fits close over the top tray holding
it in place

The ground plan of the box is
like this

4in 15 in 9 in 7½

over all about 8 wide 29 long and.
5 deep.

The hay on the top of the box is of course intended to represent the easel.

 My aluminum pans weigh two pounds each and cost—I hate to mention it—but I would rather have them than a suit of clothes so I bought a beaut of a linen suit, good fit too, at Brooks Bros for 12 dollars and paid $32 for the two trays. Of course its all out of reason for them to cost so

much but there was only one man in New York willing to touch the thing after a weeks hunt—and besides who expects anything based on reason in these unhappy days?[5]

The same man was willing to do it in sheet zinc for $16. Zinc would weight about 5 lbs (each box) and the solder wd be tin with a little <u>lead</u> in it. This solder however could be varnished over perhaps securely with Rip-olin[6] so that the paint would be safe from the lead. I'm glad anyhow that I got the lighter, more rigid and leadless aluminum. I had to convince the man by a demonstration that since aluminum solder is no good that the thing could be held together by copper rivits. He then did it with alumi-num solder and I think the solder will be quite strong enough and the paint will do its own part in holding the divisions.—It appears quite se-cure. Naturally it is not essential to have the divisions waterproof. The tray itself is waterproof & is riveted at the corners.

Davey (off for Cuba at the end of the week) is going to have Ra-binowitz[7] make the box etc (as he is doing for me) and have the man make trays of zinc for $16[00]

It now being time to close

I am Yours Sincerely

George Thwarton Smith [Henri]

(of whose roller skating invention for the health and happi-ness of humanity you have already heard much)

[1] A coachman's or chauffeur's double-breasted, rubberized coat.

[2] Stuart Davis' father.

[3] Charles Winter was an artist who, like Henri, was deeply involved with the color theory developed by Hardesty G. Maratta.

[4] One of George Bellows' gadgets; another was a set of rollers intended to squeeze the last bit of pigment from an oil paint tube.

[5] While World War I raged on.

[6] A type of household enamel that serves as a sealer.

[7] Nathan Rabinowitz.

[Card postmarked 16 July 1917]

601 Palace Ave
Santa Fe N.M

Heres our address. All O K like it better than ever

601 Palace Ave Santa Fe N. M.
Sept 19 1917

Dear John & Dolly:
 Your letter came duly and I intended writing you long ago
 I havent done anything with the palette you described, struggled to get
the plan of it one evening but it wasnt quite clear to me, besides I have a
big universal palette already established in my aluminum department pal-
ette holder wh I either exhibited to you or described before leaving. and
as it is a palette of much paint and works well I have anchored to it. It
always seems to me that the limited, special, chord etc palette[1] is most
practical for one who works for a continued time on one subject and has
determined the palette for that subject. For one changing motive and color
scheme every day it seems that the universal is most practical, applying the
principle of selection in the painting of the picture—not always easy to do
or to hold to of course. My present (universal palette) is:

12 colors. as in tubes

12 ″ to middle tint with W[hite]

12 ″ ″ high ″ ″ ″

12 intermediate colors

12 ″ ″ to middle tint with W[hite]

12 Bi Colors[2] as in tubes in R. RO. O. OY[3] and the others raised or
 adjusted to a place more truly between the color & the Hue than
 as in tubes.

12 Bi Colors to middle tint with W[hite]

12 " " " high " " "

6 Hues

6 Hues to middle tint with W

these hues are my own mix being less dark, more neutral than the tube hues.

In case of some of the darker tube notes I have added white in order to have them in more useful condition—such as BP Color[4] wh one has occasion very rarely to use in its full darkness In this collection of notes there are aproximately the notes of many chord or selective palettes and if selected and held to in any one work the result may be obtained—or nearly so. I do not mean to say that such process can be as positive as an absolutely set palette procedure, nor can one hold to it as successfully—

I have found my pans—the aluminum divided pan wh is 24 in by 15 in. (divided into two $24 \times 7\frac{1}{2}$ for convenience) very practical compact and convenient. Each compartment is $1\frac{1}{8}$ in deep $\times 2 \times 1\frac{1}{2}$. It cost some money to have it made in aluminum in N.Y. but we got one made of zinc for Lucy Blasirus here for less than $6.00 Two pans duplicating mine and a water-pan in wh to immerse the two palette pans when not in use. My notes have held better in this arrangement than in any of the previous water protected palettes, because of only the top of the paint being exposed. I have to re-mix occasionally the white notes, wh stiffen. This should be done with Turpentine, not oil. The latter results in a stringy paint after a time while the turps avoids this. There is practically no waste of paint. The palette scraping if there are any go back into the lower notes. A very practical palette could be made $\frac{1}{2}$ or $\frac{3}{4}$ in high instead of $1\frac{1}{8}$. This would cost less to fill and probably hold a full sufficiency of pigment.

If I do nothing with the palette you diagrammed here I shall want to know about it when we get back to N.Y. Winter sent me a similar and very wonderful looking diagram. I have intended writing him about it, altho I am also very vague as to its build but have neglected writing.

It took me some time to get settled down to work here. first there was a window to put in the big room of the house to convert it into a studio—this sort of thing takes time in the land of Mañana. Then I was not feeling in my usual state of energy—last winter was a hard one—I believe the war has had its spiritual effect on many of us, far more than we have known. Anyhow I was run down and was only good for a few landscapes sketches —of wh one I think is good and I devoted myself to preparations, putting up screens and repairs generally to the beautiful old Mexican adobe house. A good looking, good for nothing, lovable dog adopted us, a very beautiful kitten has grown up with us and another one is lately joined. four "burros" are occasional visitors to eat the thistles on our back hills or haunt the kitchen door for bread or garbage offerings.

The possibility of out of door sketching and the advantages of daily air off of feet, and visits to the near and far pueblos, and the possibility of getting practically all the investment back at the end of the season resulted in the purchase of a 5 seat ford. We have had some fine trips in it—one to Acoma and the Enchanted Mesa a trip there and back of 350 miles thru wonderful country. At Acoma we saw the ceremonial Corn dance. Its a good thing and maybe it will prove a good investment as I feel very much like work after a mornings ride out somewhere in the country, and maybe it will bring about the painting of some landscape that wd not otherwise be done—altho so far I have been digging away at pictures of youngsters[5] every afternoon and I think have a few that are good. Its also good to go get interesting models who live at a distance, but the devil of it is the crank, and no one but a strong armed youngster or a man who has been using his arms at something more strenuous than holding a brush should engage with it. Sometimes its dead easy, other times its beyond even a well used arm

We are having a self-starter put in to get rid of the crank nuisance.

The summer has been beautiful warmer and more comforting than last summer, (the evenings warm enough to sit out without wrap) often last summer a wrap was necessary. There has been practically no rain (bad for crops etc, but otherwise good for light etc. and the drying of canvases. For the last few days there has been rain and if it continues cool as now a fire will be necessary. Kroll is here—for 2 wks. down from Colo Springs

and Geo Bellows & family are to come from Calif. Friday 21st I dont know how long we will stay here but it will be as long as we can. New York is not inviting in any sense now. I hope dame fortune will be good enough to us to let us have enough money to continue living on and doing our work until this war is over—wh matter is a very great gamble especially as one does not feel like going about currying popularity, or grabbing the opportunity to make profit out of the sacrafice.

We have had a good letter from Davey nothing from Maratta, I hope he is doing well. I think Davey was not drawn for the service since we have heard nothing to that effect since his letter wh was written about same time as the one you rec[eive]d. Glad to hear about Stuart Davis.

Well our love to you and good luck! and to all

<div align="right">Yours
Henri</div>

1 The so-called Maratta Palette or Color Piano, which likened the color scale to the keys of a piano.

2 According to the Maratta Palette, a color of middle intensity.

3 Red, red-orange, orange, orange-yellow.

4 Blue-purple.

5 These include *Indian Girl of Santa Clara, New Mexico* (Gregorita), *Pepita of Santa Fe* (Julianito) and *Little Girl of the Southwest* (Lucinda).

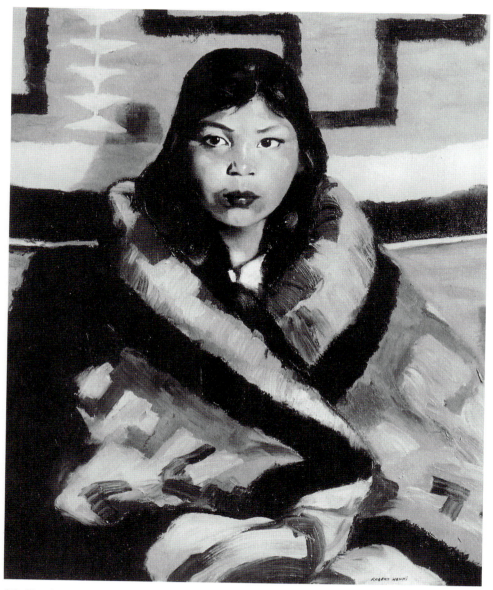

87. Henri, *Indian Girl of Santa Clara, New Mexico* (Gregorita), 1917

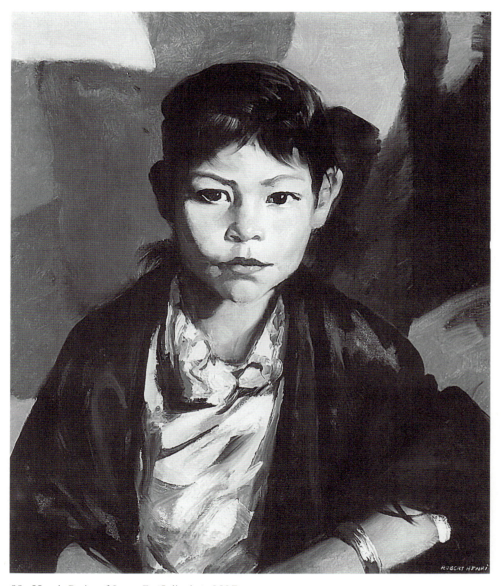

88. Henri, *Pepita of Santa Fe* (Julianita), 1917

89. Henri, *Little Girl of the Southwest* (Lucinda), 1917

When Henri spent the summer of 1917 in Santa Fe, he devoted much of his time to painting the American Indian. The motivation for this focus was eloquently shared with his future classes at the Art Students League:

[I] was not interested in these people to sentimentalize over them, to mourn over the fact that we have destroyed the Indian . . . I am looking at each individual with the eager hope of finding there something of the dignity of life . . . something of the order that will rescue the race and the nation (Robert Henri, *The Art Spirit,* Philadelphia and London, p. 148).

Henri's enthusiasm for Santa Fe prompted Sloan to venture there in the summer of 1919. He and Dolly made the trip by car, travelling with Randall and Florence Davey in the Daveys' vehicle. Sloan returned to Santa Fe each year, except 1934, through 1950, the summer prior to his death.

June 21 / 1919[1]

Dear Henris:—

About one third of our way
is done—going fine—the
girls are heroines—camped
three nights—hotels and rest
of the week which is up today
Randall & Florence send love
and Dolly and yours
John Sloan

[1] Letterhead is Hotels Statler, Cleveland.

10 Gramercy Park
June 27 1919

Dear Sloan:

The enclosed list is very complete as I made a full inventory to avoid having to buy many of the small things mentioned before I knew I had them there.[1]

Use any or all of the things freely. What remains you can judge whether worth packing up and shipping to N.Y. The packing could be done by some one there, you can pay for it and charge it up to me when you come home. The Records[2] I want, there are some very good ones, hard to get—some of them—and quite worth while. These of course should be very well packed.

The better easel is mine. It has a first rate palette to attach—with aluminum top. The other sk[etch] easel is Lucy's.[3] In fact half of the prepared compo[sition] panels are Lucy's, but use them freely, we can square up with Lucy later. The drawing pads are Laurier pads $12\frac{1}{2} \times 20$ I think—they will be servicable I think to you.

The way all the things were packed was only to carry them down to the museum and store them, so the present packing will all have to be torn up anyway.

We got a fine card from Dolly from near albany and a splendid drawing from you from cleveland. Hoping for more. We wont get off to Chicago for several days yet[4]—

Yours
Henri

[1] At the Museum of Art and Archeology (now the Museum of Fine Arts of the Museum of New Mexico in Santa Fe).

[2] Phonograph records.

[3] Lucie Bayard was a Henri student who had accompanied the Henris to Monhegan the previous summer.

[4] Henri painted two portrait commissions in Lake Forest, Illinois, one of $3\frac{1}{2}$-year-old Edward Herbert Bennett, Jr., the other of the child's mother.

July 5 / 1919[1]

Dear Henris:—

We are plugging along—spent three enjoyable days in Chicago. Eastern Iowa was O.K. but after a rain we found that rumors of the rottenness of the roads were not unfounded Some mud but Randall[2] got us through allright The nights we camp out are the ones that seem the most sport to me—the girls[3] seem to prefer hotels, of course hot baths have their good points.

Iowa is immense and quite wonderful in its grain fields I think it would be fine to paint as seen from the automobile—but once the roads get wet, good night, it is impossible to take your eyes off of the ruts in the mud! Its hard to keep a car on the upper side of the road but Davey is a wonder at the wheel.

It will take us more than a week longer to reach Santa Fe.

Omaha has apparently grown a good deal since I was here in 1910.[4] I shall try to see my two portraits here but dont know whether I'll succeed.

Well Im tired—a long ride today—finished Iowa and most did me up—Im feeling fine though the work does me good but I fear Ill need a vacation when I get home!

Love to you both from Dolly and yours

John Sloan

The Daveys send best love

[1] Letterhead is Hotel Fontenelle, Omaha, Nebraska.
[2] Randall Davey.
[3] Dolly Sloan and Florence Davey.
[4] Sloan meant 1911, when he went there to carry out a pair of portrait commissions.

c/o Akers 401 San Francesco Lane
Santa Fe Aug 26 / 19

Dear Henri:—

I was glad to get your long and interesting letter I had been taking myself to task for not writing to you (postcards I did send I believe) but I had got a streak of work[1] and found myself so in "state of collapse" at the end of my days work that I had not energy left to get my thoughts together.

You are quite right about the fineness of the climate here—but for some reason or other I find myself much played out after my days painting I have been going quite hard at it—that may be the reason I have 13 canvasses under way all memory things I have done nothing outdoors—contrary to my usual custom in Gloucester I have made no work in the open I see things, the life of Santa Fe, on landscape and make them afterward from memory and I think it is producing results some of the things seem more like "works" and less like studies

The people at the Museum[2] have been most kind. I have the studio in the palace[3] which you had in 1917 and thanks to you there are plenty of canvasses—I don't think much of the pulp board have not used it and do not think it permanent enough to paint on on account of the action of the atmosphere on the edges it rots out I fear.

[246]

We are located at the end of S. Francesco St just where the narrow Gage
D & R. G[4] tracks cross it have a furnished room and kitchen where Dolly
struggles with a wood fire—great disadvantage not to have Gas in Santa
Fe! We dont pay very much and are fairly comfortable the people in the
house are kind to Dolly—there is a large yard and a couple of little boys
one 6 years smokes big cigars! the other aged 3 has only got as far as
cigarettes. the landlady is Spanish a De Meara I think the name her
husband, Jack Akers, is one of ten aldermen, and back in the old days here
ran a gambling house, he's about 60 years old now and a fine man. It's
interesting to have him tell of his experiences in the wild days.

The Daveys have a little adobe house a new one in the old Santa Fe
style (like the museum) and are quite nicely fixed—Our trip out was a
record breaker for expense, it cost Davey and me each about $750.00! We
did not quite get here had to come by train the last 90 miles roads were
so fearful I have no idea where all the money went tho some of our hotel
stops were very expensive two and three day ones confined to our rooms
mostly on account of our rough travelling clothes which made meals in
rooms necessary.

Last Sunday Dolly and I with a Mr & Mrs Sievers (musicians) took a
walk to Monument Rock in the Sana Fe Rio Cañon 9 miles each way.
Quite a feat for us I made a little memo sketch in book and painted a
picture from it.[5]

We saw the Corn Dance at Santo Domingo—very good I have 3
paintings from that occasion The Daveys are just back from the Hopi
Snake Dance in Arizona took a week to do it and a couple of hundred
dollars bit the dust of Limbo. I painted 3 things while he was away, so
dont care $5000.00 to the "good" some day! maybe?

Dr Hewett has asked Dolly and me to go with them (in your Ford) to
the dance at San Ildefonso next week Sep 6th

Here is a list of my things so far—to give you an idea

1 – Two young girls Mex kids flirting under that shed on San Fran-
cesco St near to us [*Old Portale, Santa Fe*]
2 – The old palace one end of the porch, evening. [*Palace of Governors*]
3 – Inside the church at San Domingo mass before the dance back of
church sightseers congregation a few Indians present in front,
tawdry altar.
4 – Squaws in a row outside the Kiva between dances. [*Squaws in the
Dance*]
5 – The Koshari, spirits of ancestors at the foot of steps leading to the
Kiva [*Ancestral Spirits*].
6 – A dance at the De Vargas Hotel. Sante Fe [*Hotel Dance, Santa Fe*]
7 – Two Mex girls and mother sitting on doorsteps [*Santa Fe Daughters*]

8 – Two young Mex (or Spanish) girls strolling on road in bright colored sweaters [*Two Girls of Santa Fe*]

9 – Arroyo evening looking up arroya toward mountains [*Twelve Apostles*][6]

10 – Moonlight street on outskirts Santa Fe a cow and a small well-house [*Street in Moonlight, Santa Fe*].

11 – Santa Fe cañon. mountains [*Santa Fe Canyon*].

12 – Mountains, "Blood of Christ" Range, late evening [*Mountains, Evening*].

13 – Mother (black shawl) and Daughter gaily dressed husky girl walking along beside adobe wall hills in back with cornfield between [*Mother and Daughter, Santa Fe*].

Almost none of these are "sketches" some I have worked several days on. I expect with your knowledge of Santa Fe and of my work you may get a fair idea of them from the list. You may also detect a secret satisfaction— and I'll confess that Im pretty well pleased. I was a "dead one" when I arrived, relaxing from the camping motoring work and Im not in best health now but <u>thats</u> partly, thank goodness, from overwork! We have passed "<u>your</u> house" on Palace Ave a couple of times, it is occupied a romantic place to look at.

I am just as well pleased that you wish tin stuff stored here again and I spoke to Mr Walter[7] today and was very glad for as he said that means we can hope to see them (the Henris) again out here he told me to tell you that "Fluffy Henri"[8] is quite well. I forgot to ask if there were any kittens tho' of course it may not be that sort.

I will (unless you let me know to the contrary) send the victrola records to you when I leave here I rather think you may want them but I can not think of anything else that you could not spare or course a couple of crates of canvasses might be useful to you but Ill not send them unless you notify me to We will leave here about the last of Sept or 28th or thereabouts—we are not coming back in the Simplex[9] I am game in fact would like to but Randall has not got to work much yet and he wants to stay till November or December. In fact he's talking about buying a place here! but I dont feel sure this will come off—tho his grandmother who died last month left him some money.

Now Im about at the end of my story so will tie a knot first saying how glad I am that so many portraits and good ones have been the results of your work this summer[10] and sending from Dolly and myself best love to you and Marjorie her letter was fine by the way much enjoyed by all Im sorry mine is not of a more amusing sort but Ill try again in a week or ten days Meanwhile let us hear from you if you get time

Well so long from yours always

John Sloan

[1] Sloan produced 24 paintings in Santa Fe that summer.

[2] The Museum of Art and Archeology.

[3] Palace of the Governors, an adobe structure built in 1610.

[4] Denver and Rio Grande Railroad.

[5] *Santa Fe Canyon*, 1919.

[6] This painting was so named by Sloan because he observed twelve looming sandstone formations on Little Tesuque Creek.

[7] Paul Walter was secretary at the Museum.

[8] A cat.

[9] Randall Davey's car.

[10] These include Henri's two portraits of the Bennett family and one of Edward Winton McVitty painted in Falmouth, Mass.

<div align="right">
Falmouth Mass

Sept 14 1919
</div>

Dear John and Dolly

Your letter was fine. I am particularly glad to hear that you have been painting Santa Fe—or any thing else, from memory. You have an unusual gift of memory both of sensations and sight and while these several years of more or less direct transcript—painting before the subject—may be considered the most excellent information gathering—and very useful—Im quite certain your best work will come from dealing with the memories which have stuck after what is unessential—to you—in experiences have dropped away Of course in many of the Gloucester things, even though painted in the presense of the subject, this thing did happen

That beautiful Gloucester street which you sent to the Luxembourg exhibition[1] I have always felt was done in a trance of memories undisturbed by the material presences—That is if you did do it at all out of doors and with the street before you at Santa Fe it seems to me the necessity of working from memory is all the greater for a physical cause—the light is so dazzling there that it would take a long time to get the eyes accustomed so that the shift from color to pigment would be possible. A great many of the paintings I have seen of New Mexico have been dazzled into whiteness —when in fact New Mexico is very deep and strong in color. But anywhere—even in a studio working from the model to get the thing which hangs together there comes a time when it is better to have the model sit down behind you instead of in front so that you can go ahead.

Anyhow, all work that is worth while has got to be memory work—even with a model before you in the quiet light of a studio. There has got to come a time when you have what you want to know from the model, when the model had better be sitting behind you than before—and unless such a time as this does come its not likely the work will get below the surface done two here. We expect to be in N.Y in Oct—or maybe a day or two before the 1st Oct.

90. Sloan, *Ancestral Spirits*, 1919

91. Sloan, *Street in Moonlight, Santa Fe,* 1919

92. Sloan, *Santa Fe Canyon*, 1919

Shall expect to see you soon. Give our best to the Daveys, and to all our old friends at Santa Fe.—I envied you the trip in the celebrated ford with Dr & Mrs Hewett to San Ildefonso Its too bad poor Cresenfio was not alive to be one of your welcomers there—I hope you met Diegito my old friend of the Drummer picture in the Museum.[2]

 Best to Dolly

Yours

 Henri

Falmouth Mass until Oct 1.

[1] Sloan's *Main Street, Gloucester*, 1917, which was included in the "Exposition d'Artistes de L'Ecole Américaine" at the Musée de Luxembourg in Paris, Oct.–Nov. 1919.
[2] Henri's painting titled *Portrait of Dieguito*, painted in 1916 and presented to the Museum of Art and Archeology.

93. Sloan, *Main Street, Gloucester*, 1917

94. Henri, *Portrait of Dieguito,* 1916

1920
TO
1929

Dear Henris:—

Here we are again—our trip out on the train less eventful than last year's automobile camping experience but a fatiguing thing—We stuck to schedule right through, only 3 hours in Chicago and then on to Santa Fe the train on the dot in running time until only 5 miles out of Lamy a freight wreck in Apache Canyon held us up for 3 hours R Davey had come down to Lamy in his Ford to meet us but went back at dark having been given no definite news of the whereabouts of the hold-up—if he had known he'd have come the five miles and taken us off the train. We arrived in Santa Fe after nine oclock in the evening Tuesday June 1st Parsons and his daughter happened to be at the station and rode us to our house in his rig. They asked for you both and hoped as everyone else has that you would be able to get out this summer for a while anyway. Our house is quite satisfactory and we have plenty of room for "youze" and will be most happy to have you altho of course up the Canyon at "Casa Davey" there would also by that time be accomodations for you and a welcome. Which brings me to an account of our trip out there with Davey Thursday afternoon—he took us in his most disreputable-looking Ford (with a "wonderful engine" of course) They have made and are making splendid improvements in the place have thrown the second floor into a large living room and a bedroom it was cut to seven rooms formerly—put on new roof and are building a studio—have 3 horses, one apiece for the family, and a pair of pigs Randall makes a fine figure on horseback just like the best "movey" horsemen. Florence with bobbed hair and riding breeches is also a fetching type. Billy too, astride his sorrel horse, is most fetching.

We had a nice dinner cooked by Florence they are roughing it with all the work going on about them—Randall has about 9 men on adobe work and carpentry—has had as many as 14

There place is beautifully placed the Government Reserve to the north of them and sixty acres about them including a mountain peak The Santa Fe river hurries past and Davey pulls out trout now and then when he gets time They have <u>picked out</u> a place for us not far away which can be had for less than $900.00 and the beauty of the whole place with its wonderful skies and a large lake (caused by the damming of the river for Santa Fe water supply) make it seem very attractive as a summer location.

Dramatic thunderstorms in the evening all about us none very near were beautiful to observe and R took us home in his car.

I have my boxes, opened, and am ready to get to work when I feel so moved but have not yet felt acclimated last year we reached these heights gradually as it were by the sweat of our brows and this years rapid trip by train hoists us here so swiftly that we feel it more. Dolly has a headache most of the day, and I feel a bit dizzy at times but this will soon pass.

I met Dr Hewett today he has just returned from the East said he had stopped at 10 Gramercy[1] but had found that you were away he seemed glad to see us again and of course asked for you both. So did Paul Walter whom I have also seen he's at the First National Bank now and the Museum dont have the same air of efficiency that it had when he was there. He is still working for the Museum's interests, and I fancy his presence in the bank is a good piece of strategy in those interests.

On the train coming from Chicago was a little Irish beauty of 8 years of age who had come all the way from Dublin alone—Dolly heard of her and took her under her wing—she got off at Raton N.M. there to take a short trip to Cimmaron in the mountains where her mother was to meet her— Nora Parker, her name, a very intelligent little colleen making the best of a hard experience, laughing to keep from tears.

This afternoon a rain with distant thunder lasting about an hour left gray black clouds above the range, and a new thin coat of snow on the highest peaks, most awe inspiring and beautiful. Many patches were there before gleaming in the sun so warm in the town below

Once more dont forget how pleased we'd be to have you if you can get here. Our best love to you both with good wishes.

<div style="text-align: right">Yours always
John Sloan</div>

[1] Henri's studio/apartment in New York was at 10 Gramercy Park South.

[*From Dolly Sloan to Marjorie Henri*]

<div style="text-align: right">105 Johnson St
Santa Fe, N.M.
June 9, 1920[1]</div>

Dear Marjorie,

Well here we are, four large rooms, a back and sleeping porch. Much larger than I had hoped for but far from the street so I do not get much dust.

Randall's place is wonderful. We have been out there several times to

dinner. We walked out last Sunday. Later on four of Randall's pupils from Chicago three women and one man, then Parsons came out with his daughter Mrs. Higgins. After a nice day Parsons drove Sloan and I home in his wagon. Parsons his daughter and Daveys are coming here tomorrow night to dinner. Florence looks well and is working hard, for they are living in the place with the work going on around them. It will be some place when they get through.

Sloan has started painting so he is feeling happy. I seem to feel the change more this year than I did last, suffer with headaches most of the time, but I suppose that will soon pass off. Florence was quite a hit socially in Chicago. There were several special stories with photographs of her that went over the country. She was very happy to see us both and she is really very very nice. Florence has bobbed her hair and so has Dolly.

Do you think you will get out this summer. Everyone wants you both to come.

Last Sunday's <u>New Mexican</u> had a double column header reading "The Sloans here for the Summer". I am sure if you and Henri would come you would have it spread full page across the front. I think they would even cut out some of the conservative news.

I heard the other day that your lovely house was rented for $160. a month. New York is not the only city profiteering in rents, How is Mrs. Lee. Give her my love, also Viv.[2] And keep a large share for yourself and Henri

<div style="text-align:right">

From

Dolly and John Sloan

</div>

[1] From a typed transcription.

[2] Nickname for Violet Organ, Henri's sister-in-law and Marjorie Organ Henri's sister.

<div style="text-align:right">

105 Johnson St.

Santa Fe N.M.

July 3 / 1920

</div>

Dear Henris:—

We had a letter from Marjorie a couple of days ago. A good letter and amusing and wise too. In reference to her advice as to horseback riding we are considering the matter. In the matter of buying a place, the consideration period has passed we are the proud owners of a beautiful orchard and gardens and four room adobe cement covered house on Calle Garcia N. 108 We also have that necessary adjunct a mortgage to be held by the Santa Fe Building and Loan Association We have a lot 89 front by 193 feet deep, about 6 or more apple trees 2 apricot, 4 plum trees, 4 or

more pear trees, 4 peach trees, a grown up grape arbor, 3 young vines, about 250 or 300 asparagus plants about 16 square yards of raspberries several gooseberry bushes 3 or 4 sorts of currants, rhubarb plants —besides these practical things there are a dozen rose bushes large lilac bushes, peonies, sweet peas, canterbury bells, wonderful poppies 10 inches across a honeysuckle vine over the front porch and others in the back garden and many other perennial plants. Also in the front, a beautiful tamarack tree with soft feathery cedar-like foliage There are fine glimpses of the mountains from the garden and I intend to build an observation platform about 12 or 15 feet high so that we may each evening see the clouds hanging round the peaks of the Sangre de Cristo range

We are having modern plumbing and Bath room put in Knocked down wall between hall and South Room for Living Room will combine Bed Room & Dining room perhaps by having big divan bed Next year perhaps we can afford to have an Ell added to the North End making a fine studio with a large window on N. wall (there is no window north at present. We do wish you two could get out here to see how splendid a place it will be for us not too much housework either Dolly has rather surprised me by her ecstatic enthusiasm for her new home and this doubly pleases me. I am straining my financial resources of course, to do this, but I believe it is a wise move—we are only two minutes walk from the old palace, right in town you might say, so the property value is assured We are paying $1850^{00} cash for it (getting $1400 from the Building & Loan Assoc.) the improvements will cost $800. or more—furniture, at least $500. Everybody says we can rent it from Oct to June for 40^{00} a month (8 months $320) this amount more than meets the B & L Assoc ($243.60 per year) and in 8 years pays that off.

If I pay off the loan I cut my dues in the B & L Assoc from $20.30 per month to $9.80 a month I then would go on paying the 9.80 for eight years and get at that time $1400^{00} together with my share of profits from loans and investments.

You understand that a nice equipment of furniture etc is necessary to get a good tenant for the winter We might get as high as $45^{00} a month if its nicely equipped. They tell us that there should be an income from the garden and orchard as well. The former owner is an old Frenchwoman, Mme. Martin she planted the orchard 30 years ago and is still fond of it so much so that she is supervising and working for us every day, weeding, pruning, watering the whole place, and has just had a plowman turn all the weeds under. She is a fine character—fought 3 days in the streets of Paris "une Communarde"[1] in 1871—made her escape from the vengeance of the Bourgeois after the fall of the Commune. She has a stern sense of right, a contempt (real) for money and loves every leaf & flower and fruit in the place—She has a place on College St. a very noticeable garden, maybe you remember it. She likes Dolly and, of course, the name Sloan having been borne by a wonderful Doctor some years ago in Santa Fe, I shine with a borrowed luster. He was evidently a very great friend of all the poor people here. Dolly hears of him everywhere.

I believe you would be pleased to hear Dr Hewett speak of you—he does so much want you to come out this summer—he told me when I saw him yesterday that he was going to start his batteries on you in a couple of weeks hoping to persuade you to come—and we do wish he may succeed—you know you cant beat the climate anywhere on earth!

Daveys place is progressing rapidly, its going to be the real thing when

he gets through which will be in a couple of weeks now We have walked
out there two or three times its 3 miles up the Cañon a nice walk he
has also taken us up in his Ford thats a rougher way to do it. Then too
Randall turns the air blue anathematizing the poor old "Lizzie"—She got
a $20⁰⁰ aliment today Speaking of "Lizzies"—I had the honor of help-
ing "Henrietta"² Ford out of the mud at the west gate of the Palace the
other day after a heavy rain—Bradfield and others left in her for Chaco
Cañon explorations a couple of days ago—So you see your old car is work-
ing for past & present & future in Archaeological researches.

In view of what Marjorie said in her letter about the possibility of your
going abroad and in that way becoming not so conveniently accessible I
am going to ask you [to] loan me $500⁰⁰ I may not be high and dry till
October—but I'd better have this margin in hand in case of emergencies—
If this is too much make it as much less as you choose. I will send you my
I.O.U. on its arrival and be as satisfied to have proved you ready to help, as
I know you will be to help. I hope that I will hear that you think well of
this venture—it's really not a risky proposition I am quite certain that I
could, if not too much rushed, get my investment back and a good margin
to boot at any time I wish to sell.

Just a word or two as to my painting—I am under way and while the
acquiring of property has been a little distracting I'm leaving all the details
to Dolly to manage and am going on with my work I have one large (for
me) 26 × 35 of the Corpus Christi procession which is I think extra suc-
cessful I have a "Boys Swimming in the Santa Fe River"³ which is also a
good one a moonlight Church of Guadaloupe⁴ which is interesting tho'
small (16 × 20) another evening, mountains back of town⁵ 16 ×
20 and another big tree by Esaquia Madre silhouetted against evening
sky⁶—I have just started a 26 × 32 of the Plaza promenade in the evening
with band playing⁷ I have great hopes for this one.

I am going to show my etchings (N.Y.) 40 of them at the Museum
next week have been cutting mats for them—government postcard stock
makes fine mats tough and good color.

Here, as well as anywhere, I'll cut off this long screed with love to you
both from both of us and again the hope that you'll get out before sum-
mer's over

Yours always
John Sloan

You see The Observatory has it's Practical use!

[1] A member of the Paris Commune, an insurrection following the the French defeat in the Franco-Prussian War.

[2] The name given by Marjorie to Henri's old car, which he left in Santa Fe.

[3] *Boys Swimming, Santa Fe.*

[4] *Guadalupe Church, Moonlight.*

[5] *East at Sunset, Kitchen Door.*

[6] *The Acequia Madre, Evening.*

[7] *Music in the Plaza.*

<div style="text-align: right">

108 Calle Garcia
Santa Fe, N M
July 20 / 20[1]

</div>

Dear Henri:

Thank you for the loan of $500[00]. Your check arrived day before yesterday. I have not time to write at length today but in regard to the studio,

95. Sloan, *Boys Swimming, Santa Fe,* 1920

your suggestion for immediate construction is good, but maybe you for-
got that I have at my disposal "your" studio in the Palace for this summer. I
find it quite satisfactory and building is so fearfully expensive now I think
it best to wait for next year before adding the studio. I might even plan it
and have it built in spring before I come out.

Our best regards to you both and a promise to write further in a day or
two when we hope to be installed in the new place.

Glad you approve of the Observatory!

Yours
John Sloan

[1] From a typed transcription.

108 Calle Garcia
Santa Fe N M
Sep. 17 / 20

Dear Henris:—

 This long silence must be broken if it takes all my ink and hearts blood to finish this letter.—Your admonition to provide myself with a studio I have followed out and believe me Ive done it about right! adobe covered inside & out with sand finish plaster 12 feet high 18 × 24 inside mea-

sure cement floor, toilet & shower bath (4 × 6 ft) window 7½' × 9 ft. and the observatory on the roof 8 × 8 ft 8 ft above roof It stands in the orchard about 100 feet away from the house and while it provides me a

96. Sloan, *East at Sunset, Kitchen Door*, 1920

97. Sloan, *Music in the Plaza*, 1920

splendid workshop for next summer the supervision of the building has taken all my time for the last five weeks! and has knocked a big hole in this summer's output but it has been an interesting experience for me an expense too—you may believe—with the toilet and shower bath (put in to make it a good renting proposition apart from the house) it stands me $1300⁰⁰—I'm well indebted to the Building and Loan Assoc you may be sure and of course I must <u>hustle</u> this winter! But Ive the best studio in Santa Fe (outside of one, which is a whole church).

And then our house, its a duck! my own design of furniture—I even designed the floor painting and electroliers[1]—I do wish you had managed to get out here to see it—we hope to rent it for $50⁰⁰ a month during the winter the studio we are giving to a young Philadelphia artist (very strong promising work) Will Shuster for $20⁰⁰ a month—could get more but he needs the place and I like him.

Dr Hewett asks after you when I see him he has been in Chaco Canyon all summer so outside of an occasional visit to Santa Fe he has been away all the time. He says he's sorry you could not get out. I gave him my painting of the Ancestral Spirits made last year and he is much pleased with it.

The Annual Fiesta was pulled off this week three days one day of Indian ceremonies was the most interesting a special ex. at the Museum I had only 4 pictures to contribute ("Two Senoras") (Music in the Plaza) ("The Corpus Christi Procession") and ("Acequia Madre") Davey had four—Nordfelt[2] had an interesting series of Indian Ceremonials in P. Cézanne style (nearly) Paul Burlin has become more subjective (literary)

I am going to get all the good licks in, during the remaining short time here, that I can—but Ive got to console myself with the thought that next summer Ill be perfectly fixed.

We leave here Oct 1ˢᵗ and if you have not flown will see you in N.Y by the 4ᵗʰ or 5ᵗʰ Dollys regards to Marjorie and to you and my own best to you both

<div align="right">Yours always
John Sloan</div>

I enclose photos Please keep for me as I have no duplicates of these

[1] An electrified chandelier.
[2] B.J.O. Nordfelt was a New York artist who moved to Santa Fe.

Ten Gramercy Park, New York, N.Y.
September 19 1920[1]

Dear Sloans:

As you know, there was once a chance that we would drop in on you all at Santa Fe for a long or a short stay.

The chance has passed. We haven't dropped in anyplace at all. The summer, except for the portrait at Buffalo,[2] and the other one at Hyannis, Cape Cod, Mass.,[3] has been nil.

We had no sooner returned from Hyannis, and were contemplating a long and wonderful trip which was to have taken in Santa Fe and the New Sloan residence while on the wing, when we got a hurry call from Atlantic City telling us that my mother was very ill, and not expected to live. Dr. Frank was himself ill and unable to look after her.

So we went to Atlantic City and there we stayed. It looked very serious at first, but the Missus is made of the good long living stuff, and she gradually defeated the Doctor and the nurses in their prophecies and pulled through, and now after a long convalescence is as well as ever.

Of course at Atlantic City all ideas of work were out of the question and I had to get used, for once, to the idea that existence could go on without painting. It was hard to get settled to that new form of life. I made a short visit to the sick chamber about every two hours, and we spent the rest of the time walking up and down that awful boardwalk, until we wore it down to all its treadbare shallowness. People seem to take very little of what we like of them when they go to Atlantic City. The one thing that I did not get terribly tired of was the hydro-planes, and they are always beautiful to me.

Well, by the time my mother was out of danger and the terrible worry was over, a situation in New York which had already brewed, but owing to all attention being on my mother, had been neglected, claimed attention. This was the Studio Situation. (These two words should have had every letter written in caps—so all enveloping are their importance at this time in New York) Anyhow we found ourselves called upon to decide whether we would buy our place (cooperative plan) or move out—where—at what fabulous price? If I had felt free to go away to some foreign place away we would have gone. (I don't know what we would have done with our stuff, for to hire storage is as difficult as finding a gold mine in N.Y.,—but perhaps we could have shipped it out somewhere.) But after my mother's illness, altho now recovered, I could not feel safe in going far, and with the proposition of purchase on the cooperative plan not at too unreasonable a figure, the thing to do seemed to buy, and that is what we have done. That is we are in it. have paid a part down and will have the rest to pay in a few days when they are ready to close it all up. It has taken a

lot of time and attention and I find that I can't deal in real estate and paint at the same time.

By the time I had paid my part down, and had a pretty clear idea of what the deal meant I was just making up my mind to pitch into work (this was two weeks ago) when I woke up in the morning with a perfectly established cold in the head. Dr. Adams was out of town. No one should ever get a cold when Dr. Adams is out of town. I went to Miller and I suppose he did the right thing for me, but in whatever is the case I have been good for nothing whatever for two weeks. Today I decided to paint anyway, but I didnt get at it until 6 P.M. which was rather late to begin a day's work, but what I did was encouraging. And I plan to begin tomorrow taking, belated, the great medicine I have always advocated as a cure all—painting.

What a great howl of woe this letter is!

But you can't expect any kind of a letter from a man to whom his own best cigar tastes like the rankest cabbage.

Besides I have always advocated alike the joys of laughter and the joys of groaning.

I suppose you will be coming back pretty soon so I advise you to enjoy every minute you have left of beautiful Santa Fe and make up your mind that while you will come bodily to New York you will remain in the spiritual remoteness, and aloofness which may be possible in Santa Fe.

I have a dream of building about me a house of canvasses the interest in the construction of which will make them impervious to the attacks of everything but the material influences of this new world of Profiteers, Prohibitionists and the like. Materially they can hurt enough, and that is as much hurt as they should be allowed to do.

The directors of the New Society[4] have had a meeting and the hope is for a fine exhibition.[5] A catalog about the same size as the Yellow Book is proposed with every one represented—fifty or sixty reproductions, no literature. We have a good President in Melchers[6] and a good secretary in Kroll. Kroll is like a vicious watch dog against any art judging creeping in, and Melchers is simple, human, unpretentious, and very much interested.

In our purchase here[7] we include the rear half of the floor below. It is my plan to have my mother come and live in that.

Kroll brought report from Woodstock that George Bellows is having a big season of work. Likewise of very advanced work by Speicher and McFee.[8]

Well, heres to you Both and to all the other Santa Feans,

Robert Henri

[1] From a typed transcription.
[2] *Portrait of Arthur D. Bissell, Esq.*, painted in June 1920.

[3] *Portrait of Fayette Smith,* painted in July 1920.

[4] The New Society of Artists.

[5] Its 2nd Annual Exhibition was held at the E. Gimpel and Wildenstein Galleries, 8–17 Nov. 1920.

[6] Gari Melchers (1860–1932) was a figure and portrait painter.

[7] The top floor at 10 Gramercy Park.

[8] Henry L. McFee (1886–1953), was an artist who, together with Bellows and Speicher, helped to found the Woodstock, New York, art colony.

<div align="right">

108 Calle Garcia
Santa Fe, N.M.
June 11—1921

</div>

My Dear Henri:—

Yes, we got here—spite of floods and storm. our train was the first that had gone through a 10 mile washout section near Syracuse, Kansas for 24 hours and after we got through the tracks were wiped out so that since then no through train has come that way—we reached Lamy only 20 minutes late—trains are now 24 hours late and worse! good luck say we.

We found our little "Dobe" house still in good order and very comfortable even the first night the studio I built last year still stands tho' a few bad leaks have developed in the roof I've been tinkering around the house, studio and garden for a week now and enjoy it very much—have not done any painting, but when I get started Ill make up for lost time Our garden looks fine honeysuckles huge poppies yellow roses and snowballs in bloom and the fruit trees in good condition apparently, tho' the bearing will be scant on account of late frosts. Snow covered mountain tops greeted us the first morning some still left.

I have seen and talked to Dr Hewett the Chaco Cañon trip is off for the present as typhus fever is rife among the Navajo Indians.

A great book! Knut Hamsen's "Growth of the Soil" (English edition) if you can get it, read it, its one of the big works, I believe.

Hope you are in Woodstock by this time[1] and having a good time our love to you both

<div align="right">

Yours, John Sloan

</div>

[1] The Henris spent the summer in Woodstock with George and Emma Bellows, Eugene and Elsie Speicher, and Leon Kroll.

98. Henri, *Portrait of Fayette Smith*, 1920

[*From Dolly Sloan to Marjorie Henri*]

June 11th 1921

Dear Marjorie

Just to show you how saving I am I am writing this letter to enclose with Sloan's to Henri

We arrived here safely in the worst rain storm I have ever seen—but in spite of all the terrible floods we had a most comfortable trip.

Tuesday night Florence[1] gave us a welcome home dinner and party—we had a wonderful time—among the most prominent present were Daveys Sloans Nat Stern, Mr and Mrs Ewart Ashley Pond and Ralph Chase a friend of Daveys from California it was a wild party—cocktails dancing with strong men stunts Davey was in fine form just about the same form he was in the night he gave the party before leaving for Chicago.

I do not so far see much of Florence she is quite chummy with Mrs Ewart so I guess I will not see her often she looks well and says she loves it out here and never wants to leave.

I am in a very peculiar position I hear all the gossip—both sides—but as I am only a summer resident I will be able to keep out of it all.

Having been used to the old Phila crowd who always seem to want to help and encourage each other, it seems strange to me to land among a lot of artists who apparently seem to have their hammers out, they act toward each other like a bunch of stupid business men. Fortunately for me I have always been polite to all of them—so I do not have to take sides. How is Mrs Lee Give her my love. are you now settled in Woodstock

Let me hear from you when you have time

Our best to you both

Lovingly
Dolly

[1] Florence Davey, Randall's wife.

June 18 1921

Dear Sloans:

I have been waiting impatiently for this letter—or these letters from you both—I hadn't any real uneasiness about your getting past the flood but I wanted to hear how near you came to it anyway—I did not know the RR line was so much put out of business as you say—the papers held the news nearer to Pueblo wh I knew was well off the route.

Winter[1] was uneasy and called me up for news before we left for Wood-

stock. I told him it is a big country out there and that the RR was most likely quite safe in the region you passed through. Anyhow you got through all right so thats all right and you have had an added experience.

We arrived here in Woodstock Tuesday & would have been able to go to work next day if I had felt like it in my very excellent studio—but have spent the days getting used to the climate—resting up and getting rid of the drowsyness wh seems to come with the near-mountain air. I have lazed, smoked and read "The Lost Girl" by D H Lawrence wh is good. We have the 2 vols of "Growth of the Soil" of wh you speak so well. Roberts[2] loaned them to us to read and they say like you that its a fine work.

Bellows and Speicher & Kroll have big pictures under way. Bellows has a full length of Emma quite advanced. He came to Kingston and got us at the train and drove us here to our Woodstock house. We are well up the hill outside the town. Bellows went away Wednesday to paint a portrait in Tuxedo. Maratta seemed OK when we arrived but since has been sick with a touch of pleurisy. M^rs M. never looked better.

This looks as if it will be a good summer if the models are available wh we have not as yet fully investigated. Its beautiful weather, cool enough with the sun and called for a fire yesterday with rain. Its not as near my sort as Santa Fe is, however.

I wish we could have come out there. I'm sorry to hear you are not to have the Chaco Canyon trip—but maybe it is waiting to give us a chance.

Sorry we were not present at the Davey's party—it sounds good in Dolly's letter. Give them our best and to Dr Hewett and all the rest. I read in the paper that Paul Burlin had sailed for europe.

Lets hear from you often.

<div align="right">Yours
Robert Henri</div>

[1] Charles Winter and his wife, Alice, had shared a cottage with the Sloans in Gloucester in 1914.

[2] Mary Fanton Roberts.

<div align="right">Santa Fe, N.M.
July 26, 1921[1]</div>

Dear Henris:—

It's nearly time I wrote to you—so nearly time that I think I'll write anyway.

We're here, and the mountains and everything. I have five or six paintings under way—not many, there is so much to do around the place that interests me about as much as painting which don't sound virtuous but it

seems that I'm happy at it so it's all right. I have another building job under way now—adding a new room to the house, as per plan—it will make it much more comfortable—will accomodate another family larger than ours and thereby make it easier to rent. I'm wiser, I hope, and labor is cheaper and so is material. I hope to get off under $300.00. I feel that it's not a foolish expense and of course hope that you will approve of it. It will be a dandy help in putting you two up if you should chance to visit old Sandy Feet[2] again.

My sisters Marianna and Bess are here—were with us for about five days—now have taken apartments of their own—which is better all around. Marianna has not been well for quite a while and her doctor thought she would do well here. Has been x-rayed here by "T.B." expert but has not that popular ailment. She has auto-intoxication he says and she is much relieved to know it's not the white plague.

Davey is fine and healthy and happy too. He's ranching and riding—has no automobile now. Three horses, one stallion. He has been working on some water color drawings and etching. They are of interest, but not wonderful.

I think, by the way, that I am getting stronger things this year. I may be mistaken but that is my impression. Will Shuster is going ahead fine, has some strong heads. His T.B. is slowly retreating before the rare climate.

"Shadowland" Magazine for August has an article and three reproductions of my pictures.[3] I like the article. The two color reproductions are not so well printed in the copy I have—the proofs which I saw before I left New York were, or course, much better. But on the whole it is a very good bit of notoriety and will help.

Outside it's raining tonight. We seem to be getting an unusually heavy supply of rain in Santa Fe this summer—good for crops. The fruit crop was frostbitten. I have no apples this year.

J. A. Davis, the hardware man,[4] took Dolly and me to Las Vegas to the Cowboys Reunion July 4th, but as it rained all that day and we had to start back at 3:30 in the afternoon of the next day we didn't see much of the show but we enjoyed the trip in his super Ford. Some of the little Mexican towns on the way were fine stuff but too far to get to without a car. Suppose I'll have to have some kind of a car next year. I get tired of being dependent on the kindness of friends for my trips out of town.

(July 25th) Yesterday we made the trip to Cerillos in Mr. Davis's car and visited the old turquoise mines near there. A romantic trip all through, got some small pieces of turquoise on the big dump piles and thought the little town of Cerillos a beautiful sight. Started a painting from a sketch I made. Feel that I am started to turn 'em out now. I have three or four that I like, things that are a bit more positive than my former things out here, I think.

I guess I'll call it off at this point—don't seem to have anything more to

say. I hope that you are all well and happy—we are,—some deliciously cool nights!

Best regards to Marjorie and your mother and yourself from both of we'uns.

<div align="right">Yours
John Sloan</div>

1 From a typed transcription.
2 Sloan's clever way of referring to Santa Fe.
3 Edgar [Holger] Cahill, "John Sloan," *Shadowland* 4 (Aug. 1921), 10–11, 71–73.
4 J. Ashby Davis was a plumber and hardware dealer in Santa Fe.

<div align="right">Woodstock NY
Oct 15 1921</div>

Dear Sloans

Of course I owe you a letter for ever so long. Intended regularly to write it, but have been off writing all summer, and somehow? got almost used to having a stack of unanswered letters unanswered.

Anyhow I hear you are back in New York. We will be there Nov 1 and hold mutual exhibitions of the summers work[1] Hope yours wont all be scattered before then

Until Nov 1.

<div align="right">Yours
Henri</div>

1 Henri produced 95 paintings of landscapes and children in Woodstock between June and October.

<div align="right">[26 April 1922; undated][1]</div>

Dear Henri:—

Here is my act of thanksgiving on return to the world—I am in position to return you $400^{00}, leaving a balance of $500^{00} still due you. I am paying G.B.[2] the $100^{00} I owe to him also shooting out some to Santa Fe so that I more really may be the owner of that little dobe home & Studio.

I spend part of the day in bed but feel that I'm getting well every hour.[3] Hope you and Marjorie will be able to come in to see us soon

<div align="right">Yours ever
John Sloan</div>

1 Letterhead is John Sloan, 88 Washington Place, New York City.
2 George B. Luks.
3 Sloan was recovering from hernia surgery.

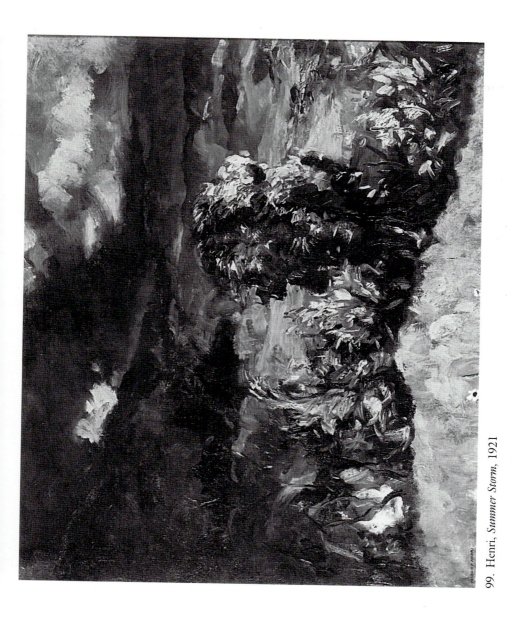

99. Henri, *Summer Storm*, 1921

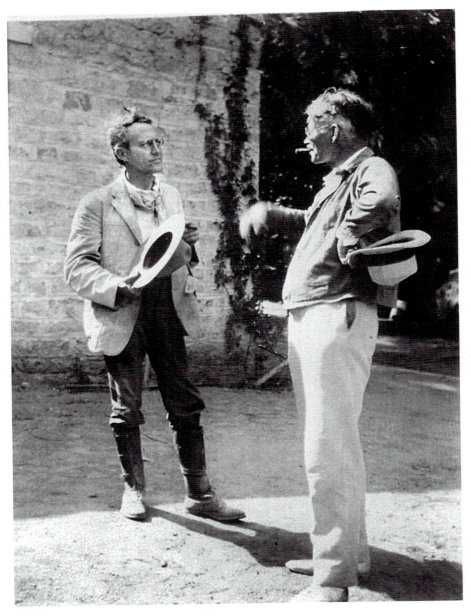

100. Sloan and Henri in Santa Fe, 1922

Dear Henris

This is my last stunt in front of Applegates on Camino Monte Sol by moonlight front left wheel in a trench—being a Lizzie Shus[1] & I were able to step into the ditch put our shoulders under the wheel and lift it ashore. Good wishes.

Yours
John Sloan

Sep 8/22

[1] Will Shuster.

88 Washington Place
New York City
November 1, 1922[1]

Dear Henris:—

Here we are at 88—safe and sound and still a bit dizzy in our heads from our travels. Our trip from Santa Fe to Kansas City in the Stutz was a wonder. It was really a great thing to do and R.D.'s[2] driving is another wonder. The last day, Sunday, the 30th,[3] he made 365 miles—got into

Kansas City which we had to make in order to use our expiring summer rate tickets before Nov. 1st.

The mountains of Colorado were snow edged, the Raton Pass a beautiful road through hills with the browns and neutral yellows and grays of an old Paisley shawl. We crossed the pass on the beautiful new road in fifty minutes, slowing down on the descent side and through a couple of little mining towns.

The roads in Kansas were quite dry and with D's driving, perfect. I drove no more than fifty miles—he could get, or rather dared get more speed and we needed speed to get to K.C. in four days. The Kansas plains were beautiful too, seen at such a good rate of speed. I think they'd be a little tiresome walking or "on Ford".

The autumn foliage in the far west seems to be all yellows, positive and neutral. The absence of reds and red-oranges is agreeable. My mind went back to those tones when we drew near the east, which with its great haziness and splashing reds seemed carpetlike.

We found our place in fine condition. Mrs. Cahill had moved out a few days since, first having had the whole shebang well cleaned. This makes Dolly happier though there are of course details which she will look after.

I went with R.D. to see his boss and look at his job in Kansas City. It looked like a good chance to him. He made a good impression I think. They have got out a special circular about him of which I'll enclose a copy. Between R.D. and R.H.[4] one gets the impression that they should be enjoying great advantages in their instructor. R. says he didn't say "favorite pupil"[5]—didn't say he didn't say the other things! Circulars are out for the Artists Coop Galleries[6]—looks like a good crack to put over the group exhibition plan[7]—we should get the old 8 together—maybe.

Dolly and I send our best regards to you both and of course wish we had not had to uproot ourselves from that beautiful dry spot. It's coolish here and so foggy. Well, that's enough for today. Will let you know if anything turns up.

As to finances we had just enough to get to New York—good trains extra fare and comfort, but if you have a couple of hundred I can use them to placate a patient landlord.

Good wishes to you both from us both

<div style="text-align:right">

Yours
John Sloan

</div>

[1] From a typed transcription.
[2] Randall Davey.
[3] Actually, October 29.
[4] Robert Henri.
[5] It was included in the circular that he had been Henri's favorite pupil.

[6] An undertaking that opened later that month on three floors of the building at 724 Fifth Avenue.

[7] A plan of group exhibits organized by the artists themselves, without benefit of a jury. Henri had originated just such a series of exhibitions for the MacDowell Club in November 1911. They were discontinued in May 1919.

[*Davey and Sloans driving to K.C.*]

Nov 15 / 22

Dear Henris:

The check of $200⁰⁰ reached me betimes and has been chucked into the jaws of the landlord not a bad one he never put up any complaint as to my delay in payment and I thank you for the timely loan of the money.

Today for the first we received our Santa Fe New Mexican paper dated of course several days back but from the home town and very welcome and interesting to me.

I have had a couple of letters from Shuster he tells me that my "Cricket"[1] now has a shelter tent along side his house. Hope a big wind on the Loma dont whisk it away! By the way you should see the new Ford— nifty! slant to windshield top fills in side at rear—I dont seem to be able

to get its beauty! (in the sketch) and dropped $50⁰⁰ in price here in N.Y.C about $385⁰⁰! I wont get one however cant see myself driving in traffic and retaining my sanity.

I went in to see J. Bowes[2] at the New Coop Galleries today nicely fixed up in light gray—3 galleries each 20 × 30 ft—not enough to house more than 3 letters of our Independent Alphabet[3] I have entered for one of the first groups— he has opened under auspices of the Heckscher foundation and is going to charge admission 50 cents! He wanted to get the patron list of the Heckscher thing and give to that organization the admission receipts— still it dont seem right to charge each member of group $10 and then hold off the general public by an admission charge. Maybe the patrons & isses[4] will come and buy—I dunno—

Went to a meeting called to talk over the possible formation of a sort of Artists and Art Lovers club at Mrs Oliver Harrimans[5] this P.M. good deal of talk in which I did at least my share and "amused them" told them we wanted real patrons of art—buyers not patronizers People who would buy things they liked—not committees deciding by vote what to buy to do 'emselves proud. Dont know what will come of it. Perhaps naught.

I have put in my spare time the past week making frames, 8 of them. Am in full harness at the League[6] teaching till my spinal marrow burns Tuesday and Friday evenings—Bad luck! Mary Roberts[7] had seats for an Isadora Duncan Russian symphony dance last night (Tuesday) I couldnt get away until 10.30 & saw but one number "The March Slav" Tchaicowsky wonderful she is as ever she was and will be always—strong

bodied, not fat, beautiful human thing—and the reserve of her art—and her loneliness, as a goddess is lonely—A full house but none of the swells. She deals such incautious apparently ingenuous slaps to them they have I suppose gradually found it best to stay away. Or then maybe never came. Last evening she said speaking of millionaires "you see I know about them I lived with one for eight-years"—that has a twist for the Puritan tail in it hasnt it. I hear it said that "she lacks tact"—well, so does God Almighty and many another artist is like His Reverence that way. Her performance a week or so ago in Boston (the Athens of America is it not called) was stopped by the police (they cant stop bootlegging but they can bare legging)—they said her blood red dress which she wore in the "Dance Slav" last night was indecent. She told how she had worn it for twenty years past!

Nat Smolin my private pupil has come back with me this month— three mornings a week—abroad this summer automobiling in France & Italy he spent 3 weeks in Germany says its terrible there—starving! and a handfull making millions—he prophesys an overturn by January.

Well, the sweeping Democratic Victory here in the U.S. following just 2 years after a sweeping Republican victory proves that theres not a great deal of partisan voting going on here and perhaps that is of some good portent—The "throw 'em out" spirit.

The other night we went to the Owen Cattells and saw the "movies" they took in San Ildefonso—Marie and Julian making pots and firing them they got back to N.Y. in their Ford after doing 9000 miles this summer

Here I've run out of matter of interest—hope you are still in good working form. Shus tells me you are making water colors in addition to your regular work "in oils" Well Dolly and I send to Marjorie and you our very best wishes and kindest regards If you get a few minutes drop us a line—we will let you know when Florence reaches New York is we hear of it how foolish this interest I dont believe we are really interested in the slightest its just a sort of comic strip

<div style="text-align:right">

Well, Adios
from Yours Always
John Sloan

</div>

[1] Sloan's car.

[2] Julian Bowes, a sculptor, who was in charge of the gallery.

[3] The Society of Independent Artists, of which Sloan was president, hung all works in alphabetical order according to the artists' last names.

[4] Abbreviation for and misspelling of "patronesses."

[5] Grace Carley Harriman (1873–1950) was a civic leader and a neighbor of Henri's.

[6] The Art Students League of New York.

[7] Mary Fanton Roberts.

c/o International Banking Corporation
Calle de S. Jeronimo, Madrid, Spain
August 26 1923

Dear Sloans:

Paris—physically pretty much the same. Dress of people much changed—dressed, men & women, much the same as in New york. This makes great difference in aspect. A franc was worth six cents and you paid about twice as much for things on an average as in the old days—so we averaged 12¢ for what used to cost 15 to 19¢.—I have to stop this now because having refused to risk what the spanish barber might do to me Marjorie has determined to cut my hair and is standing over me with the sizzors in her hand and a look in her eye that may mean blood—so this will be continued later—in the hospital perhaps.

Aug 30—

Well, the hair cutting was a pretty good job after the second go at it on the 27th to correct mistakes. When we left Paris where not much happened except the Louvre which was all different in hanging from the old days—and gave a new view of old pictures as well as some new ones.—Among the new ones is a great Delacroix—the burning of some old fellow—I have forgotten his name—on the top of a pile of his worldly possessions, chattles and women—a wonderful womans back in it. It looked to be the finest nude ever.[1]

Speaking of nudes, we went to the Folies Bergere and saw a Review that was mainly made up of nude women—but the girls of the New York Follies—in New York—were much better. We went to see Louise Pope (Mme Henri Hortal) at a place called Angles sur l'Anglon near Chatelrault, which is near Poitiers—down half way to Bordeaux. They live in an ancient house on a street that tumbles down a hill. It is picturesque. There are chateau ruins, and some miles away a great church of St. Savin[2] with fre[s]cos—very old, 11 cent. I think, primitif and very interesting. We had a good time with them. Hortal is O.K. Good fellow. We did think of going into Brittany which was near, but somehow we went to Poitiers and bought tickets to Irun[3] where we arrived after a 12 midnight to 7 or 8 something ride. Bought tickets there after a day in Irun for Madrid and with another night on the train arrived in Madrid Aug. 2.

The hot wave that seems to have gone all over the world was here to meet us and it was so hot that that was about all there was to do for two weeks. To speak of the state of the thermometer would be a misrepresentation—unless fully explained—In the shade, on the building in wh the American Consulate is housed, the thermometer read from 116° to 118°, F. Of course it is so dry here that it was not so killing as it sounds. In fact I

have suffered much more in NY heat. But we just drank water, beer, wine, etc. and sweated it seemed ever so much more than we drank. This did not prevent us from going to the Bull Fights where we saw some stirring and tragic events—that is several of the fighters are in the hospital.—and we also got busy about a studio—got one, and gave it up—and now have got another—Its hard to find anything free. The old state of affairs no longer exists. Spain got rich in the war. Madrid has built whole new business and other quarters, has more than doubled its inhabitants—dresses more like the rest of the world It is still very spanish however and with the new studio we will probably sign for tomorrow things look pretty good.

Madrid thinks it has many autos—but there are not many—each one makes as much noise, horn tooting, etc as 50 make in N.Y. (It was also a horntooting New Years day effect in Paris). Here most of the cabs are still horse pulled. There are, as far as I could see, few Fords in evidence in France. But here there are many good looking Fords. some of them are taxis others private. I would like to jump in and take the wheel—

If things go well and any pictures are sold in America we may later take a Ford view of spain. Its all mighty interesting—and I would not care to miss what we are experiencing but just the same it would be fine to be back on a Ford trip around old Santa Fe.

I can see the procession under way—Davis[4] with his latest ford Shuster with his little yellow buggy you in yours and maybe Davey would join in the grand Stutz.[5] I would bring up the rear.

It is remarkable how much resemblance there is between this country and Santa Fe.

Give our love to all the old friends, and let us hear from you

<div align="center">Sincerely
Robert Henri</div>

c/o International Banking Corporation
 Carerra de S. Jeronimo
 Madrid, Spain

The Museum of the Prado is a wonder—and nowhere are there more wonderful or more perfectly seen pictures.

[1] *Death of Sardanapalus*, 1826.
[2] The Church of St.-Savin-sur-Gartempe, c. 1061–1115.
[3] Irún, a town in northern Spain near the French border.
[4] Stuart Davis drove to Santa Fe and at Sloan's suggestion spent the summer of 1923 in New Mexico.
[5] Stutz Bearcat automobile.

c/o International Banking Corporation
Carrera de S. Jeronimo
Madrid, Spain.
Oct 31 1923

Dear Sloans:

We have not got one single letter from either of you since we have been over here. Have you written? Marjorie wrote you from Paris in July and I wrote from here in August. Both were long letters, did you get them?

We want to hear all about everything—your summer at beautiful old Santa Fe. Are you back in N.Y.? Whats the news? How much work did you do, what trips? I guess I will have to take ford lessons from you when we get back.

Here we have had ups and downs and had a lot of delays as to work. Started with a bad studio and had unheard of heat that it was impossible to work in. Chucked the bad studio and were delayed in getting a new one—got it at last.—a fine one. Am working in it now, and hope to get something worth while. Another delay of a whole month was because of a bad cold I took a week in getting well established in my head and throat—then 2 weeks in bed with a doctor who didnt know much and another one later who knew more—I was in some need of Dr Adams[1] all the time—and then I had another week of getting well enough to work.

Many things have changed here. The world doesnt stand still and when it moves out of old habits it doesnt always move into good ones. Cognac costs us ninety American cents a quart. Thats one good thing that still remains. Its cool now and hot sunny spain in gone, but the light is clear when not overcast and I am very hopeful of getting some good work. We will be here for some time, may go south to Malaga later when we dont like the weather, but the address at the head of this letter will hold good until further notice.

We talk now of the next time we go to Santa Fe—so you see New Mexico still has its grip on us. We missed it in spite of all the trip over here and we will be glad to be back again—altho this has its uses and is well worth while.

Lets hear from you,

Henri

[1] Henri's doctor in New York.

[*Drawing by Marjorie Henri of John and Dolly Sloan, with Marjorie's self-portrait gracing the easel. Card postmarked 24 Dec. 1923.*]

[December, 1923; undated]

Dear Henris:—

Well, we have struck luck—George Otis Hamlin[1] has bought the entire collection of twenty paintings which you saw hanging in his apartments I withdrew "The Cot" to show it at a Grand Central Gallery Ex.[2]—I saw that they missed it very much from their walls I had a bright idea named him a price for the lot and the next day he took my offer So that I will soon be out of debt all around and we feel very very happy—the price was $5000.00 altho the newspapers seem to think it was four times that my press agent E. H. Cahill[3] may have made a mistake (This is all strictly confidential) Dolly and I are quite happy. My letter of recent date

carried news so thoroughly that there is nothing but this great big item to add now. I am sending you 700⁰⁰ herewith inquired of my bank if there was any more direct way to send you the money, but they said not. I want to get it into the mail at once so Ill wait a letter before writing any longer Thanks very much for the money which Ive had the balance due you Ill knock off as soon as I get another payment from G.O.H. He is paying in two payments of 2500.00 each—I have told no one but you of the financial details.

I hope that you are having a good time and getting some work done to add to your feeling of happiness.

Your book[4] we got the other day—it is certainly a dandy thing. Forbes Watson[5] gave it a nice notice in "The Arts" magazine. There have been other good ones—I did not like the one in the "Freeman" by—Thos Craven[6] very poor and prejudiced for ulta modern patter of parrots

The book should become a classic, a book that's not a book.

Well so long—hope to get a letter from you pretty soon Dolly sends her best to you both and I also

<div align="right">

Yours Always
John Sloan

</div>

$ 711.00 Due Fall 1922
 375.00 Ford sale
 ———————
 1,086.00
 − 11.25 — Credits
 ———————
 1,074.75 Kaune bill 3.05
 − 700.00 Battery Storage 4.00
 ——————— Yeats Book 4.20
 $ 374.75 ———————
 Balance due Henri 11.25

[1] George Otis Hamlin was a New York businessman.

[2] Painters and Sculptors Gallery Association Exhibition, Dec. 1923.

[3] E. Holger Cahill was a writer and promoter of American Art.

[4] *The Art Spirit* was published earlier in 1923. It provides insight into Henri's philosophy and teaching through his letters to students and a pupil's notes of his classroom critiques.

[5] Forbes Watson (1880–1960) was a critic for the *New York World* who became editor of *The Arts* magazine in 1923.

[6] Thomas Craven (1889–1969) was a writer, critic, and lecturer on art.

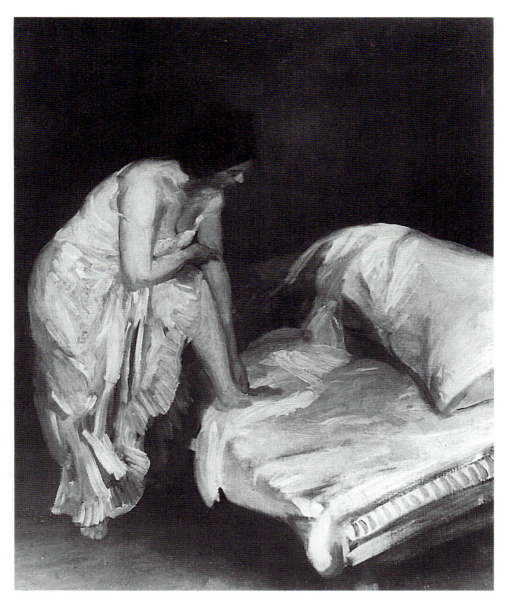

101. Sloan, *The Cot*, 1907

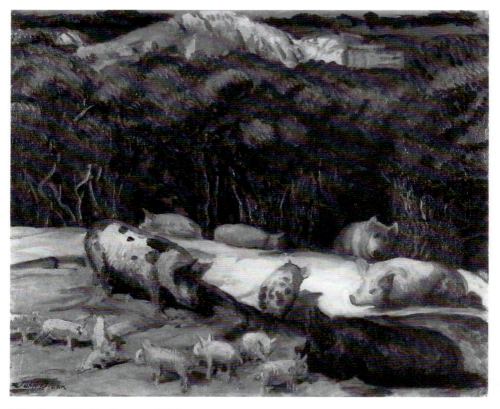

102. Sloan, *Pig-Pen-Sylvania*, 1916

*The Hamlin purchase of twenty Sloan paintings included works produced be-
tween 1907 and 1922 with a variety of subjects. Among them were three shown
here:* Pig-Pen-Sylvania, *1916;* Signals, *1916;* Blonde Nude, *1917.*

Dec 24 / 23[1]

Dear Henris:—

'Tho I have not yet had your letter congratulating me on my good for-
tune in selling the George Otis Hamlin collection of Sloan pictures and
telling of your joy in receiving seven hundred dollars on account I must
write to you again and enclose a check for the balance of my indebtedness
$374.[75] this is a pleasure which I can defer no longer I am now facing

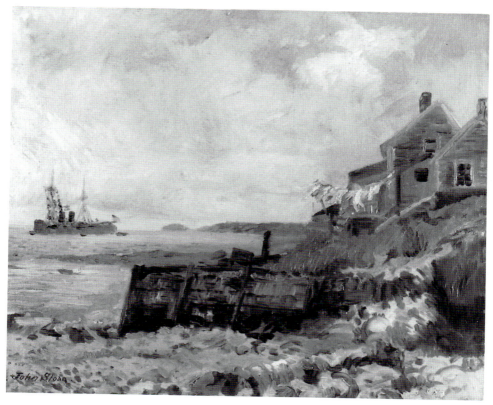

103. Sloan, *Signals,* 1916

the world free from all debt—should I die—there would be no good rea-
son for the purchase of the contents of my store-room! Thats a pesimistic
way of looking at it. I have other ways of course.

The slight exaggeration of the magnitude of the purchase price[2] for the
pictures has caused me some embarrassment and much amusement—
several kind friends have written advising us to put our capital in some safe
investment—Liberty Bonds, one of the most frequent—this combination
of the ideas of Liberty and Bondage appeals to the average American of
today.

I have been working painting and that always gives a fair sense of well
being. Dolly who has had a beautiful Hudson-seal-rat-coat made for her-
self is also in a fine frame of mind—we are quite happy 'tho we do miss
you two peoples very much—of course, we can hardly do you the injury of

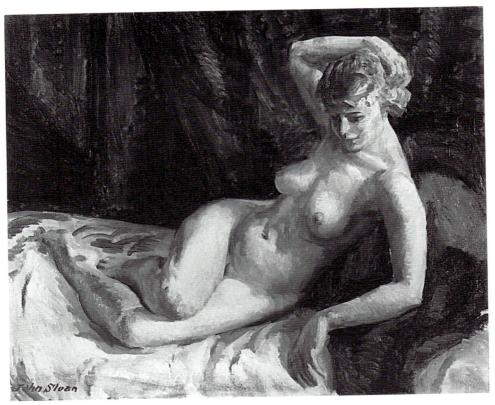

104. Sloan, *Blonde Nude*, 1917

wishing you back and my teaching jobs[3] make it impossible for us to run over to Spain and see you so I guess we will have to wait until you find it necessary to come back to the good old U.S.A. of the K.K.K. Hooray!

Romeike,[4] whom I employed for the purpose, has found more than thirty notices in the newspapers of my "big sale" of paintings, so that, you see, when E. H. Cahill says he will "tell the world" he means it.

"Captain" Bill Mannix died not long ago the career of a notable crook is thus closed—You will remember him as a Press reporter in Phila. Started a row at one of our studio parties. Passed bad checks wrote innumerable fake news stories all over the world wrote a Diary of Li Hung Chang which passed as genuine and was published it must be his chiefest achievement for they are bringing out a new edition with a preface by Ralph D. Paine (whom you should remember also) in which Paine tells

GOYA. 777. M. DEL PRADO.
Muchachos cogiendo fruta.

TARJETA POSTAL

Madrid Dec 1923

Merry
Christmas
and a
Happy New
Year
from Robert
and Marjorie
Henri

to John
and
Dolly

letter soon to follow.
got yours and it
was one of the finest
letters I have ever read

about Mannix's tricks He wrote the diary in prison with very few facilities for Chinese material

We saw in yesterdays World a notice that Macbeth is to give a showing of your paintings next month I suppose that you know of this—I will go to see the ex. and, later on, tell you about it.

Redfield has been in Hospital in Phila. some serious kidney trouble, rumor has it.

To speak of the weather indicates that Im beginning to run short of material—but anyway Santa Fe has had a big snowstorm nearly twelve inches or six or ten anyway the most snow for years this is of course good for trees and vegetation in that dry land—but bad for flat roofs Im especially concerned about three such, but have had no bad news of them so far. There has been no snow nor any cold weather to speak of in New York so far this winter—it may have some up its sleeves for us, but it cant last long.

Tried to draw something about the muskrat coat and the ladies[5]—but it has no point nor anything—it fills up and brings me to the place where I wish both of you a very happy New Year and lots of em Sent you my New Year etching a week ago—hope it reached you

Well Dolly joins me in our best loves and good wishes.

<div align="center">

Yours

John Sloan

</div>

[1] Stamped letterhead: John Sloan, 88 Washington Place, New York.
[2] Sloan sold twenty paintings for $5,000; the newspapers reported the amount to be $20,000.
[3] At the Art Students League of New York and as a visiting critic at the Maryland Institute of Art in Baltimore.
[4] A news clipping service.
[5] Figures are (from left): John Sloan, George Otis Hamlin, Dolly Sloan, and Mrs. Hamlin.

<div align="right">

c/o International Banking Corp.
Carrera de S. Jeronimo
Madrid, Spain
December 28 1923[1]

</div>

Dear Sloans:

The first letter we got from you was one of the finest letters any one ever got. We read it and reread it and will read it again in future times. Now comes this new letter with its great news—great for you and great for the Hamlins. The money is more needed by you now than a whole lot more will be needed later, and the Hamlins have been fine friends and appreciators of your work, and besides that it is just another of Hamlins investments that will return great interest if the time ever comes—not too soon—to turn the paintings into money again. So it is a great event working good in every way, materially, spiritually and financially, and in every direction. I am mighty glad of it and I am proud of the Hamlins and I am mighty glad too that they have twenty thousand dollars worth of paintings for the price paid. I also think that Cahill is quite an artist too, and that his gesture in the matter will have a fine effect on any sluggish collector who may have been for the last several years almost decided to buy one of your pictures.

I almost hated to see that check of yours for seven hundred in the letter, for it seemed a crime to cut such a hole in the amount, would have liked to know that you were rolling, for a while anyway, in the whole sum total.

In reference to this your account and mine agree leaving now a balance in my favor of $374.75. I will send your check to my bank in New York (The National City Bk of N.Y. Fifth Ave Branch) to be deposited to my credit. I am rather surprised your banker did not tell you that you could have deposited it in my bank direct, but maybe there are reasons why they should not have done this.

<div align="center">

[295]

</div>

We lived through all you told us of the summer in Santa Fe in your first letter as you told it and felt sadly how much we had missed, for with all the novelty and change of being here there was no such fun as old Santa Fe is capable to give. I think I told you in a former letter how terribly hot it was here, impossible to work, how later we had to wait to get a decent studio, how I had practically a month of bad cold. Well I have been working like a steam engine for the last two months from good, bad and indifferent models doing indifferent, bad and maybe some few good things. The study spirit has been strong on me. This does not always produce a great many pictures but it is the most fun and I have enjoyed it. The studio is large and fine and while we had a rainy period through a good part of November there has always been sufficiently good light, and all through December it has been fine clear sunshine. Its cold enough, not like NY can get but chilly and demanding a heavy overcoat. It is interesting to see the Spaniards who have always been hot summery to me now going about all muffled up as if they were at the north pole. There are still a good many who wear the cloak, and the women of the common people wear the heavy woolen shawls we have sometimes seen in pictures. Christmas was noisy, particularly in the night when it is customary for young fellows to wander over the city making all the racket they can with any kind of an instrument, musical or otherwise. Tin pans very often.

An incident we liked was that for several days before Christmas country people came to town with great droves of turkeys to sell alive. They often blocked traffic. It was rather tragic to see the droves dwindle. One down a busy, crowded, narrow street between our hotel and the studio was about a hundred strong to begin with. Each time we passed there were some missing. Today as we passed there were only six unelegant ones remaining. If they are not sold before New Years perhaps they will have to live, the poor things!

Right near the studio is the best vaudeville theatre in Madrid and it is not only most convenient but it is a great pleasure. There is a clown rather permanent there that I think you would delight in, his name is Rampar, he doesnt do much of anything but talk, he starts to do a balancing act on the top of a table and some chairs but he is continually distracted by some other idea, an imitation of one of the other acts, or some other thing and it is only at the very end that he does the thing he started out to do in the beginning. Then there are great singers and dancers. One we have just been seeing several times in Argentinita. She was a pupil of Argentina who you may have seen in New York. When I first saw Argentinita it was 17 years ago. She was little known then. A beginner. Now she is a great master of dancing, preserving much of the old style. Wonderful gestures. And is also a good singer and excellent comedienne. Another is Marie Conesa, a plump and beautiful woman with wit and fine dancing. Does some Mex-

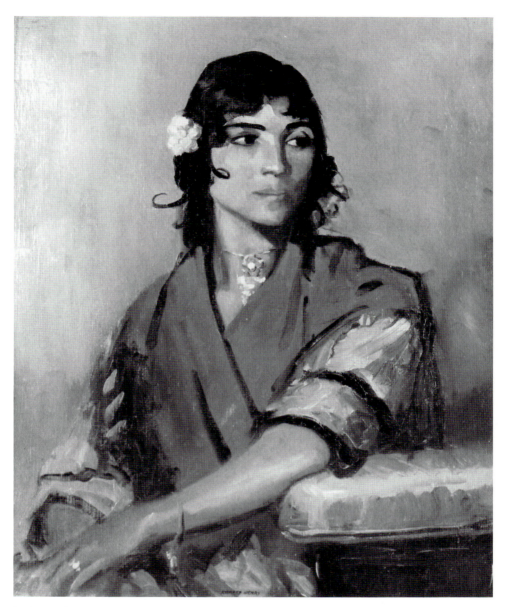

105. Henri, *Argentina of Madrid*, 1924

ican dances and songs that are facinating. Somehow these Spanish dancers and singers have a spirit and vivacity that is wonderful. The curious thing about them is that they do not represent the people at all. Other women are possibly so restricted that they can only go to mass, observe the conventions, which are many and most limiting, eat sweet things, drink chocolate, and grow fat. Naturally it is not respectable to think much, and it appears that all they miss goes into the wicked but free ones, and so these have all the vitality, wit, wisdom and possibility of expressing beauty that all the others miss.

I am mighty glad you like the book. It has been rather a surprise to me, for things read better printed well on good paper than they ever did in the manuscript. It was a big job and took a lot of time—a lot more than I would have ever dreamed of giving it. But, once started I had to go on. And now I am glad I didnt know the measure of the job and that it is done. Miss Ryerson[2] has been sending me the clippings, and they have certainly given the book a great welcome. I have also received some fine letters. There are also a few extra requests to lecture before clubs. All you got to do is to write down what you have to say so anybody can read it, then they have you come and talk it.

I am glad you have that teaching job in Baltimore. The Charcoal Club fellows are fine fellows. Hope you will meet them. And the director of your school is one of them. I dont envie you much the trip by RR so often. But then you have had the Pittsburg trip and this one is nothing to that.

Back to your first letter. I think the making of the wall was a great thing to do because the place seemed to me to need just that and I am pretty sure that it made you feel that you were in your own place instead of being in the place that you and all the other people in the neighborhood were in. That was always one of the fine things about the Safford place. I wish we had a place there of our own. I would like it about a third or a half mile further out towards the canyon on the same side of the river as the Safford house. One of those old places there made over livable. If you can find some one to buy 20,000 worth from me I will put it in such a place. I shall need of course the full value for I suppose it would eat up fully that amount to buy and fix up such a place.

A very nice little dancer just came in to arrange for poses. She came with her father who told me he was an ex-bullfighter. Was a picador with Mazantinito whom I saw get gored in the back many years ago here in the Madrid ring. He got well enough to live a year, but died at the end of that time. The fact that I had seen Mazantinito, and therefore himself as the picador in the ring, made everything right between us. I start with the little dancer on Monday and I hope I will do so well that this little dancer will pay for the house in Santa Fe.[3]

There are very few foreigners here in Madrid. The only ones from our

world that I know—artists—are Maurice Fromkes,[4] who has been here three years, and C C Cooper.[5] We ate Thanksgiving dinner with the Fromkes, or rather they ate with us, and we have seen Cooper who was sick. This is a great place for colds, and Cooper had a bad one. He is here making his usual churches and street scenes.

About the Independents Ex[6] all I can do is send my check and trust that you can find something for it. There are pictures at Macbeths, Daniels, Ferargil. I think that Bellows has some that were in the hands of Bowes, or perhaps there is something that could be had thru Viv.

Well I guess this will be about all, and hoping to hear from you soon.

Yours
Henri

[1] From a typed transcription.
[2] Margery Ryerson, a Henri student, compiled *The Art Spirit*.
[3] In January he painted six portraits of the thirteen-year-old Dorita.
[4] A painter of figure and religious subjects.
[5] Colin C. Cooper was an artist Henri had known since their student days.
[6] The Society of Independent Artists' annual show.

c/o International Banking Corp.
Carrera de S. Jeronimo, Madrid, Spain
Jan 31 1924[1]

Dear John and Dolly:

I read by the papers that Sloan and Henri were the first to sell pictures at the New Society![2] I also have heard that I sold a drawing. This is a wonderful state of affairs and I hope that it is only a sign of what is to occur in 1924. I am now wondering if there have been still more strange people coming into the society show. There have been other pictures by Sloan and Henri on exhibition there and they have been equally for sale. I am wondering too if anything happened at the Macbeth show.[3] I expect that the next mail will tell if that panned out as usual or if it too had a sensation—a sale—in it. Living and hoping.

I received your letter with the check for $375, final payment of your indebtedness to me. The check has been sent to my bank in New York for collection. We got also the fine etchings, yours and that of the Hamlins. Altogether these things have made us homesick. We think of lots of fine times we are missing and are mighty sorry we were not with you all at the Kennedy Thompson party which followed the New Society dinner. It was mentioned in a letter from the Thompsons and it sounded like very much of a party.

Our life here is a very quiet one. Working every day with the usual

variations of success and failure, occasional visits to the Prado, and regular twice a week visits to our neighboring variety show where we have arranged with the management for the same very good seats to be reserved for us so that we are never worried about getting a good place no matter how popular the show is. Perhaps I said in a former letter that the women singers and dancers of Spain are unique for their wit and vivacity, that it seems as though all the spirits that convention and religious institutions have repressed in the "good" women come out in the free ones. And I dont remember whether I mentioned our Clown, Rampar by name, who is a regular institution in our variety show, and good for a steady laugh each time. He would suit you. Once in a while we meet with the Maurice Fromkes, go to a show with them and afterwards eat dinner with them in a german restaurant called "Heidelberg". In spite of all the recent criticisms of the germans the desire to get some really good food has driven some of the most violent haters to a treaty of peace during meal hours. The last time we went was after a show that had all the wonderful costumes that were worn in Madrid in the sixties or thereabout. Its a pity to compare the clothes of that time with those of the present. I have not seen Fromkes work yet. Am going this coming Saturday. Have heard from others that he is doing fine. He has been here three years.

I wonder how much your sale of twenty thousand magnitude had to do with the courage of the New Society buyer. It may just be, and if so the Hamlin purchase may be the cause of many other good things. Hope so.

Marjorie says she is going to write Dolly one of these days and that she will expect Dolly to answer her one of these days. We have read the J.S. article about the Indians in the Arts and Decoration.[4] So we are to have our Indian Dances taken away from us and the Indians. It will be a wonderful country by the time we get back, judging from all the suppressions we read of. Just read, by the way, that a book by Floyd Dell has been suppressed. Have you read it? Marjorie says send it along if it is available, and doesnt cost too much. It appears that the main fact about prohibition is that you can get anything that is prohibited, the only difference being that you have to pay twenty people for it instead of only having to pay one or two.

The fire in the stove is going out and it is near half past eight so we are about to leave the studio for the hotel and our nine o'clock dinner. They tell us that we will have no need of the stove by the end of Feb. We will see about that. Good Night. Please write soon for we need your letters.

Yours,

Robert Henri

[1] From a typed transcription.
[2] The 5th Annual Exhibition of the New Society of Artists, held at the Anderson Gallery, 2–23 Jan. 1924.

³ Henri and Grace Ravlin exhibited in a two-person show at the Macbeth Gallery, 2–21 Jan. 1924.

⁴ "The Indian Dance from the Artist's Point of View," *Arts and Decoration*, 20 (Jan. 1924), 17, 56.

[*From Marjorie Henri to Dolly Sloan*]

Madrid March 6ᵗʰ 1924

Dear Dolly—

We are just over "La Carnaval" It began Sunday—lasting until late last night Most everyone in fancy costume in the streets—much drinking— and at night many masked Balls, which a respectable person could attend until 2 A.M., at which time arrived the Ladies of the Night to eat up the poor men, who were half seas over. These dances are very very rough, so we hear—So not speaking the language perfectly, and not knowing any real people here we didn't go, much to my sorrow—Judgeing from the attitude of the men in the street, any morning or afternoon, I think we done right, tho hated giving in to my wiser feelings—It seems that terrible things happen Ladies with three or four sheets to the wind are thrown from an upper balcony to a lower, being caught by the skirts, or garters by the men below—Well maybe what we've heard is much better than what actually occurs.

Had a letter from Edith Glackens the other day—She said she had never seen you look prettier than at the New Society Dinner and that your dress was gorgeous.

By the time this letter reaches you, the Independents Show, and the Dance will be over and without us—How can such things be I ask. It doesn't seem right nor proper. We go no place here, there is what is called the British American Colony—but [by] no means our Colony. We've been asked around a lot, but having been accustomed to strong meat in the way of friends and Parties, these egg shell China—highfalutin empty gawther-ings make you feel ashamed of yourselves—so not for us. I was dragged to two or three "teas"—in fine places, decked out almost as meuseums, we eat at a long authentic table, drank tea, & ate fat-ey pastry—The talk was of old furniture, How to approach antique dealers. Servants of years months, or days, and Cawn't I paws you some more cake Mrs So & So—? Its really very good yes, isnt it, and so simple to make, Remind me, wont you, to give you the recipe—. OH Yes really good things can be gotten in Spain, if one only knows where to look—Pushed you off the sidewalk—OH you mustn't be so easy going Just remember An Anglosaxon never gives way —Fix them with a look my dear! What are they really when you come right down to it—Savages, Really Negroes, you know, and such children,

even the King they say can be wound around ones finger—etc—etc—

Bob is painting every day—We go to the Prado a lot, and at 5.30 twice a week to our favorite Variety Theatre, around the corner. Two weeks ago, we quit our Hotel—couldn't stand the food another minute—We are now living in the apartment connected with the studio—The studio is huge, ¼ or more larger than ours at 10 Gram—An entrance Hall, large bedroom and bathroom—We eat in about three times a week—The other nights dine at the German Restaurant—By this time I have nerve and Spanish enough to go into any store, and if I dont see what I want, ask for it, Begosh! I'm wearing out all my old clothes—Tonight we had fried chicken, rice artichokes, salad, grapes and raisins, and a half bottle of wine between us—The wine costs less than .24 a bottle, & is much easier than making coffee. Well this is all about us, We miss you both and the goings and comings like every-thing—but its an experience and as M<u>r</u> Yeats[1] used to say—One can't be always in the same place.

I expect an answer to this, more than an answer, a Diary—all about everything and everybody. Read the other night that John D[2] is no more, said to Bob that probably now Harp playing in Heaven is a thing of the past—and Golf reigns in its stead—It isnt every day, or year, that the richest man in the World enters the Kingdom—so they'll have to show him a good time, when he arrives

We intend leaving Spain May 1st and going to Ireland—if we can get our old house. Am awaiting a letter now. We've had one letter from the Irish Land Commission, everything, except the body of the letter in Gaelic—the "Dear Sir", and "Yours truly", date, etc—all in a foreign language—We're keeping it, so you'll get a look at it some time in Oct—I didn't send to the Independents, because tho I have a lot of drawings they are all on sheets of paper this size—& most of them in pencil—Have many ideas in color started, but none complete, or that I am sure of, also to get any thing past the Customs since the Revolution is some job—But next year I'll be in strong—Our love to you and John—Viv has written that she is going with you to the Independents Dance—Have a good time, Dam youse I say—Yours Marjorie

[1] John Butler Yeats.
[2] John D. Rockefeller's death was reported prematurely; he actually died thirteen years later, on 23 May 1937.

The Henris left for Ireland in June 1924 and occupied the same house on Achill Island that they had rented for four months in 1913. By the end of the summer they had purchased the place.

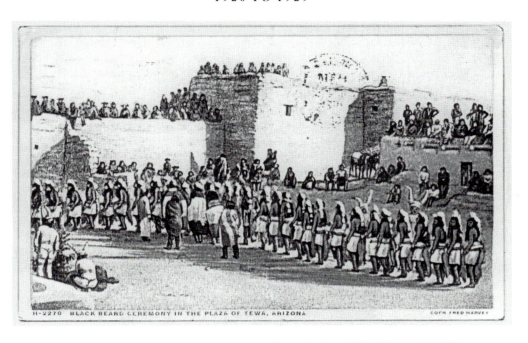

H-2270 BLACK BEARD CEREMONY IN THE PLAZA OF TEWA, ARIZONA COPR FRED HARVEY

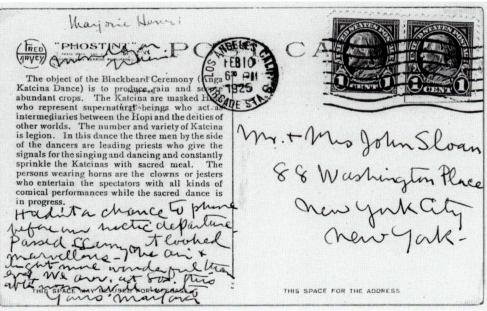

"PHOSTINT"

The object of the Blackbeard Ceremony (Anga Katcina Dance) is to produce rain and secure abundant crops. The Katcina are masked Hopi who represent supernatural beings who act as intermediaries between the Hopi and the deities of other worlds. The number and variety of Katcina is legion. In this dance the three men by the side of the dancers are leading priests who give the signals for the singing and dancing and constantly sprinkle the Katcinas with sacred meal. The persons wearing horns are the clowns or jesters who entertain the spectators with all kinds of comical performances while the sacred dance is in progress.

THIS SPACE FOR THE ADDRESS

Henri initiated a long series of paintings of Irish children which he continued during annual visits through the next four years. He came to refer to his subjects in the same way he spoke of the portraits he had created in San Diego, Santa Fe, Madrid, and elsewhere—as "My People," without further designation as to name or origins:

My love of mankind is individual, not national. . . . Everywhere I see at times this beautiful expression of the dignity of life, to which I respond with a wish to preserve this beauty of humanity. (*The Art Spirit*, p. 148)

(New Number) 314 Garcia Street
Santa Fe, N.M.
June 25, 1925[1]

Dear Henris:—

I suppose that you are now well settled for the summer in your Irish manor house—as we are, now, in our little gray "dobe" home in Santa Fe. We found it necessary to spend the first three weeks in repairing, cleaning and adding to our house which we now think about perfect, excepting the plastering of our party wall which is still in the rough "dobe". The tenants of the last winter were awful in their ravages! He and she both artists and a kid boy who just smashed at will. For the first time in five years experience with tenants we have sent them a bill of damages, which we hope we may get.

This land looked better than ever to me this time,—love for it has sprung up in place of surprise. I have not been about much (being so busy with my carpenter and plasterers. We have turned that little back portale into a nice cool breakfast room) but yesterday we hitched up the Ford and made a trip to San Juan pueblo and saw the races—no dance but a general countryside Fiesta with all sorts of side show catch penny booths and an amazing gathering of Indians, Mexicans and tenderfeet. Wonderful color and the hilly pueblo most beautifully situated. I had never visited San Juan before.

Dolly is riding, she is now using her second horse. The first one died after two weeks, not at all from overuse. It had acted queerly and one afternoon she gave it its own way and it took her to a Mexican household in Agua Fria where the family all rushed out and cried over it and patted it—they had sold it through a dealer and were glad to see it again. That night it stood trembling in our corral and then laid down and died. May have gotten hold of some poisoned scrap intended for cats—for George Valdes[2] tells me that our tenants poisoned cats during the winter.

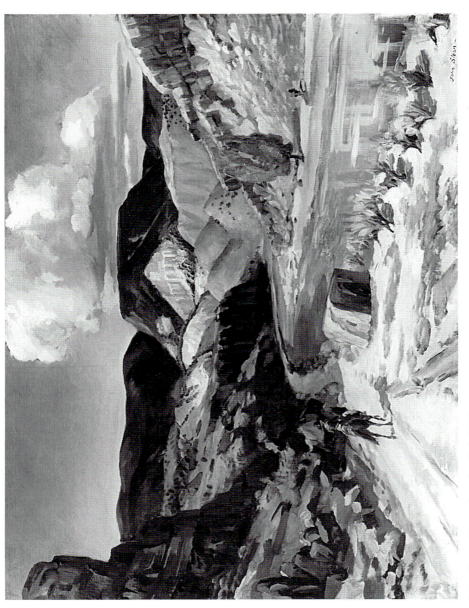

106. Sloan, *Chama Running Red*, 1925

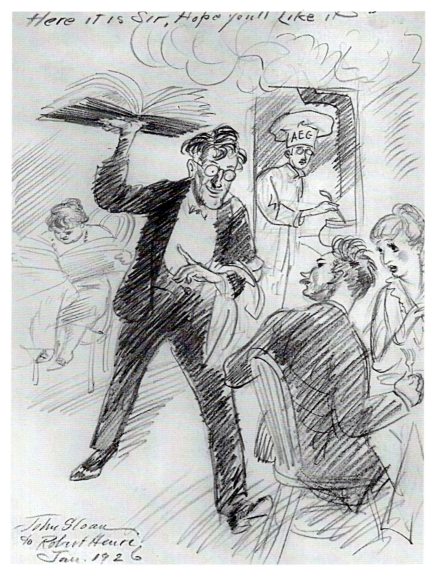

107. Sloan, *Here It Is, Sir, Hope You Like It,* Sloan presenting Henri with a copy of
A. E. Gallatin's just-published book, *John Sloan,* 1926

Santa Fe is extra dry this summer so far. We are now forbidden to use water for any other than household purposes. We need rain very badly—but oh the beautiful skies—you know them—and the generous heat of the sun and the soothing cool of the shadows.

I have seen Parsons and his new house. It is certainly a well done job. I think it is splendid.

Shuster seems about as well as ever, not very well, but pretty busy in his art iron-work. We miss the Daveys, but it enables us to pass a rather more restful summer. I have not entered the Museum as yet, have been too busy. Nor have I made any attempt to paint—but that is coming soon, now that the house is finished. We are keeping good hours so far, early to bed and early to rise.

Yesterday at San Juan Fiesta I recognized a familiar face, Homer Boss![3] no other—with Miss Kent, sister of Rockwell K. They, or at least he said he was stopping near Alcalde which is only about three miles from San Juan Pueblo. He had only arrived a day or so before.

Ashby Davis took us for a ride in his new Jewett car—to Truches, a large Mexican town in the mountains north of Chimayo, higher than Santa Fe by a thousand or two feet or more. I do not remember you speaking of having been there. It is beautifully situated on a sort of flat topped ridge, the great Truchas peaks are near—the highest in the range, one marked by a cross shaped gully "The Cross of Truchas". Truchas means trout; there are plenty of them in the stream toward the mountains.

Well, we are very happy and feeling well. I will feel better when I have painted something, but working on the house is nearly the same joy to me.

We hope that you two are both happy and well and be sure that you are always in our thoughts. Write when you have time. We are only one-fourth of the circumference of the globe apart—might be worse! This pen has gone "fluey" or dry or something. It's about bedtime, nine-thirty or so—so goodbye.

<div style="text-align: right;">

With our best love to you both
Yours
John Sloan

</div>

[1] From a typed transcription.

[2] The Sloans' gardener.

[3] Homer Boss was a former Henri student who assumed control of the Henri School when Henri stepped down in 1912.

Apr 16 1926[1]

Dear John:

I have just received a letter from Wm Preston Harrison of Los Angeles, just a friendly letter dealing with various topics. One of them is that he has tried to get in touch with you but has failed. Says he has written you several letters but gets no answer. He wants to buy one of your pictures for the Los Angeles Museum (Harrison Collection).[2]

Have you received letters from him within the last several months? If you have not, putting this together with your failure to receive other mail, notices NSA[3] etc. perhaps there is something wrong with your mail delivery.

I have written Mr Harrison that I do not believe you could have received his letters else he would have surely had answer. Harrison is O K and a good man.

Its nice down here and I am working along with hope that Ill be through soon[4]—expect to be back by 20th.

Yours
Henri

[1] Letterhead is The Virginian, Lynchburg, Va.
[2] Harrison subsequently purchased Sloan's Gloucester painting of *The Town Steps*, 1916, presenting it to the museum in 1927. He had acquired a Henri oil, *Pepita of Santa Fe* (Julianito), 1917, in the year it was created, and in 1925 commissioned a portrait of Mrs. Harrison.
[3] The New Society of Artists.
[4] Henri was in Lynchburg, Virginia, having accepted a commission to paint the portrait of Mrs. Robert C. Watts.

[*From Dolly Sloan to Marjorie Henri*]

June 9, 1926[1]
Santa Fe

Dear Marjorie

Your letter received. In it you say you will be in Spain until June 25th 1926 so I am rushing this letter off right away, to Spain. Your letter of the 21st of May reached here this morning. Henri's instruction written by him says until June 6th but I know you always leave a forward so this will finally reach you. Sloan sent to Ireland a postal card en route.

We came out very nicely. Took the Lake Shore Limited to Chicago Saturday evening May 29th, arrived in Lamy 8:20 A.M. Tuesday morning on the California Limited. Had a compartment so Sloan was able to lie abed all the way from Chicago.[2]

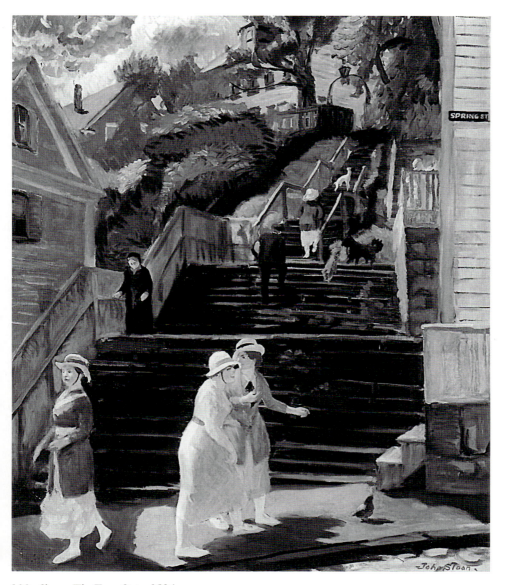

108. Sloan, *The Town Steps*, 1916

I do not know whether he is better or not. It is so hard to get the right food here and also hard to get your prescriptions filled. Of course the change has something to do with it, so I will just go on and take good care of him and hope for the best.

Florence[3] has to go back to New York on July 22nd when Hitzrot returns from abroad to have the cyst operation. We saw her Saturday night and of course she does not feel very chipper.

Dave[4] was playing tennis yesterday and broke a bone in his ankle. He was to leave for Colorado Springs this coming Sunday. I do not know whether he will be able to or not.

Shusters all seem well and send you their best. Dr. Hewett has not come here yet. Ashby Davis has not been so well, had his tonsils out. He wants to be remembered to you both.

Mrs. H. P. Whitney[5] has purchased a complete set of etchings[6] and presented them to the Metropolitan Museum. They have not officially accepted as yet but Kraushaar[7] says they will take them. Preston Harrison has bought for the Harrison Gallery "Town Steps, Gloucester, Mass.". He will take some time to pay, but he is perfectly good. We have not received the Mrs. H.P.W. check as yet, but that also is very good.

I have a new horse, will take my first ride tomorrow. $45.00, Blackie by name.

I also have a wonderful maid. She will do everything but cook so it looks as if I will have a very easy summer and I guess in a week or so Sloan will be acclimated and start to work and build up for the Fall. He has had "Thank Heavens" no return of those awful pains.

We had dinner at Mary Roberts[8] two nights before we left New York. It was very nice, just the four of us. Jacque Thomas has just dropped in and said to say Hello for her. Sloan just added too bad about Davey, he might have broken his arm playing checkers.

Let me hear from you and I will write immediately.

<div align="center">

Love to you both

from

Dolly and John Sloan

</div>

[1] From a typed transcription.

[2] Sloan was suffering from a hernia, as he had four years earlier.

[3] Florence Davey, Randall's wife.

[4] Randall Davey.

[5] Gertrude Vanderbilt (Mrs. Harry Payne) Whitney (1875–1942), an important collector and patron of art.

[6] The ten prints in his "New York City Life" set created in 1905–06.

[7] John F. Kraushaar was Sloan's dealer and owner of the gallery bearing his name.

[8] Mary Fanton Roberts.

[Written by Dolly Sloan]

<div align="right">

July 29, 1926[1]
Santa Fe

</div>

Dear Marjorie and Henri

This is the morning after my birthday. Helen[2] gave me a birthday dinner. Enough said.

I think your letter was a wonder and I will keep it and some day we can have it published and used against European travelers.

I suppose that you and Henri have been informed of the death of Roshanara.[3] We were on a picnic with Olive Rush,[4] the Kreymborgs[5] and Paul Rosenfeld and it was mentioned. Of course you know who Kreymborg is and Rosenfeld is the musical critic for the Dial and he has written a beautiful critique of Miss Enters[6] dancing and apparently from the way he spoke he was an ardent admirer of Roshanara. When you hear that a girl like Roshanara has gone on it makes you pause and wonder if the arts aside from painting are worth while after all, though I do remember Henri has painted her[7] and she will live in that way. You as an artist will live in the drawings you have made and I who have never done anything will count when I am gone as John Sloan's wife and your friend.

Santa Fe is filled with artists and writers from the East and without the Cultural Colony it is spoiled by the Harvey System[8] to some degree.

Ashby Davis and the Shusters are always asking for you both. Kroll is here and he speaks affectionately about Mr. Henri.

Now I will confess the Sloans' faults. Sloan has bought a Studebaker car for $800.⁰⁰ and some dollars. He has a year to pay it. We also increased the debt on the house for $1000.⁰⁰ which he borrowed from Shuster to let him build a studio and sleeping quarters.

Sloan is really not well and I do not know just how to handle him. Foster insists that the only way he can be well is to have an operation.[9] I will not agree to anything like that out here. I would rather if possible to build him up physically and decide after we are back in New York about operating. He has not gained an once in weight. He has not had any pains but is full of gas all the time.

We are both happy, and I am happier but worried about Sloan's health. I guess in my last letter I told you that Mrs. Whitney had bought for $1500.⁰⁰ dollars the complete set of Sloan's etchings, and the Metropolitan accepted the gift. Mr. Harrison bought "Town Steps" for $850.⁰⁰ for the Harrison Gallery. He has sent $450.⁰⁰ to Kraushaar but Kraushaar is in Europe and I suppose when he comes back he will send it on to John Sloan.

According to all reports there is great suffering in the East with the hot

weather and electric storms. It seems hard to believe out here. Our place is looking wonderful. Sloan has painted about four canvases, small, but he feels they are important.

Well, Marjorie dear, I will close and go out and cook lunch. Let me hear from you when you feel like it and I want you both to know how much the Sloan family love the Henris.

<div align="center">Adieu</div>

Good luck, good fishing and good health always

<div align="right">Love to you both
from
Dolly and John Sloan</div>

[1] From a typed transcription.

[2] Helen Niles.

[3] Roshanara (1894–1926), whose real name was Olive Craddock. Born in Calcutta, she was an English dancer specializing in Indian and Asian performance styles.

[4] An illustrator who had studied with Howard Pyle.

[5] Alfred Kreymborg was editor of the monthly *Glebe*.

[6] In 1925 Sloan began a series of etchings of the dancer Angna Enters.

[7] In May–June 1919.

[8] Fred Harvey's restaurants were established throughout the West and Southwest along the route of the Atchison, Topeka & Santa Fe Railway.

[9] Dr. Joseph Foster, Sloan's doctor in Santa Fe, recommended an appendectomy and a second hernia operation, which were subsequently performed.

<div align="right">[August 1926; undated]</div>

Dear Robert Henri and Marjorie:—

We have just passed our 25th Wedding Anniversary and pulled off a big party to celebrate the occasion—about 80 guests plenty of moonshine and orange juice a really successful stunt—we missed you both, and, if wishes were fulfilled, you would have been whisked over here the night of the Fifth of August, and Im sure, you would have enjoyed it. We had the garden brightly illuminated, and, as we have had plenty of rain the past season, everything looked beautifully theatrical—dahlias & hollyhocks fruit trees and vines all lit by the electric lights. The whole crowd had a good time Dolly and I kept off the liquid and saw to it that things went smoothly—Dolly is still narrating the amusing incidents. The Santa Fe Fiesta is over now, wound up with the big Conquestadores Ball last night which we did not attend—The artists and writers of the town laid off this year as we found that our whimsicallities of former years were not wanted by the dignitaries of the Fiesta—consequently, I believe the impression of the Fiesta this year is that it fell dully.

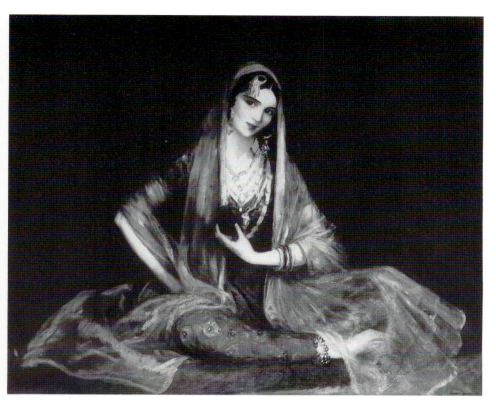

109. Henri, *Roshanara*, 1919

My health is, I think, improving I have not done much painting as yet, but have made a start and feel that I will produce more in the next five weeks—

Shuster is adding a studio, reception room, and two bedrooms to his house and I think when finished it will about make it a real domicile—less of the hovel atmosphere—he painted a portrait of me which he has presented to me—it is a very good canvas and a "likeness" as well, simply, directly, painted

[313]

I am sending you a print of a plate which I made out here as a Souvenir of the Wedding Anniversary[1]—I sent out about 50 proofs to invited friends—to square us in the event of presents (of which by the way there were many)

The Studebaker car is going fine—I can drive it pretty completely now—and it is quite a thing to be able to run out 40 miles and back without the nerve tension of a Ford and in much less time where the route lies over goodish roads.

I suppose that you are busy painting by this time and I hope that you are enjoying it—and, of course, the fishing (which by the way is good here this season, they say) With our best and fondest regards—yours always

Dolly and John Sloan[2]

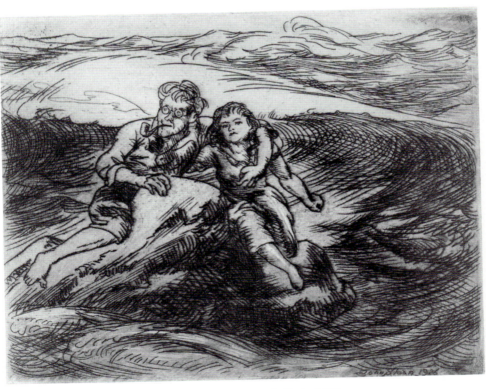

110. Sloan, *Twenty-Fifth Wedding Anniversary*, or *On the Rocks*, 1926

We are planning to go to Gallup for the Intertribal Indian Fiesta August 24th we have heard of it for the last 3 years and everyone says it is a splendid exhibition—With the Studebaker it will probably be an easy trip

[1] *Twenty-Fifth Wedding Anniversary*, or *On the Rocks*.
[2] The letter is in John Sloan's handwriting.

Santa Fe New Mexico
314 Calle Garcia
June 22nd 1927

Dear Marjorie & Bob

Well here we are in Santa Fe and in our own house we left New York on the 9th of June spent the 10th in Chicago with Frances Strain and her sister[1] left Chi[cago] Sat and arrived at Lamy on Monday June 13th Ashby Davis met us at Lamy & we stayed with himself & wife until last Wednesday the 15th Mrs Davis is a charming person nothing exciting happened after you all left except Sloan was in awful bad shape I thought he might collapse but he didn't but he is still far from well we are taking it very easy going to bed early & getting long night sleep. I had to do all of the preparing to come out so what with the anxiety about Sloan & packing when I arrived here I went to pieces saw the doctor & he told me it was the awful strain I had been under and I was very very anemic

He has ordered sun baths & I am taking them every day. you start with 5 minutes and add one minute a day. Sloan is taking them too. Dave had gone to the Springs before we arrived but Florence only left the other day—I find her quite changed. when I see you in the Fall I must tell you all of the gossip about Florence on her birthday party they now have a Packard straight 8, and I believe are feeling poor Davey can not afford to send Bill to school this winter so Grandpa is going to do it. Florence tells me they will all be in New York this coming winter Bill is really a fine boy outside of the wear and tear of 3 dogs on the place the place is fine house clean and all of my bed & floor blankets sent to the laundry. Shus[2] is in fine physical condition they send their best to you both Sloan is sorry to report that Shus paintings are not up to the standard that Sloan hoped they would be. I saw Dr. Hewett in the street but he was busy so he did not see me. Rockefellers here bought a large tract of land in the Lamy road & are going to put up a million dollar foundation. it is surprising the number of worth while houses that have been built since we left last fall. You and Henri had better come out before the town changes entirely [Viv][3] was sweet enough to call me up before we left town I was quite blue and appreciated it.

I thought your letter was a knock out & I am looking forward to hearing about the ride home in the Ford—I see by the papers that they are going to let Lindy[4] take one months rest. we left before he came in to New York so we did not see the excitement

I hope my next letter will be a bit more cheerful, but I felt I wanted to write to you—

Our love to you both.

<div style="text-align:right">
From

Dolly & John Sloan.[5]
</div>

[1] Gertrude. Frances Strain had studied with Sloan and in the 1930s assumed charge of the Renaissance Gallery at the University of Chicago.

[2] Will Shuster.

[3] Nickname of Henri's sister-in-law Violet Organ.

[4] Charles A. Lindbergh, after returning to the U.S. following his solo flight across the Atlantic.

[5] This letter is in Dolly Sloan's handwriting.

<div style="text-align:right">Sep 8 1927[1]</div>

Dear John & Dolly:

We got your fine letter with pictures of yourselves as horse riders—very fine—and as you said in the letter that no doubt your letter would cross one of mine I made up my mind to write immediately so to bring that as near true as possible—but it is already a good bit of time since I made that fine resolve. I have been off letter writing all summer—in fact I have hardly attended to anything, business or otherwise where writing was necessary. Somehow this is the busiest place I get to—here where most of the things one has to do are lopped off. Its a strenuous life. Sleep is necessary in this air and I get to bed about 2 or 3 am. up about 10 or 10.30. Fifteen minutes in the green house urging on the flowers. a breakfast on trout.— I never get tired of them. Then somehow there are things to do that eat up the period between breakfast and painting. The model is always here waiting. As soon as I get through painting I rush in a bit of food, rush on my rubber boots and other things until I am thoroughly water proof Then the ford is rumbling at the front door and Pat[2] and his son Edward and I are off down the hill and on to Keel Lake with the hope of getting a big sea trout or a big brown trout and with the certainty of getting a number of small ones—except maybe an exceptional day when they cant be induced to rise at all—wh is very seldom.

With this unusual weather (that seems to be all over the world—I wonder who put those spots on the sun!) it is strenuous work—sometimes it is a hurricane on the lake—Pat and I have some heavy rowing at times—

we have two pairs of oars and even with them we are sometimes driven to beach the boat and wait for a lull. Edward, Pats son takes care of the Ford. I am making a good driver of him (better than I am myself) and he nurses the car quite well—It is a ford sedan—all closed in rain and all open in a minute when so wanted. It is a good looking thing and of a very handsome plymouth blue. Perhaps they are not equal to the Detroit make—I do not think they are—but it acts like a ford and goes.

We had a big flood—one of our storms and it washed an ocean of water down the mountain—it seemed as if Corrymore Lake had broken loose. It came thru the house in parts knee deep. We took up a part of the floor in the studio. The water disappeared through it—where it went God knows. We never found an outlet from under the house. This land is bog (turf-peet) for about 6 feet down—then it is all big stones sand and gravel—there must be many underground "rivers". Anyhow it was an exciting flood—came on us in an instant as if something had broken loose. We have had ditches dug above the house to drain floods off and it is likely not to happen again. This was the big storm—or flood, rather—for 20 or 30 years, etc. It carried away one of the bridges—stone—down in Dooagh (the village) We had crossed it in the Ford coming home from the lake in the dark. They say our lights were still going up the hill when the bridge went—five minutes perhaps after we crossed it—and it collapsed completely. Next day I made a reputation by driving down the steep road which had been wrecked as a road and fording the stream—there was just one place this could be done. A half hours work with half the village helping or looking on got stones etc into shape for the crossing and then the little ford did it—as many a ford in New Mex has done much worse. It would have been nothing to you but I got a reputation something like Lindeberg's on it. I am now not only the american who paints the children and pays them a man's day's wages for it but I am a man of might! They havent experience in these things here.

Well, the work (painting) is being done. I dont know how it is—may be some good. Have had a lot of interest and enthusiasm in it during the doing—This business of fishing, being for hours outdoors in the boat, weathering storms, walking a good bit, rowing against hard winds seems to put me in fine form. I am tired when I sit down to dinner at about 12 oclock, night, and I wouldnt write a letter or do anything for the next two hours before going to bed for anything, but next day I am in fine form for painting. I think I ought to have a photograph taken of my waist line before the steamer trip home restores it. The biggest trout I have caught was a sea trout one and a quarter pound—I havent had the luck to run into any of the very big ones but I still hope. We do not go much to our old lake (Corrymore) above us—but go down to Keel Lake, 5 miles, where the sea trout can come in Keel Lake is much larger—about 2 miles

by one and a half, and open to all winds—connected by a small stream with the sea over a beach of about ⅓ mile. Its up this river in high tides & flood that the sea trout come to the lake.

Our ford trip from Cork to Dublin Dublin to Achill was uneventful and the country we passed through had nothing to compare with our country out here. Of course we have made some trips to places in this vacinity but extended travel is not very inviting because the hotels are the limit both in food & beds. (one pays New York prices and there is worse than nothing for it.)

I have intended making a snap shot of the ford—but havent got to it.

Sun Baths

Storm Baths.

Yours. R.H.

¹ Stamped letterhead: Robert Henri, Corrymore House, Keel P.O. Achill ID., Co. Mayo, Ireland.

² Patrick O'Donnell, caretaker of the Henris' house, manned the rowboat for Henri's fishing trips.

Dear Henri:—
Here is the fifteen hundred with joy and thanks and hopes that I will not need your generous boost in finances for some time

Yours always
John Sloan

Feb 9 / 28

Beginning in September 1928 there were a series of sudden, violent storms while Henri was fishing on Keel Lake near his Achill Island studio. He subsequently blamed the weather and a resulting cold for an attack of neuritis that crippled his left leg during the return trip to New York in November.

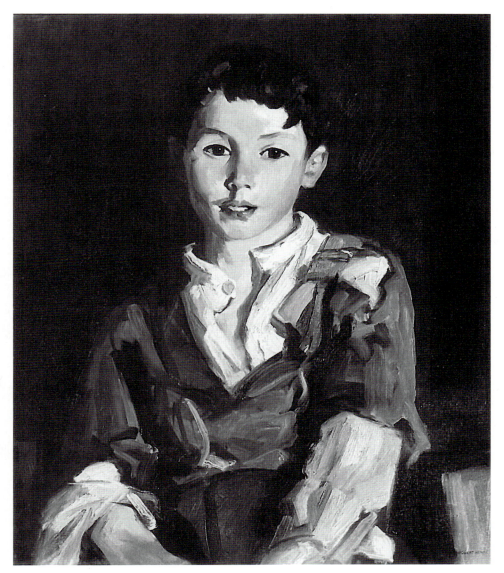

111. Henri, *The Brown-Eyed Boy* (Thomas Cafferty), 1926

Henri entered St. Luke's Hospital for what he thought would be a brief stay, but he was destined never to leave. When word of his condition began to circulate, friends sent cards and visited. Marjorie did her best to make him feel at home, placing one of his paintings on the wall opposite the bed and changing it on a regular basis; Sloan brought in a few of his own recent works before departing for Santa Fe (author's conversation with Margery Ryerson, 3 Jan. 1977).

Henri was never informed that he had prostate cancer which had spread to his pelvis and lower spine (St. Luke's Hospital records). He died on 12 July 1929, less than a month after Sloan wrote him a final letter.

Santa Fe, Sunday June 16 / 1929

Dear Henris:—

If wishes were airplanes you would have found yourselves mysteriously snatched up and transported to this place before this—it is more than usually beautiful—mountains have still spots of last winters snow, the spring was late—waiting for us perhaps roses have arrived since we. The sun has shone industriously and with what seems more than its usual benignity the shade is cool of course; our little house is clean and Dolly has put all our Lares & Penates back in proper position. our car is in good condition and today we took an 80 mile trip roundabout on new good roads to Española (new roads since last summer) Ashby Davis and Mrs. were along—Davis made inquiry of Safford (mentioning no names) as to rental of his house—S. said he would rent it if he could get $300. per month—it has had a bath room and 2 bed rooms added recently, and this rate is not high judged by the rentals for Summer—although if you requested he might make some special reduction to you as an "old customer" or on a years stay.

We have been here only a week today but have already built a room 10 × 12 in the garden it is not anything permanent so dont think us foolish— sides of muslin and no roof an excellent sunbath room and we have had a couple of good sun saturations already Ill bet a few exposures of that leg of yours (and the rest of you)—would soon put a new set of nerves in you (forget a prescription take often if you choose)

Ashby Davis has sold out the Wood Davis Hardware Co and is a retired business man now—I think I can get him going at painting and am going to see what he will do—I think there is some of the necessary desire within him.

Shuster has just returned to Santa Fe from a three weeks examination in the Army Hospital at Ft. Bayard & says he feels as tho' released from a term in jail He has applied for a Disabled Officers Pension which if it is granted will give him nearly three times the income he now has. He has

some very good heads painted from pencil sketches he made in Juarez this spring also some small landscapes not so important.

Well thats about all for this time I hope to be able to write to you once a week or so, and be sure that we both send you both our love and good wishes and hopes that you may soon be able to join us in Santa Fe

Yours always
—Dolly and—John Sloan[1]

[1] This letter is in John Sloan's handwriting.

PATRONS ARE REQUESTED TO FAVOR THE COMPANY BY CRITICISM AND SUGGESTION CONCERNING ITS SERVICE 1201

WESTERN UNION

CLASS OF SERVICE

This is a full-rate Telegram or Cablegram unless its deferred character is indicated by a suitable sign above or preceding the address.

NEWCOMB CARLTON, PRESIDENT J. C. WILLEVER, FIRST VICE-PRESIDENT

SIGNS
DL = Day Letter
NM = Night Message
NL = Night Letter
LCO = Deferred Cable
CLT = Cable Letter
WLT = Week-End Letter

The filing time as shown in the date line on full-rate telegrams and day letters, and the time of receipt at destination as shown on all messages, is STANDARD TIME.

Received at 52 Lincoln Avenue (On the Plaza), Santa Fe, N. Mex. No. 530 and 531

47V VQ 13

NEWYORK NY 1116A JUL 12 1929

JOHN SLOAN

SANTAFE NMEX

MR HENRI DIED TODAY FROM SUDDEN HEART ATTACK FUNERAL PRIVATE WRITING

EMMA S BELLOWS

933A

THE QUICKEST, SUREST AND SAFEST WAY TO SEND MONEY IS BY TELEGRAPH OR CABLE

EPILOGUE

Dear John & Dolly

I am writing this from 146 East 19th N.Y. and it is just a note to explain that you will hear from Marjorie in detail all about everything as soon as she is able to write. She has had no sleep for two days and her eyes look as big as cart wheels. She really is a wonder—just think she knew last Dec. that Robert Henri would never get well and she has kept him happy and entertained every day for 8 months.

Dr. Lambert[1] said only last week that Mr. Henri was is such good condition that he thought he would live until Sept. anyway—then last Sat.[2] something radical happened and he began to go down very fast. The last two days he knew no one.

There is to be no funeral, his own desire, and everything will be as simple as possible. Raymond Lowes is taking care of the financial end and all the dealers have been notified to stop sales, and, until the fall there seems nothing much to be done.

Of course John and all his friends can do a lot later on but just now with every one out of town and the Galleries all shutting up for August things seem to be at a stand still.

Marjorie plans to go to Ireland directly and straighten things out there—Viv will go with her—She has plenty of money and the trip will do her good I am sure.

Losing Mr. Henri is just about the most terrible thing that could happen to me too and I know how even more so it is for you and John—He was and is a great man.

With lots of love
 to you both
 as ever
 Emma

July 12th 1929

[1] Dr. Sam Lambert was Henri's attending physician at St. Luke's Hospital in New York.
[2] 6 July 1929.

Immediately upon learning of Henri's death, Sloan began organizing a Robert Henri Memorial Association, "an effort to fulfill his life dream in the founding of a memorial hall, consisting of a series of galleries for unrestricted exhibitions"

("*Sloan Would Honor Lincoln of U.S. Art,*" Santa Fe American, *July 1929. Henri scrapbook). Sloan quickly chose a committee, composed of Speicher, Luks, Andrew Dasburg, John Marin, Randall Davey, Walter Ufer, Paul Dougherty, Mary Austin, and Witter Bynner to spearhead a nationwide drive. However, Marjorie squelched the idea for a two-million-dollar structure, contending that Henri would not have approved of money coming from the pockets of art students and artists for such an undertaking.*

Marjorie employed Mrs. George Bellows as the intermediary to make her views known to Sloan.

[*From Emma Bellows*]

Woodstock, Ulster Co. N.Y.
July 18th 1929

Dear John

Knowing your great love for Robert Henri I understand your wish to do him honor and assure for him the high place he earned and won. The idea for the $2,000,000 Art Gallery is a great one and so like you to think of it directly. To me raising the money seems the least part and the wise directing the most difficult. It needs careful planning of many things which I do not think can be gone into hurriedly and before starting a list of names for that do you not think it wise to be considering a memorial exhibition at the Metropolitan Museum as the most immediate and vital thing?

I know Mr. Henri drilled into me that an exhibition at the Metropolitan was the important event for George and to wait until that happened before planning anything else. I believe a list of Artists names had to be handed in petitioning the Directors to give such an exhibition and although that may, and I hope, will not be necessary in the Henri case, still, a note to Bryson Burroughs[1] from many artists asking the question—when will the Henri exhibition be? might start something.

When I left New York Marjorie was planning to go to Atlantic City and rest for two weeks at least—Doctors orders—and I do not think that she is in a condition to decide or discuss anything right now. She kept up wonderfully but said herself that she was about at the end of her rope.

Gene and Elsie[2] have had a very depressing home coming. Elsie's mother passed on late in May and just as Gene began painting the terrible news about Mr. Henri came. Gene will do anything he can but agrees with me that the Metropolitan is the next step and thinks confusion might arise in the public mind if we started too many things at once

Let me know what you think about all this as it is so easy to make

mistakes at a time like this We want the finest things to happen for Robert Henri in the finest way, after his own manner don't we?

<div align="center">As ever
Emma Bellows</div>

[1] Bryson Burroughs was Curator of Paintings at the Metropolitan Museum of Art.
[2] Eugene Speicher and his wife.

In the spring of 1930, Sloan initiated a letter-writing campaign requesting that the Metropolitan Museum of Art hold a Robert Henri Memorial Exhibition. His letter includes the names of nine other artists, two magazine editors, an art critic, and a collector whom he hoped would join the cause. Three additional individuals wrote supporting the plan: Charles A. Platt, an architect; Mabel Choate, a civic leader and daughter of a Metropolitan Museum founder and trustee; and Allen Tucker, an artist.

<div align="right">New York, May 1st 1930</div>

Mr. Edward Robinson, Director
Metropolitan Museum of Art
New York C.

May we earnestly suggest for the consideration of the Board of Directors of the Metropolitan Museum of Art that a comprehensive Memorial Exhibition of the work of Robert Henri be presented in the Museum in the near future.

<div align="center">(Signed)</div>

1	Sterling Calder	8	R[andall] Davey
2	Gari Melchers	9	James Frazer
3	Irving Wiles	10	Eug[ene] Speicher
4	Forbes Watson	11	Frank Crowninshield
5	Gif[ford] Beal	12	Mrs. Harry Payne Whitney
6	P[aul] Dougherty	13	Mary Fanton Roberts
7	G[eorge] Luks		

[*From Violet Organ to Dolly Sloan*]

243 Central Park West
[June 1930; undated]

Dear Dolly—

You've been waiting for that letter Marjorie promised in her telegram of a few weeks ago—I know you have been worried at the silence on her part, but she just put off writing you from day to day—and now she is not well enough to even think of it. . . .

Of course you know she has phlebitis—hope that's the right spelling—but the cause is not the varicose vein as the doctors first supposed but a cancerous growth that is stopping the circulation of her leg and eventually will cause her death. . . .

Up to a week ago I know Marjorie firmly believed everything the doctors said. All the things she has to do for Bob kept her from despairing, but for the last week she has been so quiet and listless that I'm wondering if she guesses and is beaten. . . .

Marjorie meant to write you at length about the pictures for the Memorial. Bob has left a pretty definite list of what he considers his best work. Working on that list to begin with and with pictures in the studio and some in storage, it won't be necessary to call for pictures owned by Museums and different people. There are enough pictures on hand to select his best from, and that is what Marjorie meant to do. I know for we have talked the matter over many times. So please Dolly don't do anything about borrowing pictures for the Memorial. You spoke about the Preston Harrison portrait and "Diegito." I think that is the name of the Indian picture in the Santa Fe Museum—Marjorie doesn't want you to do anything about them till the matter is well talked over.

Only Bobs finest things are going into the Memorial and as you know you have to live with a picture or else see it constantly, to be really sure it is all you meant it to be when you painted it. You know Bob always studied his pictures after he painted them, so I think and I'm sure you will agree that we had best confine our choice for the Memorial to those pictures we know Bob thought well of—to his finest only That doesn't say that "Diegito" and the Harrison portrait arent his finest, but that there are enough pictures to choose from without borrowing them or any others.

Do let me hear from you Dolly and forgive me for keeping you waiting so long for this letter, but I was so sure Marjorie would finally get to writing you herself about the pictures.

My love to you and John

Affectionately
Viv.

John Sloan's final artistic tribute to his long-time friend came in the form of an etching of him—produced from a sketch made some thirty years before—which served as the frontispiece for the Metropolitan Museum catalogue. He also wrote a poignant and personal introduction, reproduced below.

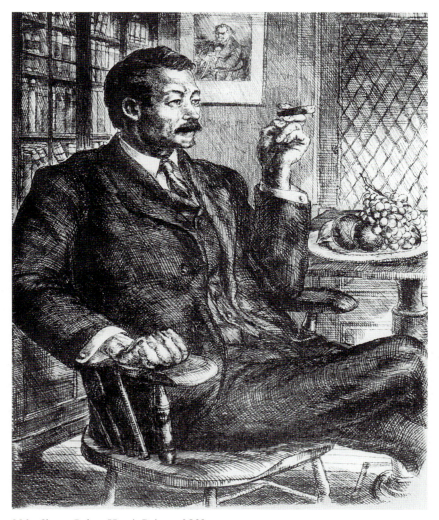

112. Sloan, *Robert Henri, Painter,* 1931

Robert Henri

✳

The Metropolitan Museum of Art is doing artists and that portion of the public interested in American art a valuable service in presenting a memorial exhibition of the work of a distinguished painter who has been a leader in the development of art in the United States.

Robert Henri, although he always held that art knows no nationality and claimed for the artist world-citizenship, was born in the United States, and his work and, or course, his outlook on life were marked by characteristics unquestionably the product of the American environment.

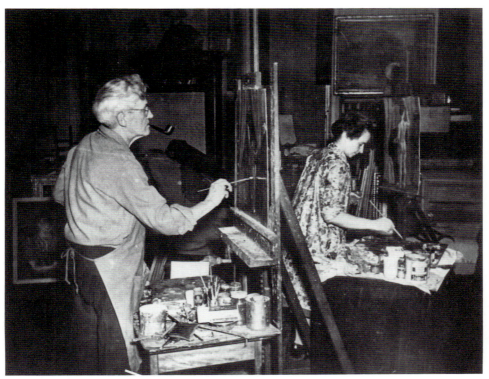

113. John Sloan and his wife Helen painting in the studio at the Hotel Chelsea, New York, 1950

Marked qualities of all his canvases are preoccupation with life about him, scenes and people presented with what might be called studied nervous energy, and direct means of expression.

For the last twenty years of his life Henri usually exhibited portraits or studies of personalities—children, men, and women—splendid in their direct statement of understanding of the human family, but his earlier canvases of city streets and landscapes are not to be overlooked. As one of those who profoundly felt his influence, the writer regards this little-known phase of Henri's work as having had a distinct influence on American painting of today, and the examples of this type of painting in the present exhibition should be given full attention.

Robert Henri gave as much of his life to helping others to free self-expression as he gave to his own work. His thirty years of teaching were devoted to the emancipation of the art spirit in the United States. His work and his inspiration as a teacher were factors in preparing for the earnest and growing interest in art which is so clearly in evidence in this young country today.

In assembling the material for this exhibition the chief objective has been to get together from the canvases in the possession of his estate a showing of works which will appeal primarily to fellow artists, for it is by the artists that the direct appraisal of his life work must be made. This selection has been augmented by a few important paintings from public and private collections, and it is hoped that the exhibition will afford students of art a full opportunity to form an estimate of the work of Robert Henri—his own monument—varied in character and subject matter, but consistent throughout with his high ideals of art in America.

<div style="text-align: right">John Sloan.</div>

March, 1931.

Chronology

✳

ROBERT HENRI		JOHN SLOAN
June 24. Born Robert Henry Cozad in Cincinnati, Ohio.	1865	
	1871	*August 2*. Born John French Sloan in Lock Haven, Pennsylvania.
Fall. Enrolls in Chickering Clasical and Scientific Institute, Cincinnati.	1875	
	1877	Moves to Philadelphia.
Winter. His father shoots an employee in Cozad, Nebraska, a town he founded; is indicted for murder; a warrant issued for his arrest. Cozads move to Denver.	1882–83	
Fall. Family assumes new identities. Robert Henry Cozad becomes Robert Earle Henri, later drops his middle name. Parents move to Atlantic City; he is placed in a boarding school in New York City.	1883	
November. Produces his first painting.	1884	*Fall*. Enters Central High School; in same class as William Glackens.
October. Enrolls at the Pennsylvania Academy of the Fine Arts in Philadelphia.	1886	
Fall. Enrolls for second year at the Academy.	1887	
May. Exhibits with fellow students, first press notice of his work.	1888	*April*. Leaves school just prior to graduation to help support parents; job with dealer in books and fine prints. Teaches himself etching.
Fall. To Paris, enrolls at the Académie Julian. Remains in Europe for three years.		
	1889	Begins painting on his own.

1890–91 *Winter.* Attends an evening drawing class at the Spring Garden Institute.
Fall. Works as a freelance artist; enrolls at the Pennsylvania Academy.

September. Returns to the U.S.; lives with his brother and sister-in-law at 628 North Sixteenth Street, Philadelphia.

1891

January. Enrolls in life and portrait classes at the Pennsylvania Academy.
September. Begins teaching at the School of Design for Women in Philadelphia. Moves to a studio at 806 Walnut Street.
December. Meets John Sloan at a studio party for Academy alumni and students.

1892 *February.* Employed in the Art Department of the *Philadelphia Inquirer;* rents a studio at 705 Walnut Street.
Fall. Attends nights class at the Academy, drawing from casts.
December. Meets Robert Henri at a party in Charles Grafly's studio.

March. Elected president of the Charcoal Club, among whose members are Sloan, Glackens, George Luks and Everett Shinn.
September. Sloan rents Henri's former studio at 806 Walnut Street; Henri inaugurates Tuesday evening discussion group there.
October. Japanese artist Beisen Kubota demonstrates ink technique at 806 studio.
Summer. To France.
September. After continuing to occasionally occupy the 806 studio with Sloan, moves to 1717 Chestnut Street, which he shares with Glackens.

1893 *March.* Helps found the Charcoal Club in protest against higher fees charged for the Pennsylvania Academy's night class. Meets Luks and Shinn there.
September. Moves from studio at 705 Walnut Street to 806.
October. Witnesses Oriental brush-and-ink drawing by artist from Japan; serves as an influence upon his own art.

1894 Two articles appear recognizing his poster style illustrations.

Summer. To Paris with Glackens, Grafly and Elmer Schofield. Impressed by Frans Hals' paintings in Holland. Meets Canadian artist James Wilson Morrice.
Winter. Organizes an art class in Paris.

1895 Leaves the *Inquirer* for the *Press.* Appointed art editor of the short-lived magazines *Moods* and *Gil Blas.*

February. To London for a Velasquez exhibition.

1896 *Summer.* Commences painting two murals for the Pennsylvania Academy lecture room.

August. Travels through Germany and Italy.

Spring. Paints in Normandy, Paris.

September. Returns to Philadelphia.

October. First one-man show (at the Pennsylvania Academy).

November. Begins teaching art class in Sloan's studio at 806.

December. Exhibits at the Macbeth Gallery in New York

March. First work accepted in the National Academy of Design Annual in New York.

June. Marries Linda Craige, one of his art students; honeymoon and extended stay in Paris.

April. Four oils shown in the Champ-de-Mars Salon in Paris.

June. One of his paintings is purchased by the French Government for the Luxembourg Museum.

April. Trip to Madrid; copies Velasquez paintings in the Prado.

August. Returns to U.S.

September. Moves to 512 East Fifty-Eighth Street, New York.

Fall. Commences teaching at the Veltin School, through 1902.

April. Organizes group exhibit at The Allan Gallery, including himself, Sloan, Glackens, Alfred Maurer and three others.

June. Rents studio in the Sherwood Building, Fifty-Seventh Street and Sixth Avenue.

September. Awarded his first prize, a Silver Medal at the Pan-American Exposition, Buffalo.

March. One-man show at the Macbeth Gallery.

October. Begins teaching at the New York School of Art, the former Chase School; continues to instruct there through 1908.

1897 Permits Henri to conduct a private art class in his studio; in return, is allowed to observe sessions. Begins painting seriously.

1898 *May.* Meets Anna M. (Dolly) Wall, whom he marries three years later.
June. Hired by the *New York Herald,* moves to Manhattan.
October. Returns to Philadelphia and the *Press.*

1899 Begins creating full-page "puzzle" drawings in Art Nouveau style, reproduced in color supplement of the Sunday *Press.*

1900 *October.* First painting accepted in a national juried show is exhibited at the Art Institute of Chicago.

1901 *April.* Participation in the Allan Gallery exhibition; represents his first showing in New York City.
August 5. Marries Dolly Wall.

1902 *August.* Begins creation of fifty-three etchings to be used as illustrations in an edition of the novels of Charles Paul de Kock.

April. Elected to the Society of American Artists.
June. To Boothbay Harbor and Monhegan Island, Maine, with Edward Redfield.
January. Organizes a group exhibition at the National Arts Club; includes work by himself, Sloan, Glackens, Luks, Davies, and Maurice Prendergast.
May. Wins Silver Medal at the Louisiana Purchase Exposition.
Summer. To Cooperstown, New York, for a portrait commission.
April. Elected an Associate member of the National Academy of Design.
October. Awarded the Norman W. Harris Prize at the Art Institute of Chicago.
November. Wife Linda becomes ill; dies the following month.
February. Exhibits at the Modern Art Gallery with Sloan, Glackens, Luks, Shinn, and Ernest Lawson.
March. To Aiken, South Carolina, for a portrait commission.
May. Elected an Academician by the National Academy of Design.
Summer. Teaches a New York School of Art class in Madrid.
October. Moves to Beaux Arts Studio building, Fortieth Street and Sixth Avenue.
March. Serves on jury for National Academy of Design Annual Exhibit; withdraws two of his three paintings during judging. He, Sloan, and Glackens discuss the advisability of a separate exhibition.
May. Announces formation of The Eight: himself, Sloan, Glackens, Luks, Shinn, Davies, Lawson, and Prendergast, to exhibit in February at the Macbeth Gallery.
Summer. Teaches New York

1903

November. Loses his full-time job with the *Press* when it subscribes to a syndicated Sunday supplement.

1904

January. Participates in National Arts Club show arranged by Henri.
April. Moves to New York, locating on the same floor as Henri in the Sherwood Building.
September. Relocates to 165 West Twenty-Third Street.

1905

Begins creation of his ten "New York City Life" etchings.
November. Receives Honorable Mention at the Carnegie Institute Annual, his first museum award.

1906

February. Exhibits with Henri, others, in Modern Art Gallery show.
March. Substitutes for Henri at classes of the New York School of Art, his first role as a teacher.
May. American Water Color Society invites him to show the "New York Life" etchings; four were deemed "too vulgar" and not hung.

1907

March. Rejection of a Sloan painting, plus those by Glackens, Luks and Shinn during jury of the National Academy Annual causes Henri to remove two of his own canvases in protest. Meets with Henri to search for alternate exhibit site.
April. Joins with Henri as member of the Eight.
October–December. Teaches one day a week at the Pittsburgh Art Students League.

School of Art class and paints in
Holland.
August. To England for a portrait
commission.
September. Moves to 135 East
Fortieth Street.
January. In Wilkes-Barre for two
portrait commissions.
February 3. Opening of The Eight
exhibition at the Macbeth Gallery;
sells two works from show.
May. Marries Marjorie Organ, a
comic strip artist on the *New York
Journal.*
Summer. In Madrid with New
York School of Art class.
December. Resigns from the
school faculty due to unpaid sal-
ary.
January. Opens the Henri School
of Art in the Lincoln Arcade;
teaches there through 1912.
August. Begins producing paint-
ings incorporating the color theo-
ries and palette arrangement of
Hardesty G. Maratta.
October. Awarded the Philadelphia
Art Club's Gold Medal; moves to
10 Gramercy Park, his New York
residence for the next twenty
years.
March. Rejection of two of his
portraits from the National Acad-
emy Annual results in Indepen-
dent Artists Exhibit, where they
are shown.
June. Awarded a Silver Medal at
the International Exposition in
Buenos Aires.
Summer. To Holland and Spain.

March. Declines invitation to ex-
hibit in Independent Show orga-
nized by former student Rockwell
Kent.

1908 *February.* Participates in The Eight
exhibit.
May. Experiments with creating
lithographs.
August. In Henri's absence, selects
his work to be included in the
Eight travelling show, appearing
in eight cities between September
1908 and May 1909.

1909 *March.* Visits Henri to discuss
their idea of a Permanent Exhibi-
tion Gallery to provide artists
with better exposure to the
public.
Summer. Introduced by Henri to
the Maratta color system, pallette
arrangement, and pigments.
May 3. He and Henri to Newark
to help hang The Eight travelling
show at its final venue.

1910 *March.* Serves as treasurer for the
Exhibition of Independent Art-
ists; is represented by drawings,
paintings, and prints.
April. Six of the "New York City
Life" etchings are accepted for the
Paris Salon.
June. John Quinn purchases
seventy-six prints, including all of
his de Kock etchings.

1911 *January:* Receives final payment
for *Philadelphia Press* picture puz-
zles; continues creating magazine
illustrations.

August. To Monhegan Island, Maine; produces 260 panel paintings in seven weeks.
November. Begins teaching at The Modern School of the Ferrer Society; there through 1916.
November. MacDowell Club inaugurates his plan for year-round, jury-free, artist-organized exhibitions; Henri in initial show.
December. Invited to join the Association of American Painters and Sculptors, sponsors of the 1913 Armory Show.
Winter. His paintings purchased by the Pennsylvania Academy and Museum of Fine Arts, Boston.
Winter, Spring. Attends Association meetings but plays minor role in plans for forthcoming Armory Show.
April. Teaches his last class at the Henri School.
June–August. In Spain with art class from his former school.
September. To Paris; views Autumn Salon.
October. Returns to New York; preoccupied with nursing his mother back to health.
February. Represented in the Armory Show by three paintings and two drawings.
June–October. In Ireland.
February. Awarded Carol Beck Gold Medal by the Pennsylvania Academy.
June. To San Diego, La Jolla, California; serves as art exhibit coordinator for San Diego's forthcoming Panama-California Exposition.
October. Returns to New York.
January. Exhibits in San Diego Exposition and Panama-Pacific Exposition in San Francisco; wins

March. Agrees with Henri not to exhibit in the Kent Independent.
June. Moves to apartment at 155 East Twenty-Second Street.
December. To Omaha to carry out his first portrait commission.

1912 *January.* Accepts membership in the Association of American Painters and Sculptors.
February. Organizes and participates in group exhibit at the MacDowell Club.
May. Rents studio at 35 Sixth Avenue; begins teaching private students there.
October. He and Dolly move to apartment at 61 Perry Street in Greenwich Village.
December. Becomes art editor of *The Masses,* an independent magazine.

1913 *February.* Exhibits two oils and five etchings in the Armory Show.
February. Moves to apartment at 240 West Fourth Street.

1914 *Summer.* To Gloucester, Massachusetts; paints there for the next four summers.
December. Ceases contribution of his art to *The Masses.*

1915 Awarded Bronze Medal for etching at San Francisco's Panama-Pacific Exposition.

Silver Medal at the later.
July. To Ogunquit, Maine.
October. Begins teaching Portrait
and Composition classes at the
Art Students League; continues
instruction and lectures there
through 1927.
March. Helps plan the Forum Ex-
hibition of Modern American
Painters with Alfred Stieglitz,
others.
July–September. To Santa Fe;
paints his first portraits of Ameri-
can Indians.

Summer. In Santa Fe serves as ad-
viser for the new museum there.
Fall. Crusades for Philadelphia to
establish a permanent Eakins gal-
lery.

Winter. Begins study of Jay Ham-
bidge's theory of Dynamic
Symmetry.
August. Monhegan Island, Maine.
May. Participates in final group
show at the MacDowell Club.
Summer. Portrait commissions in
Lake Forest, Illinois, and Fal-
mouth, Massachusetts.
Fall. Founding member of the
New Society of Artists, New
York.
April. Awarded Portrait Prize at
the Wilmington Society of Fine
Arts.
Summer. Portrait commissions in
New York State and Illinois pre-
vent vacation in Santa Fe.
April. Testimonial dinner for him
at the Salmagundi Club, New
York.
Summer. To Woodstock, New
York.
Fall. Publication of *Robert Henri:
His Life and Works* by William
Yarrow and Louis Bouché.

October. Moves to 88 Washington
Place.

1916 *January.* First one-man show at
the Whitney Studio, forerunner
of the Whitney Museum of Amer-
ican Art.
Summer. Teaches privately in
Gloucester, Massachusetts.
September. First classes taught at
the Art Students League; instructs
there for next fifteen years.

1917 *March.* First one-man show at the
Kraushaar Gallery; becomes
Sloan's long-time dealer.
April. Participates in the first Soci-
ety of Independent Artists Exhibi-
tion.

1918 *Spring.* Elected president of the
Society of Independent Artists, a
post he held for twenty-four
years.

1919 *June.* As a result of Henri's enthu-
siasm for Santa Fe, Sloan travels
there; returns annually for next
three decades (except for 1933).
September. Arranges to include In-
dian paintings in the 1920 Inde-
pendent Exhibit.

1920 *June.* Purchases a home in Santa
Fe at Calle Garcia No. 108. Re-
mains in New Mexico for four
months.

1921 *February.* The Metropolitan pur-
chases a painting, his first sale to
a museum.

Spring. Publication of *Robert Henri* by Nathaniel Pousette-Dart.

Summer. Portrait commission in Los Angeles.

October–December. To Santa Fe.

July. To Paris.

August. Madrid; stay of eight months.

October. Publication of *The Art Spirit*, edited by Margery Ryerson, former Henri student at the Art Students League.

June–October. To Achill Island, Ireland; purchases Corrymore House, where he stayed in 1913.

November. Returns to New York.

January–May. Los Angeles; paints several portrait commissions.

April. One-man show, Macbeth Gallery.

June–October. Ireland.

February. One-man show, Memorial Art Gallery, Rochester.

Summer. Exhibits at Philadelphia Susqui-Centennial International Exposition.

July–October. Ireland.

Winter–Spring. New York.

May–October. Ireland.

November–Spring, 1928. New York.

Spring. Final lectures at the Art Students League.

May–September. Ireland.

October. Returns to New York; enters St. Luke's Hospital.

January. Awarded the Temple Gold Medal at the Pennsylvania Academy.

Spring. Voted one of three top living American artists in an Arts Council of New York poll.

July 12. Dies of cancer at St. Luke's Hospital.

July. Marjorie Henri dies of cancer at St. Luke's Hospital.

1922 *Fall*. Visiting critic for art classes, Maryland Institute, Baltimore.

1923 *December*. Sale of twenty paintings to George Otis Hamlin for $5,000 (price reported in press is $20,000).

1924 *April*. Serves on jury for the Carnegie International's American Section.

1925 *December*. Publication of A. E. Gallatin's *John Sloan*.

1926 *June*. Awarded Gold Medal for etching at the Philadelphia Susqui-Centennial International Exposition.

1927 *Spring*. Moves studio to 53 Washington Square.

June. To Santa Fe.

1928 Press announces sale of twenty paintings, is nullfied by 1929 stock market crash.

1929 *Spring*. Elected to National Institute of Arts and Letters.

June. To Santa Fe.

July. Following Henri's death, Sloan seeks to establish a $2 million art gallery in Henri's name.

1930 *Spring*. Initiates letter-writing campaign for a Henri Memorial Exhibition at the Metropolitan Museum of Art.

March–April. Robert Henri Memorial Exhibition, Metropolitan Museum.

1931 *January*. Receives Carroll H. Beck Gold Medal, Pennsylvania Academy.
January. Elected president of the Art Students League.

1932 *March*. Resigns as League president.

1933 *November*. Chosen to head George Luks School following Luks' death.

1935 *Spring*. Moves to Hotel Chelsea, 222 West Twenty-Third Street.
Fall. Resumes teaching at League; there through 1938.

1936 *March*. Exhibition of one hundred etchings at Whitney Museum.
Publication of *John Sloan* by Frank Jewett Mather, Jr.

1937 *February*. Retrospective Exhibit of etchings, Kraushaar Gallery.

1939 *Fall*. Publication of *Gist of Art* by John Sloan, edited by Helen Farr, one of his former students at the Art Students League.

1943 *May 4*. Dolly Sloan dies.

1944 *February 5*. Marries Helen Farr.

1951 *September 7*. Dies in Hanover, New Hampshire, following cancer operation.

1952 *January–March*. Retrospective Exhibition at the Whitney Museum.

Selected Publications: John Sloan

✳

American Art Nouveau: The Poster Period of John Sloan. A selection of hitherto unpublished prints and autobiographical recollections by the artist, collected by Helen Farr Sloan. Lock Haven, Pa., 1967.

Brooks, Van Wyck. *John Sloan: A Painter's Life.* New York, 1955.

du Bois, Guy Pène. *John Sloan.* New York, 1931.

Elzea, Rowland. *John Sloan's Oil Paintings: A Catalogue Raisonné* (2 volumes). Newark, Del., 1991.

————, and Elizabeth Hawkes. *John Sloan: Spectator of Life.* Wilmington, Del., 1988.

Gallatin, A. E., editor. *John Sloan.* New York, 1925.

Goodrich, Lloyd. *John Sloan 1871–1951.* New York, 1952.

Hawkes, Elizabeth H. *John Sloan's Illustrations in Magazines and Books.* Wilmington, Del., 1992.

John Sloan: Paintings, Prints, Drawings. Hanover, N.H., 1981.

Kraft, James. *John Sloan: Printmaker.* Washington, D.C., 1984.

Mather, Frank Jewett, Jr. *John Sloan.* New York, 1936.

Morse, Peter. *John Sloan's Prints: A Catalogue Raisonné of the Etchings, Lithographs and Posters.* New Haven, Conn., 1969.

Scott, David. *John Sloan: Paintings, Prints, Drawings.* New York, 1975.

————, and E. John Bullard. *John Sloan 1871–1951.* Washington, D.C.

Sloan, Helen Farr, editor. *John Sloan, New York Etchings (1905–1949).* New York, 1978.

Sloan, John. *Gist of Art.* New York, 1939.

St. John, Bruce. *John Sloan.* New York, 1971.

————, editor. *John Sloan's New York Scene from the diaries, notes and correspondence 1906–1913.* New York, 1965.

Selected Publications: Robert Henri

※

Henri, Robert. *The Art Spirit*. New York, 1923.

Homer, William Innes. *Robert Henri and His Circle*. Ithaca, N.Y., 1969.

Perlman, Bennard B. *Robert Henri: His Life and Art*. New York, 1991.

——. *Robert Henri, Painter*. Wilmington, Del., 1984.

Pousette-Dart, Nathaniel. *Robert Henri*. New York, 1922.

Read, Helen Appleton. *Robert Henri*. New York, 1931.

Sandoz, Mari. *Son of the Gamblin' Man*. New York. 1960.

Yarrow, William and Louis Bouché, editors. *Robert Henri: His Life and Works*. New York, 1921.

Index

✳

Page numbers in boldface indicate illustrations

Académie Julian, Paris, 22n, 213
Adams, Herbert, 100
Alexander, John White, 100
Allan Gallery, The, New York, 49, 50
Alleys, Dixon, 94
American Art News, 138, 210
American Item Art Company, Philadelphia, 59
American Water Color Society, New York, xxi
Anshutz, Thomas, xxii, 137; wife of, 137
Argentina (Spanish dancer), 296, **297**
Argentinita (Spanish dancer), 296
Armory Show, 215
Art Institute of Chicago, The: annual exhibition of, 43n
Artists' Coop Galleries, New York, 280, 282
Artists' Packing and Shipping Co., New York, 49n, 177, 225
Arts and Decoration, 301n
Art Spirit, The (Robert Henri), 298, 299n
Arts, The, 288
Art Students League of New York, The, 282
Ashcan School, xx
Association of American Painters and Sculptors. *See* Armory Show
Aust, Mary, 326

Barnes, Dr. Albert C., xx
Bayard, Lucie, 245n
Beal, Gifford, 225, 327
Beinecke Rare Book and Manuscript Library, Yale University, xix
Bell, Eric, 202n
Bellows, Emma (Mrs. George), 226, 229, 274, 325

Bellows, George, xx, xxii, 207n, 226, 237n, 240, 270, 271, 274, 326
Blashfield, Edwin H., 100
Blasirus, Lucy, 239
Blavatsky, Madame Helena, 203n
Blossom, Mary C., 149
Boss, Homer, 307
Boutet de Monvel, Maurice, 69
Bowles, Julian, 282
Boycott, Captain Charles Cunningham, 217n
Breckenridge, Hugh H., 9, 15, 41n
Brontë, Branwell, Charlotte, and Patrick, 171
Brooks, Van Wyck, 203
Burlin, H. Paul, 226, 268
Burroughs, Bryson, 327n
Bynner, Winter, 326

Café Francis, New York, 109
Cahill, E. Holger, 276n, 287, 292, 295
Calder, Alexander Milne, 27, 35n
Calder, A. Stirling, xxii, 97, 113n, 115, 327
Campbell, Laura, 109n
Carlsen, Emil, 100
Carnegie Institute, Pittsburgh, 43n, 55n, 100n, 197
Cattell, Owen, 283
Cézanne, Paul, 268
Chapman, Carlton Theodore, 100
Chappell, Minnie, 115
Charcoal Club, The, 4, **4**
Chase, Ralph, 273
Chase, William Merritt, 96n, 100, 150
Chemistry and Technology of Mixed Paints, The, 232n
Choate, Mabel, 327

Churchill, William W., 67n
Collier's magazine, 109, **111**
Conesa, Marie, 296
Connah, Douglas John, 96, 97, 134, 159
Constable, John, 172
Conquestadores Ball, Santa Fe, 312
Cooper, Colin C., 62, 299; wife of, 62
Corcoran Gallery of Art, Washington,
 D.C., biennial, 225n
Cox, Kenyon, 100
Cozad, Nebraska, 11n
Cozad, Robert Henri. *See* Robert Henri
Craftsman, The, 209n
Craige, Linda (Henri's first wife), 26, 38n.
 See also Linda Henri
Craige, Mrs. T. Huston (Henri's mother-
 in-law), 102, 103, 106, 108
Crane, Frank, 18, 27
Crane, Walter, 16
Craven, Thomas, 288
Crooks, Miss, 29n
Crowninshield, Frank, 327
Curran, Charles, 100

Daingerfield, Elliott, 100
Daniel Gallery, New York, 299
Dansig, Mike, 14
Dantzig, Meyer, 62
Dasburg, Andrew, 326
Daumier, Honoré, 37
Davey, Bill, 315
Davey, Randall, xxii, 225, 285, 310, 315,
 326, 327; and Henri, 196, 197, 206n;
 in Santa Fe, 244, 245, 246, 248, 258,
 259, 261, 273, 275, 279, 308, 357;
 Sloan on, 225
Davies, Arthur B., 41, 63; and exhibitions,
 38n, 62, 79n, 195n, 205, 206n, 210,
 213n; as member of The Eight, xxii,
 138
Davis, Edward Wyatt, 35, 234; on *Phila-
 delphia Press* staff, 5n, 32; and Sloan, 4,
 9, 16, 18, 19, 30, 208
Davis, J. Ashby, 275, 307, 310, 320
Davis, Stuart, 209n, 233, 285
de Kock, Charles Paul, novels of, 56, 57,
 64n, 74n, 78n
Delacroix, Eugène, 284, 285n
Delaware Art Museum, Wilmington, xix
Dimock, Edith. *See* Edith Glackens
Dix, Eulabee, 203

Dougherty, Paul, 326, 327
Dreyfus, Captain Alfred, 33n
Duchamp, Marcel, 215
Du Mond, Frank Vincent, 53, 100
Duncan, Isadora, xxii, 282–83

Eakins, Thomas, xx
Eight, The, xxii, 138, 213n, 280; exhibi-
 tion of, 140, 141, 150, 158, 176, 177,
 178, 179, 183, 184, 195
Enters, Angna, 311
Exhibition of Contemporary Art, Boston:
 annual exhibition of, 67
Exhibition of Independent Artists, New
 York, 195, 195n
Exposition d'Artistes de l'Ecole Améri-
 caine, Paris, 252n

Farley, Richard Blossom, 225
Farr, Helen. *See* Helen Farr Sloan
Ferargil Gallery, New York, 299
Field, Hamilton Easter, 226–27
Finch, Jessica G., 213n
Finney, Harry, 21
Fisher, Elizabeth, 159, 160, 161, 165, 171
FitzGerald, Charles, 80, 107n, 108
Florance, Eustace Lee, 8
Folies-Bergère, 284
Foster, Dr. Joseph, 312n
Fox, George B., 8
Frazer, James, 327
French, Frank, 100
Fromkes, Maurice, 299
Fuhr, Ernest, 49, 92

Gaborian, Emile, 209
Gallatin, A. E., 206
Garden, Mary, 191
Gist of Art (John Sloan), 203
Gimpel, E., and Wildenstein Galleries, an-
 nual exhibitions of, 271n
Glackens, Edith Dimock (Mrs. William J.),
 80, 80n, 148, 301
Glackens, William J., xx, 21, 31, 32n, 53–
 54, 55, 80, 108, 122, 148; and exhibi-
 tions, 21, 49, 79, 138, 210; as graphic
 artist, 9, 21, 29, 32n, 33, 36; and
 Henri, 14, 16; as member of The Eight,
 xxii, 138; and Sloan, 18, 19, 37, 63
Goya, Francisco, xxii, 129
Grafly, Charles, 3, 14, 21, 41, 190

Grand Central Painters and Sculptors Gallery Association, exhibition of, 287
Grier, George W., 5
Gruger, F. R., 73, 92, 100n

Hals, Franz, xx, xxii, 163
Hamlin, George Otis, 287, 288, 290, 295, 295; collection of, 295n; wife of, 295
Hamsen, Knut, 271
Harriman, Grace Carley, 282
Harris, Hartman K., 151, 159
Harrison, William Preston, 308, 310, 311, 328
Harvey, Fred, 312n
Haynes, Arthur S., 78
Heckscher Foundation, 282
Held, Anna, 160
Henri, Linda (first wife), **26**, 56, 57, 58, 75, **93**, 100, 101, 102, 106
Henri, Marjorie (second wife), **182**, 185, 197n, 207n, 284, **287**, 301, 320, 325, 326, 328; letters by, 191–92, 202, 216–17, 301–2
Henri, Robert (Robert Henry Cozad), xx, **2**, 7, 9, 24, 27n, 37, 41, 56, 65, **93**, 112, 115, 122–23, 138, 149, **154**, 164, 173, 215, **278**, 326, 331; and American Indians, 240, 244; as artist, xx, 41, 94n, 152, 229, 232, 234–35, 238–39, 240, 249, 276n, 296, 304, 317; *Art Spirit, The*, 112, 288, 304; commissioned portraits by, xx, 102, 173, 244; death of and memorials to, 320, 325–26; and The Eight (group and exhibition), xxii, 138, 177, 173, 176; in group exhibitions, 24, 79n, 80, 195n, 213nn, 215, 281n; and illness, 286, 318, 319, 325; marriage of, to Linda Craige, 25; marriage of, to Marjorie Organ, 177; as member of exhibition juries, 84n, 100, 138; and National Academy of Design (New York), xix–xx, 138; and Sloan, 3, 134, 136, 137, 158, 159; students of, 25, 36, 50, 51; as teacher, 25, 48n, 49n, 50n, 70, 112, 175, 177, 190, 192n, 213, 215, 244, 307, 331
—paintings of: *A Café—Night*, 49n; *Achill Girl*, **218**; "And this is what happened in the studio Oct. 22, 09" (graphite), **203**; *A Peasant*, 24; *The Art Student*, 104, 104, **105**; *Augustina of Madrid*,

297; *Ballet Girls*, 49n; *Bishop Henry C. Potter*, 94; *Blind Gypsy Woman*, 202n; *The Brown-Eyed Boy*, **319**; *Burnt Head—Monhegan*, 80n; *The Café Terrace*, 45n, **46**; *The Children of Mrs. George Sheffield*, 106, 108, 113, **114**; *Cliff and Seas*, 80n; *Cliffs and Seas, Monhegan*, 76; *Concarneau Street Scene*, **10**; *Consuella—Gypsy Girl*, 202n; *Diegito*, 328 *(see also Portrait of Dieguito)*; *Dutch Girl in White*, **157**; *Dutch Soldier*, 160n, **162**; *East River Snow*, **42**; *El Matador*, 129n, **131**, 133, 138; *El Picador*, 185, **186**; *El Tango*, 185n; *The Equestrian*, 197n, 198; *Eva Green*, 173, **174** *(see also Negro Girl Smiling)*; *F. Ambrose Clark*, 94; *Gertrude Vanderbilt Whitney*, 229; *Girl in White*, 170n; *Girl in White Waist*, 80, 80n, **82**; *The Green Cape*, 45n; *Gypsy Girl "Pura,"* 202n; *Herself*, 225, **231**; *Himself*, 225n, **230**; *Indian Girl of Santa Clara, New Mexico*, 240n, **241**; *In the Garden of the Luxembourg*, 24; *Island of Manana*, 80n; *John Sloan*, 84, **88**; *Lady in Black*, **91**, 92n; *Landscape at Black Walnut, Pa.*, 9n, **60**; *La Neige* (The Snow), **38**, 38n; *La Reina Mora*, **135**; *Laughing Child*, **156**; *The Laundress*, 229; *Little Girl of the Southwest*, 240n, **243**; *Martche in White Apron*, **181**; *Meeaune Cliffs, Achill Island, County Mayo, Ireland*, **217**; *Monhegan Fish Houses*, 80n; *Mrs. Robert C. Watts*, 310n; *Mrs. William Rockwell Clarke*, 192n; *Negro Girl Smiling*, 173 *(see also Eva Green)*; *Night—14th July in Paris*, 24; *Normandie Interior*, 24; *On the Marne*, **36**, 38n, 49n; *Pepita of Santa Fe*, 240n, **242**, 308n; *Portrait of a Girl*, 80n; *Portrait of Arthur D. Bissell, Esq.*, 270n; *Portrait of a Young Woman*, 55n; *Portrait of Byron P. Stevenson, Esq.*, 92n; *Portrait of Dieguito*, 252n, **254** *(see also Diegito)*; *Portrait of Edward Herbert Bennett, Jr.*, 245n; *Portrait of Edward Winton McVitty*, 249n; *Portrait of Fayette Smith*, 271n, **272**; *Portrait of Frank L. Southrn, M.D.*, 80n, **86**; *Portrait of George Cotton Smith*, 175, 176; *Portrait of John Butler Yeats*, **204**; *Portrait of Lieutenant Don Clemente Cordillo Alveriz De Sotomayor*, 129n; *Portrait of Miss E*, 80n; *Portrait of Miss Leora*

Henri, Robert (*cont.*)
 M. Dryer in Riding Costume, 70n, 71;
 Portrait of Mrs. George Cotton Smith, 175,
 176; *Portrait of Mrs. George H. Smith,*
 160, 161, 165n, 168, 170, 172; *Portrait
 of Mrs. Sheffield in Red,* 109, 112; *Por-
 trait of Mrs. William Preston Harrison,*
 308n; *Portrait of Sarah J. Field,* 14, 15n,
 20; *Portrait of Young Woman in Black,*
 80n; *Portrait of Young Woman in White,*
 80n; *Profile—Suzanne with Cup,* 22n,
 67n; *The Rain Storm—Wyoming Valley,*
 59, 59n; *Roshanara,* **313;** *Rolling Sea,*
 77; *Spanish Girl of Madrid,* 185n, **187;**
 Spanish Gypsy Mother and Child, 129n,
 130, 138; *Street Scene with Snow,* **73** (*see
 also West 57th Street, New York*); *Summer
 Storm,* **277;** *Una Chula de Pasco* (A
 Pretty Girl Dancing), 185, 185n; *Volen-
 dam Street Scene,* 200; *West 57th Street,
 New York,* 70n (*see also Street Scene with
 Snow*); *The White House (Concarneau),*
 49n; *Willie Gee,* xx; *Young Woman in an
 Old Fashioned Dress,* 45n; *Young Woman
 in Black,* **83;** *Young Woman in White,* **95**
 —studio of, in Ireland: Corrymore House,
 Achill Island, 318n
 —studios of, in New York: 512 East Fifty-
 Eighth Street, 53; Sherwood Building
 (Fifty-Seventh Street and Sixth Avenue),
 53, 96n; Beaux Arts Studio (Fortieth
 Street and Sixth Avenue), 165n; 135
 East Fortieth Street, 169, 170n, 191; 10
 Gramercy Park, 258, 269, 271n
 —studios of, in Philadelphia: 806 Walnut
 Street, 2, 4, **6,** 9n; 1717 Chestnut
 Street, 11
 —travels of, in Europe: Belgium, 161,
 163, 164, 165, 170; Britain, 160, 163,
 164, 165, 167, 168, 170–72; France, 8,
 24, 170; Holland, 141, 148, 150, 160,
 170, 195, 196, 197, 201; Ireland, 129,
 215, 216, 217, 302, 316, 317, 318;
 Spain, 129, 133, 185, 202, 285, 296,
 298, 300, 301, 302, 304
 —travels of, in United States: Aiken,
 South Carolina, 103, 115; Boothbay
 Harbor, Maine, 74, 74n; Chicago, Illi-
 nois, 245; Cooperstown, New York, 94,
 94n, 96n, 97; Falmouth, Massachusetts,
 249; Monhegan Island, Maine, 74, 74n,

207, 208, 245n; Ogunquit, Maine, 227,
 229n; Santa Fe, New Mexico, 234, 238,
 239, 244; Wilkes-Barre, Pennsylvania,
 173, 175, 176
Hensche, Mr. and Mrs., 117
Hewett, Dr. Edgar L., 225, 258, 261,
 271, 310, 315
Hoeber, Arthur, 210
Holzhauer, Emil, 215
Hopper, Edward, 104n
Hopper, Josephine Nivison (Mrs. Edward),
 104n
House Beautiful, The, 138
Hovenden, Thomas, xxii, 15

Independence Movement, xx
Independence School of Art, 215
independent exhibitions, 206n
International Society of Sculptors, Painters
 and Graver, London, exhibition of, 78

Jackson, Joseph, 65
Jeffries, Jim, 201n
Johnson, Jack 201n
Johnston, Mrs. Charles, 203n
Jones, Hugh Bolton, 100
Jones, Isham, 100

Käsebier, Gertrude, 149, **154, 155**
Kelly, James B., 5
Kendall, William Sergeant, 100
Kent, Dorothy, 307
Kent, Rockwell, xxii, 138, 205, 206n
King, Fred, 203n
Kirby, Rollin, 119
Komroff, Manuel, xix
Kost, Frederick Weller, 100
Kraushaar, John F., 310, 311
Kreymborg, Alfred, 312
Kroll, Leon, xxii, 226, 240, 270, 271n,
 274, 311
Kuhn, Walt, 195n, 213

La Farge, John, 69, 100
Lamberg, John, Jr., 47n
Lamberg, Dr. Sam, 325
Laub, Joseph, 4, 5, 27, 32, 35, 92, 191,
 208
Lauter, Flora, 196
Lavary, Sir John, 76
Lawrence, D. H., 274

Lawson Ernest, xxii, 138
Lee, Richard Henry (John Jackson Cozad, Henri's father), 11n, 98n
Lee, Theresa (Henri's mother), 9, 11n, 99, 185, 269
Lichtenstein, Carl B., 183
Lincoln Arcade, New York, 192
Lindbergh, Charles A., 316n, 317
Literary Digest, 203n
Loeb, Louis, 100
Los Angeles Museum, 308
Louvre Museum, 284
Low, Will H., 100, 170
Lowes, Raymond, 325
Luks, George B., xx, 56, 100n, 121, 326, 327; and exhibitions, 79n, 138, 210, 213n; as member of The Eight, xxii, 138; and Sloan, 19, 276n
Luxembourg Gallery, Paris, 38n

Macbeth Gallery, New York, 38n, 176, 177, 184, 294, 299
Macbeth, William, 141
MacDowell Club, New York, 213nn, 281n
MacNeil Hermon A., 100
Manet, Edouard, xx, 118
Mannix, Bill, 292
Maratta, Hardesty G., 209, 232, 237n, 240, 274
Maratta painting pedium and palette, 232, 240nn
March, Alden, 64, 65
Marin, John, 326
Matisse, Henri, 215
Maurer, Alfred, 49n
Mazantinito (bullfighter), 298
McClure's magazine, 29, 32, 32n, 33
McFee, Henry L., 270
Melchers, Gari, 270, 327
Metropolitan Museum of Art, The, 118, 310, 327, 329, 330
Mielatz, Charles, 108
Miller, Kenneth Hayes, 96
Millet, Frank Davis, 100
Millet, Jean-François, 37
Moods magazine, 16, 20
Moreno, Milagros, 133
Morrice, James Wilson, 74n, 75, 169
Morris, Harrison S., 15, 47n; wife of, 149
Mouquin's restaurant, Philadelphia, 99, 208

Munsey's magazine, 169
Murphy, John Francis, 100
Murphy, William M., 203
Museum of Art and Archeology, Santa Fe, 245n, 249n, 252n, 258, 328

National Academy of Design, New York, 138; annual exhibitions of, xix, 45n, 48, 69, 70, 173, 206n, 210
National Arts Club, New York, 79n, 80n
National Gallery, London, 164
New Mexican (newspaper), 259
New Society of Artists: annual exhibitions of, 270, 299, 300, 308n; dinner, 299, 301
newspaper photographers, 66
New York Commercial Advertiser, 213n
New York Evening Sun, 80, 183, 184
New York Herald, 21, 24, 27, 31, 34, 104, 121n
New York Journal, 177, 197n
New York School of Art, 96, 119n, 138n, 150
New York Sun, 76, 138
New York Times, 43n, 184
New York World, 177, **179**, 288n, 294
Niles, Helen, 149, 151, 159, 161, 196, 197, 312n
Nivison, Josephine (Mrs. Edward Hopper), **105**
Norfelt, B.J.O., 268
Noyes, Carlton E., 67
Nude Descending a Staircase (Duchamp), 215

O'Donnell, Edward, 317
O'Donnell, Patrick, 316, 318n
Omar Kiam, 225
Organ, Marjorie, 177. *See also* Marjorie Henri
Organ, Violet (Henri's sister-in-law), xix, 41n, 259n, 316, 325, 328
Outcault, Richard, xxi

Pach, Walter, 115
Paine, Ralph D., 292
Panama-Pacific International Exposition, The, San Diego, 219, 220n, 225
Parrish, Maxfield, 99
Pattison, James William, 138
Paxton, William M., 67

Pennell, Joseph, 16
Pennsylvania Academy Alumni Association, 51n
Pennsylvania Academy of the Fine Arts, The, xx, 138n; annual exhibitions of, 45n, 80, 91n
Penn, William, statue of, 27, 35n
Perrine, Van Dearing, 49
Perry, Clara Greenleaf, 159, 160
Peters, Gustav A., 64n, 109
Peterson, Cori, 160n, 196n
Petitpas restaurant, New York, 202n
Pfeiffer, Frederick, 62n
Philadelphia Art Club, 19, 191
Philadelphia Centennial Exposition, xx
Philadelphia Inquirer, 18
Philadelphia Ledger, 9, 65n, 75
Philadelphia North American, 53
Philadelphia Press, 9, 21n, 34, 35, 50n, 51n, 64, 66n, 209n; and Sloan, 18, 20, 31, 34, 55, 64, 66, 108
Philadelphia Water Color Society: annual exhibitions of, 108, 112
Photo-Secession, 150
Pittsburgh Art Students League, 149–51, 169
Pittsburgh Index, 169
Platt, Charles A., 327
Playboy of the Western World, The, 217n
Pond, Ashley, 273
Pope, Louise, 149, 151, 159, 160, 161, 191, 284
Potts, Sherman, 117, 149, 150n
Prado Museum, 285, 300, 302
Prellwitz, Henri, 100
Prendergrast, Maurice B., xxii, 79, 138, 213n
Preston, James M., 18, 19, 20, 27, 30, 34, 100n, 108
Preston, May Wilson (Mrs. James M.), 100n
Price, Willard Bertram, 49
Prohibition, 283, 300
Pyle, Howard, 312n

Quimby Co., The Frederick J., 64n, 73, 74, 76, 68, 92

Rabinowitz, Nathan, 103n, 209, 237
Rath, E. J., 109n
Ravlin, Grace, 301n

Redfield, Edward W. 43, 51, 54, 58, 76, 77, 294; and exhibitions, 18–19, 48, 51, 54, 59, 67, 69; and Henri, 72, 74; as member of Sloan-Henri circle, xxii, 9, 28; and Sloan, 15, 19, 35–36, 41
Rembrandt van Rijn, xxii, 144
Reuterdahl, Henry, 150
Roberts, Mary Fanton (Mrs. William), xxii, 209n, 274n, 282, 310, 327
Roberts, William, 209n
Robinson, Edward, 327
Rockefellers, 302n, 315
Roosevelt, Theodore, 184
Rosenfeld, Paul, 311
Roshanara (Olive Craddock), 312
Rothermel, Peter Frederick, 15
Rubens, Peter Paul, 118
Rudy, J. Horace, 20, 43, 54, 55, 56, 69, 78
Rush, Olive, 311
Ruyl, Louis H., 18, 27, 30, 31, 33, 35
Ryerson, Margery, 299n, 320

Saint Elmo Lewis, Elias, 15, 20
Saint Luke's Hospital, New York, 320
Santa Fe American (newspaper), 326
Santa Fe Fiesta, 312
Santa Fe Museum, 328. *See also* Museum of Art and Arheology, Santa Fe
Santa Fe New Mexican (newspaper), 282
Sartain, Emily, 13, 20, 51
Saturday Evening Post, The, 34, 109n
Schofield, Elmer, xxii, 14, 41n, 54, 58, 92, 97, 100
School of Design for Women, Philadelphia, 13, 13n
Scribner's magazine, 99
Shadowland magazine, 275
Shakespeare, William, 170n
Sheffield, Mrs. George, 101, 102, 113n, 115
Sherwood Building, 53, 80, 92, 96n
Shinn, Everett, xx, 16, 20, 56, 108, 138, 183, 184n; as member of The Eight, xxii, 138; and Sloan, xxii, 18
Shirlaw, Walter, 100
Shuster, Will, 268, 275, 279n, 285, 307, 310, 311, 313, 315, 320
Sloan, Bess (sister), 275
Sloan, Dolly (Anna Maria Wall, first wife), 28, 29–32, 57, 93, 148, 219n, 295n; al-

coholism of, 92, 175, 191; and Henri, 55, 75, 136, 149; and John Sloan, 29n, 47n, 108, 168, 311; letters by, 190–91, 258–59, 273, 308–10, 311–12; in Santa Fe, 246, 258, 259, 291, 304

Sloan, Eleanor (cousin), 118

Sloan, Helen Farr (second wife), xix, 13, **330**

Sloan, Henrietta Ireland (Mrs. James Dixon, mother), 137, 168

Sloan, John, 3, 7, **11**, 56, 58n, 62, **93**, **155**, 203, **278**, 306, **330**; accusations against, of personal impropriety, 28–32; on American Indians, 247, 301, 304, 307; as artist, xx-xxiii, 22, 73, 94n, 100, 169, 208, 215, 312, 330; biography of, by A. E. Gallatin, 306; commissioned portraits by, 210, **212**, 213; diary of, 112, 138, 177; etchings of, xxi, 56, 62, 108, 112, 117, 149, 262, 310n; and exhibitions, 49, 72, 79n, 195n, 213n, 215, 262; finances of, 262, 263, 280, 282, 288, 290, 295, 299, 300, 311, 318; *Gist of Art*, 203; and Henri, 64, 94, 134, 136, 137, 158–59, 169, 170, 185, 270, 286, 299, 326–31; as magazine illustrator, 8, **14**, 109n; as member of The Eight, 138, 177, 185; marriage to Dolly, 29n, 47n; and National Academy of Design, New York, xx, 138; travels of, 117, 183, 232, 233, 244, 246–48, 257, 262, 274, 275, 304, 315, 320

—as newspaper artist, at: *New York Herald*, 25, 31; *Philadelphia Inquirer*, 8, 18; *Philadelphia Press*, 18, 25, 30, 31, 34

—paintings of: *The Acequia Madre, Evening*, 263n, 268; *Autumn Dunes*, 225n; *Ancestral Spirits*, 247, **250**, 268; *Blonde Nude*, 290, **292**; *Boys Swimming, Santa Fe*, 263, **264**; *Brace's Cove, Gloucester*, 225n, **228**; *Chama Running Red*, **305**; *Chinese Restaurant*, **223**, 225n; *Clown Making Up*, **224**, 225n; *The Coffee Line*, **101**, 101n; *Collier's* illustration (lithograph crayon), **111**; *The Corpus Christi Procession*, 268; *The Cot*, 287, **289**; *Dock Street Market*, 84, 84n, **87**; *Dramatic Music*, 22n, **23**; *East at Sunset, Kitchen Door*, 263n, **266**; *East Entrance, City Hall, Philadelphia*, xxiii, 51n, **52**; *Fifth Avenue Critics* (etching), xxi, 109n, **110**;

Gloucester Trolley, **234**; *Guadalupe Church, Moonlight*, 263n; *Haidresser's Window*, **180**; *Here It Is, Sir, Hope You Like It* (graphite), **306**; *Hotel Dance, Santa Fe*, 247; *Independence Square*, 43n, **45**, 47n, 49n, 51, 53, 67n, 80n; *The Look of a Woman*, 84n; *Main Street, Gloucester*, 252n, **253**; *McSorley's Bar*, **222**; *Memory* (etching), **103**, 103n, 108; *The Moonstone*, by Wilkie Collins (New York: Charles Scribner's Sons, 1908), book illustration, graphite, 183; *Mother and Daughter, Santa Fe*, 248; *Mountains, Evening*, 248; *Movies*, 225n, 227; *Mr. Gottlieb Storz*, 210n, **212**, 213n; *Mrs. Gottlieb Storz*, 210, 210n; *Music in the Plaza*, 263n, **267**, 268; *Music (Terpsichore)*, 22n; *My Two Friends, Robert Henri and John Butler Yeats*, **205**; *The New Magdalen*, by Wilkie Collins (New York: Charles Scribner's Sons, 1908), book illustration, graphite, 183; *Old Portale, Santa Fe*, 247; *Old Walnut Street Theater*, 43n, **44**, 47n, 49n; *On the Pier* (newspaper illustration; pen, brush, and ink), **12**; *Palace of Governors*, 247; *Pig-Pen-Sylvania*, xxiii, **290**, 290; *Portrait of Robert Henri* (lithograph crayon), 84, **89**, 329; *Renganeschi's Saturday Night*, **221**; *Robert Henri, Painter* (etching), xxiv, **329**; *The Row at the Picnic*, **61**; *Santa Fe Canyon*, 248, 249n, **252**; *Santa Fe Daughters*, 247; *The Saturday Evening Post* (illustration for E. J. Rath's "His Nobler Ambition: Little Wellington Joins de Gang"), lithograph crayon, **111**; *The Sewing Woman*, 67n, **68**, 80n; *Signals*, 290, **291**; *South Beach Bathers*, 150n, **153**; *Squaws in the Dance*, 247; *Stein, Profile*, 138, **139**, 208; *Street in Moonlight, Santa Fe*, 248, **251**; *Sunday, Girls Drying their Hair*, 225n; *Sunday, Women Drying their Hair*, **226**; *The Town Steps*, 308n, **309**, 310, 311; *Tugs*, **47**, 47n, 49n; *Turning Out the Light* (etching), 109n, 112; *Twelve Apostles*, 248; *Twenty-Fifth Wedding Anniversary* (etching), xxiii, **314**, 314, 315n; *Two Girls of Santa Fe*, 248; *Two Senoras*, 268; *Une Paysane* (newspaper illustration by Sloan of a Henri painting; pen-and-ink), **25**;

Sloan, John (*cont.*)
 Violin Player, 84, **90**, 92n; *Wet Night on Broadway,* 209n, **211**; *Woman and Butterfly* (pen, brush, and ink), **17**; *The Women's Page* (etching), xxi, 109n, **110**, 112; *Yeats at Petitas',* 203n, **206**; *The Young Mother,* 55n
 —studios of, in New York: Sherwood Building (57th Street and Sixth Avenue), 80, 92, 96; 165 West 23rd Street, 97, 129, 149, 168; 35 Sixth Avenue, 213; 88 Washington Place, 276n, 279, 295n
 —studio of, in Philadelphia: 806 Walnut Street, 3, **6**, 7, **11**, 18–20, 27, 35, 41, 51, 67, 74n
 —studios of, in Santa Fe: 105 Johnson Street, 258; Studio Building, 265; Calle Garcia N., 108, 258–61
 —as teacher, at: The Art Students League of New York, 295n; The Charcoal Club, Baltimore, 298; Maryland Institute of Art, Baltimore, 295; New York School of Art, 97, 101, 104, 107, 108, 109, 112, 115, 117, 133, 175, 176; Pittsburgh Art Students League, 149–51, 169
Sloan, Mariana "Nan" (sister), 13, 20, 21n, 50, 119n, 275
Smedley, William Thomas, 100
Smolin, Nat, 283
Sneddon, Robert, 203
Society of American Artists, 48–49, 98, 100, 283n; amalgamation with the National Academy of Design, 106, 107n, 138; annual exhibitions of, 49n, 84, 85n, 102, 104, 115, 299
Sotter, George William, 56, 99
Southrn, Frank (John A. Cozad, Henri's brother), 11n, 16n, 137n, 269
Southrn, Jane (Mrs. Frank, Henri's sister-in-law), 137n
Spanish-American War, 32
Speicher, Elsie (Mrs. Eugene), 271n, 327n
Speicher, Eugene, 196, 270, 271nn, 274, 326, 327
Sprinchorn, Carl, 138
Stein, Eugenie, 94n, 208
Stephenson, Byron, 99, 100
Stern, Nat, 273
Sterne, Laurence, 165, 170, 171
Storz, Gottlieb, 210n, **212**, 213n
Synge, John Millington, 217

Taft, William Howard, 183, 184
Tchaikovsky, Peter Ilich, 282
Third Class Carriage, 37
Thomas, Jacque, 310
Thompson, Kennedy, 299
Thouron, Henry T., 22
Thurnscoe School of Modern Art, Ogunquit, Maine, 229n
Tittle Walter, diary of, 70
Toch, Maximilian, 232n
Town Topics, 80
Tucker, Allen, 327

Ufer, Walter, 326
Ullman, Mr. and Mrs. Albert E., 138n

Valdes, George, 304
van de Venne, Adriaen, **147**
Vedder, Eliju, 69
Velasquez, xx, xxii
Veltin School, New York, 41

Wall, Anna Maria. *See* Dolly Sloan
Walsh, William S., 121n
Walton, Izaak, 116, 117
Ward, Cabot, 226
Watson, Forbes, 288, 327
Weir, J. Alden, 225
Western Pennsylvania Exhibition Society, Pittsburgh, 14
Whistler, James Abbott McNeill, 36
Whitman, Walt, xxi
Whitney, Gertrude Vanderbilt (Mrs. Harry Payne), 177, 229, 310, 311, 327
Widow Cloonan's Curse, The, 34, 38n
Wiles, Irving, 100, 327
Williamson, Charles S., 9, 31n, 38n, 100
Winter, Alice (Mrs. Charles), 274n
Winter, Charles, 235, 274n
Woodbury, Charles H., 225
Woostock, New York (artists' colony), 270, 271nn, 274, 276n, 326
Worcester, Massachusetts, Art Museum, 169
World Exposition, Paris (1910), 33n
World War I, 233n, 237n

Yellow Book, 270, 288
yellow journalism, 65
Yellow Kid, The, xxi
Yeats, John Butler, 203, 219, 302